Up-helly-aa

Up-helly-aa

Custom, culture and community
in Shetland

CALLUM G. BROWN

MANDOLIN

The right of Callum G. Brown to be identified as the author of this work has been asserted by him in accordance with the Copyright, Designs and Patents Act 1988.

Published by Mandolin,
an imprint of Manchester University Press
Oxford Road, Manchester M13 9NR, UK
and Room 400, 175 Fifth Avenue, New York, NY 10010, USA

Distributed exclusively in the USA by
St. Martin's Press, Inc., 175 Fifth Avenue, New York,
NY 10010, USA

Distributed exclusively in Canada by
UBC Press, University of British Columbia, 6344 Memorial Road,
Vancouver, BC, Canada V6T 1Z2

British Library Cataloguing-in-Publication Data
A catalogue record for this book is available from the British Library

Library of Congress Cataloging-in-Publication Data applied for

ISBN 1 901341 07 0 *paperback*

First published 1998

05 04 03 02 01 00 99 98 10 9 8 7 6 5 4 3 2 1

Typeset
by Graphicraft Limited, Hong Kong
Printed in Great Britain
by Redwood Books, Trowbridge

Contents

Contents

List of illustrations

Preface

This book is about tradition and culture. At the end of the second millennium, ritual calendar customs seem out of place, disconnected from the medieval or early-modern society which must, we feel, have given birth to them. This is as much a problem for the historian as for the casual observer. Ritual masquerade in outlandish costumes and annual homage to long-dead heroes of myth and legend seem infantile habits for the grown men of Shetland who work in high-tech industry, carry mobile phones and use the Internet as a prime means of communication in an island archipelago. More worrying for all but the most passionate of enthusiasts, such events seem to have little bearing either on 'real' customs or 'real' history. Customs like Up-helly-aa seem travesties of the history they purport to portray and of the customs of their ancestors.

Many historians dismiss such customs as 'inventions' of the Victorians who, with their obsessions for social order and tradition, replaced the 'real past' with synthetic history better to control the plebeians of the machine age. But 'tradition' is a slippery eel of a concept, for it is an innately 'contemporary' thing. Tradition is only tradition if it has resonance in the present day, and that resonance changes as people find new things from the past, new myths by which they can derive feelings of belonging and identity. This book is about that process. It peels back the layers of 'reality' surrounding Britain's premier winter custom, tracing its roots over nearly four centuries. This is not an exercise in debunking 'myth' – some alleged community lie about its past – but an exploration of how a community's deepest heritage is preserved and celebrated through every invention and transformation of custom. A community ritual of the late twentieth century may appear to be a pastiche of a custom from the fifteenth or sixteenth century, but in fact it is something deeply modern.

As a 'sooth-moother', I was introduced to Up-helly-aa by my former student Bill Steele as a recreational outing, little realising that the hospitality of Karen and the enthusiasm of their children Gavin, Adam and Duncan would lead to a book. Residents of Ultima Thule, and others, have been unfailingly kind: amongst them, my oral-history respondents (some of whom are anonymous, the others acknowledged), George Dixon (formerly Stirling Archivist), Angus

Johnson (the Assistant Shetland Archivist), Trudy Mann (North Highland Archive in Wick), Charles Manson (Secretary to the Up-helly-aa Committee), Ian Tait (Shetland Museum), and the others to whom I spoke informally or who lent me materials. I am indebted to Bronwen Cohen and Jonathan Church for permission to quote from their unpublished theses, and to Lynn Abrams, Robert Poole and Brian Smith for reading earlier drafts and trying to save me from conceptual and factual errors. Most of all, Lynn's personal and professional support has been a bulwark during my obsession.

My debt to Brian Smith (Shetland Archivist) goes well beyond the normal bounds of an historian's gratitude to an archivist. He challenged and stimulated me in interpretation all the way, and his contribution will become evident in the notes throughout the book. He was unfailing in his help, opening his personal files to me, running searches on his admirable computer index, and sending me contemporary and historical sources whenever he found them. Any strength this volume has owes much to him, whilst the flaws are entirely mine. He should have written this book.

Note on the calendar

Recent European peoples have had two available calendars: the Julian and the Gregorian. In 1600 the Scottish Privy Council ordained the adoption of the Gregorian calendar, whilst it was not until 1752 that the British parliament made this change for the new United Kingdom as a whole. The effect of this calendar reform, as enacted in 1752, was the removal of eleven days (between 3 and 13 September inclusive), for reasons of greater astronomical accuracy and so as to bring this country in line with Europe. The consequence was that Christmas and New Year were 'officially' brought forward by eleven days, but many communities – perhaps most – resisted this by continuing to celebrate those occasions on their accustomed days: these were now 5 and 12 January respectively (with the date of Twelfth Night moved back by the same eleven days to 17 January). To confuse matters, the gap between the two calendars widened to twelve days in 1800 (and to thirteen days in 1900), and places in Shetland, as elsewhere, celebrated 'old Yule' on either 5 or 6 January.

In the text that follows, the customary convention is adopted of indicating Christmas (or Yule) and New Year celebrated under the old calendar as Old Style, or 'OS' for short, whilst the new dates for those occasions (on 25 December and 1 January, with Twelfth Night on 6 January) as New Style, or 'NS' for short.

I am indebted to Robert Poole for advice on calendar change.

Abbreviations

NS New Style (dates for Christmas and New Year: 25 December and
 1 January – see 'Note on the calendar')
OS Old Style (dates for Yule and New Year: 5 and 12 January – see
 'Note on the calendar')
SA Shetland Archive, Lerwick
SOHCA Scottish Oral History Centre Archive, Department of History,
 University of Strathclyde, Glasgow

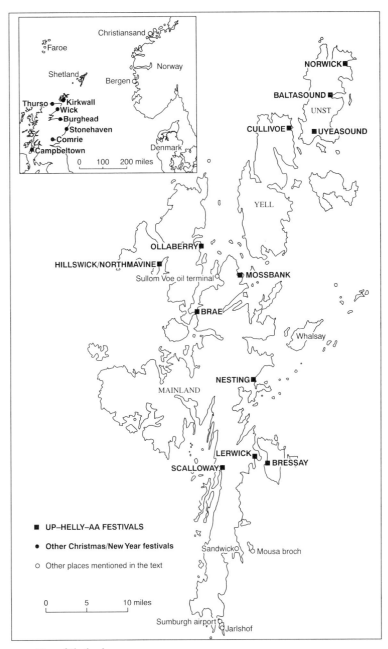

Map of Shetland

1

The festival of Up-helly-aa
in the 1990s

A NIGHT-TIME army of a thousand men march in lavish costumes of masquerade with huge flaming torches, singing praise to medieval Norse heroes as they draw a Viking ship to its ceremonial funeral pyre. This pageant takes place in the 1990s in a highly sophisticated modern society, but it is a moving tableau of a world we have lost. Before industrialism and nation-states were formed, the ritual year of local calendar customs was the backbone of popular culture, conferring belonging and identity upon people in their own communities. Some customs were transformed by state patriotism and liberal revolutions into national rituals and public holidays, whilst many others withered and died from municipal disfavour or popular apathy in the late nineteenth century. But though reduced in number, local calendar customs are still to be found across Europe. In certain places at one point in the year, winter or summer, the community comes together in a ritual celebration – a parade of the village bounds, a carnival of masks, or a casting of flags – whose form is claimed as 'traditional' and 'time-honoured'. Amongst the winter customs of Europe in the late twentieth century, Up-helly-aa in Shetland is the most stunning. The Viking ship and Norse warriors are icons of island identity, conveying power and machismo, and marking a robust and passionate patriotism for community.

Calendar customs are defined by two things: the seasons and ritual. Summer is majestic in Shetland, where a dialect phrase, the 'simmer dim', describes the special quality of the twilight at midsummer; so close to the Arctic, the days are long and the sun lights the night sky from below the horizon. But this community places its central festival not in sweet summer, but in dark and foul winter. At the time of Up-helly-aa in late January the sun rises at 8.35 a.m. and sets at 4 p.m., with heavy cloud reducing adequate light to between mid-morning and early afternoon.[1] During the thirty-one days of January in 1995, the island capital

Lerwick had gale-force winds on nineteen days, sleet or snow on fifteen, air frost on thirteen, and rain on twenty-nine.[2] In the vastness of the Northern Atlantic, the twenty-three thousand Shetlanders are the most northerly, the most exposed and the most isolated community of the British Isles. It is emblematic that they place Up-helly-aa in their winter gloom.

If the calendar custom is framed by its season, it is governed by its ritual – by the annual replication of a 'traditional' festival liturgy. The ritual has to be observed with precise rectitude, its leaders a priesthood under yearly scrutiny from the laity for evidence of heretical deviation. Ritual is the engine for custom, the motivation for a community to invest its time, money and passions in celebrating itself, the propulsion which gets people out of their homes in all weathers to parade or cheer. Ritual is the very essence of 'tradition'. If there is no ritual, there is no custom.

Up-helly-aa is short in duration, but its liturgy of ritual is long.[3] It starts early in the morning of the last Tuesday in January when a large placard known as the 'Bill' is attached to the Market Cross in the centre of Commercial Street in Lerwick. In it the 'Guizer Jarl' proclaims the calling of Up-helly-aa and takes the opportunity to make satirical and near-defamatory remarks about many local people. It is the collective product of a 'Joke Committee', and its lampooning humour on local affairs is eagerly read by groups huddling in the wind. It is signed at the bottom by the Jarl and bears his seal with the words 'We axe for what we want'. The Bill is an extraordinary thing for the visitor and incomer. 'The first time I saw the Lerwick Bill at the Market Cross,' recalled a new arrival from England, 'if this had been my home town, writs would have been flying like autumn leaves. I had never seen anything quite like it.' The Bill affirms the community, recording its major events of the previous twelve months. But it is also a test of belonging: 'I must admit that the first time I realised they were talking about me I was rather taken aback. . . . If you live in Shetland, you've got to come to expect that something you do in the year will be recorded in the Up-helly-aa Bill.'[4] Recourse to the law of defamation is sometimes threatened, especially by civic officials who are satirised in the Bill, but 'cocking the snook' at authority is fundamental to this calendar custom.

As the winter sun rises, there is activity half a mile away in the dock area of town. A group of forty-three men, including a handful of boys, gather in spectacular Viking dress, with horned helmets, chrome breastplates, leather waistcoats and carrying large shiny axes and shields. At their head is the Guizer Jarl himself, a local man (but never a woman) who has been appointed to this revered position for the year. He is

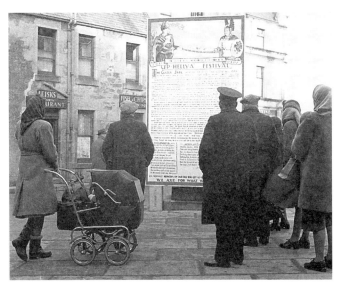

1 Up-helly-aa Bill, 1949. The scene at the Market Cross in the middle of
Commercial Street, Lerwick, on the morning of the first Up-helly-aa after the war.
Since the 1890s, the Bill has been eagerly read by Lerwegians for its satirical, and
often close to defamatory, mockery of local people and events. (Courtesy of
Shetland Museum)

dressed in the most striking costume with a chain-mail vest of chrome
medallions upon a leather tunic, sheepskin epaulettes with chrome but-
tons on his shoulders, and on his head a chrome helmet with plumes of
black feathers. For armament, the Jarl (pronounced 'yarl') wears a dag-
ger in its sheath, a 4-foot axe hanging at a jaunty angle through his belt,
and on his left arm a shield of aluminium and chrome illustrated with a
black raven. Bearded and fearsome, the Norse warrior is on parade.

Led by the Scottish pipe-and-drum band of the town's British Legion,
the Vikings start a day-long procession round the town, waving their
axes and shouting grunts of warlike greeting to the hundreds of cheering
onlookers. At various stages en route, they sing *The Up-Helli-Aa Song*:

> *From grand old Viking centuries Up-Helli-Aa has come,*
> *Then light the torch, and form the march, and sound the rolling drum;*
> *And wake the mighty memories of heroes that are dumb;*
> *The waves are rolling on.*
> Chorus:–
> *Grand old Vikings ruled upon the ocean vast,*
> *Their brave battle songs still thunder on the blast;*

Their wild war-cry comes a-ringing from the past;
We answer it 'A-oi!'
Roll their glory down the ages,
Sons of warriors and sages,
Where the fight for Freedom rages,
Be bold and strong as they![5]

They call first at a shopping centre and the British Legion Club for ex-servicemen, where gifts of model Viking ships are exchanged. The Vikings march to the Market Cross, past the Jarl's proclamation, and then turn along Lerwick's main thoroughfare, Commercial Street, to a photo-call at the pier. They climb on board a mock Viking ship known locally as 'the galley' which, with colourfully painted dragon head, shields, and mast with crow's nest, rests with furled sail on a wheeled float on the pierhead.

Our galley is the People's Right, the dragon of the free,
The Right that, rising in its might, brings tyrants to their knee

As hundreds of onlookers watch, the squad of men is photographed standing in the galley in fighting pose, waving their axes in the air. The photo-shoot over, they reorganise and march off to the sound of the pipe band playing 'Scotland the Brave', heading up the hill out of the old town towards the headquarters of the Shetland Islands Council.

On the flagpole atop the town hall flies a large red flag with the image of a black raven.

In distant lands, their raven-flag flew like a blazing star;
And foreign foemen, trembling, heard their battle-cry afar

At precisely eleven o'clock the squad of Vikings enters the council chamber, still singing and waving their axes, and settle down with councillors, wives and guests to speeches from the Council Convenor, the Lord Lieutenant of the County (the Queen's representative) and the Jarl. The Norse costumes make a striking sight in the dark-panelled council chamber, and match the Viking themes in the stained-glass windows. A toast is made to Måløy, a village in Norway occupied like the rest of that country by the Nazis during the Second World War, which donated a silver cup to commemorate Shetland's role as a seaborne resistance base.

By the middle of the day, the squad of Vikings is continuing its tour with visits to old folks' homes and to primary schools in the town. The schools are bedecked in drawings and paintings of Vikings, galleys and shields, and each child – girls as well as boys – is dressed in a paper helmet with horns and a tunic, and is holding a shield, an axe and a

paper imitation of a flaming torch. The children sit transfixed in the middle of the school-hall floor, whilst the squad of men encircle them and sing *The Up-Helli-Aa Song* in robust and stentorian tones.

> *On distant seas, their dragon-prows went gleaming outward bound;*
> *The storm-clouds were their banners, and their music, ocean's sound*

The children in their turn sing the song back, word-perfect from practice year after year. Later in the day, older children from primary 7 (11–12-year olds) and the secondary school will take part in the junior Up-helly-aa with their own Guizer Jarl and his squad of Vikings. The children have been 'high' with excitement for weeks, and now that the day is here they are wide-eyed in wonder.

As the Vikings' tour comes to a close in the afternoon, Lerwegians are starting to forgo the pretence of normal work. Lerwick is coming to a standstill, as hundreds of men disappear to make preparations for the night. Coaches and container lorries are emptied of their normal loads, whilst schools and community venues around Lerwick are made ready by clearing away desks and chairs and lining up hundreds of cups, saucers and plates. Vast quantities of sandwiches and cakes are prepared, and thousands of cans of beer and bottles of liquor of all kinds are procured and secreted in various locations.

In the darkness of evening, at 6.50 p.m., groups of people start to collect in Prince Alfred Street and round the corner into Lower Hillhead Street. In addition to the squad of Vikings there are more than nine hundred other figures dressed in a wide variety of weird outfits: squads of pink elephants, American footballers, nuns, 'black and white minstrels', and one group of '101 Dalmatians'. In all, there are nearly fifty different squads, each dressed in different outfits, many of them with their faces masked and a few already drinking from cans of beer. Nearly a thousand men – but no women – are out guizing tonight.

The central part of the festival takes less than eighty minutes. Its main feature is fire – and lots of it. The primary combustion comes from a 3 × 4 inch wooden stave, some 4 feet long. Its end has been wrapped in paraffin-soaked sacking and nailed in place, and then grouted with cement to prevent fire spreading to the shaft. This is the torch, which is held above the head either in the hands alone or balanced in a tin can tied at the waist. When set alight, it sends red and orange flames several feet into the air, casting a heat that is felt many metres away, and toasts the head of the man beneath. At the muster, one of these torches is given to each of the thousand guizers. They take up their position by

7.15 p.m. in lines four abreast, and the Guizer Jarl passes up the ranks accompanied by the brass band playing a tune written especially for him each year. At 7.30 p.m. precisely, the street lights of the town are switched off, and at the signal of a maroon,[6] the torches are lit. Starting at one end, the flame is passed from torch to torch, the lines of men becoming progressively illuminated in flame like a massive human wick catching light. A roaring sound and the reek of burning paraffin fills the air. The torches held to the ground for lighting create a red fog as the paraffin starts to burn, turning the scene into a hellish haze. But once turned aloft, the torches settle down to yellow flames. In little over a minute, the sub-zero chill of the January night is transformed by the combined heat of the torches.

By the light of the flames, the Viking galley becomes visible, set on top of a large float and surrounded by the Jarl's squad of Vikings. The galley is some 30-feet long and strikingly adorned. At its bow is a dragon's head and behind it a pole topped by a wooden sculpture of a man's hand, painted red and pointing skywards. In the middle the white square-rigged sail is unfurled on the mast, and bears the motif of the black raven, while along the gunwales rest more than thirty painted shields, neatly overlapped and nailed in place. At a signal, the brass band strikes up the tune of *The Up-Helli-Aa Song* and the assembled guizers join in with the words. The Guizer Jarl and his men take up position in front of the galley, whilst the remaining fifty squads counter-march past them to fall in behind in a double crocodile line.

The galley and its honour guard move off to process for nearly an hour through Lerwick's suburban streets high above the harbour. Though snow lies on the ground, the night is now warm from the fiery torches. Seen from afar, the effect is that of a huge, luminous orange snake constantly coiling and uncoiling as the procession of galley, men and torches takes turns left and right in the tree-lined avenues in front of the town hall. Thousands of spectators line the streets, children hoisted high on adults' shoulders. This is the first sight of the guizing outfits, for they have been strictly guarded secrets, known only to the Up-helly-aa Committee, which has authorised the costumes and prevented duplication. Some guizers with large padded outfits find walking difficult, and are being roasted in layers of foam and fabric with a torch above their heads. But this is the night of Up-helly-aa, and it is expected that guizers should bear the discomfort and keep their masks on.

The procession moves round six streets in the gridiron of Lerwick's late Victorian 'new town' in front of the town hall. As they march, the

guizers sing *The Up-Helli-Aa Song*, and after an hour or so they reach their destination. The galley is brought to a halt in the middle of a small park in front of the town hall, and the one thousand torch-bearers curl around the ship in a circle some twenty deep. Another maroon is fired and, whilst they march round it, *The Galley Song* is sung:

> *Floats the raven banner o'er us,*
> *Round our Dragon Ship we stand;*
> *Voices joined in glad-some chorus,*
> *Raised aloft the flaming brand.*
> *Every guizer has a duty*
> *When he joins the festive throng;*
> *Honour, freedom, love and beauty*
> *In the feast, the dance, the song.*
>
> *Worthy sons of Vikings make us,*
> *Truth be our encircling fire:*
> *Shadowy visions backward take us*
> *To the Sea-king's funeral pyre.*
> *Bonds of Brotherhood inherit,*
> *Over strife the curtain draw;*
> *Let our actions breathe the spirit*
> *Of our grand Up-Helli-Aa.*[7]

In the middle, the Guizer Jarl stands on the galley and calls for 'three cheers for the boys who built the galley', then three more cheers 'for the torch boys' and, finally, three cheers for Up-helly-aa. Someone else calls for three cheers for the Guizer Jarl. As he climbs down, a bugle call sounds, and at its last note the squads of guizers start to hurl their torches into the galley, falling back to let the others come forward to throw theirs in turn. One thousand torches are forming a dome of converging arcs against the night sky, landing like flaming artillery inside the ship. The ropes and sail catch fire quickly, and then combustion takes a hold in the wooden hull. When the mast is burnt through and falls, a cheer goes up, but the red hand still points upwards, silhouetted amidst the fire. When all the torches have been thrown, the guizers re-form into a circle around the galley, and amidst the crackling of the 30-feet flames they sing *The Norseman's Home*:

> *The Norseman's home in days gone by*
> *Was on the rolling sea;*
> *And there his pennon did defy*
> *The foe of Normandy.*

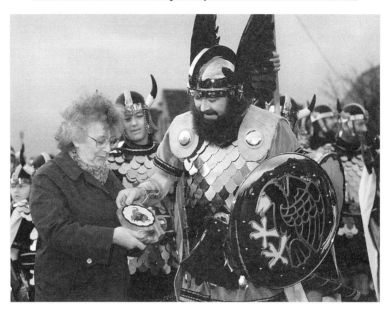

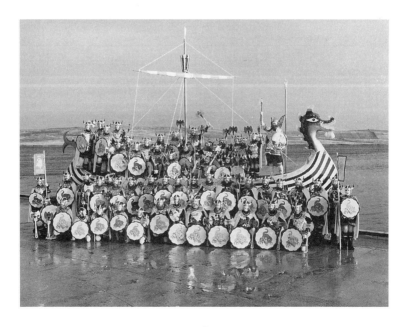

*Then let us ne'er forget the race
Who bravely fought and died;
Who never filled a craven's grave,
But ruled the foaming tide.*[8]

As the guizers break ranks and mill around the flaming timbers, the Guizer Jarl is congratulated by his squad members and shaken by the hand. Photographers and camera crews move him into position to be captured, with axe aloft, against the backdrop of the burning galley. It will burn for many hours and smoulder till morning, but after lingering only a few minutes, the people turn their backs to leave. They are heading off to party the night away.

The public festival is over, but the community's ritual is not. When the guizers and the spectators leave the scene of the galley-burning, they go to prepare for social events which take place throughout Lerwick. From around 9 p.m. until 8 a.m. the following morning, a significant proportion of the people of Lerwick, together with many from the 'country' (that is, other parts of Shetland), expatriates returned for the festival and visitors, collect to socialise in a very ritualised way. These events are not called 'parties' or 'dances', but are referred to as 'the halls'. Twelve locations are utilised, including schools and public halls. To each hall, a host and hostess have issued invitations to those people – mostly local and the majority women – who have not been guizers earlier in the evening, and these in turn are allocated 'duties' to perform during the night's proceedings. A highly organised and what might be described as 'respectable' evening unfolds, accompanied by light meals, sandwiches and tea served continuously through the night until dawn. At each of the halls is a dance floor and Scottish country dance band, and from around 9.30 p.m. onwards each of the fifty squads of guizers

2 (Opposite above) The Guizer Jarl and his mother. The cuddly warrior. The Jarl's squad stops outside the house of the Guizer Jarl's mother, where he presents her with a shield to commemorate the day. It is common practice for squad members to present brooches and jewellery fashioned from the materials and motifs of that year's squad outfit to wives, mothers and daughters. The outfits are made of the finest quality material – including chrome, hide, leather and aluminium. (Courtesy of Malcolm Younger)

3 (Opposite below) The Jarl's squad on Lerwick Pier with the galley. This is a formal pose on the morning of Up-helly-aa, and is the most common and enduring image of participation for members of the Jarl's squad. Each Jarl adopts a Norse hero's name for the year, and this is borne on his standards. Every man must sport a real beard, with only the young boys exempt. (Courtesy of Malcolm Younger)

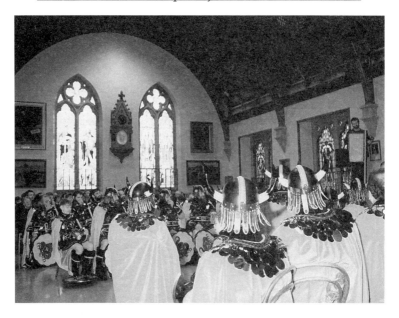

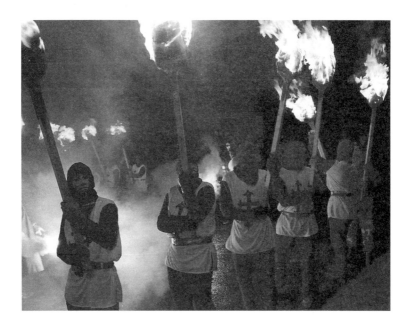

arrives at each of the twelve locations in turn. They make an entry in their guizing outfits onto the dance floor to applause from the audience. The squad leader is formally received by the host and hostess, and he and his men are invited to perform a 'skit' or short dramatic performance. These skits reveal the intent of the particular guizing outfit which each squad is wearing. Some of the sketches are little more than homages to some cartoon character, pop star or public figure, performed to live music played by an accordionist or fiddler in the squad, or accompanied by pop music from ghetto-blasters. Though some of the squads are under-rehearsed, many of the skits are clever, taking the form of satirical narratives about local people and events – including those in public positions like the Chief Executive of the Shetland Islands Council. It is biting, incisive wit, sometimes seemingly merciless. Community scandal and gossip – from suggestions of corruption to sexual impropriety – are given public performance in each of the twelve halls. In 1994, members of one squad, dressed as nuns, enacted sexual seduction of a council official in reference to allegations of preferential treatment over a nunnery's planning application. In another year, squad members were dressed as white elephants; one person recalls: 'The white elephant was a comment on the Islands Council's building an oil-rig repair yard. It costs millions to build, and there had never been an oil rig near it.'[9] One entire squad in the 1990s consisted of guizers all dressed up as a local politician; he was furious, and his wife 'slapped the faces of the squad members'.[10] Like the Bill at the start of the day, squad-guizing is a critical personal test for local people. One incomer recalled that when he stood for the local council, an entire squad dressed up to look like him.[11] Such jokes are much appreciated by the audiences in the halls, and the laughter is loud.

After a squad has performed its sketch, the host and hostess invite the squad leader to choose a dance, and the guizers then select women

4 (Opposite above) The Jarl's squad in Lerwick Town Hall. The splendour of the civic reception on the morning of Up-helly-aa, when both the Shetland Islands Council convenor and the Guizer Jarl drink from the Måløy cup to commemorate Shetland's help to the Norwegian resistance during the Nazi occupation. The Town Hall was constructed during the Norse cultural movement of the early 1880s and the main hall echoes a Viking long-house with depictions of Norse heroes. (Courtesy of Malcolm Younger)

5 (Opposite below) A squad with lit torches. Almost a thousand guizers light up their torches at the start of the procession. The guizers are grouped in fifty 'squads', each with a different disguise which is being publicly unveiled for the first time, and whose purpose will be revealed in dramatic 'skits' to be performed at the 'halls' during the night. (Courtesy of Malcolm Younger)

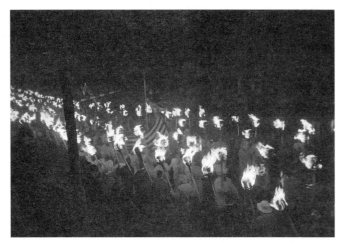

6 The torch procession. The guizers and galley wind their way round the streets of Hillhead above the old town and in front of the Town Hall. (Courtesy of Callum Brown)

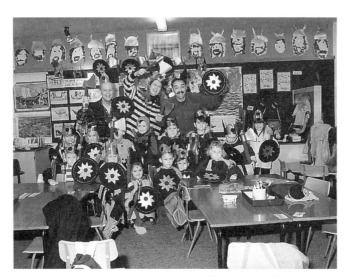

7 A Lerwick primary school classroom scene. Each January, children spend considerable time learning of Up-helly-aa and Shetland's Norse past. On the morning of the festival, the Jarl's squad will visit, and festival songs will be sung, whilst older boys will participate in a Junior Up-helly-aa an hour before the main event. (Courtesy of Malcolm Younger)

from around the hall for the St Bernard's Waltz or Strip the Willow. Guizers dance in their masks, though most women seem to know their partners. Afterwards, if things are running to schedule, there may be time for some socialising and drinking by the visiting squad, and perhaps some food from the continuously operating kitchens. But the timetable is tight for the circulation of squads around the halls, and one group of guizers may have to fade away to make room for the next. Squads move between the halls in lorries or buses, many fitted out for the night with disco units blaring techno music, forming parties on wheels with stacks of beer and whisky on board. On arrival at a hall, the guizers collect themselves and their costumes and enter with the loudest reception reserved for the Jarl's squad which performs songs from the pantheon of Up-helly-aa tunes. The circulation of guizers takes all night, continuing until eight o'clock in the morning until each hall has received every one of the fifty squads.

The halls are events of striking ritual. They are highly organised, with the host and hostess expected to meet everyone who comes formally, whether guest or guizer. All guests must undertake their share of tasks – perhaps two or three hours of 'work' during the night, with men acting as stewards and women as food-servers in the dining areas. Yet, for all the formality and ritual, there is considerable 'letting down of the hair'. The guests are well dressed for the occasion; the women in particular are – in the parlance of both many men and women locally – 'dressed to kill'. Some women are awaiting the arrival of a particular squad which contains a boyfriend or husband, and some are waiting to flirt with a guizer. Indeed, there is a sexual potency in the meeting of members of the Jarl's squad in their battle gear with young women in voluptuous short dresses, and after the dances some couples seek private space in a quiet corner of the building. There is a contrast here between formality and informality. Some of the halls are licensed premises and a few have reputations for 'saloon' behaviour and considerable sexual licence. But other halls are, in a formal sense, teetotal events with no alcohol consumed in the public areas; this applies especially in the schools where the terms of the let to the host and hostess tend to dictate a rigorous prohibition. However, even in such halls there is a secluded room (such as the caretaker's office), often quite small, where tables and chairs are laid out in the manner of a pub, and to which arriving guests repair to deposit plastic bags containing bottles and cans of beer and spirits. During the evening, the guests go every so often to this room to have a drink, and then return to the dance floor and the

dining areas for jigging and sustenance. In this manner, the halls contain apparent contradictions of sobriety and propriety on the one hand, and drink and release on the other.

The day following Up-helly-aa night – the Wednesday – is a local public holiday in Lerwick. The town is quiet, shops are closed, and little stirs till evening when there is a Guizers' Hop. Despite its name, it is not an event in guizing outfits, but a standard dance with the Guizer Jarl as the guest of honour. Meanwhile, the galley has been reduced to ashes and is but a circle of charred ground in the public park. The guizing costumes have done their work, and are stored in homes as mementos; they can never be worn again at Up-helly-aa, as that is strictly forbidden. Only the Jarl's squad outfits are likely to be seen again, for they may be called upon for some public event or tourist extravaganza during the summer months. On Thursday, the town returns to work. However, the ritual is not yet over.

Festival, geography and the calendar

Every year since 1873 (excluding wartime) the people of Lerwick have met to celebrate Up-helly-aa. Whilst other communities in Scotland and England have winter fire festivals (including other communities in Shetland), none can match the Lerwick Up-helly-aa for its scale, the vigour of its modern celebration or its significance to the local people. Geography seems to add to the importance of the event. Shetland is an archipelago of islands, with Lerwick situated on 'Mainland' – a long and bizarrely shaped island with highly varying landscape ranging from moorland, peatbog and sandy tombolos, to fjord-like inlets or 'voes'. Mainland is surrounded by more than a hundred smaller islands, fifteen of them inhabited. Shetland is the most northerly part of the United Kingdom, depicted for cartographic convenience on many maps of Britain as a little box lying just off Aberdeen, or on others bordering on invisibility at the northern edge. Lying some 120 miles north-east of mainland Scotland, they are closer to Oslo, the capital of Norway, than to London. From Edinburgh, Scotland's capital, it is quicker by air, land or sea to almost anywhere in Western Europe than it is to Shetland. The ferry upon which the islands depend for the import and export of basic foodstuffs takes over fourteen hours from Aberdeen, and an air flight takes longer (and is more expensive) between Shetland and London than between London and most European capitals. Modern telecommunications, television, radio and the Internet lessen the isolation, but

heighten the sense of being at Britain's periphery. Shetland is in the United Kingdom, yet very far from it.

Local custom and ritual like Up-helly-aa seem appropriate in that geographical position. This does not mean than calendar rites will automatically exist in isolated places, for there are many island communities in Britain where no such customs exist in winter or any other season in the late twentieth century. There is no rule which equates island isolation with calendar customs. Indeed, where winter fire festivals exist elsewhere in Britain, they tend to be located in coastal or rural towns or villages which enjoy overland communication with adjoining areas. Lerwick Up-helly-aa is different because it has not only survived the twentieth century, but has thrived – the number of participants nearly tripling in the last ninety years. The climate and the darkness of January are also important. The weather can be savage for Up-helly-aa, but the guizers defy it all: as the festival programme proclaims in bold italic letters every year: '*THERE WILL BE NO POSTPONEMENT FOR WEATHER*'.

The brevity of the festival on one evening in January is not unusual in the history of calendar customs. In pre-industrial society, calendar customs were numerous and widespread, if not universal. They were inherent elements in the social order, the rhythm of the year imposing what one historian has described as 'perpetual patterns' upon calendar customs: 'a yearning for light, greenery, warmth, and joy in midwinter, a propensity to celebrate the spring with symbols of rebirth, an impulse to make merry in the sunlight and open air during the summer, and a tendency for thoughts to turn towards death and the uncanny at the onset of winter.'[12] However, customs in the twentieth century have certainly resisted those perpetual patterns. The big difference between calendar customs in Britain now compared to two, five or ten centuries ago is that, with the exception of modern national celebrations like Guy Fawkes and the 'mass culture' of Christmas, there tends to be only *one* calendar custom worthy of the name in a single place. In the society of pre-industrial and early industrial Europe, a community's year was traditionally composed of a *series* of customs dotted throughout the calendar, collectively marking the seasons, economic events and occasions of important religious or local rites. In the twentieth century, localities in Britain rarely have a calendar of customs: most often only a single custom in the calendar, if they have one at all, that can be described as a community event.

At the same time, modern community festivals like Up-helly-aa tend to be more or less distinctive to one community or, at most, a

group of communities. A community in twentieth-century Britain is often known for its single custom, and the existence and nature of that custom becomes the emblem of the place – an emblem which is promoted by the tourist board and covered by national television and press as a seasonal curio, especially if, like Up-helly-aa, it is photogenic. In Shetland, the Viking galley emblem is everywhere: on tourist association badges in bed-and-breakfast houses, in advertisements for Shetland businesses and products, and in the crest of the Islands Council. The image of the Viking warrior is similarly used, advertising pubs and fish-and-chip shops, and giving its name to Lerwick's new bus station. On the last Wednesday of January, most Scottish and some British newspapers carry a photograph of Up-helly-aa the night before, and Scottish television news will show a thirty-second item on it. Similar coverage extends to other single and singular calendar customs from around Britain, including neighbouring Orkney where the Christmas Day and New Year's Day 'Ba' (or ball) game of traditional pre-rules street football at Kirkwall gets the same press treatment each year. By the end of the twentieth century, a calendar custom is something by which a community is identified, principally for its curiosity.

The commemoration of such customs in the wider public domain is important. The Lerwick Up-helly-aa, the Kirkwall 'Ba' game, and the summer Common Ridings of the Border towns of Scotland join a rich variety of similar events in England and Wales as icons of a world we have lost. For those not within those communities, responses and reactions may be extremely varied. Many of us see them as hangovers of a less urban and less commercialised age, gratifying but curious survivals of a time when communities were more harmonious and strongly bound. For others, including some professional historians, such festivals are the object of metropolitan derision, the dressing-up in guizing outfits the devotions of regional peoples sadly lacking in sophistication and historical knowledge, and perhaps not long from a peasant condition. It is all the more interesting for us, perhaps, because these are customs of our own country – a modern, high-tech society in which guizing, parading and ritual singing seem out of place. Most important of all, contrary to the notion of perpetual patterns, Britain is a country like many others in which the impact of seasons upon people's lives has mostly disappeared. The modern workplace has eroded variations in light and weather, and the seasonality of the domestic environment is evened out by central heating and electric light; even those recreations which are traditionally seasonal (like tennis and sun-seeking holidays)

are made aseasonal (or at least not seasonally confined) by sports centres and international airflight. Modern society has done much to break down the 'perpetual pattern'; where it seems to survive, it strikes many as a window on the past.

In those respects, the modern calendar custom is a different 'thing' from the equivalent calendar custom of earlier periods in British history. But is it the same 'thing' to the community concerned? Is there a continuity in content and meaning within the calendar custom of a locality? In one vital respect, it is very different. In those places like Lerwick where a calendar custom has grown in scale to be a major modern 'festival', the significance of the occasion spreads around the calendar. Though the public event of Up-helly-aa lasts less than an hour and half, its sheer scale and complexity reveals a level of preparation that requires attention to it by large numbers in the community stretching back long before the night of celebration in late January. Similarly, to describe Up-helly-aa as a 'winter fire festival' is to diminish its year-round symbolism. Indeed, to describe Up-helly-aa as a calendar custom lends it an inappropriate air, because it is not merely an event but a permanent community institution in some very modern ways.

Festival and community

Up-helly-aa is a man's event. There is a virility and defiance in the night's proceedings, with man and fire pitted against the dark and the winter elements. Women are excluded from direct participation, though there have been rumours over the years that one or two – on one occasion, reputedly, a journalist – have been spirited into the procession concealed beneath guizing outfits. But without apparent equivocation, Up-helly-aa reveres male strength, bonding and ability to organise. In celebrating the community, the event seems to celebrate man alone.

The core images of the festival are of supreme masculinity. Some might perceive a phallic symbolism in a thousand men carrying flaming torches balanced on their loins. The Guizer Jarl and his squad are the very epitome of machismo appearance. There are few images which, certainly to Western eyes, can compete with that of a Viking in horned helmet, breastplate, axe and shield for its evocation of naked warlike intent. British schoolchildren are traditionally exposed in history lessons to depictions of Norse invaders in such outfits coming in Viking longboats in the 'Dark Ages' of the eighth to twelfth centuries. They came in such portrayals to attack Britain's coastal peoples, raping and

pillaging as they went. More recent archaeological discoveries of greater Viking settlement (as distinct from mere raiding) around Britain, and the more sympathetic and sophisticated interpretations given in heritage exhibits such as the Jorvik Centre in York, may be changing popular perceptions. However, for most Britons the Norsemen have been perceived as raiders not as settlers, and certainly not as in any sense 'our forefathers'. Few British people would consider themselves as bearing a Norse lineage in their blood.

But this Norse heritage is portrayed very differently in Shetland, in neighbouring Orkney and in Caithness on the adjacent Scottish mainland. In those places the Norse people are presented in history lessons, community festivals and cultural events as longstay residents, as vital contributors to the human-made landscape, to political and social history, and, above all, to language. The image of the Norseman in those places is not shorn of warlike aggression, but it is an aggression perceived as a vital ingredient of human survival against the sea and the weather. The Viking epitomises the indestructibility of the human spirit against the odds of nature: of survival on the most marginal of agricultural lands, and of valour in tackling the most venomous seas in Europe for the fruits they can offer. For Shetland children, the Norse were their forefathers – if not literally in all cases, then certainly the precursors of the islands' contemporary community. Though Picts, 'Beaker people' and other earlier residents lived there and have left their considerable built environments of fortified brochs, souterrains, cairns and subterranean stone villages,[13] it is the Norse heritage of heroic sagas, individual bravery, and mighty struggles with enemies which dominates the Shetlander's sense of history. The Norse heritage in buildings and archaeological remains is actually extremely poor in Shetland, but, instead, the Norsemen of the Middle Ages become individuals with stirring and 'real' stories. They are not artists' hazy sketches, but have names, certainly the men, and the man who is the Guizer Jarl in the annual Up-helly-aa adopts the identity of a 'hero' for the festival: Earl Thorfinn the Mighty (1975), Magnus Erlendsson (1992), Brúsi Sigurdsson (1996). The heroic deeds of such men are in wide circulation in local Shetland books and culture, and those of the chosen hero for the year are retold at length in *The Up-Helly-Aa Programme*. Shetlanders have a familiarity with 'their' heritage.

The Viking costume of the Guizer Jarl and his squad is warlike in effect but far from authentically fearsome. The squad actually has to perform little in the way of collective physical movement, parading

leisurely without military precision and, except for having to wave axes from time to time, not attempting any synchronised action or simulation of war-like action. The beards, grown by every man in the Jarl's squad, should add to the warrior appearance. Yet, despite their evident pride in parading in their finery, they seem remarkably subdued – almost pointedly peaceable – in their posture. Their armaments are brandished in mock aggression, and in their deportment the Vikings are reassuringly unthreatening. More than anything, perhaps, the Jarl's squad seems endearingly shy – cuddly even, an effect accentuated on hearing their soft Shetland accents. The machismo seems to evaporate.

There is greater potency in male camaraderie. The basis of the festival is the squad, a group of men numbering fifteen or upwards who decide to come together to enter the festival as a guizing group. These are not temporary groups, for they must exist for more than fifteen years before they can become the Jarl's squad and their leader the Guizer Jarl. Entry to the ranks of guizers is available to all those born in Shetland, and to incomers after five years of residency; exception is made for those non-residents who are able to play an instrument in their guizing group.[14] A young man may collect a squad about him and enter the festival, each year in a different outfit, developing a seniority by age of being in existence. Each year in October a mass meeting of guizers seeks nominations for the one vacant seat that has been created by the retirement of the previous Jarl from the fifteen-strong Up-helly-aa Committee. The man so elected knows that in fifteen years' time he will become the Guizer Jarl, and his squad will become the Jarl's squad.

A squad goes through years of development. Normally, each squad has a regular meeting place – somewhere that acts both as a centre for the manufacture of their guizing outfit, and also as a place of drinking. One veteran who has been guizing for more than thirty years and has been in the Jarl's squad three times comments:

> The squad is really a men's club. It started on the last Friday in August, your entry fee was a bottle of whisky. The meetings begin on a social basis when you agree on what you are going to be [in guizing outfit], telling jokes and stories, how you are going to—. It passes the winter. They might meet once a week, getting ideas, depending on how long it takes. Sometimes I've seen us just before Christmas with eleven ideas up on the blackboard and still not decided which one to put in. Therefore you would be meeting most week nights making the suits. If you've got your idea end of September you would have two meetings a week and then three or four when it was necessary.[15]

A squad's guizing idea is submitted to the Up-helly-aa Committee for approval (principally to avoid duplication with another squad), and manufacturing of outfits proceeds. The squad designs its outfits and orders the materials from commercial suppliers – many of whom advertise deliberately for this event in the *Shetland Times*. Most squads make their outfits, though increasing numbers – it is reported by offended purists – have them made up by professional costumiers in mainland Scotland. The costs are high. Each guizing outfit may require £100 to £200 from each man depending on the mode of manufacture and the brilliance of the materials. On top of that, there is the cost of the squad ball – between £1,000 and £2,000 when squad members bear the cost of meal, band and drinks for partners and guests. Then, there are squad suppers and the drinks at squad meetings. Each squad has a barman or steward who is in charge of dispensing drinks, and especially the whisky measures. This is a heavy commitment in time, money and friendship.

The commitments become even heavier for the Jarl's squad. A squad inflates in size – sometimes tripling – as friends and relatives of the Jarl are admitted. Friends from overseas – notably in Canada, Australia and New Zealand – will be invited and will be honoured to join, flying in for Up-helly-aa in January. For the new Jarl's squad, the year begins in the middle of February when it takes over the special residence known as 'The Bunker' in a ceremony with the outgoing Jarl's squad. The expense starts here with the obligatory exchange of gifts, the new squad presenting an engraved silver-plated hip-flask to the retiring Guizer Jarl. From then on, the new Jarl's squad is at work on the design and manufacture of its costume. The aim is to be as lustrous in Viking dress as possible. The materials include chrome, aluminium, hide, leather, wolf or bear skin, and the finest material for the tunic. The cost is in excess of £1,000 per man, plus slightly lower amounts for the small group of boys; many of those who know that they will be in a squad some years in advance will open special personal savings accounts.[16] Costumes are also made for the expatriate squad members who will arrive at Up-helly-aa. In addition to the usual entertainment expenses, the Jarl's squad faces paying for several extras – including the buying and making of gifts for relatives to mark the occasion.

For the Guizer Jarl himself, the costs of holding the post are great. Though his costume is not new, having been passed down from Jarl to Jarl, he has his own trim to add, and may also want to include adornments of brooches or buckles. He also has numerous gifts and mementos to present throughout the year. He has social events to perform all year

long – notably being guest of honour at every one of the fifty squad balls. It is reliably said that the cost of being Jarl in the late 1990s reaches a five-figure sum in pounds sterling, and that some Jarls, on knowing fifteen years in advance of their impending honour, take out special loans and mortgages to fund their year in office. A few informants who deride the seriousness with which the post is taken say that some Jarls, who are often men of modest means from working-class backgrounds, nearly bankrupt themselves and their families in the process. Whatever the truth, there is no denying both the monetary expense and the devotion to the rituals – or fetishes, as some would have it – of creating the finest costume and giving the most notable presents.

The squad is an intense male collective. After Up-helly-aa, each squad holds a 'de-brief' or 'greetin' meeting'[17] which on occasion can involve disciplining a member for some offence – like drinking in the procession; more serious breaches are dealt with by the Up-helly-aa Committee. Each squad has its own rules and punishments, many involving drink, and transgressions can be committed to poetry or song in the squad den. The squad is often described as a 'secret society' and 'drinking club'. 'It was very secretive', one respondent recalls. 'It was worse than the Masons. In fact it's easier to be a Freemason in Shetland than it was for me to get into a squad.'[18] For those who do not join squads, it is usually the drinking customs which either alienate them or make them feel that others see them as 'party-poopers'.[19] Yet, there is little evidence of deliberate exclusion for anyone who qualifies to be a guizer by virtue of being born in Shetland or residing in Lerwick for five years. Upon the squad is erected the structure of much male social activity in the town.

The Jarl and his squad are the embodiment of Up-helly-aa; the galley, however, is the key symbol. It is a properly built clinker boat, 30 feet in length, 6 feet in the beam, and 20 inches deep at the waterline. It is constructed in a modern custom-built warehouse near the harbour known as the 'Shed' by a group of men led by experienced boat-builders. A regular plan adopted several decades ago is faithfully and minutely replicated each year. The work is painstaking, involving the making of ribs and planking, carving of the head, cutting and stitching of the sail, installing the rigging, and the manufacture of thirty or so shields. And all have to be painted to very precise designs. In this, tradition has been long established, and innovation is small and carefully considered. The galley may have to burn, but it has to be a work of craftsmanship. Custom will not allow deviation from either the design or the manner of production, unless by due decision of the all-powerful Committee.

The image of the galley is the most well-known icon of modern Shetland. It forms the instantly recognisable motif of the Lerwick community and of the group of islands as a whole. Seen in relief, it adorns books and calendars, its raven sail motif replicated on many different surfaces; photographs of its burning appear on the front covers of guides to the island. The fact is that Up-helly-aa has become the motif for Shetland as a whole – a development not discouraged by the festival's organisers, and one readily exploited by promoters of tourism in the islands and the Islands Council's corporate identity. This is not to suggest that Up-helly-aa has become a tool of public relations consultants and media hype. Far from it; the organisers jealously guard the 'purity' of the community event, and avoid inappropriate compromises with those who might wish to exploit its name and photogenic appeal. Nevertheless, Up-helly-aa has in the 1990s a business air, a consciousness that visitors to the island wish to know about the event and appreciate its rituals.

Most tourists to Shetland do not see Up-helly-aa, because they come in summer. So, the Shed is opened as a summer museum where a second galley is on permanent display along with the Guizer Jarl's uniform and a selection of the varied costumes of recent decades. Around the walls are shields and banners, as well as old Bills. The most important element in the museum is the photograph collection. On tables around the walls rest massive albums which contain two photographs of every squad – one with masks on and one with masks off – since almost the start of the twentieth century. Each photograph is the same: a posed shot in the manner of a class photograph at school, with squad members in rows standing, sitting or cross-legged on the floor. The pictures were – and continue to be – taken by the official photographer appointed by the organising Committee in the four days before Up-helly-aa. The photo-shoot defines the day by which the costumes have to be ready; it is their first official outing, though the photographs are taken in secret to conceal the masquerade theme until Up-helly-aa night itself. There are literally hundreds of these photographs, possibly as many as fifteen hundred, each containing from ten to forty men – in all likelihood, totalling more than twenty thousand men. Of course, many individuals appear again and again from year to year, but this is a record of the male population of Lerwick – probably the majority of the adult male residents in the town during the twentieth century. Until the 1960s the photographs are in monochrome, showing what are – by modern standards – very amateurish costumes similar to Edwardian amateur dramatic societies, with the men dressed in empire themes of native

22

dress or uniformed soldiers or sailors. As the photographs become more up-to-date, there is a noticeable improvement in the ambitiousness and in the calibre of guizing dress. By the 1970s the outfits become much more professional, and quite capable of passing muster as costumes for film extras. The visitor might become bored and bemused with the fastidiousness of the photograph collection. But Lerwegians have a love affair with posed community photographs; there can be few places in Britain where so many photographs and videos of a local festival (and of other community events) are taken, especially by professionals.[20]

The museum is a modest and casual affair and definitely not a shrine. It fails to convey the year-round significance of the festival. For the male population of Lerwick, being a member of a squad endows a special and unmissable sense of belonging, and possibly as many as two-thirds of those men aged between eighteen and forty participate as guizers in any given year.[21] Few Lerwick men, whatever their social class or status, have failed to guize at some point in their lives, and the occupational composition of the one thousand guizers is probably a good reflection of the male population of the town as a whole. Those in manual and technical occupations predominate, but there is a significant minority of professional occupations, including a teachers' squad composed mainly of those employed at the secondary school and Lerwick's further education college. Most squads are not occupationally based but friendship-based, and tend to include entire male members of extended families. One incomer to Shetland was struck by the varied backgrounds of the Up-helly-aa squad members:

> They were so diverse, I couldn't quite figure how they all fitted together. But the reality was that everybody fits together in Shetland, because there's no ranking because of your income, for example, and there's no ranking because of your job on the other hand because I could go out at night and stand in a pub and that's the council boss standing next to me, talking to a janitor at the school or talking to the man who swept the streets or collected the rubbish. They would all be in the same bar, and everybody would be friendly. And you wouldn't find it strange to be in the same club or the same squad together.[22]

Though Lerwick has many other clubs and hobby societies, Up-helly-aa and its squads weave through many of the social, civil and educational institutions of the community.

Up-helly-aa is a man's affair, but it enfolds women and children within its grasp. Women's active involvement in an 'official' sense is limited: they act as hostesses and provide the bulk of the catering at the

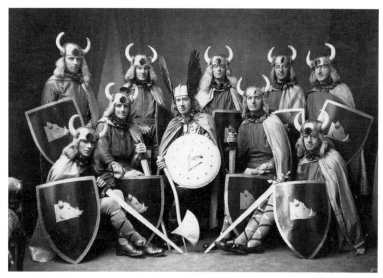

8 The Jarl's squad *c.*1921. The photograph collection held in the 'Shed' provides a unique record of much of the male population of Lerwick during the twentieth century. (Courtesy of the Shetland Museum)

halls on festival night, but beyond that there are no formal functions as guizers or organisers. However, they do take a hand in assisting some squads with the manufacture of guizing costumes; as one woman remarked: 'It's the women that are lying on their knees afore the men sewing up their legs and things like that.'[23] However, it is the children of the community – especially the younger children – with whom the maintenance of Up-helly-aa fervour resides. Children are intimately aware of the preparations that go on within the town, with fathers and brothers involved in squad work for the festival. Up-helly-aa is a major element in the curriculum of the primary schools. In one school, the reception nursery class learn *The Up-Helli-Aa Song* and visit the Galley Shed, and from the age of five the children each year make costumes, photo-collections and pictures, shields, axes and helmets, watch videos of the festival, and do colouring work for guizer costumes. Up-helly-aa is integrated in teaching; it is used to assist the transition from drawing to writing, and, in later years, in history, language development and maths work. Throughout, boys and girls share the classroom experience of Up-helly-aa, but in primary 7 (11–12 years) things suddenly change. Boys in that year join older lads from the secondary school in the junior

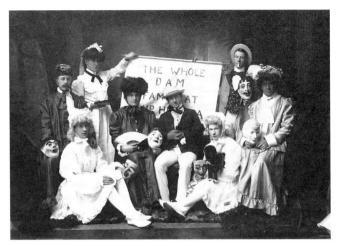

9 The Whole Dam Family squad, masks off, 1907. In the days before the festival, each squad has two photographs taken – with masks on and off – by a photographer appointed by the Up-helly-aa Committee. In the first three decades of the century, these were printed as postcards which were sent to Shetlanders overseas. This one was sent by one of the guizers to a lady in Aberdeen: 'I hope you will enjoy the spectacle of The Dam Family. We had a splendid Up Helly A – the finest I ever had in fact. You will get a good description in the papers, but I will write you all the news on Monday.' (Courtesy of the Shetland Museum)

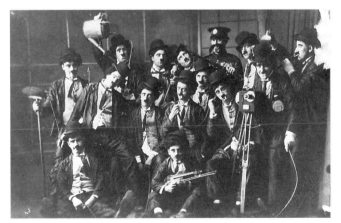

10 Charlie Chaplin squad, masks on, 1920. Depicting cinema and television stars (including Teletubbies, 1998) has been a feature of Up-helly-aa throughout the century. Squads often fight for the privilege of guizing as the latest craze, and the festival contains decidedly modern cultural imagery. (Courtesy of the Shetland Museum)

Up-helly-aa, organised out of school, which mimics the real thing with its own Guizer Jarl (democratically elected by eligible boys), squad, galley and impressive costumes. Boys are being taught to be men. Speaking of the girls, one headteacher comments: 'Some of them get very keen on Up-helly-aa, and this makes it difficult in primary 7 with the boys who are permitted to go on in the junior Up-helly-aa Jarl's squad. You know, you've got equal opportunities throughout the school, and then you've got this in primary 7.'[24] On the eve of puberty, Up-helly-aa becomes gendered. Infused with the festival, its trappings and ritual from a very early age, Lerwegian boys start their rites of passage to manhood within the framework of Viking history.

History and community

Up-helly-aa is an obvious pastiche of the past, and few Lerwegians would deny its essential modernity. Yet, when asked about the significance of the festival, a Lerwegian will invariably answer that 'it is tradition'. The literature on the festival repeatedly uses the words 'custom', 'history' and 'time-honoured', and there is an unmistakable collective acceptance that the festival is a legitimate homage to what is regarded as the founders of Shetland civilisation. The festival reflects the easy familiarity of the community with its perceived origins. The word 'jarl' in the title 'Guizer Jarl' is a conscious accentuation of that familiarity, adding to the Norse place names by which the geography of Shetland (and also of Orkney and Caithness) is known. From the 1880s, Norse names have been given to new streets and housing estates in Lerwick, deriving from Shetland's own version of the Norse tongue, Norn, which developed in the Middle Ages and which was still spoken into the eighteenth century, and which has left a vibrant dialect of vocabulary and distinctive pronunciation in modern Shetland. But from 1469 Shetland became part of the Scottish kingdom, and in the sixteenth and seventeenth centuries it started to be colonised by Scots landowners, clergy and others. Norn declined, and Scots-English became the dominant language.

During the last five hundred years the majority of Shetlanders have made precarious livings from the sea (primarily) and the land (less productively). Out-and-out prosperity is really very recent, arriving with the discovery of oil in the Shetland basin to the east of the islands in the early 1970s. The islands entered a boom which has not altogether ended, resulting in the wide distribution of the gains in new occupations, community facilities and homes. Asked about the impact of oil on Shetland

identity, one local man commented: 'Strengthened – look at the houses round the countryside now, and compare them to the old croft houses, you can see the difference.'[25] The islands were strategically vital to oil exploitation, and with their transformation into an oil-industry construction site in the mid-1970s, a series of political consequences flowed from their new bargaining power. The Shetlands avoided emasculation of their identity within a vast Highland local authority (that would have had boundaries larger than many European nations), and were granted all-purpose local government for the first time in 1975. In 1974, Shetlanders bucked national British trends by voting 73 per cent against staying in the European Economic Community. With oil flowing in 1979 and the new Islands Council in the midst of securing unique oil-related tax revenues for the community, Shetlanders bucked Scottish trends by voting 72 per cent against devolution for Scotland.[26] In the same year a new political party emerged, the Shetland Movement, which by the 1990s was the largest single group on the Shetland Islands Council.

By the mid-1990s, the outside observer was tempted to see links here: the Norse heritage, Up-helly-aa, oil prosperity and what appeared to be a new Shetland political consciousness. Beneath the sheen of glitzy costumes and popularised heritage, the modern festival of Up-helly-aa seemed to affirm a new confidence in the islands' identity. Shetlanders appeared to be rejecting the blandishments of both European centralism and a rampant Scottish nationalism which proclaimed that 'It's Scotland's Oil'. Yet, in September 1997 Shetlanders changed their minds very dramatically. At the second devolution referendum, islanders voted 62 per cent in favour of establishing a devolved parliament in Edinburgh, moving (along with Orkney) very significantly towards the rest of Scottish public opinion.[27] What some had mis-read as aspirations to Shetland independence in the 1970s turned out in reality to be no more than a defiant gesture – a cocking a snook – at European centralists, Scottish nationalists and the Edinburgh-based establishment of Scottish civil government. With assurances of its very own seat in the new parliament, and hopes of better treatment for its fishing industry, Shetland became part of constitutional change in Scotland.[28]

Such playful fickleness in politics is underscored by quite rational equivocation in Shetlanders' sense of their own identity. Shetland had been invaded in the sixteenth and seventeenth centuries by land-grabbing Scots and in the 1970s by Scots workers with their 'rough' Scots culture. Oil and construction workers infected Up-helly-aa. 'We were frightened

of these oil people', recalls one guizer. 'They come and get drunk and that's not what it's about. And they'd be able to put in squads as well, and it caused a lot of trouble. I mean [what Up-helly-aa is about] is laughter, music, dancing.'[29] So the five-year residency rule was introduced to qualify as a guizer, and Shetlanders voted 'no' to devolution and rule by Scots in Edinburgh. In Shetland, national and local identities are precisely deployed: 'I regard myself as a Shetlander. My wife is Scottish. ... I usually put British [on my passport]. My wife would always put Scottish. Although the whole place is run by Scotland. It's a thing you've been brought up to.'[30] Sharpened by rapid economic change and incomers, identities are carefully balanced contradictions.

Shetlanders juggle with identities as they juggle with their many guizing masks. Switching hats is second nature. An incomer recalled an experience in 1985:

> We were standing at the bar, I kid you not, and we both had a beer each, and the door of the bar opened, and this white elephant walked in. I kid you not. It was an absolutely wonderful suit. I looked in astonishment at this, and nobody reacted in this bar. I couldnae believe it. And this thing walked up to the bar and the barmaid said: 'Is it the usual you want, John?' ... I have never been in a place where people dress up so much, and it doesn't just happen at Up-helly-aa. ... It's like a Norman Wisdom film, but they don't bat an eyelid.[31]

Identities are adopted and dropped as need arises, the synthetic and the 'real' seemingly confused and contradicted. Up-helly-aa seems to encapsulate much of this. It is a festival of synthetic pageantry for a 'real' Norse history. It combines 'respectable' and 'rough' culture – drink and sobriety, social order and chaos, civic obsequiousness and defamatory satire. Machismo posturing and male-bonding sits side-by-side with the rising gender equality of the late twentieth century, resisting 'equal opportunities' and perpetuating traditional gender roles in a way rarely permitted in the rest of Shetland or British life. The festival has also survived the oil-boom, when prosperity and technology have seen off so many calendar customs in the last one hundred years. No place in Britain has experienced such a turnaround in economic fortunes as quickly as Shetland since the mid-1970s, yet it retains a thriving historical pageant extolling the virtues of a medieval warlike race. The modern Up-helly-aa is infused with contradictions.

It is a very perplexing festival, for its history is even more amazing than its contemporary anthropology. Stretching over four centuries, the

story of this modern festival uncovers the most bizarre, violent and dangerous customs of community celebration to be found possibly anywhere in the world, involving guns, flaming tar-barrels, home-made hand-grenades and mass poisoning. As outrageous as the activities were, it is their cause that is the fascination. Why did a 'civilised' community come to celebrate itself in images of power and machismo and with weapons of violence and destruction? The search starts in the literature of Shetland folklore and legend and in the discoveries of the modern historian and social anthropologist. But then the hunt really begins in the town of Lerwick in the early seventeenth century, *before* the winter fire festival was born. Only by following the trail so far back can an understanding emerge of why a calendar custom was needed at all and what purpose it has fulfilled over the centuries.

Notes

1 Data supplied by Lerwick Observatory.
2 *Shetland in Statistics 1996* (Shetland Islands Council, Lerwick), pp. 8–10.
3 The description that follows is based on the Up-helly-aa festivals of 1993, 1994 and 1997, the first through personal observation and the last two from the videos, *Up-helly-aa 1994* and *1997* (Lerwick, Norfilm).
4 SOHCA/10/02, pp. 2–3, interview with Michael Peacock (pseud.).
5 Words by J. J. Haldane Burgess, MA, music by T. Manson, published in *Up-Helly-Aa: The Songs, the History and the Galley Shed* (Lerwick, Up-helly-aa Committee, n.d.), pp. 4–5.
6 A marine flare.
7 Words by John Nicolson, music Norse traditional tune, published in *Up-Helly-Aa: The Songs*, p. 6.
8 Originally titled *The Hardy Norseman*, arranged by Ronnie Mathewson, music Norse traditional, published in ibid., p. 7.
9 SOHCA/10/01, p. 5, interview with Terry Johnson (pseud.).
10 SOHCA/10/03, p. 2, interview with Peter Black (pseud.).
11 SOHCA/10/02, pp. 1–2, interview with Michael Peacock (pseud.).
12 R. Hutton, *The Stations of the Sun: A History of the Ritual Year in Britain* (Oxford, Oxford University Press, 1997), p. 426.
13 Shetland is rich in pre-medieval structures. Notable examples are the near-perfect Mousa broch, two thousand years old, and the stone village at Jarlshof which dates from as early as 2000 BC.
14 When Jim Wallace, the MP for Orkney and Shetland, was invited by a squad to participate, he was given a triangle to play.
15 SOHCA/10/03, p. 1, interview with Peter Black (pseud.).
16 SOHCA/10/06, p. 19, interview with Barbara Anderson and Jane Manson.
17 'Greeting' (Scots vernacular) = crying.

18 SOHCA/10/01, p. 2, interview with Terry Johnson (pseud.).
19 Ibid., p. 5; SOHCA/10/02, p. 2, interview with Michael Peacock (pseud.).
20 It is a variant on the 'living history' of old photographs discussed in R. Samuel, *Theatres of Memory: Volume 1: Past and Present in Contemporary Culture* (London, Verso, 1994), pp. 315–47.
21 These calculations are based on at least 900 Lerwick-resident guizers in 1996, and a male occupied workforce of 3,190.
22 SOHCA/10/01, p. 5, interview with Terry Johnson (pseud.).
23 SOHCA/10-06, p. 10, interview with Barbara Anderson.
24 SOHCA/10/04, p. 2, interview with Margaret Rorie, Headteacher at Bell's Brae Primary School Lerwick. I am very grateful to Mrs Rorie and her staff for compiling a catalogue for me of Up-helly-aa based activities in each stage of the school.
25 SOHCA/10/03, p. 6, Peter Black (pseud.).
26 *Shetland in Statistics 1996*, p. 61.
27 The equivalent figures for the whole of Scotland were 74 per cent and 64 per cent. *Shetland Times* 19 September 1997; *The Scotsman* 13 September 1997.
28 The Scottish Office, *Scotland's Parliament* (White Paper), Cmd. 3658, July 1997, p. 27.
29 SOHCA/10/03, p. 5, interview with Peter Black (pseud.).
30 Ibid., p. 6.
31 SOHCA/10/01, p. 4, interview with Terry Johnson (pseud.).

2

Understanding custom

THERE IS no definitive approach to the study of calendar customs. Various groups of scholars have an interest in them: local and 'in-house' historians (often writing at the behest of twentieth-century festival organisers), folklorists, social historians, sociologists and anthropologists. They each have their own agendas, preoccupations, methods of research, forms of analysis, and their own historical narratives. There is little agreement to be found between them, resulting in considerable disputation over each other's skills and grasp of evidence. The results are surprisingly divergent stories about the same customs.

The folklorists

Folklorists have developed rich and detailed accounts of the folk beliefs of the Shetlanders. Most of this work has been the product of a romantic endeavour in cultural preservation, and the folk-history narrative that emerged from the 1870s onwards tended to absorb Up-helly-aa within it. In the last three decades of the nineteenth century, a number of local people started writing down oral traditions, some with as much interest in preserving the Shetland language as the stories told in it: people like Arthur Laurenson, Laurence Williamson and John Spence. Between the 1880s and the 1930s, the most influential Shetland folklorist was Jessie Saxby, who wrote for both a popular and an academic market, and by her work Shetland's folklore was absorbed into the national directories of British calendar and other customs written in the middle decades of the twentieth century. These directories were compiled by Mary Macleod Banks, who produced many volumes on British calendar customs in the 1930s and 1940s, and F. Marion McNeill who published extensively on Scottish folklore and customs. McNeill's four-volume *The Silver Bough*, published between 1957 and 1968, remains popularly perceived in the

1990s as the authoritative guide to Scottish folk tradition. Up-helly-aa features prominently within it, but what she says about it was largely drawn – sometimes word for word – from what Saxby had written. In addition, there were others – landowners, journalists and retired gentlemen in search of a hobby – who published pot-boiling accounts of folklore history for the tourist trade of the Highlands, Hebrides and Northern Isles. The aggregate effect of this work was to raise the profile of folklore studies simultaneously as academic and popular, an area in which anybody with a good ear and a gift for storytelling could contribute to our understanding of a fast-disappearing world of peasant and island belief.

Folklorists have had a major impact on understanding the origins of the modern festival of Up-helly-aa. This started with the term 'Up-helly-aa' which, from an early date, they placed in the context of belief in the existence of fairy groups and their supposed activities during 'the merry month of Yule'. The first recorded mention by a known Shetland folklorist of the name 'Uphellia day' appears in an article published in the early 1870s by Arthur Laurenson. The article, 'On certain beliefs and phrases of Shetland fishermen', was primarily concerned with the ethnic and linguistic distinctiveness of the islanders. It portrayed the fisherman as an important link with the past through his perpetuation of Norse names for boating items and through his 'close contact with the wild powers of nature from which he with hardship wrings a bare subsistence, has a blinder faith in the ancient ways than other men'.[1] Laurenson stated that the last trace of the medieval Roman Catholic Church in Shetland lay in 'remembrance of certain holidays and saints' days, now of course no longer celebrated, although not forgotten', listing eleven days, including 'Boo Helly (fifth day before Christmas)', and 'Antinmas (twenty-fourth day after Christmas), or Uphellia Day'.[2] It is significant that he says that Up-helly-aa, like the other days, are 'no longer celebrated', but he does not elaborate on what those celebrations might have been. Laurence Williamson only ever published one page of work in his lifetime, in 1897, on which he provided a 'List of the "Merkis-Days" or "Rets o' da year" still observed in Shetland'. He described 29 January Old Style (OS), 17 January New Style (NS), as 'By oldest people called *St. Antony's Day*, now *Fower-an-twenty Day* and *Uphelly a*'. Yule ends.'[3] It is interesting here that 'Uphelly a' is being described as the *new* name for an older occasion, for by 1899 the modern Lerwick festival of that name was in existence. The longevity of the term was certainly not being asserted by these authors. Indeed, John Spence's 1899 volume

on Shetland folklore makes no mention of Up-helly-aa or festive events on the twenty-fourth day.[4]

Indeed, the terminological origin of 'Up-helly-aa' and its variants are far from certain. Epistemological authorities have a tendency to cite one another regarding it. Jakob Jakobsen, a Faroese linguist who spent two years collecting Shetland language in 1893–95 and published his Norn Dictionary in 1932, uses Williamson's definition of 1897 almost word for word. He suggested 'helli', meaning 'holy-day' or 'festival', must be regarded as an old Norn word, and viewed 'uppi' as Old Norse for 'at an end' (and still in use, he said, in Norway, Faroe and Iceland). Despite this, Jakobsen concluded that 'it is, however, doubtful whether the compd. is old in Shetl.'[5] Indeed, he cites *Jamieson's Scottish Dictionary*, originally published in 1808, which says that the term 'uphalie day' or 'ouphalliday' is Lowland Scots for 'the first day after the termination of the Christmas holidays'.[6] In other words, the origin of the term was being placed in central, southern and eastern Scotland, and not in the Northern Isles of Shetland and Orkney or their Nordic neighbours. This claim is accepted by other Scottish dictionaries, whilst English ones do not even list the term.[7]

It seems incontrovertible that the term was indeed a common one in Lowland Scotland in the sixteenth and seventeenth centuries. There is sufficient documentary evidence cited by folklorists to believe that 'Uphellie', 'Uphellya' or 'Uphalliday' was the celebration of Twelfth Night. Much of this evidence concerns suppression after the Reformation when presbyterian kirk sessions sought to ban the 'merry month of Yule'.[8] The celebration of Christmas was perceived by presbyterians as a 'popish' practice akin to the celebration of saints' days, which were also banned. Church authorities in Elgin in Morayshire were particular vigilant between the 1580s and 1630s in suppressing 'Uphalie day', repeatedly prosecuting individuals for 'clinking basons' and other metalwares (for the fairies reputedly could not abide iron); the inhabitants were put 'under the paynis of publict repentance at the leist during this tyme quhilk is superstitiouslie keipitt fra the xxv day of December to the last of Januar nixt thairefter'.[9]

The use of the term in Shetland is first recorded by a presbyterian minister, George Low, in 1774, when he noted of islanders that 'Their Festivals are Christmas, Newyears-day, Uphaliday (the last day of Yule).'[10] However, it is not clear whether he was recording a local usage or applying the Scots term for the occasion (which is likely to have been familiar to his readership). Certainly, there appears to be no other

reference to the term in Shetland until the early 1870s when an anonymous newspaper correspondent referred to 'up-hale-night' as twelfth night OS (17 January) for some Shetlanders and Twenty-Fourth Night OS (29 January) for others.[11] This mobility in the celebration of 'end of Yule' in Shetland has never been satisfactorily explained, but in later folklorist accounts it became accepted, seemingly wrongly, that 'four-and-twenty night' was the universal Shetland date.[12] Robert Poole has suggested that one possible explanation for some Shetlanders starting in the nineteenth century to celebrate the end of Yule on 29 January is that pedants pushed back Twelfth Night by a further twelve days, unaware that it had already been moved a total of twelve days in 1752 and 1800; pedants were certainly at work in some places in Shetland where Yule OS was held on 6 rather than 5 January.[13] As to the name, it seems plausible to conclude – though probably impossible to prove – that Up-helly-aa as a term in Shetland derives from Uphalie day in Lowland Scotland, possibly introduced by Scottish settlers in the seventeenth or eighteenth centuries, and that it was originally Twelfth Night but was relocated by some rural Shetlanders to Twenty-Fourth Night. However, we know nothing of the use of the term for either date in Lerwick itself until after 1870 – an issue we consider in Chapter 4.

Irrespective of these problems, folklorists at the beginning of the twentieth century were linking the origin of the term Up-helly-aa to a narrative of folk belief in the islands. The narrative that developed centred on Shetlanders' belief in fairies or primitive folk scattered in the hills and often underground, and who had distinctive Norse names in the islands: 'trows' and 'peerie hill-men' who inhabited the island before the Picts or Norse, followed by later groups called the 'Muke Maisters', the Finns and the Picts, whilst from the sea there were the 'sea-trows', the 'selkies' and the Seal-folk.[14] Though McNeill in the 1950s registered similarities between both beliefs and types of fairy throughout Scotland, the selection of Shetland's folk belief for association with the term Up-helly-aa gave it distinction – primarily of having a current-day festival which, however loosely, was 'based' on folk tales. The term Up-helly-aa endowed Lerwick with the special status of being a modern town with a 'folk festival' which sustained some linkage with previous belief in fairies.

The linkage was largely the creation of Mrs Jessie M. E. Saxby, the daughter of a Shetland doctor. In 1888 she and her brother published a volume which celebrated, in fiction and in autobiography, what her brother described as the 'melancholy isles of furthest Thule'.[15] This book

is a lovingly constructed portrait of rural Shetland in the 1830s and 1840s of their youth, describing in some detail the games and activities of Christmastime. Her brother narrates how they had spent their Yule – mostly in a series of football matches in which their uncle, the 'Mester', press-ganged local lads to play on his front lawn for several days. Meanwhile, Saxby gave an account of the 'folklore of Yule'. She described 'the Yules' as successive days each with their own names, beginning with 'Tul-ya's e'en' seven days before Christmas: 'On that night the Trows received permission to leave their homes in the heart of the earth and dwell, if it so pleased them, above ground.' This was followed by 'Helya's night', 'Thammasmass e'en', 'Byana's Sunday' and 'Yule-day'. 'Football', she said of the last, 'was the amusement of the men while the brief day lasted; dancing the amusement of the evening. Trows are excessively fond of dancing, and always try to join the revels, but they can only do in the disguise of a mortal.' Seven days later came 'New'r' day', and from then until 'Twenty-fourth night' work and play went hand in hand:

> On Twenty-fourth night the doors were all opened, and a great deal of pantomimic chasing and driving and dispersing of unseen creatures took place. Many pious ejaculations were uttered and iron was ostentatiously displayed, 'for Trows can never abide the sight o' iron.' The Bible was read and quoted. People moved about in groups or couples, never singly, and infants were carefully guarded as well as sained by vigilant and learned 'wise women'.
>
> Alas, the poor Trows! Their time of frolic and liberty was ended, and on Twenty-fourth night they retired to their gloomy abodes beneath the sod, seldom finding opportunity to reappear again, and never with the same licence, until the Yules returned.[16]

This account of 1888, issued as part of a romantic guide for tourists, was reused twice by Saxby over the next four decades, but on each occasion with important alterations and additions. In 1915 her article in the journal of the grandly named 'Viking Society for Northern Research, University of London', replaced the words 'On Twenty-fourth night' with 'On Up-Helly-Aa, shortly before midnight'.[17] In 1932, she reproduced her 1888 account but with a new conclusion: 'Young men and boys disguised as Grulicks formed processions and marched through the toons with lighted torches. These at midnight were piled with other material into a huge bonfire, and amid noise and hearty congratulations the Trows were banished to their homes in the hillsides.'[18] With each successive

repetition of her 1888 account, Saxby's narrative becomes more elaborate and, most importantly, affirms a linkage with Up-helly-aa.

In the mid-twentieth century, F. Marion McNeill recycled Saxby's description again, adding her own elements. In her account, Up-helly-aa involved the young men dressing as 'grulicks' (alternatively, 'grulacks', and also 'skekklers'), using suits of straw adorned with ribbons, led by the 'Skudler', whose attire was more elaborate and bright. The people were 'chasing' the little people, the 'trows', back to the underworld at the end of the 'merry month of Yule'.[19] McNeill also provided an elaborate account of the grulacks in the context of Yule itself, even providing a photograph of a supposed group of 'skekklars [sic]' or grulacks, with the caption: 'The custom is fast disappearing';[20] in reality, they were a Lerwick Up-helly-aa squad of 1939, dressed in guizing outfits most recently described in Saxby's 1932 book. In this way, historical 'source', pageant and narrative become blended. McNeill goes on to cite a long list of domestic and community rituals associated with the celebration of Yule and New Year, OS, and includes extensive footnotes explaining the Norse origins of terms. Her rendering of the Up-helly-aa story relied on Saxby's, emphasising the 'pantomimic chasing of unseen creatures' which ensured that 'the trolls were one and all back in the underworld'.[21]

This recirculation of almost identical accounts is a characteristic problem associated with the work of early folklorists. Historians are wary of much folklorist research for this reason, perceiving in it an absence of empirical verification (through documentary or other evidence) and an uncritical and often plagiaristic copying. It must not be inferred, however, that such accounts should be dismissed as 'untrue'. Indeed, as we shall see in the next chapter, there is considerable evidence that in certain particulars the accounts reflect verifiable local customs in Shetland in the eighteenth and early nineteenth centuries. However, the problems make historians unwilling to accept the folklorist's narrative at anything like face value.

The issue with folklorist accounts of history is not solely to do with accuracy.[22] The problem with belief systems, and the way in which early folklorists gathered them, is that we do not know precisely when and where the beliefs were held, whether they were held simultaneously, how and when they changed, and how 'belief' is to be interpreted both as a mental process and in social and cultural terms. In relation to Yule and Up-helly-aa customs in Shetland, the critical figure is Jessie Saxby, whose accounts provide virtually the only significant source for the

complex narratives of supposed customary activity in the 'toons' of Shetland. She does not specify which 'toons', and does not mention Lerwick except in relation to the modern event of burning 'a beautiful model of a Viking ship' – which she judges 'a pretty pageant' but 'a queer travesty of old Norse customs'.[23] When Saxby, and later McNeill, conclude accounts of the 'old' customs and beliefs with a reference to the modern Up-helly-aa festival in Lerwick, the imputation arises that the one led to the other, forming a continuum of custom and belief in that community.

It is not a case of historians alleging, for instance, that Saxby produced the customs she described from the fertility of her own imagination; rather, it is a case of properly appreciating how and why her account was developed in the context of the period in which she was writing. In this case, her account of Yuletime and related customs became part of a master narrative within which the modern Up-helly-aa festival was mythologically located; it became used, especially by McNeill, to provide a 'rational' historical account of a 'lost culture' which was 're-placed' by the modern Up-helly-aa festival. For McNeill, Saxby's account became a 'verification' of sorts of the cultural 'authenticity' of the spirit of modern Up-helly-aa. Notwithstanding that both Saxby and McNeill make clear that the actual activities of boat-burning and the songs that

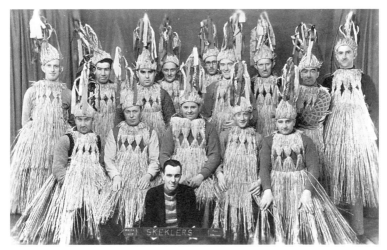

11 Skeklers squad, 1939. This photograph was used in a 1961 book on folklore
to suggest that these were 'Shetland Yule Guizers' whose 'custom was fast
disappearing' when, in reality, they were an Up-helly-aa squad in Lerwick where
such a custom never existed. (Courtesy of the Shetland Museum)

were sung were recent creations, the implication is clear from both writers (and those who have borrowed from them for later publications) that the people of twentieth-century Lerwick have constructed a thoroughly modern festival with complete justification on the relics of those former customs and beliefs. This is most obvious by the progression in their narratives from tales of 'trows' and 'grulacks' onto the galley-burning of modern Up-helly-aa. By making this linkage, an invitation is being made to associate the 'modern' with the 'old'. For this reason, the work of the folklorists is not 'neutral'; it stands as part of the development of an essential ingredient in any twentieth-century 'custom' – a lineage of historical continuity which endows the activity with 'tradition'.

The moral of all this is that folklore accounts require care. The folklorists' narrative – certainly on Shetland folklore – is a social construction, providing in a deliberately archaic vocabulary an indistinguishable mixing of 'folk belief' and modern popular behaviour which gives an image of a lost and innocent society. Despite the academic respectability conferred in the 1910s by the University of London upon the Viking Society for Northern Research, the folklorist movement of the late nineteenth and early twentieth centuries was infused with romanticism. Its collection of oral tradition, often laboriously and 'scientifically' rendered in research papers and articles, was openly receptive to local enthusiasts like Jessie Saxby who presented a highly charged discourse. This discourse used Shetland language – 'trows', 'grulacks' and so on – to impute a belief system and behavioural patterns wholly divorced from those of modern readers. It was a lost world whose relics in language and custom were to be found in Up-helly-aa – relics of an island people who literally 'believed' in that alternative world and who literally chased unseen creatures. The act of retelling tales of fairies itself created the fairy-tale which could masquerade as academic 'research'. More dangerously, it created an historical impression of a society dominated by such 'belief'.

Folklore studies developed in various directions, one of the ugliest being its use in the inter-war period by some in Scotland, as elsewhere, in the eugenic search for 'racial purity'.[24] But the discipline has come a long way, especially since the 1960s. As Ruth Bottigheimer has commented: 'The lingering positivist belief in an unbroken oral tradition, a survival of nineteenth-century nationalistic need to underpin and fabricate a convincing folk identity, has died out among folklorists and folk narrativists.'[25] Amongst the new issues is the social ambiguity of

the folk-tale narrator in a literate society and the effect this has on the formulation of fairy-tale content and the way researchers understand it. This clearly has a bearing on how one approaches key folklorists in Shetland, including Jessie Saxby – the researching folklorist scribe who was raised in the 'folk' community and immersed from a young age in the fairy-tale beliefs she relates. Yet, historians view most of folklore studies sceptically. As Robert Poole has said, 'no serious folkloric synthesis has appeared because folklore studies as a discipline no longer has a viable theoretical framework'.[26] Such work of synthesis of customs has now passed largely to historians.

The historians

If folklorists have viewed the origins of Up-helly-aa through rose-tinted glasses, academic historians have performed little better. The study of the history of calendar customs has developed rapidly in the last three decades, and in this there has been application of skills of empirical verification, critical treatment of both written and oral sources, and the posing of meaningful questions about the significance of such events. Unlike folklorists, historians do not generally start from 'beliefs' but from customs: what the people did at calendar occasions, and what those actions 'meant' in the society concerned. Yet, for all the historical rigour, significant weaknesses in methodology and in framing the questions being posed have left Up-helly-aa – and very possibly other modern customs – seriously misunderstood.

Up-helly-aa as a winter fire festival has many other customs in common with it. Ronald Hutton's survey summarises British fire festivals, showing that they have been common in the northern and north-eastern part of Scotland and in the north-east of England.[27] The use of 'clavies', or lighted pots or torches, was apparently common on the Moray Firth coast in the eighteenth century where they were carried round fields and byres of livestock to bless them. One clavie custom survives at Burghead on that coast, where a half tar-barrel atop a pole is carried round the streets on the night of 11 January – New Year's Eve, OS. Burghead's custom seems to have been transplanted there sometime after the village was built in the early nineteenth century, whilst other similar customs with fire are thought by McNeill to be relatively 'recent' innovations – including the swinging of fireballs of paraffin-soaked ropes and rags at Stonehaven.[28] Venetia Newall found that the carrying of blazing tar-barrels by men in fancy dress at

Allendale in Northumberland developed out of a Methodist watch-night service in about 1858, although the people there – as she also suggested for Lerwick's Up-helly-aa – now believe it to be pagan and prehistoric.[29]

In fact, similar Yule and New Year customs have been quite common. At Comrie in Perthshire at the bells of New Year on 1 January, young men in the 1990s carry flambeaux or torches in a parade around the village, accompanied by guizers and elaborate satirical props – including carriages and large cardboard structures. At New Year 1997, the satirical costumes included a man guizing as a bishop riding in a quite elaborate mock-up of an episcopal sedan chair, with blunt placard references to the Roman Catholic Bishop of the Isles, Roddy Wright, who in 1996 had fled his post after media revelations of his sexual relationships and his illegitimate child.[30] Another 'costume' comprised at least two men jointly 'wearing' a large mock-up of the skyline of Hong Kong, with placards alleging that the British government was deserting its residents in the handover to Red China – including Scots 'kith and kin'. The number of torch-bearers at Comrie has dwindled to a mere nine in 1997, but the event shares with Lerwick Up-helly-aa not only the torch theme, but also the satirical guizing.

Many events around Scotland have resonances with the Lerwick festival. At Campbeltown on the Kintyre peninsula on the west Highland coast in the 1860s, it was customary at New Year OS (12 January) for young men to process round the town with flaming tar-barrels above their heads which were deposited in a heap at the Cross. The antiquity of this custom is unknown, but it met with local opposition – notably from a local newspaper – and ended in 1880.[31] At Dingwall in Easter Ross around 1870 there was a 'burning of the crate', in which local youths bought a large wooden crate from a crockery dealer, filled it with combustibles soaked in paraffin, and set it alight to be towed by a horse along the High Street amidst 'a riot of whooping and dancing', ending at midnight – reputedly with an effigy of the Norse Jarl Thorfin.[32] Other instances in the late nineteenth century of parading with blazing tar-barrels at Hogmanay or New Year's morning include Newton Stewart, Garlieston and Minnigaff in south-west Scotland,[33] whilst the practice was also common in some localities in England, including Lewes in Sussex and Burford in Oxfordshire.[34]

Though it may be correct that Burghead's 'clavie' tradition was important to that community in the early nineteenth century,[35] there is considerable evidence from the surrounding Morayshire parishes

between the 1650s and 1730s of 'the heathenish idolatrous custom and practice of burning torches' at Hogmanay.[36] Guizing and running amok was also well known in the Gaelic-speaking Highlands and in north-east Scotland, including, reputedly, the smearing of doors and windows on Christmas Eve with 'sowens' (soaked oat-husks) and the drama of 'Goloshan' which was reputedly widespread and still performed in Biggar in central Scotland in the 1960s.[37]

The elements of Up-helly-aa – flaming torches and tar-barrels, guizing, mumming or drama, satire, and even the Norse theme – seem to have parallels in various places in Scotland at various times since at least the seventeenth century. The problem with most of these events is that they have been chronicled only in the nineteenth or twentieth centuries in towns and villages which sprang up or developed with commercial fishing and early industrialisation. How they developed in such early urban communities remains mysterious. The transportation of customs from elsewhere is clearly an important possibility, but the transportability of customs is only hazily understood by historians. The most mobile people in the seventeenth and eighteenth centuries – migrants, seafarers, fishermen, whalers, soldiers and sailors – were important carriers of customs to new places. Seatowns developed similar customary activities and rituals wherever the polyglot of European seamen stopped over, and within some countries – like Scotland – there was high mobility of farmworkers.[38] In such conditions, it seems highly plausible that customs were also extremely mobile, and, in the process, a considerable degree of amalgamation or adulteration of customs may have occurred in individual localities. Nonetheless, whilst some Scottish rituals like bonfires, guizing and mumming plays have very long histories indeed, the fact remains that existing sources date other rituals – notably tar-barrelling, crates and satirical guizing – largely to the early or middle of the nineteenth century.

And it is in the nineteenth century that historians have concentrated their efforts to understand the origins of Up-helly-aa. The Saxby–McNeill master narrative setting the festival in a fairy-tale context has had a minimal impact on the festival's own or 'in-house' literature. The two 'official' history books of the festival ignore it. In the first major book about Up-helly-aa, published in 1948, C. E. Mitchell wrote that the meaning of the festival was obscure, adding briefly that 'it is almost certain that Up-Helly-Aa had some connection with a pagan religious festival'.[39] The most recent celebration of the festival, published in 1982 by James W. Irvine, makes virtually no mention at all of the link to the

culture of 'trows' and 'grulacks' developed by Saxby.[40] In effect, the modern Up-helly-aa festival has been almost oblivious to the Saxby–McNeill master narrative. In its place there is a virtually unanimous cultural focus on the Vikings or Norsemen. These books by Mitchell and Irvine do not stand apart from the mythology of the festival, for they are essential relics along with other memorabilia of the event – the programmes, photographs, artefacts and costumes. In local terms in the second half of the twentieth century, it is the Norse theme which explains the origins of the festival.

Academic historians delve further. The modern academic community thrives on theory and dispute, and those who have studied and written-up their research on Up-helly-aa have produced extremely varied, and indeed contradictory, interpretations. Dispute has focused on two issues: the origins of Up-helly-aa, and the way in which those origins have given rise to either a 'legitimate' people's festival or to a manufactured occasion. Social historians Christopher Harvie and Graham Walker described Up-helly-aa as originating in 'a somewhat uncouth but genuinely Norse "Yule" custom' being turned in the 1880s by 'synthetic conservatism' into 'a controllable, and thus partly invented past' – a custom of capitalist control which, amongst other things, summoned 'the sailor home from the sea at the right time'.[41] This interpretation was described as 'drivel' by the Shetland archivist and historian Brian Smith, attributing it to 'the inadequacies of social control theory'. He marshalled considerable evidence to demonstrate the complexity of the origins and transformation of the festival – evidence and perspectives to which we shall return.[42] An intellectual historian, Bronwen Cohen, was also criticised by Smith for portraying Up-helly-aa as predominantly a conversion, instigated by a new urban bourgeoisie, of unruly plebeian customs into acceptable rational recreation. Cohen had written:

> Up-Helly-Aa was no spontaneous, popular creation, but developed as an orderly and controlled form of celebration that answered the needs of the City Fathers, and provided a number of the island's intellectuals with the opportunity to project to a wider audience, and indeed to posterity, the product of their romantic exploration of Shetland's Norse past, conveying [to] Shetlanders an inescapable sense of their Norse identity.[43]

This emphasis on the festival emerging as a result of municipal-led social control of an unruly popular event was echoed by a social anthropologist, Jonathan Church, who in the 1980s undertook participant

observation by joining the Jarl's squad, supplemented by documentary research. He described how mid-Victorian Yule celebrations of 'spontaneous violence and property damage . . . had become too powerful a form of resistance', and how Up-helly-aa emerged as 'accommodating to the developing Lerwegian civil society and [working] through the structures of dominant authority'. The festival's development required, according to Church, 'the invention of tradition, borrowing from the Orkneyinga Saga', making it the product of what he termed 'confabulation' in which gaps of folk memory or identity were artificially filled at the outset by 'Lerwick's predominantly socialist intelligentsia'. He concluded: 'Up-Helly-Aa is spectacular, but it is not spectacle. In many ways it redefines, albeit briefly, the notion of a Shetland public that has been confabulated most recently by the Shetland Islands Council.'[44] For Church, the festival's origins lay in ideological manipulation in the late nineteenth century, and still in the 1980s it offered the community a definition of itself as a common people in the midst of local government reorganisation which had given the islanders, in 1975, their own elected local authority for the first time.

Counterpointing this stress on Up-helly-aa's manipulated origins and consequential contemporary 'imprisonment' by its past, a study by folklorist Venetia Newall in the late 1970s came to very different conclusions:

> Up-Helly-Aa is a genuine folk festival. For Shetlanders it is a tangible embodiment of their past, a community in microcosm, and a conscious recreation of history as viewed through the eyes of local people. Up-Helly-Aa is a pageant, arranged with meticulous military-style organisation, involving all levels of the community. It is a carefully directed occasion for licence, a channelling of destructive tendencies into something creative. Ordinary social mores are relaxed and special set of rules and conduct prevails. The event embodies a deliberate presentation of history, emphasising pride in national origins of a people with an unjustified inferiority complex, stemming from their geographic position as a no-man's-land, where many nationals of different countries have paused and settled, or moved on. It is educational, at the same time providing an opportunity for satirical social comment and expressive of social change. The key post of Guizer Jarl provides a satisfying means of rewarding achievement and community service.[45]

Newall was sympathetic to the legitimacy of the festival – not necessarily in terms of historical 'accuracy', for in a sense that may not be the

issue – but rather in the terms that the people of Shetland (or, to be more precise, the people of Lerwick) had long before 1977 developed Up-helly-aa into a community event in praise of themselves and their community's history. The fact that that history might be 'wrong' was, for Newall, not the point; the festival was a community celebration of itself, still uncommercialised and – whatever had happened in the nineteenth century – by the 1970s free from conspiratorial manipulation.

Despite this work in the 1970s and 1980s, academic commentary on Up-helly-aa is still far from satisfactory. In some quarters folklorist accounts are still being recycled, but a more subtle problem is that of marrying the evidence of early-modern customs with the existence of late nineteenth- and twentieth-century festivals. Ronald Hutton's magisterial survey of the ritual year in Britain over the last millennium offers by far the best attempt at this, providing a way of viewing popular calendar customs in the round. But setting the early-modern custom beside the twentieth-century festival tends to emasculate continuous and long-term change and to exaggerate sharp discontinuities (like late Victorian 'social control'). On the one hand, Hutton describes Lerwegian festive disguise at Christmas as 'skeklers' and 'gulicks' (*sic*) being at large on the twelve days, dressed in straw hats and handkerchiefs, firing guns to gain admittance to homes where they danced and were rewarded with refreshments and money. On the other hand, he states that Up-helly-aa was 'sponsored by the local Total Abstinence Society after 1870, to divert the island's young men from their accustomed drunken rowdiness on Christmas and New Year's Eve'.[46] The first tends to perpetuate romantic imagery (and sources), whilst the second tends to emphasise the manipulation and erosion of 'custom' by the modernity and sensibilities of bourgeois urban society.

The devil lies in the detail. Continuities and discontinuities in the evolution of rituals emerge best from in-depth study on *individual* customs. For this reason, by far the best research on Up-helly-aa has been by Brian Smith. As the local archivist since 1975, employed by Shetland Islands Council, he has an intimate knowledge of the records, printed and manuscript, relating to Up-helly-aa and its precursors. The course of his daily work has drawn him to go over the sources, sometimes including fleeting but vital references in local newspapers and criminal-court records, and to accumulate an unmatched personal file of notes. This has allowed him to develop an understanding of the complexity of the festival's origins and development in the nineteenth century (which we will encounter in later chapters), and to generate a series of important

perspectives on it. He concluded one recent article on the event thus: 'Up-Helly-Aa' is a complex animal. Contrary to what the theorists say, it *was* a "spontaneous popular creation", in all its phases. It was an urban movement, created and refined by generations of young men who were, like many of us, radical in everything except in their relations to women.'[47] Here, Smith invests the common people of Lerwick with a proprietorship of the festival. He does not envision that the common people were wholly united, for he provides a sophisticated exploration of the ideological partnerships and confrontations between many interest groups. It was out of a mélange of late-nineteenth-century ideologies and popular movements that Smith depicts the evolution of the festival of Up-helly-aa as a modern, popular and consensual foundation.

If every local calendar custom in Britain had its Brian Smith, then historical synthesis would be made so much easier and surer. Unfortunately, Smith has disseminated only fractions of his research on Up-helly-aa, and none of it within the academic community. He has not written for the usual academic history journals, nor thought of a book on it himself. This is why the academic scholars on calendar customs have continued to promote an impoverished and often utterly wrong account of the Lerwick festival. By contrast, Smith has ensured that local people in Shetland are well informed on the history of their own festival. As a relatively isolated community of 23,000 people, it has developed a keen sense of its own history, surrounded by archaeological legacies, and fostered by a vigorous flow of articles in local newspapers, journals and local-history books. Much of this has been written by Smith himself. When he delivers a lecture on Up-helly-aa to a local society, publishes a two-page article about it in the *Shetland Times* on the Friday before the festival, writes the potted history for the festival programme, or contributes the historical introduction to the Up-helly-aa Committee's *Song Book*, he is giving the community a learned legitimation of its festival. His legitimation becomes part of the collections of Up-helly-aa memorabilia to be found in many Lerwick homes. The historian here is interacting with the community in a very intimate way, providing by far and away the most accurate, well-researched and 'learned' account there is, surpassing anything produced by so-called 'experts' on calendar customs or popular culture.

Professional history, as Raphael Samuel memorably put it, 'fetishizes archive-based research'.[48] Academic history is a closed world of specialists who devote most of their time talking to and writing for each other. Their research work is the pinnacle of a hierarchy of history that filters

'down' through textbooks and citation to popular history books and school texts. The professionals consult documentary evidence in the archive and research library, leaving great swathes of human experience and heritage out of scholarly study. The modern memory-keeper is no longer, like Jessie Saxby between the 1880s and 1930s, *in* and *of* the community. The modern professional historian is a distant being. Nonetheless, as Samuel expertly chronicles, recent decades in Britain have witnessed the explosion of interest in 'heritage' – in making the past fashionable in clothes, architecture and design ('Retrochic'), in resurrecting the past for television period dramas, heritage trails, 'heritage centres', 'heritage holidays', historical theme parks and 'living history' centres re-creating the past in packaged form for the visitor. As Samuel wrote, there has been 'an enlargement of the notion of the historical'.[49] He commented:

> 'Living history' tells us as much about the present as it does about the past. In the spirit of the age – the here-and-now – it is centrally concerned not with politics or economics, the subjects of yesteryear's grand narratives, nor yet, except tangentially, with religion (typically absent in accounts of the recent past), but essentially with that great preoccupation of the 'Me' generation: lifestyles.[50]

This, as he goes on, alienates the academic:

> 'Living history' is offensive to the professional historian. It shows no respect for the integrity of either the historical record or the historical event. It plays snakes and ladders with the evidence, assembling its artefacts as though they were counters in a board game. It treats the past as though it was an immediately accessible present, a series of exhibits which can be seen and felt and touched. It blurs the distinction between fact and fiction, using laser-beam technology and animatronics to authenticate its inventions and produce a variety of reality-effects.[51]

As Samuel noted, the professional historian hates 'heritage' – both the word and the industry (including the charitable National Trusts of England and Wales and of Scotland) which claims to preserve, restore and 'reclaim' it. Some historians merely disdain it as 'this heritage junk',[52] whilst others in the 1980s and early 1990s saw it as an element of the right-wing Thatcher cultural revolution which fed the people an acceptable form of the past (as in the core history curriculum for schools) and a promotion of acceptable values (such as 'Victorianism'). Samuel urged historians to take lessons from the heritage industry. It enlarges notions

of the past, advances forms of study and learning (especially multi-media and object-based research), it slows down the obliteration of landscape in both country and town (and thus is, as he described it, a 'residuary legatee of the planning idea'[53]) and challenges hegemonies of historical memory – whether of the state or professional historians. More fundamentally, he urged the professional historian to engage with 'memory' (popular history in its widest and most eclectic forms) and with the people's 'theatres of memory' (the places in which, and the mediums by which, the people engage with that memory).

Up-helly-aa is one such theatre of memory. It is a community 'place' in which popular history is produced without 'academic' learning, but in which the present Shetland community is celebrated by constructing perceptions of the past within a participant festival. The professional historian – as with Brian Smith – may have an important part to play in developing that memory. But popular memory is essentially a thing in itself. On some occasions – perhaps all – the professional historian needs to engage with such theatres of popular memory without abandoning professional responsibilities. A modern festival like Up-helly-aa, just as much as the Jorvik Centre, is an important location of historical aware-ness, as much deserving of study as the carnival in Renaissance Europe calls for the application of scholarship and theories of understanding about how the 'past' was conceptualised in relation to fourteenth- and fifteenth-century society. For the academic historian to denigrate twentieth-century popular history as commercialisation or historical 'invention' reveals more about the profession than about society. In any event, there is an overwhelming and embarrassing irony for academic historians of customs: 'popular history' in Shetland has been by far the most 'accurate' and scholarly.

Festivals and theories

Up-helly-aa contains themes which link it to the long history of popular festival, not just in Scotland or Britain, but in Europe. A common way of proceeding has been to isolate the constituent elements of behaviour. First, it is a calendar custom, which like so many customs over the mil-lennia have been dictated jointly or severally by the seasons and religious almanacs. It contains guizing (also known as mumming), a popular theme involving very often – as in this case – elements of gender cross-dressing which survived in various places in the twentieth century – including amongst European-derived communities in Newfoundland.[54]

Second, Up-helly-aa has elements – notably in the 'Bill', the dramatic 'skits' and the guizing outfits – of ridicule and satire which are common themes in the history of such customs. It has a carnivalesque theme of popular power, symbolised in the suspension of normal activity and the popular takeover of public places led by the Guizer Jarl (and his catch-phrase of the people's physical power: 'We axe for what we want'); this resonates with the inversion of the social order associated with the 'Lords of Misrule' of earlier centuries, when the relative status of elites and common people were temporarily reversed during popular customs, and a plebeian was made 'Abbot', 'King', or 'Prince' for the duration.[55] Third, within the parties in the halls at night is to be perceived the conflicting themes of puritanism and respectability on the one hand and 'rough' culture on the other – a contest associated with the popular culture of the Victorian and Edwardian periods.[56] Fourth, the procession through the streets and the reception in the council chambers echoes the civic ritual which arose within many popular customs in Britain from the middle of the nineteenth century onward, and which today are characteristic of so-called 'traditional' community customs and festivals.[57] There are other elements, too, which we shall discover. But what makes Up-helly-aa even more fascinating is that unlike so many festivals that historians have studied, it has grown and thrived in the twentieth century, becoming a vast and consuming community event for the inhabitants of Lerwick.

The study of the history of popular customs has mushroomed within social history in the last three decades. Its main impact has been in early-modern history which studies the period roughly between the fifteenth and eighteenth centuries. This was the period of the Renaissance and the Reformation, of the break-up of feudalism in many countries, and of the development of ideologies which assaulted the absolutism of monarchy. Such events – and especially the Reformation – have been dramatically reinterpreted as a result of the study of popular culture, involving the recent affirmation by Ronald Hutton that 'the most important and well-loved rituals of the late medieval church in England and Wales were reproduced in folk custom after they had been driven out of formal religion at the Reformation'.[58] It would be highly relevant to see if the Scottish Reformation and its aftermath had the same impact upon popular customs north of the border, but Scotland has not produced significant scholarly interest in this issue thus far.[59] However, it seems not unreasonable to expect some very broad similarities – especially in relation to one important aspect of Hutton's work. He

overturned the notion of festivals as 'pagan survivals', and located their emergence to late medieval Christianity.[60] Yet, Hutton has ambitiously surveyed British customs from the medieval to the contemporary, arguing for 'a full-blooded reapplication of the theory of "survivals" to folk customs which has recently become so unpopular amongst folklorists'.[61] For Hutton, 'the rhythms of the British year are timeless, and impose certain perpetual patterns upon calendar customs'.[62]

This approach has its problems, and has already been subject to criticism.[63] One of the major difficulties is the status due to the work of left-wing historians on eighteenth- and early nineteenth-century customs. In the 1970s and 1980s, Marxist-inspired social historians argued that custom and ceremony were interwoven into social relations in the English local community, and that those customs had a major impact upon the manner and conduct of protest against agricultural change – including those elements often referred to as the Agricultural Revolution.[64] Bob Bushaway's study of the south of England between 1700 and 1880 established a useful agenda for the historian of customs. Popular rites, he argued, were an important element in customary relations between social groups in rural society, and the calendar customs were the basis of local identity, interlocking to provide 'a frame of reference in which was expressed a perception of the social structure of the community, and also of its physical delineations'.[65] In other words, in the face of enclosures and changing landowners' views on property rights, custom legitimated the people's traditional benefits: through the connection of those customs to the church (often involving disbursements to the poor), to national holidays (like Oak Apple Day, Christmas and New Year, when largesse was often distributed), to the parish or manor (when Rogation or walking of the bounds involved customary benefits in the form of food and drink) and so on. These customs became more, not less, important as the countryside was changing, and popular 'rites' symbolised and contained the common people's 'rights'; defence of the one was also defence of the other. Under constant threat of disappearing rights (such as to gleanings from harvested fields, or green and dead wood from forests), customs provided the common people with forms for social protest – including rituals of status reversal and the ceremonial abuse of property and of elites – which offered annual restatements of common privileges. Customary behaviour, including calendar customs, was built into protest with economic change.

In these ways, Bushaway argued, the early-modern historian's vision of custom did not pertain to the late-modern period. Customs

which had developed before the eighteenth century (many less than a hundred years' previously) became reaffirmed in a wholly *new* context of rapid change between 1700 and 1880. Other social historians contributed to understanding how customs like sports and fairs developed this new significance in the eighteenth and nineteenth centuries, perceiving the popular culture of the period as overwhelmingly resistance to, and negotiation over, economic change. Claims to custom hardened as the threat of capitalism increased: the new factory workers claimed customary rights (like the weekly custom of taking 'St Monday' as a holiday) to which they had little right,[66] and 'traditions' were invented by new social groups – including the middle classes – absorbing the past in sometimes unhistorical ways into their very new, and usually urban, culture. 'History' was being raided to provide identities in industrial society – not just identities for social classes, but for whole countries like Scotland with its nineteenth-century rage for the 'Highlandism' of the kilt and the myth of the savage warrior.[67]

Much of this research in the 1970s and 1980s seemed to show that between the 1780s and 1880s class struggle dominated popular culture as the bourgeoisie and the state sought to stifle, suppress or transform what they considered the 'rough culture' of the new working classes.[68] Historians emphasised the contest between 'respectable' and 'rough' recreation in the Victorian period, in which calendar customs – along with sports, fairs and a myriad of 'traditional' activities – were faced with an onslaught from the concerted power of the churches, puritanism and the state. The concept of 'rational recreation' became the litmus test of respectable leisure, in which a pastime was judged by its 'usefulness' in educational, spiritual or economic terms, and which was deployed to eradicate traditional pursuits by a mixture of persuasion (through Sunday schools, mechanics' institutes and other organisations) and enforcement (especially by the police).[69]

In the social historian's narrative, what occurred in the 1860s, 1870s and 1880s was the final death of customary popular culture and the emergence of commercialised, regulated and truly urban forms of leisure and recreation. Within those three decades, practically all 'folk' sports were regulated with rules and organising bodies and turned into the modern competitive sports we have today; traditional fairs were mostly suppressed, and calendar customs like 'harvest home', Shrove Tuesday and many others lost significance in their traditional form, as either modern forms were introduced or they were downgraded in importance with the development of national bank and public holidays

legislated by parliament. This death of custom, most historians have
agreed, was not caused solely by 'rational recreation', because they have
perceived it as failing also in late Victorian and Edwardian Britain. Just
as rational recreation was assisting in destroying custom, so the decline
of religion helped to destroy popular adherence to church-based rites
and promoted acceptance of 'secular' leisure. However, this sharp dis-
continuity in the late nineteenth century is being challenged. Recent
research shows that the notion of rational recreation was still active in
the twentieth century, founded on the sustained strength of popular
religiosity and government concern. In Scotland, the churches and moral
campaigners pursued drinking and gambling ferociously in the 1920s
and 1930s, and from the mid-1930s to the present the state became the
sponsor of 'rational leisure' in the form of sport, countryside pursuits,
opera, theatre and youth and community centres.[70] Equally, research in
the mid-1990s shows that the puritanism and church adherence of the
people in Scotland and Britain as a whole remained very strong until
remarkably late – certainly into the 1920s and 1930s and probably until
the 1950s.[71] This means that the struggle between notions of 'rough',
'traditional' and 'irreligious' customs on the one hand and 'respectable',
'useful' and pious recreation on the other was not over in 1900 – an
important perspective when we come to examine Up-helly-aa in Ler-
wick in the twentieth century.

All historians accept that popular customs changed dramatically in
the last forty years of the nineteenth century, and most of them agree
on the importance of social and economic factors in contributing to
that transformation. What they disagree about is the question of *agency*
– or how it happened and who instigated it. The early 1970s saw much
discussion by historians of 'social control', blaming the Victorian elites
for suppressing and commandeering popular culture – with public
schools applying rules to football whilst town councils outlawed riotous
pre-rules 'ba' games, parliament outlawing cock-fighting but permitting
fox-hunting, and so on.[72] The problem with 'social control' is when it is
extended from what might be regarded as 'obvious' examples such as
these to other cases where *attempts* at suppression or control might be
evident, but which may not have been the *cause* of change to a custom
or sport. This is the problem that Brian Smith has identified with the
'social-control' explanation of Up-helly-aa's birth: it imputes agency to
a powerful elite, and impotence to the common people. Evidence aplenty
of suppression of street culture by police action is to be found in Victor-
ian Britain, but historians in the 1980s and 1990s became increasingly

unhappy with 'social control' as an overarching explanation.[73] The new historical approaches of postmodernism shifted the agenda towards perceiving culture in more sophisticated ways – in discourses of identity contained in the symbols and language of activities – whilst post-structuralism rightly criticised the left-wing preoccupation with under-standing societies in the past in terms of a structure of divided social classes in constant struggle.[74]

For the most part, it has not been historians who have applied these new perspectives to popular customs of the present century. Whilst social historians have struggled with how to comprehend changes to culture in the past, they have rarely done the same with the present. Even when the attempt has been made, there is a retreat from the con-temporary and from non-historians' theories and methods. David Cannadine noted in his study of the Colchester Oyster Festival that 'The period since 1945 is too recent for serious historical analysis', and asserted the need for historians 'to listen to anthropologists'.[75] For all the good intentions, few historians follow customs through to the present and engage with social-anthropological skills.[76] As a consequence, the study of contemporary calendar customs and community ritual has been largely the preserve of social anthropologists. The main interest of those anthropologists studying in Scotland has tended to be with the social organisation of rural communities and their survival and transforma-tion. Much of this work viewed rural communities – and especially Highland and Hebridean crofters of the 1950s and 1960s – as a neo-peasant and relatively economically backward society in which pre-secular systems of social organisation and community ritual could survive.[77] In such studies the dominant theme was that of the displacement of tradi-tional patterns of activity (including church-going) by economic change, technology and the key impact since the 1970s of 'white-settlers' – incomers buying up holiday and retirement homes and undermining the very society that had attracted them in the first place.

A more recent and in many ways exciting development within social anthropology has been symbolic anthropology. This replaces a structural (or 'social') understanding of communities with a *symbolic* understanding, acting in many ways like postmodernism within the history profession. Traditionally, sociologists and social anthropologists perceived societies and communities as 'objectively' defined – by struc-tural definitions of space (of nation or city for instance), and by 'object-ive' substructures (of social class, race, religion and gender). People within such 'objective' groups, it used to be argued, thought alike and

acted alike in ritual behaviour. Such structural determinism was broken down by symbolic anthropology in which 'culture' was related to both community and the individual. Through their culture, people can express their joint membership of groups (such as a nation or a town's community) whilst at the same time deploying it to the individualistic nature of their own experiences and inclinations. Thus, symbols within community festivals and rituals enjoy both a common simplistic role in giving a community an outward character or appearance, and a complex role in providing private character or appearance to groups and individuals within that community.[78] In symbolic anthropology, therefore, the importance of symbolic expression of community 'increases as the actual geo-social boundaries of the community are undermined, blurred or otherwise weakened'.[79] Such boundaries are weakened by social change – by economic growth, contraction, emigration, immigration and so on – and in such circumstances of change and uncertainty the people invest community conventions with increased symbolic value – perhaps like Up-helly-aa during the oil expansion in the 1970s. In extremes of change, the community becomes defined decreasingly in structural terms, and increasingly through symbolic representations of itself.

In this context, conventions and customary behaviour become vital as the setting in which rituals acquire such symbols. The origins of symbols – or of the conventions or rituals within which the symbols are set – is also significant. Anthropologists have indicated the extreme importance of history – of the past – in this. The past is used as a community reference, but is used in a selective manner to resonate with the present.[80] A popular or folk history can be constructed which is ahistorical – a myth – and impervious to empirical or rational scrutiny by historians. Where the past is well known through an annual local historical pageant, for instance, it can confer a familiarity, orderliness and comfort to a people in shock from social change. As one of the leading authorities on symbolic anthropology Anthony Cohen has written: 'In our everyday discourse, the past, itself symbolic, is recalled to us symbolically. Simple "historical" labels are made to describe complex and often ideological messages.'[81] Historical symbols then become a shorthand for complex messages.

Shetland has featured quite prominently in recent symbolic anthropology through Cohen's work on the island of Whalsay. He showed that here in the 1960s and 1970s economic life changed substantially as a result of capital-intensive fishing technology, but crofting remained

highly valued by the people even though its financial returns were very small. He adduced that the croft was a family territory with long associations, a symbolic resource, within which, during times of intense social change, the identity of the community could be stabilised.[82] In terms of ritual, he showed the importance of the funeral and the 'spree' or traditional party as ritual occasions on which, through their customary methods of organisation, symbols indicative of community boundary were professed. He emphasised these were not occasions of cultural survival or revival, but were older cultural activities invested with new significance because of social and economic change. Like Bushaway's work on eighteenth-century England, economic change heightened a community's sensitivity to custom. For Cohen, the capacity to respond to change in peripheral communities 'revitalises the boundary as perceived from inside and thereby signals the renewal of the community'.[83] He concluded:

> It is as if people stand at the boundary and witness its blurring, its fading, feel themselves being tugged across the line. So they reach in to their cultural and symbolic reserves to create and assert an updated sense of distinctiveness, of difference from the other side. They contrive new meanings for apparently old forms. They use the very symbolic devices in virtue of which they imagine themselves to be regarded as anachronistic, parochial and peripheral; and, by their use, neutralise these perceived implications.[84]

One recent and major application of symbolic anthropology has been Gwen Kennedy Neville's study of the Common Riding of Selkirk in the Scottish Borders.[85] It is one of four main (or 'real') such ridings in the Borders, in which a medieval custom of riding the bounds of the burgh's commons was undertaken, often annually, to prevent encroachment by rural landowners upon the town's boundaries. Neville focuses on the Selkirk Common Riding, an event taking place in the late twentieth century between 4 a.m. and 11.15 a.m. on the Friday before the second Monday of July. At its core it involves the marching of the bounds of the burgh's ancient common lands with young men 'casting the colours', in which a number of standard-bearers perform tricky manoeuvres with large flags, followed by a two-minute silence in a lament for Scots who died at the hands of the English army at the Battle of Flodden in 1513. To this core event there are additional parades to a Flodden memorial, and to the memorial to the town's more recent war dead of the twentieth century, as well as other stops on a fixed processional route. With a series of dinners, dances and the annual race

meeting, the Common Riding extends into a week-long festival which dominates the town's calendar.

Neville's study draws out various issues. First, she examined the rituals and symbols in the occasion, notably civic symbols in relation to religious ones, and deploys the image of the mother – as in mother country – as the overarching theme which describes the event. The Riding is for Selkirk, she concludes, an important 'symbolic boundary marking and the symbolic statement of the town as mother', displacing the former similar role held by the church. Second, the event involves considerable commemoration of the dead of the town, merging national patriotism with what she terms 'a civic nationalism'.[86] It also, clearly, acts to mark boundaries, marking 'ourselves' from 'others'. Third and more broadly, she describes the Riding as performance, ritual and play. As performance, it is a literary event, strongly romantic in the way of romantic literature (of Sir Walter Scott, for instance), idealising the inhabitants' experience and community against the outside world, and affirming 'the world of the real and idealized past against the world of the future'.[87] As ritual, it annually represents the meaning of the town, with flags, horses and the very procession becoming a liturgy within which are contained symbols of the community's construction which, through validating leaving and staying at home, creates 'a cultural world in which the corporate – the town – becomes the mother of the individual'.[88] And as symbol, the Common Riding contains strong links with Roman Catholic forms of worship, utilised in the strongly anti-ritual environment of a town that has been presbyterian for four centuries. Controversially for some historians, Neville perceives medieval Catholic church symbols translated into civic ones, creating histories of meaning relating to a hierarchical community and a disappeared 'more stable imagined world'. 'As such,' she continues, 'the symbols of town and mother and the accompanying symbolic paraphernalia representing town-ness and children of the town all work to find loyalties and ties that construct *corporateness* with the possibility of the *detachable individual*.'[89] By this, Neville means that the festival's symbols validate a Protestant and capitalist world where the town is mother, and where the individual can leave to seek fortune, and to which he or she can return. As a civic event, she argues that it represents the ' "sacralization" of the town':

> The town has become home, mother and protector, just as the church was once home, mother and protector, but with an important

difference. The town is made up of 'citizens'; it creates in its civic self-construction the idea of the person as 'detachable individual' who can leave or stay or alternate between them. The town offers a passport to capitalism and colonialism, a temporary visa to remain away while retaining one's citizenship.[90]

In the case of Selkirk, a 'traditional' medieval ritual had turned into something different. Against the background of industrial revolution in the eighteenth and early nineteenth centuries, industrial crisis accompanied by emigration from the beginning of the twentieth century onwards, and local government reform in 1975 which abolished the town's own council, the community's identity was successively challenged by industry and population growth, by economic insecurity and emigration and, finally, by dissolution or weakening of civic identity. Each challenge weakened older definitions of the community and sharpened the symbolism of popular ritual in the Common Riding. As change impacted on structural boundaries – of townscape by industry and in-migration, of family and community by emigration and the creation of a 'Selkirk diaspora', and of civic identity by the end of municipal self-government – so the community increasingly placed its identity in the symbolic boundary of the Common Riding to which only those with legitimate claims to Selkirk origins were admitted.

The Common Ridings of the Border towns are massive local events, containing as much community investment as that of Lerwick for its Up-helly-aa. Unfortunately, we still lack a detailed historical perspective on their evolution, but immediate points of similarity emerge. In both cases, the community has become defined by a single calendar custom, and one that absorbs the community throughout the year. Each of these events is a time for expatriates to return, to renew acquaintance; it is a time when a local man, not a civic leader or politician, is affirmed as community hero for the duration; and participation confers status, largely on men alone. But despite these parallels between Up-helly-aa and the Common Ridings, there is an important caveat. Unlike the Border towns, Lerwick is not a medieval burgh with a long tradition of civic government and community identity. Despite the strength and sheer 'quantity' of history on the Shetlands as a whole, Lerwick contains comparatively 'little' history; it is a community no more than three centuries old compared to Selkirk's nine centuries.

A. P. Cohen's work on Whalsay also offers strong parallels to how we should perceive Up-helly-aa in nearby Lerwick. Both communities have experienced the same general economic, cultural, linguistic and

social developments of centuries, and especially in recent times with oil expansion and high-technology industrial development (in Whalsay's case in fishing). But there are differences. Whalsay lies at the periphery of the Shetlands Isles, Lerwick lies at its centre. Lerwick is the capital of the islands and, as such, has undergone much more profound social and economic change than Whalsay, and for a very much longer time. Lerwick is in itself at the periphery of a greater entity – mainland Scotland – which in its turn is sometimes regarded as at the periphery of Britain.[91] The Lerwegian community is thus both periphery and centre, whilst Whalsay must be regarded as solely periphery. Up-helly-aa as the principal community festival of Lerwick thus represents a different – and perhaps more intriguing – phenomenon to the 'spree' in Whalsay.

There is one other critical issue in comparing Up-helly-aa with festivals like the Common Riding or the role of rituals in Whalsay. Since the late 1960s, Shetlanders as a whole – and not merely Lerwegians – have increasingly identified with this single festival as an emblem of their sense of separateness from Scots. 'Regional' Up-helly-aa festivals have, since 1900, been copied throughout Shetland, at the last count some eleven of them, most created since the 1960s. It has become not a single custom but many. Meanwhile, over the same period, Scots as a whole have developed increased political and cultural awareness of themselves as a 'nation', with their own identity separate from that of England. Recent studies have highlighted the way in which support for the Scottish national football team has focused patriotism into ninety minutes, especially in matches involving England.[92] Recreational symbols of national identities are crucial in peoples' perceiving themselves as nations or communities – the ability of what Benedict Anderson calls 'the shrunken imaginings of recent history [to] generate such colossal sacrifices', to inspire 'so many millions of people, not so much to kill, as willingly die for such limited imaginings'.[93] The Selkirk Common Riding, located close to the border with England, deploys a powerful symbolism of nationhood in its commemoration of Scotland's greatest military defeat at Flodden. Up-helly-aa has no such reverential symbol, but there is an obvious temptation to see it as a carnivalesque manifestation of a 'national' boundary, separating Shetlanders from outsiders, and specifically from other Scots. Bronwen Cohen and Peter Worsley have emphasised the role of Shetland intellectuals in promoting a racially-based Norse romanticism in Shetland in the late nineteenth century, seeing Up-helly-aa as a 'devised' custom popularising a Shetland 'nationalism as counterculture', but one that led to no serious

impact on political life.[94] This may not be the whole story, for quite apart from imputing agency to intellectuals rather than the people, it locates Up-helly-aa within only one ideological context (of romantic national-ism) when the issues behind the festival are in reality – as we shall see – more complex.

Yet, there is an issue concerning 'the imagined community' behind Up-helly-aa. In the 1990s the community that is being 'boundaried' in the multiple festivals of Up-helly-aa has grown to be not merely Ler-wick but the people of an archipelago of isolated islands – an area with a distinctive linguistic, geographical and economic heritage 'imagined' in the context of the medieval diaspora of the Norse. We must consider whether Up-helly-aa may be the festive symbol of something which veers towards, and gets pretty close to being, an alternative 'national' identity, conferring upon Shetlanders something different from being Scots or Britons.

Notes

1 A. Laurenson, 'On certain beliefs and phrases of Shetland fishermen', *Proceedings of the Society of Antiquaries of Scotland*, vol. 10 (1872/3–1873/4), p. 713. Laurenson went on to write much on Norse mythology and history in the Northern Isles; see C. Spence (ed.), *Arthur Laurenson: His Letters and Literary Remains* (London, Fisher and Unwin, 1901).

2 Ibid., p. 716.

3 Published in *Manson's Shetland Almanac and Directory*, 1897, p. 18.

4 J. Spence, *Shetland Folk-Lore* (Lerwick, Johnson and Grieg, 1899).

5 J. Jakobsen, *An Etymological Dictionary of the Norn Language in Shetland, Part II* (1932, reprint Lerwick, Shetland Folk Society, 1985), pp. 1000–1.

6 *Jamieson's Dictionary of the Scottish Language* (Aberdeen, 1867), p. 591.

7 The *Scottish National Dictionary* (1974) gives it as the feast of the Epiphany on 6 January, with a 1478 Old Scots source. The *Shorter Oxford* (1933–56) does not list it. Other suggestions have appeared – one being that the origin of the term is an Old Norse word 'opp-hellgr'; P. A. Jamieson, *The Viking Isles: Pen Pictures from Shetland* (London, Heath Ganton, 1933), p. 144.

8 F. M. McNeill, *The Silver Bough, Volume Three, A Calendar of Scottish National Festivals* (Glasgow, MacLellan, 1961), pp. 126–9.

9 Quoted in J. M. McPherson, *Primitive Beliefs in the North-east of Scotland* (London, Longmans, 1929), pp. 24–5.

10 G. Low, *A Tour Through the Islands of Orkney and Shetland* (first published 1774; Kirkwall, 1879), p. 82.

11 SA, D6/292/8. Newspaper cutting, *Northern Ensign*, February 1873.

12 McPherson, *Primitive Beliefs*, p. 25. Hutton cites Shetland's yule celebrations as cov-ering the twelve days, and does not mention twenty-four; R. Hutton, *The Stations of*

the Sun: A History of the Ritual Year in Britain (Oxford, Oxford University Press, 1997), p. 95. One linguistic historian felt that Up-helly-aa in Shetland was not the same occasion as Uphalie in Lowland Scotland; J. Geipel, *The Viking Legacy: The Scandinavian Influence on the English and Gaelic Languages* (Newton Abbott, David and Charles, 1971), p. 55.

13 Such as Dunrossness and Sandness; *John O'Groat Journal* 3 February 1878. I am grateful to Robert Poole for this advice on possible reasons for the distinctiveness of the Shetland calendar.

14 J. M. E. Saxby, *Shetland Traditional Lore* (Edinburgh, Grant and Murray, 1932), pp. 77–87; F. M. McNeill, *The Silver Bough: Volume One, Scottish Folk-lore and Folk-belief* (first published 1956; reprinted Edinburgh, Canongate, 1989), pp. 118–19, 125–6.

15 B. Edmonston and J. M. E. Saxby, *The Home of a Naturalist* (London, 1888), p. 122.

16 Ibid., pp. 140, 146.

17 J. M. E. Saxby, 'Foys and fanteens (Shetland feasts and fasts)', *Old-Lore Miscellany of Orkney, Shetland, Caithness and Sunderland*, vol. 8 (1915), p. 30.

18 Saxby, *Shetland Traditional Lore*, p. 86.

19 McNeill, *The Silver Bough, Volume One*, p. 119.

20 McNeill, *The Silver Bough, Volume Three*, plate opposite p. 132.

21 Ibid., p. 138.

22 These problems with the work of folklorists are discussed in the English context by Bob Bushaway, *By Rite: Custom, Ceremony and Community in England 1700–1880* (London, Junction, 1982), pp. 14–21.

23 Saxby, *Shetland Traditional Lore*, p. 87.

24 See for example D. A. Mackenzie, *Scottish Folk-Lore and Folk Life: Studies in Race, Culture and Tradition* (London and Glasgow, Blackie, 1935), esp. pp. 8–40.

25 R. B. Bottigheimer, 'Fairy tales, folk narrative research and history', *Social History* vol. 14 (1989), p. 349.

26 Robert Poole, 'Signs and seasons: British calendar customs in perspective', *Social History Society Bulletin* vol. 22 (1997), p. 49.

27 Hutton, *Stations of the Sun*, pp. 43–4.

28 F. M. McNeill, *The Silver Bough, Volume Four, The Local Festivals of Scotland.* (Glasgow, William MacLellan, 1968), pp. 224–5; see also E. J. Guthrie, *Old Scottish Customs: Local and General* (London, Morrison, 1885), pp. 223–5.

29 V. Newall, 'The Allendale Fire Festival in relation to its contemporary setting', *Folklore* vol. 85 (1974), pp. 93–103.

30 The fun-poking Roddy Wright theme was to be found in a Lerwick Up-helly-aa squad four weeks later: the squad was called 'Randy Roddy Right'; *Up-helly-aa Festival Programme*, 1997.

31 A. Martin, *Kintyre Country Life* (Edinburgh, John Donald, 1987), pp. 172–3.

32 *Glasgow Herald* 29 January 1927, quoted in McPherson, *Primitive Beliefs*, pp. 23–4.

33 M. M. Banks, *British Calendar Customs: Scotland, Volume II* (London and Glasgow, Folk-Lore Society, 1939), pp. 37–9.

34 Bushaway, *By Rite*, p. 73.

35 Hutton, *Stations of the Sun*, p. 43. As late as 1939, one folklorist implausibly maintained that it 'had been observed there from time immemorial'; Banks, *British Calendar Customs*, p. 29.

36 McPherson, *Primitive Beliefs*, pp. 19–23.

37 Walter Gregor, *Notes on the Folk-Lore of the North-east of Scotland* (London, Folk-Lore Society, 1881), p. 158; Banks, *British Calendar Customs*, pp. 50–72; McNeill, *The Silver Bough, Volume Three*, pp. 82–7; and idem, *Volume Four*, p. 208.

38 W. Rudolph, *Harbor and Town: A Maritime and Cultural History* (Leipzig, Edition Leipzig, 1980), pp. 29–88; T. M. Devine (ed.), *Farm Servants and Labour in Lowland Scotland, 1770–1914* (Edinburgh, John Donald, 1984).

39 C. E. Mitchell, *Up-helly-aa, Tar-Barrels and Guizing: Looking Back* (Lerwick, T and J Manson, 1948), p. 1.

40 J. W. Irvine, *Up-helly-aa: A Century of Festival* (Lerwick, Shetland Publishing, 1982).

41 C. Harvie and G. Walker, 'Community and culture', in W. H. Fraser and R. J. Morris (eds), *People and Society in Scotland, Volume 2, 1830–1914* (Edinburgh, John Donald, 1990), p. 354.

42 B. Smith, 'Up-Helly-Aa' – separating the facts from the fiction', *Shetland Times* 22 January 1993.

43 B. J. Cohen, 'Norse imagery in Shetland: An historical study of intellectuals and their use of the past in the construction of Shetland's identity, with particular reference to the period 1800–1914', unpublished Ph.D. thesis, University of Manchester, 1983, p. 478.

44 J. T. Church, 'Political discourse of Shetland: confabulations and communities', unpublished Ph.D. thesis, Temple University, 1989, pp. 17, 195–6, 198.

45 V. Newall, 'Up-Helly-Aa: a Shetland winter festival', *Arv* 34 (1978), p. 93.

46 Hutton, *Stations of the Sun*, pp. 43, 95. Hutton's source is J. R. Nicholson, *Shetland Folklore* (London, Robert Hale, 1981), p. 147, which in turn seems to have drawn upon the Saxby account of 1888 (probably in its 1932 incarnation).

47 Smith, 'Up-Helly-Aa' – separating the facts from fiction'.

48 R. Samuel, *Theatres of Memory: Volume 1: Past and Present in Contemporary Culture* (London and New York, Verso, 1994), p. 3.

49 Ibid., p. 152.

50 Ibid., p. 196.

51 Ibid., p. 197.

52 David Cannadine, quoted in ibid., p. 261. Ironically, Cannadine is one of the few to have ventured into twentieth-century calendar customs, and to have argued for the use of other than historians' skills in understanding them. D. Cannadine, 'The transformation of civic ritual in modern Britain: the Colchester Oyster Festival,' *Past and Present* 94 (1982).

53 Samuel, *Theatres of Memory*, p. 293.

54 G. M. Sider, 'Christmas mumming and the New Year in Outport Newfoundland,' *Past and Present* 71 (1976). Sider employed a rather narrow Marxist perspective which most historians today would regard as outmoded.

55 N. Z. Davis, 'The reasons of misrule: youth groups and charivaris in sixteenth-century France,' *Past and Present* 50 (1971); P. Burke, *Popular Culture in Early Modern Europe* (London, Temple Smith, 1978), pp. 178–204.

56 H. Cunningham, *Leisure in the Industrial Revolution c.1780–c.1880* (London, 1980); P. Bailey, *Leisure and Class in Victorian England: Rational Recreation and the Contest for Control 1830–1885* (London, 1978).

57 Cannadine, 'Transformation of civic ritual'.

58 R. Hutton, 'The English Reformation and the evidence of folklore', *Past and Present* 148 (1995), p. 113.

59 Hutton, *Stations of the Sun*, p. 419.

60 R. Hutton, *The Rise and Fall of Merry England: The Ritual Year 1400–1700* (Oxford, Oxford University Press, 1994).

61 Hutton, *Stations of the Sun*, p. 416.

62 Ibid., p. 426.

63 Poole, 'Signs and seasons', pp. 46–53.

64 E. P. Thompson, *Customs in Common* (London, Merlin, 1991).

65 Bushaway, *By Rite*, p. 34.

66 D. Reid, 'The decline of Saint Monday, 1766–1876,' *Past and Present* 71 (1976); Cunningham, *Leisure in the Industrial Revolution*, pp. 58, 145–7.

67 H. Trevor Roper, 'The invention of tradition: The Highland tradition of Scotland', in E. Hobsbawm and T. Ranger (eds), *The Invention of Tradition* (London, Cambridge University Press, 1983); J. Prebble, *The King's Jaunt: George IV in Edinburgh* (London, 1988); G. Jarvie, *Highland Games: The Making of the Myth* (Edinburgh, Edinburgh University Press, 1991).

68 R. W. Malcolmson, *Popular Recreations in English Society 1700–1850* (London, 1973); Cunningham, *Leisure in the Industrial Revolution*.

69 Bailey, *Leisure and Class*; R. Storch, 'The policeman as domestic missionary: urban discipline and popular culture in Northern England 1850–1880', *Journal of Social History* vol. 9 (1976).

70 C. G. Brown, 'Popular culture and the continued pursuit of rational recreation', in T. M. Devine and R. J. Finlay (eds), *Scotland in the Twentieth Century* (Edinburgh, John Donald, 1996); and C. G. Brown, 'The Scottish Office and sport 1899–1972', *Scottish Centre Research Papers in Sport, Leisure and Society* vol. 2 (1997).

71 C. G. Brown, *Religion and Society in Scotland since 1707* (Edinburgh, Edinburgh University Press, 1997), pp. 42–66, 147–57; C. G. Brown, 'Essor religieux et sécularisation', in H. McLeod, S. Mews and C. D'Haussy (eds), *Histoire Religieuse de la Grande-Bretagne* (Paris, Editions du Cerf, 1997), pp. 315–37; C. G. Brown, 'The secularisation decade: the haemorrhage of the British churches in the 1960s', in H. McLeod and W. Ustorf (eds), *The Decline of Christendom in Western Europe c.1750–2000* (New York, Orbis, forthcoming).

72 Cock fighting was made illegal in England and Wales in 1845 (by the Cruelty to Animals Act) and in Scotland in 1850 (by the Prevention of Cruelty to Animals (Scotland) Act).

73 F. M. L. Thompson, 'Social control in modern Britain', in A. Digby and C. Feinstein (eds), *New Directions in Economic and Social History* (Basingstoke, Macmillan, 1989).

74 P. Joyce, *Visions of the People: Industrial England and the Question of Class 1848–1914* (London, Cambridge University Press, 1991).

75 Cannadine, 'Transformation of civic ritual'.

76 The academic journal *Past and Present* has made a speciality out of publishing research on custom; rarely an edition goes by without one or even two articles in

this area. Yet, Cannadine's is one of the few of the last twenty years even to claim to move substantially into the twentieth century.

77 F. Vallee, 'Social structure and organisation in a Hebridean community [Barra]', unpublished Ph.D. thesis, University of London (LSE), 1954; T. H. Owen, 'The Communion season and presbyterianism in a Hebridean community', *Gwerin* vol. 1 (1956); J. Littlejohn, *Westrigg: The Sociology of a Cheviot Parish* (London, Routledge and Kegan Paul, 1963); J. B. Stephenson, *Ford: A Village in the West Highlands of Scotland* (Edinburgh, Paul Harris, 1984).

78 A. P. Cohen, *The Symbolic Construction of Community* (Chichester, Ellis Horwood, 1985), pp. 70–5.

79 Ibid., p. 50.

80 Ibid., p. 99.

81 Ibid., p. 101.

82 A. P. Cohen, 'The Whalsay croft: traditional work and customary identity in modern times', in S. Wallman (ed.), *The Social Anthropology of Work* (London, Academic Press, 1979).

83 A. P. Cohen, 'Symbolism and social change: matters of life and death in Whalsay, Shetland', *Man* vol. 20 (1985), p. 320.

84 Ibid. See also A. P. Cohen, *Whalsay: Symbol, Segment and Boundary in a Shetland Island Community* (Manchester, Manchester University Press, 1987), esp. pp. 73–96, 132–9.

85 G. K. Neville, *The Mother Town: Civic Ritual, Symbol and Experience in the Borders of Scotland* (New York and Oxford, Oxford University Press, 1994).

86 Ibid., p. 24.

87 Ibid., p. 97.

88 Ibid., p. 97.

89 Ibid.

90 Ibid., pp. 10–11.

91 For an extreme and distorted example of the 'Celtic fringe' approach to British history, see M. Hechter, *Internal Colonialism: The Celtic Fringe in British National Development 1536–1966* (London and Henley, 1975). Contrast this with L. Colley, *Britons: Forging the Nation 1707–1837* (London, Vintage, 1996).

92 G. Jarvie and G. Walker (eds), *Scottish Sport in the Making of the Nation: Ninety-Minute Patriots?* (Leicester, Leicester University Press, 1994).

93 B. Anderson, *Imagined Communities: Reflections on the Origin and Spread of Nationalism* (London, Verso, 1991 edn), p. 7.

94 B. J. Cohen, 'Norse imagery in Shetland', passim; P. Worsley, *Knowledges: What Different Peoples Make of the World* (London, Profile Books, 1997), pp. 300–3.

3

Misrule without custom:
Lerwick 1625–1800

Leir-vik (**Norn: 'mud bay'**)

LERWICK was born, and remains, both a transit town and a frontier. It is a European gateway to the Arctic Circle, Russia and North America, and a centre for exploitation of the riches of the North Atlantic. It was born in the seventeenth century to serve Dutch fishers, traders and smugglers, and its population has annually included thousands of transients – Germans, Dutch, Flemings, Norwegians, Scots, English, Canadians, Danes and, more recently, Russians. In the seventeenth and eighteenth centuries, it was a centre of economic wars, with the French coming more than once to burn Dutch boats and threaten the town. By 1700 it was the largest settlement in Shetland. Lerwick was a product of commerce, primarily in fish, but including many other commodities. As a trading and watering hole for European seafarers, it was, in modern parlance, a 'hard' town, a man's town, where fishermen, merchants, whalers, smugglers and seamen did business, got drunk and formed casual relationships with local women.

Lerwick, like Shetland as a whole, was built on the fish trade.[1] Settled by the Norse from the ninth century, the islands came under the direct rule of Norway in 1195, and between the thirteenth and mid-fifteenth centuries it had strong trading links with Norway in fish. The weakening of Norwegian power in the fifteenth century led to Shetland and Orkney being pledged to Scotland in 1469, but Scottish influence was only gradually exerted between then and the mid-sixteenth century when there was a wave of immigration from Scotland – especially of landowners from the north of Scotland, church ministers (many of whom also became landowners) and legal officials – derisively referred to by islanders as 'land-grippers and ferry-loupers'.[2] Though Scottish and English fishermen-merchants made entries into the Shetland trade (notably from Dundee), Shetland's economic fortunes between the fifteenth and

early eighteenth centuries were dominated by itinerant German mer-
chants from the old Hanse towns who set up booths on beach-shores in
many parts of the islands to purchase fish (largely ling, cod and skate)
to sell in Europe. At first buying fish direct from tenants, by 1700 certain
officials in the islands had developed a more commercial attitude and
entered the trade as middle men, building up in due course large estates
of their own. By then, Dutch fishermen were coming in vast num-
bers, favouring the centre of operations on the beach on the west side
of the Sound of Bressay that they had created in the 1620s. At first, Ler-
wick formed a trading settlement based on shoreline booths of the kind
dotted elsewhere in the islands. But very soon it became a location of
Dutch operations, and with time Shetland merchants formed what
became the islands' first town.

In 1665–67 Lerwick achieved recognition of its importance by the
construction of a fort abutting the north end of the tiny town to protect
it from the unruly Dutch, who, nevertheless, destroyed it along with
much of the town in 1673. It remained a small community, perhaps a
few hundred people. The French destroyed the Dutch fleet in the Sound
of Bressay in 1703, and Lerwick's fortunes – and population – declined,
not to revive again until the 1760s. In 1700, Lerwick had a population of
about 700, possibly about the same in 1755, and 903 in 1792 (represent-
ing 4.5 per cent of Shetland's total population). It grew more quickly
thereafter, rising to 2,224 (8.5 per cent) in 1821 and 3,655 (11.7 per cent)
in 1871. This was significant but not startling growth by mainland stand-
ards.[3] The burgh and its immediate hinterland was a very modest pro-
vincial town, no more than a village by many standards. But it was an
incredibly flexible community.[4] When summer came, the inflation of
the burgh's population was enormous: in addition to fishing vessels,
whalers and, later, seal-hunters came each March and April in increas-
ing numbers from the 1770s en route for the Greenland and Davis Straits
hunting grounds.[5] Given the boats reputed to anchor in the Sound
during the summer months, anything from one to five thousand addi-
tional people were in Lerwick or living on anchored vessels at any
one time.

In a very striking way, Lerwick was built on the seasons. The fishing
season from May until August was the centrepiece of commerce and of
population size – a phenomenon that was to continue through until
almost the middle of the twentieth century. It was a community in
which seasonal customs might have been expected to be strong in cel-
ebration of the arrival of the fishing fleets in spring, their departure in

early autumn, and the depths of winter at Yule and New Year when the town's overseas visitors had mostly – though never wholly – left. In that gap in winter, in the months of Arctic darkness, did Lerwegians celebrate in some traditional island ways – ways which, in the fullness of time, may have acted as the origins of the modern Up-helly-aa?

Moral culture

It is reasonable to suppose that Shetland had a rich popular culture of seasonal customs. Christmas and New Year in the old style calendar, as well as medieval church rituals like the celebration of saints and saints' days, are likely to have been as prevalent here as in the Gaelic Highlands. However, such customs survived strongly in the Highlands until the late eighteenth century because of the weakness of the presbyterian rule of the Established Church of Scotland. In most of Shetland by contrast, the presbyterian system, in the full majesty of its local supervision of parish peoples, was quite a forceable presence, at least by the end of the seventeenth century.

Reformation Scotland developed a system designed to impose strict control on the moral behaviour of the people. The parish state of presbyterianism developed during the late sixteenth and seventeenth centuries into a tightly operating and intrusive supervision of citizens. In each parish the landowners formed a committee known as the board of heritors to organise the financing of statutory functions, including the construction of a church (whose size was set on a per capita principle), a manse, a glebe (also of set proportions) and a graveyard, and the collection of the minister's stipend from the teinds (a tax on rateable value of agricultural land and fisheries). A second ecclesiastical court was the kirk session, chaired by the minister, and composed normally of six to twelve lay elders. The kirk session had the power to investigate, try and punish people for a long list of offences, the main ones being fornication, adultery, Sabbath profanation and witchcraft (an offence until the 1730s). However, kirk sessions were able and willing to investigate other crimes and moral offences, including murder, infanticide, abortion, assault, drunkenness, dancing, gambling and even unfair trading (such as selling under-weight bread). Little distinction was drawn between civil and religious offences in Scotland until the nineteenth century, and many were both. In any event, secular courts (the barons' courts until the 1740s and the county courts of the justices of the peace and sheriffs thereafter) usually allowed free rein to kirk sessions to

supervise minor offences, only stepping in to enforce sessions' decisions or take over offences if they were serious. The kirk session was a vital arm of the state in early-modern Scotland, in part because of the weakness of civil power in many areas and in part because of the difficulties of communication in a country of mountains, moors and islands. In Shetland (and Orkney) in the seventeenth and eighteenth centuries, there were special local 'constables' known as Ranselmen appointed by the Stewardry Courts of the islands with a variety of powers which could assist kirk sessions – including 'enquiring into the lives and conversation of families', and surveillance of those who absented themselves from church on Sundays.[6] The parish state was powerful, and became increasingly so in the late seventeenth and eighteenth centuries as presbyterianism invaded those parts of the country – principally the Highlands, Hebrides and Northern Isles – which had been less well penetrated by the essentially Lowland Reformation of the sixteenth century.[7] In the Gaelic-speaking Highlands and Hebrides, where Catholicism and Episcopacy had survived presbyterian encroachments in the seventeenth century, a massive Church of Scotland project was under way in the eighteenth century. With successive Jacobite rebellions between the 1710s and 1740s, 'popery' and 'prelacy' became strongly associated with rebellion, and over the course of the century the work of presbyterianising the Highlands and Hebrides was vital to turning the Gaels from a clan-based Jacobite-leaning territory into fiercely puritanical Protestants and loyal Britons.[8]

In the sixteenth and seventeenth centuries, the parish state of the Reformed Kirk was uneven in its power in Shetland, partly due to a shortage of clergy.[9] But by the eighteenth century the system was in full flourish. This was best measured – as elsewhere in Scotland – by the intensity of its operations against sexual immorality. In the parish of Sandwick (twenty miles south of Lerwick) in the 1750s, between nine and fifteen cases of fornication were dealt with each year, most of them antenuptial fornication of those who had conceived a child before their wedding day. The kirk session there had a very firm grasp of local morality, evident in the unfailing submission of the penitents to session discipline, and in the low number of recidivist offenders and adulterers, and in the low number of fornicators who were not married by the time their child was born. Sexual immorality there was mostly of couples who had sex (and conceived a child) before their wedding night, and had been caught out by the kirk session, which counted back from the date of birth of the child. Moreover, the session not only punished and

rebuked sinners, but applied some unusual extra measures. For instance, in 1761 Marion Erasmus and Matthew Sinclair admitted their guilt of fornication and the birth of an illegitimate child. But Matthew was an adulterer, though his wife died before the case was heard. The session minute records:

> Whereupon they were sharply rebuked for their aggravated guilt, exhorted to hearty repentance and summond apud acta to appear before the congregation nixt preaching Sabbath in order to give satisfaction for the scandel, and also appointed to separate one from another, under the highest penaltys prescribed by Law in such cases.[10]

The instruction to separate without even the option of marriage (which was possible now that Matthew was a widower) took the kirk's powers to extreme interference in individuals' lives. This was indicative of a locality in which the minister and elders were in secure control of the moral culture of a mostly submissive community, backed up if necessary by the civil judiciary.[11]

Sandwick was probably typical of Shetland;[12] it was certainly typical of most kirk sessions in mid-eighteenth-century Scotland. Moreover, it was to maintain this close supervision of the sexual morality of Sandwick's parishioners until the middle decades of the nineteenth century, largely unhindered by the rise of dissenting presbyterians who, though they mushroomed in central Scotland after 1760, did not in Shetland.[13] With the arrival of schools of the Edinburgh-based Society for the Propagation of Christian Knowledge (SPCK), the power of the parish state became more secure in the eighteenth century, being able to educate and propagandise the young in obedience to the kirk and its stern moral codes. The eighteenth-century church demanded obedience more than piety, and if the wayward still had illicit sex, then at least they submitted to punishment and generally got married straight away.

Lerwick, by contrast, was a very different place. From its inception in the middle of the seventeenth century, the town was a nightmare for the agents of good morals and law and order. One of the very first references to the place is in 1625 when the Church of Scotland ministers told the Sheriff Principal of Orkney and Shetland that the settlement was rife with every sin imaginable. He was told of:

> the great abominatioun and wickednes comittit yeirlie be the Holland-aris and countrie people godles and prophane persones repairing to thame at the houssis of Lerwick quhilk is a desert place. To the venteris of beir [sellers of beer] thair quha as appeiris voyd of all feir

of God and misregarding all ciuell and ecclesiasticall governement in thair drunkenes and utherwayis comittas manifest bludshed. In hurting wounding and sumtyme slaying utheris and many tymes hurting wounding trubling and abusing the cuntrie people. And also in committing manifold adultrie and fornicatioun with women venteris of the said beir and utheris women evill Inclyned quha resortis thither under pretext of selling of sokis and utheris necessaries to thame.[14]

In consequence of these sins and 'great prophanes and blasphemie of the name of God', the sheriff ordered 'the said houssis to be utterlie demolished and downe cassin to the ground be the haill awneris thairof'. He banned all 'women of quatsumeuer rank or qualitie' from going to the Sound for selling socks to the Dutch; they should, instead, send their husbands, sons or servants.

Not surprisingly, the settlement thrived. Until the early eighteenth century the town was part of a large adjacent parish (Tingwall) whose church was fairly inaccessible over a poor path four miles distant; though some of the inhabitants had built their own church around 1660,[15] they had no minister and no pastoral supervision. The general assembly of the Church of Scotland in Edinburgh sent a commissioner, the Revd John Brand, in 1701 to investigate the town and its spiritual state. He reported back:

Lerwick is more than half a mile in length, lying South and North upon the side of the Sound, and will consist of between 2. and 300. Families; it is but within these few years, that it hath arrived to such a number of Houses and Inhabitants. It is become so considerable because of the many Ships which do yearly frequent the Sound, whereby Merchants and Trades-men are encouraged to come and dwell in this place, and not for the pleasantness of its situation, or the fertility of the Country about, for it is built upon a Rocky piece of Ground, wherein they can have no street, but a kind of a narrow passage before their doors, betwixt them and the Sound, which in some places will not admit of two mens going in a breast . . . Many of their Houses are very Commodious to dwell in, most of them being two stories high, and well furnished within, their Inhabitants consist of Merchants, Trades-men, and Fishers, who keep up a good Trade with Foreigners, from whom they buy much of their domestick provisions, some of them are Persons of a Considerable Stock, which they have many ways to improve for their advantage . . . [T]he town itself is considerable, and the principal one in the Countrey, much frequented by the Gentry; As also, by strangers in the Summer time. And their Minister Preaching seldom here, they are ordinarily destitute of Gospel Ordinances . . . Which want of Ordinances, maketh their Case

very sad and deplorable; It nurseth ignorance; Occasioneth much sin, especially horrid prophanation of the Lords-Day, by strangers, as well as by inhabitants: And doth effectually obstruct the conversion of Souls.[16]

As a result of this report, a minister was supplied to the town, and kirk session justice creaked into action. The intention was to bring the town under the same intense ecclesiastical supervision as existed in rural Shetland and Lowland Scotland, and that was starting to be imposed in the Highlands. In comparison to the Gaelic-speaking areas of Scotland, however, the project to puritanise Lerwick was a lamentable failure. During the 1710s and 1720s the kirk session of the town did not function fully. It did not carry out the full range of disciplinary functions expected of a kirk session. Instead, it was the higher court, the Presbytery of Shetland, that tried all cases of discipline, ordered the accused and witnesses to appear before it, and passed sentences. The local minister and his elders were seemingly unable to enforce discipline in their parish, and were merely acting as conduits to the higher court for 'fama' (the kirk's polite term for gossip) regarding pregnant girls, adulterous men and Sabbath-breakers. Moreover, the moral caseload generated from this smaller-than-average parish of 1,200 souls was staggering.[17] In August 1714 the Presbytery was supervising an astonishing twenty-six cases in progress in Lerwick, whilst the annual caseload during the 1710s, 1720s and 1730s was between thirty and fifty – the vast majority for fornication. This was at least twice the caseload of most other parishes in Scotland.

This reflects a community in which the kirk's rule was extremely weak – even when by the 1750s the kirk session was tackling its own cases. The reasons for this state of affairs was the nature of the community – a port for fishers, whalers, traders and smugglers. Local women were having sex with sailors, who were often reported to the kirk session by their first name only and who had long skipped town by the time any pregnancy had been discovered. In 1723 Janet Tulloch gave birth to a child by 'one Douglass a sailor aboard a Holance Ship', and in his absence (and that of proof of his unmarried state) she was convicted as an adulteress.[18] On about 15 October 1765 at Lerwick harbour, Christian Nice had sex with a cooper Joseph McKay and became pregnant. In July the following year, when she failed to appear when summoned by the Presbytery, the ministers and elders immediately went round to her house. She told them that she thought McKay had gone to the West Indies, and that his shipmates had told her he was unmarried. The

Presbytery as usual informed her that unless he appeared to prove he was unmarried, she would be disciplined as an adulteress.[19] In January 1759, Marion Kelman admitted becoming pregnant by James Sinclair from Orkney the previous June when his English fishing boat arrived.[20] So many cases were coming forward that session meetings often lasted two or even three days. In 1768, the session was so pushed for time it heard the cases of two pregnant single women simultaneously,[21] whilst at a 'stock-taking' in November 1773 it was found that there were three cases outstanding from 1771 and six from 1772 as well as those from the current year.[22]

Lerwick's offenders against kirk morality repeatedly refused to complete their sentences or even failed to appear to answer libels. The kirk session imposed unusually severe sentences to 'purge scandal'; for fornication, the penalty in the 1750s was appearing in church for rebuke on twenty-six Sundays in succession.[23] Many claimed they were unable to appear because of illness, whilst some said that they could not pay fines immediately because of poverty. In 1723, six men were summoned for 'going aboard ships on the Lord's Day with their men and boats and carrying several things from the said ships having bargained with them'. The men failed to appear. At the same meeting of Presbytery, another man failed to appear for the second time of asking.[24] The ecclesiastical judicial system was in a parlous state because the people of the parish were unwilling both to observe the moral law and to submit to purging of their scandals.

Sexual immorality caused a particular problem with which the church authorities were expected to deal: single-parent families. Scottish kirk sessions were responsible for distributing poor funds to paupers, principally to the infirm elderly and to single mothers for the upkeep of their children. The system for supporting children with absent fathers was used by the Lerwick session as a carrot to try to enforce the kirk's disciplinary system for fornication and adultery. If a single mother submitted to the purging of her scandal, she would get child support; mothers who failed to complete their twenty-six weeks of kirk appearances were gently reminded by the session.[25] The difficulties that could arise were illustrated by Margaret Hay from Burra in rural Shetland who, sometime in 1754–56, had a child by a Lerwick man, but then left the islands on a ship after depositing the child without financial provision with Elspet Irvine. In 1759 Elspet came from Burra to see the kirk session in Lerwick and told them that unless they gave support she would 'bring in the Child to this town & leave the same to the inhabitants

to take care of it, as it belonged to the Parish'. Fifteen months later, after consulting with the local heritors (the landowners), the session sent her six shillings to keep the child.[26]

Lerwick kept the church busy in sorting out the care of children whose fathers had been fleeting guests from the sea. The kirk session took its welfare responsibilities seriously, for its minute books in the eighteenth century contain very long lists of recipients of its poor relief – the elderly and infirm as well as the single mother and child. However, it was very far from successful in tackling the origin of the problem. The culture of sexual licence was, in its intensity, probably amongst the worst in Scotland, and ecclesiastical rule just could not control it.

Smuggling and outsiders

Like many seaports around Britain and Western Europe in the eighteenth century, Lerwick was a good-time town for sailors and fishermen. But it was a community whose sense of freedom went a lot further than sex. In 1767, the Revd John Mill, a minister in another of the islands' parishes, preached in the town and noted that his sermon on the evils of smuggling did not go down well: 'they had been much displeased when preaching on Psalm 24 and 4 ['clean hands and a pure heart'], the application making their consciences reel and fall on them.' Mill's sermon criticised the smuggling in the town, and the behaviour of 'Greenlanders' or whalers in particular. After the Customs men found a consignment of illicit Dutch gin in 1774 – some deposited in Lerwick and some in a church at Nesting ten miles to the north – Mill noted that the Lerwick merchants were so rich that they were not fazed by the prospect of their smuggling ship being confiscated and burnt. The following year, gin seized by the Customs Collector was liberated by Greenlanders from the Customs House on the instructions of Lerwick merchants, resulting in the stabbing of a Customs officer in the thigh. Mill commented that 'so hot are people upon their lusts and idols that they fly in the face of Government itself and stick at nothing for gain'. Even later, in 1787, Mill noted that a navy man-of-war was anchored in Bressay Sound to watch over thirty Greenland ships 'to keep these rough people in aw [sic] and order, least when drunk and mad with gin they should set the town of Lerwick on fire'.[27]

Smuggling became ingrained in Shetland commerce in the eighteenth century, and especially in Lerwick. It was rife all over the islands, increasing as the range of taxed or excisable goods grew, and attracted

widespread condemnation from churchmen. In Delting parish towards the north of Mainland, the Revd John Morrison said in 1790 that 'A total suppression of smuggling would contribute greatly to the prosperity and preservation of the morals of the people.'[28] Neither the church nor the secular authorities were able to impose their will against smuggling in Lerwick. However, in rural areas where kirk session justice was strong there was evidently quite effective *moral* enforcement. A case from 1764 is instructive. In November of that year, the Shetland Presbytery ordered nine men to be disciplined for being 'supposed guilty of carrying off goods of a Dutch vessel stranded at Sandwick'. The Sandwick kirk session rebuked them for the offence and 'exhort them to a more Christian behaviour in time comeing' and the minister 'intimate this sentence from his pulpit of Sandwick'. Meanwhile, the minister found the civil authorities in Lerwick failing to enforce the law:

> The Minister told the congregation further that he had spoke with the Admiral after the Presbytery and asked him the reason why he did not examine into that affair as became his office. To which he replyd that he had done so, and the proof came out against such as was guilty of the plunder. He behooved to have put the law in execution which was no less penalty than death & confiscation of movables, besides that at present it was difficult to put the law into execution for want of sufficient prison.[29]

Thus, the church in rural Shetland was taking action against smugglers when the Customs and Royal Navy failed to act.

In many ways, smuggling defined the culture of Lerwick between the Act of Union of 1707, when the British state threw in its all to suppress it in Shetland, and the mid-1820s when it effectively died out as a major economic activity. Shetland shared with the Channel Islands strategic geographical locations for smuggling at either end of Britain – with Shetland dealing in goods within the northern end of the North Sea and the Channel Islands smuggling British goods (such as woollen products) into France and commodities like tobacco into Britain. With many islands and long coastlines, smuggling was easy, and both island groups became key targets for Royal Navy and Customs action. In the Channel Islands the Customs men were so active, intrusive and abusive in the 1680s that islanders petitioned James II that they were 'being treated like foreigners'.[30] The effect in Lerwick was similar. The central commodity of illicit trade was gin, but the range of products increased as taxable items rose and as home-grown sources (of timber, for instance)

decreased. Lerwick was the single-most important place involved in smuggling in Shetland, but most parts of the islands were involved. Few people – certainly men – were totally unconnected with what was going on. Lerwegian merchants were involved in a highly commercialised way, and local men were clearly employed in the transhipment, movement and concealment of the goods. Even more people in the Shetlands were involved in the consumption of the gin and other goods. More generally, such became the scale of the activity that it seems inescapable that the local people as a whole – especially in Lerwick – were party to knowledge of the trade, to the connivance in secrecy and to keeping the authorities in ignorance, all of which demanded a community-wide commitment to a shared illicit enterprise.

Smuggling epitomised the nature of Lerwegian society. Before 1818 the place had no town council or civil status as a burgh. It had no police force, and, apart from the struggling kirk session and the sheriff court which met there, it had no indigenous forces for law and order. The town's economy was dominated by the merchants, and the merchants controlled the smuggling. Illicit trade was part of the very fabric of life for the whole social hierarchy. The elites formed a society with the pretensions and sensibilities of Enlightenment and Union Scotland. Brand in 1701 noted that Lerwick was 'much frequented by the Gentry', and its own merchant families formed a 'high society' characterised by large town houses, conspicuous consumption, dances and 'refined' sensibilities. One visitor remarked in 1774:

> The people of Lerwick in general are gay, wear fine clothes, follow the south country fashions in their utmost extent, at least as far as they can; however, I cannot say there is so much dissipation among the young people here as even in Orkney. Of old the Schetland [*sic*] gentry were remarkable for bedizening themselves with lace and other trinkets, but this is now much worn out, and plainness seems to be as much studied here as elsewhere.[31]

The frippery of a peripheral elite was clearly in decline by the 1770s. For all the cavils of ministers from the rural parishes of Shetland, gentility and even 'churchianity' was a part of this. The country minister John Mill noted Miss Betty Grierson, who died in Lerwick in 1778 aged twenty, shortly before her wedding. He commented that, in a town of great signs of irreligion, she was a communicant, 'one of the most accomplished and virtuous young ladies in the country', though her death was 'an awful warning to those of her sex whose daft heads are soon laid in the

dust'. The 'affectionate daughter' of a Lerwick merchant, Betty Grierson was – her headstone records – 'A pattern of true Innocence; / Adorn'd with Virtue, Piety, and Sense'.[32] Such words were the touchstone of 1770s Enlightenment female gentility, as true in Edinburgh as in London. In a town of raucous seafarers, it was possibly also an acknowledgement of some achievement.

Still, this was a town much in need of protection. It was the object of repeated military action by the Dutch and the French, and even when peaceable it is likely that it reverberated to the exploits of drunken sailors. The Royal Navy often kept a presence in the harbour, whilst the fort was rebuilt in 1782, renamed Fort Charlotte, and had up to two hundred soldiers barracked there. In the eyes of Mill the minister, the soldiers were just as irreligious as the inhabitants and visitors to the town; his diary acknowledges surprise at one sergeant in the Sutherland Fencibles taking communion – a man he described as 'a remnant e'ven among the worst and in the worst of times'.[33] With soldiers, Royal Navy sailors, a Collector of Customs and Customs House Officers, Lerwick seemed a town under almost permanent martial law. Yet, whilst these forces of the state were institutional 'outsiders', their loyalties were compromised by the licence of the town, and soldiers and sailors – and no doubt the Customs men as well – participated in the freewheeling atmosphere of the place.

The forces of the British state after 1707 were there to supervise both locals and visitors. In summer, largely between May and August, Lerwick came alive. Throughout its history from the seventeenth to the twentieth centuries, the town was thick with foreigners. In the years around 1700, it was reported (probably with only slight exaggeration[34]) that the Sound ordinarily attracted between five and seven hundred Dutch fishing boats, or 'busses' as they were called, and in some years (probably with much greater exaggeration) reportedly more than two thousand of them – sometimes 'so thick' in the water 'that they say Men might go from one side of the Sound to the other, stepping from Ship to Ship'.[35] This made it a town erected on confused identities. The sense of 'community' is difficult to locate in sources which dwell on incomers, smuggling, Customs raids and military protection. 'Community' itself was an illusive thing, for the sense of belonging for residents was constantly and keenly overwhelmed by outsiders. Yet, the town existed because of those outsiders, and commerce and connivance at smuggling bonded visiting traders and sailors with local merchants and their workers (and no doubt also their families). It is clear from the kirk session

records that relationships, many of them casual, were constantly being formed between visiting men and local women. There was both an economic and a cultural interdependence between residents and visitors. Drink was the common sealant on deals in eighteenth-century Britain, and the visitors' social needs in the fleshpots of Lerwick furthered the economic–social bonding. As a consequence, the sense of 'others' and 'otherness' in this community may have rested less with 'foreigners' than with 'authority' – with, as Mill described it, 'government'. The army, the navy and above all the Customs men were the 'outsiders' who interfered with the making of livings, and with the riotous enjoyment of shore leave for sailors who had spent weeks and possibly months in the North Atlantic. And, as everywhere in Britain, the navy press-gang added to community hostility to the state; in July 1777, a government tender arrived demanding a hundred men from neighbouring parishes, and the men took to the hills; the local minister preached submission from the pulpit, hoping the men might show the same eagerness when 'fleeing from the wrath to come'.[36]

Lerwick was a 'rough' town, a 'hard' town and, like many seaports, a community of portable nations. In Lerwick perhaps more than in most of Britain, culture rode on language. It was a place where languages abounded – Dutch, German, Flemish, French, Norwegian, Scots, English, together with the dialects of those countries and the dialectical remnants of Norn. Everyday discourse, especially in the summer months, involved many tongues, intertwined in business or conviviality with foreigners. People learned snatches of other languages, to entice business, friendship and relationships. Lerwick was a keyhole to foreign language in Shetland; even in rural Shetland, according to George Low in 1774, 'almost all' of the people 'speak as much Dutch, Danish, and Norwegian as serves the purpose of buying and selling', and some of them speak fluently, 'especially the low Dutch'.[37] At one and the same time, Lerwick sharpened awareness of national identities, and also submerged them in a shared commercial and social milieu on the western shores of the Sound of Bressay.

Culture without custom

Lerwick had a special place in the cultural change of Shetland. It was a community where Norn, the native language of the islands since the Norse occupation in the early Middle Ages, was probably never or very little spoken. In rural Shetland, the imposition of Scottish rule from the

fifteenth century, and rising Scots immigration in the sixteenth and seventeenth centuries, had left Norn in decay, and before 1700 most 'ordinary' people on Mainland Shetland were bilingual, speaking Norn between themselves but Scots English with the elites. Scots English denoted superiority in wealth, social status and culture, combining Norn, Lowland Scots and English vocabulary as a dialect. This transformation marked scotticisation of property (principally landownership), the judicial system (in which Norse udal law had already decayed in the early seventeenth century), and the imposition of presbyterian church discipline. The church itself became important in this during the eighteenth century, when the placement of ministers, improvement of church buildings, and the provision of SSPCK schools from 1713 and parish schools from 1765 imposed English on the general population. It was Lerwick where the onslaught on Norn language was most effectively located in the seventeenth and eighteenth centuries, squeezed out both by the urgencies of commercial transaction and social exchange with visitors, and by the growing pretensions of the merchant class. By the 1770s, Norn was a dead language, though it had left a strong impact on Shetland dialect.[38]

This helps to explain the difficulty in reconstructing the popular culture of the town before 1800. It was a place without its own civil administration; it had no town council, provost or baillies. It had no burgh heritage and no ecclesiastical significance. Indeed, it was not a 'burgh' in any legal sense, unlike most small Scottish settlements formed before the eighteenth century which were either burghs of barony or royal burghs. There was no heritage of medieval Christianity here, as in Kirkwall, the capital of Orkney. There was nothing at Lerwick before about 1620 – no houses, probably no farming, and not even much passing trade. There was, in short, no heritage of people, buildings or institutions having been in that place upon which customs or rituals could have been based. Customs or 'traditions' had to be imported – whether from the rest of Shetland or further afield – or fresh ones developed.

The historian can search for parallels in North American settlements of the same period. In the new nation of the United States, urban settlements were appearing and developing. In Philadelphia in the late eighteenth and early nineteenth centuries, traditions of street ritual and theatre were borrowed from the European background of the new citizens, with unwanted symbols (of British royalism for instance) edited out in a mélange of traditions pasted onto new calendar events of importance in the recent history of the new city, state and nation.[39] At the

same time, however, there was very rapid change to those customs in the towns of the United States between 1789 and 1801. The symbols and rituals of the French Revolution interacted with the development of domestic political culture in instigating common songs, signs and symbols within a shared national calendar of street parades.[40] Very quickly, American cities acquired a seasonally defined civic ritual and custom of holidays, parades and pageantry, adopted and absorbed within the approved lexicon which defined both local belonging and national political culture.

What is striking about the North American experience of custom development in new urban communities is how different it was from Lerwick. American towns developed street customs and civic rituals with amazing rapidity, and even more rapidly changed those customs from symbolising merely local identities into symbolising one national identity. In Lerwick, the symbols of national identity were the agencies of state military occupation, tax-avoidance catchers and moral regulation. Ritual was not popular but in many respects oppressive, intended to symbolise the power of the state, though often, in reality, its impotency. The marching of the military in and out of Fort Charlotte, the meetings of the sheriff court, the surveillance of the Customs men, and the three-day meetings of the Church of Scotland's kirk session and the Presbytery of Shetland, drew onlookers and visitors. George Low in 1774 observed the Custom House and a new but unfinished townhouse, 'a neat fabrick with a spire, but no clock', where the sheriff held court and, below, where the 'common' prison was located. But the ritual associated with such institutions in eighteenth-century Lerwick was perfunctory. There were no popular parades exhibiting enthusiasm and allegiance to town or to nation. Ritual was imposed and not participatory.

In the broader sphere of public customary activity of all sorts, Lerwick seems to have been remarkably barren in the eighteenth century. There was no farming to speak of in the area of Lerwick, the town being surrounded by 'a desert, barren, unimprovable rock, only here and there a small spot scraped out for a garden'.[41] Agricultural customs were neither established nor relevant here, as neither the calendar events of ploughing and harvesting nor the economic relationship of tenantry and service were present to actuate them. The economic activity of the town does not seem to have generated customary rituals, but domestic ones flourished. The Shetland home was renowned as a focus for dancing to fiddle (violin) music, and played host by the early nineteenth century to a strong tradition of guizing. Samuel Hibbert in 1822 reported in

great detail on a mumming play he witnessed in Lerwick, where 'warriors' acted out the prophecy of St George, and then 'guizards' entered the room dressed in white shirts and short straw petticoats, and, under the direction of a 'scudler' in a high straw cap, danced with all the women in turn – an 'amusement', Hibbert observed, the same as in a 'politer masquerade'.[42]

Such events undoubtedly derived from rural Shetland's rich catalogue of ritualised entertainment. George Low in 1774 speaks of winter dances, especially at Yule, at which special songs called 'Visecks' were sung. These were songs in the Norn language, and apparently declined and were lost because of the decline of the language. A clergyman in Unst told Low that in their place came the playing of cards, drinking and Scotch dances.[43] Despite the loss of Norn, Low observed that 'Witches and Fairies, and their histories, are still very frequent in Schetland'. 'Their Festivals', he went on, 'are Christmas, Newyearsday, Uphaliday (the last day of Yule), Bonny Sunday, Peace Sunday (Easter), Johnsmass (J. Baptist's), Lambmass, Candlemass, Hallowmass, &c., and to each of these they annex particular ceremonies, mostly drawn from the Popish times.'[44] This commentary on rural Shetland, combining a list of festive occasions with a reference to them as 'Popish', is characteristic of presbyterian ministers like Low during the eighteenth century. Such remarks were also made of the Highlands and Hebrides, parts of Scotland where presbyterianism had failed to take the firm hold during the late sixteenth and seventeenth centuries it had in the Lowlands of Scotland. The observance of such dates, including Christmas and Easter, was generally – and sometimes fiercely – frowned upon by the presbyterian system, and in earlier decades would have been the occasion for attempted suppression by kirk sessions. Low's remarks echo the sentiments of an earlier, stricter presbyterianism, but in their mildness also reflect the kinder mood of the late eighteenth century and the antiquarian interest of Enlightenment rationality. They were curios and social relics, to be recorded – as Low did – on the same page as a drawing of a prehistoric axe found buried in the ground of Shetland.

Such casual evidence indicates that Yule revelries and a folklore of fairies were clearly to be found in rural Shetland in the eighteenth century. Marking Yule was customary nearly everywhere in Britain, though Christmas was subject to considerable suppression from the presbyterian church in many places in Scotland. Notwithstanding this, Scots still celebrated Christ's birth in many ways – with the Yule-log and special bread, cakes and family customs.[45] Hogmanay and New Year were even

more well celebrated, left relatively untouched by the kirk because of its lack of obvious 'papistical' connections. During the nights of Christmas Eve and Hogmanay, the lighting of bonfires and the consumption of alcohol amidst revelry were common. During daylight on both days, there were traditions of playing games – notably shinty in the Highlands and football in many towns and villages. At Kirkwall in the Orkneys, the 'ba' game was a ritual event between men and boys from two ends of town – the 'uppies' and the 'doonies' – which involved sometimes hundreds of players in a day-long struggle to move an inflated sheep's bladder through the streets and wynds of the town to score goals at the opponents' end.[46] This was a practice which kirk and town authorities frequently – and usually unsuccessfully – tried to suppress.

The existence of revelry at Yule and New Year in Lerwick is almost certain, but we know little of what went on. Some scholars have suggested that fires and the use of flaming tar-barrels was known in Lerwick at this time – especially at the jubilee of George III,[47] but this is unsubstantiated from any contemporary source. Though the silence of the records does not preclude revelry at Lerwegian Yuletide, it does seem to point to the likely absence of a highly structured customary ritual in the town. The record of the folklorists of rural Shetland may have a relevance in Lerwick, and there may have been a passing of rural customs of seasons and other activities to the town. But the historical records we have do not provide us with evidence of this – certainly for the eighteenth century.

There is a school of thought that this kind of absence of information can be significant. The main sources on calendar customs in Protestant countries in the early-modern period tend to be those Protestants themselves who objected to them, and wrote of them in scathing terms. In those places and times when the records do not mention these customs, it follows, Protestants may have been happy with them and did not see fit to mention them. Ronald Hutton has argued in the English context: 'What we seem to have here is one of the significant silences of history: an apparently instinctive assumption on the part of Protestants that the folk practices were essentially harmless.'[48] The general lack of research into the impact of the Scottish Reformation upon ritual observances means we know little of how this research formula might work out in this country.[49] Though the historian might be able to use supposition to fill the gaps in places with *few* records of customs, the historian of a place like Lerwick with *no* records of calendar customs – and of winter ones at Christmas and New Year in particular – cannot make that leap.

79

There may be reasons for supposing that the absence of evidence in the case of Lerwick can be read as indicating an absence of highly structured Yuletide customary rituals. Though Lerwick civil society was gathering a social standing and social pretension in the late eighteenth century, it was a society whose very existence still rested upon playing host to visitors from the sea. The town was the roughest of places, compact in size, and in which cultural stratification was highly problematic. During the eighteenth century, the focus of economic growth in the islands lay in the countryside, with improving 'lairds' enforcing change to fishing methods, leaving Lerwick to suffer great fluctuation in fortune and resident population.[50] The town's social development was slow; there was as yet little notion of 'respectable' and 'rough' ends of town, of a patrician class elegantly removed from the domain of the uncouth sailor, soldier or town-dweller. It was a town whose own heritage of one and half centuries was erected upon drink and enjoyment, where the people conjoined in trading, smuggling and provisioning ships. Lerwick remained little more than a strip of houses and piers at the shoreline, forming a multilingual, laissez-faire settlement of 'sharp' merchants, traders, seamen and townspeople enjoying a remarkable freedom from effective civil control. It was a settlement awaiting the self-confidence of a firm economic destiny. The absence of ritual, therefore, may reflect the provisional nature of Lerwick as a community in the eighteenth century.

Lerwick was a small town – a village by any other measure – which had been established by free enterprise. Civil control by agents of the church, judiciary, military and the Customs was weak, each operating in an equilibrium of power with the economic interests of the merchants, seaman and smugglers. All Lerwegians to lesser or greater extents depended on the survival of this self-proclaimed freeport. This essential economic relationship defined the ethos of the place – an ethos founded upon a disregard for authority. 'Cocking a snook' at agencies of power was endemic, defining 'outsiders' not as foreigners but as the military officers, the Customs Collector and the kirk ministers. The 'boundary of belonging' was clearly marked here by economic and social relationships between those willing to do business and have fun, and those unwilling. No symbols, no customary activities, and no rituals were needed to define this. The formal hierarchy of an early-modern town existed here, but it was so contingent upon the continued freedoms of unhindered trade, sexual liaison, drink and so on that it never needed

the calendar rituals of inversion. No Abbot of Misrule, no charivari, not even the agrarian ritual of harvest home, was required. To a significant extent, Lerwick in the seventeenth and eighteenth centuries was a town based on 'misrule' – on the perceived de facto inversion of customary power between state authority and people – and in no need of ritual to remind civil power of that fact.

Notes

1 The summary that follows is based on H. D. Smith, *Shetland Life and Trade 1550–1914* (Edinburgh, John Donald, 1984), pp. 1–45.

2 C. Rampini, *Shetland and the Shetlanders* (Kirkwall, Wm. Peace, 1884), p. 15.

3 These figures are from, or calculated from, J. G. Kyd (ed.), *Scottish Population Statistics* (Edinburgh, Scottish Academic Press, 1975), pp. 65, 82; and A. T. Cluness (ed.), *The Shetland Book* (Lerwick, Zetland Education Committee, 1967), pp. 45, 50, 52–3.

4 The census returns included some categories of the military and persons on board ships in harbours, but with the census being taken in most cases in April, it excluded most later-arriving fishermen and fishing-related visitors. I am grateful to Dr Jeanette Brock for advice on this point.

5 G. Jackson, *The British Whaling Trade* (London, A. and C. Black, 1978), pp. 72–3, 78, 89; S. Ryan, *The Ice Hunters: A History of Newfoundland Sealing to 1914* (St John's, NF, Breakwater, 1994).

6 Rampini, *Shetland*, pp. 46–7; G. Goudie, *The Celtic and Scandinavian Antiquities of Shetland* (Edinburgh and London, Blackwood, 1904), pp. 241–6.

7 For the operation of the kirk session system, see F. D. Bardgett, *Scotland Reformed: The Reformation in Angus and the Mearns* (Edinburgh, John Donald, 1989); W. R. Foster, *The Church Before the Covenants: The Church of Scotland 1596–1638* (Edinburgh, Scottish Academic Press, 1975), pp. 66–84; R. Mitchison and L. Leahman, *Sexuality and Social Control: Scotland 1660–1780* (Oxford, Basil Blackwell, 1989); and C. G. Brown, *Religion and Society in Scotland since 1707* (Edinburgh, Edinburgh University Press, 1997), pp. 67–94.

8 Brown, *Religion and Society*, pp. 84–92; J. Macinnes, *The Evangelical Movement in the Highlands of Scotland 1688 to 1800* (Aberdeen, 1951).

9 G. Donaldson, 'Some Shetland parishes at the Reformation', in B. E. Crawford (ed.), *Essays in Shetland History* (Lerwick, Shetland Times, 1984).

10 SA, CH2/325/1 *et seq.*, Sandwick kirk session minutes, 23 September 1761.

11 The sheriff court, as was common in mainland Scotland, offered support to the kirk in the enforcement of its decisions. G. Donaldson (ed.), *Court Book of Shetland 1615–1629* (Lerwick, Shetland Library, 1991), p. 167.

12 It fits the pattern described in J. J. Graham, 'Social changes during the quinquennium', in D. J. Withrington (ed.), *Shetland and the Outside World 1469–1969* (London, Oxford University Press, 1983), pp. 224–9. See also J. J. Graham, 'Education in Shetland in the eighteenth century', in B. E. Crawford (ed.), *Essays in Shetland History* (Lerwick, Shetland Times, 1984).

13 Even by 1840, only about 7.9 per cent of Shetlanders were religious dissenters compared with around 30 per cent of Lowland Scots; figures calculated from data in *The New Statistical Account of Scotland, vol. xv, Shetland* (Edinburgh and London, Blackwood, 1845), p. 175, and in Brown, *Religion and Society*.

14 Acts and Statutes within the Lawting, etc., within Orkney and Shetland, *Miscellany of the Maitland Club, vol. 4* (Edinburgh Maitland Club, 1840), p. 199; also given in Donaldson (ed.), *Court Book of Shetland*, p. 126.

15 M. Finnie, *Shetland: An Illustrated Architectural Guide* (Edinburgh, Mainstream/RIAS, 1990), pp. 24–5.

16 Revd John Brand, *A Brief Description of Orkney, Zetland, Pightland Firth and Caithness* (1701), quoted in J. Willock, *A Shetland Minister of the Eighteenth Century* (Lerwick, Manson, c.1897), pp. 167–9.

17 Its population in 1755 was 1,193, when the Scottish average was 1,342. Figures from and calculated from J. G. Kyd (ed.), *Scottish Population Statistics* (Edinburgh, Scottish Academic Press, first published 1952; 1975), pp. xv, 65.

18 SA, CH2/1071/2, Presbytery of Shetland minutes, 29 May 1723.

19 SA, CH2/1072/2, Lerwick kirk session minutes, 20 July 1766.

20 Ibid., 7 January 1759.

21 Margaret Omond and Ann Sutherland both admitted 'uncleanness and with child'; ibid., 29 March 1768.

22 Ibid., 15 October 1773.

23 Ibid., 3 December 1758.

24 SA, CH2/1071/2, Presbytery of Shetland minutes, 29 May 1723.

25 For example, Margaret Sinclair 'Adulteress', who managed ten of her twenty-six required appearances within a two-year period, and who gave the excuse of 'indisposition'; SA, CH2/1072/2, Lerwick kirk session minutes, 24 December 1758.

26 Ibid., 25 November 1759 and 26 February 1761.

27 Quoted in Willock, *A Shetland Minister*, pp. 104–7.

28 J. Sinclair (ed.), *The Statistical Account of Scotland 1791–1799: Shetland* (1978 edn, E. P. Publishing), p. 419.

29 SA, CH2/325/1 *et seq.*, Sandwick kirk session minutes, 23 October 1764.

30 Quoted in A. G. Jamieson, 'The Channel Islands and smuggling 1680–1850,' in A. G. Jamieson (ed.), *A People of the Sea: The Maritime History of the Channel Islands* (New York and London, Methuen, 1986), p. 197.

31 G. Low, *A Tour Through the Isles of Orkney and Shetland* (first published 1774; Kirkwall, 1879), p. 73.

32 Quoted in Willcock, *A Shetland Minister*, pp. 108, 172.

33 Quoted in ibid., p. 109.

34 Smith, *Shetland Life*, p. 26.

35 Brand, *A Brief Description of Orkney*, p. 171.

36 John Mill, quoted in Willock, *A Shetland Minister*, pp. 111–12.

37 Low, *A Tour*, pp. 67–8; B. Smith, 'The development of the spoken and written Shetland dialect: a historian's view', in D. J. Waugh (ed.), *Shetland's Northern Links: Language and History* (Edinburgh, Scottish Society for Northern Studies, 1996), p. 33.

Misrule without custom: 1625–1800

38 Smith, 'The development', p. 34; cf. M. P. Barnes, 'Jakob Jakobsen and the Norn
Language of Shetland', in Waugh, *Shetland's Northern Links*.

39 S. G. Davis, *Parades and Power: Street Theatre in Nineteenth-century Philadelphia*
(Berkeley, University of California Press, 1986), pp. 1–22.

40 S. P. Newman, *Parades and the Politics of the Street* (Philadelphia, University of
Pennsylvania Press, 1997), esp. pp. 152–92.

41 Low, *A Tour*, p. 67.

42 S. Hibbert, *A Description of the Shetland Islands* (Edinburgh, Constable, 1822),
pp. 556–60.

43 Quoted in ibid., p. 563.

44 Low, *A Tour*, p. 82.

45 F. M. McNeill, *The Silver Bough, Volume 3: A Calendar of Scottish National Festivals*
(Glasgow, MacLellan, 1961), pp. 72–3.

46 J. Robertson, *Uppies and Doonies: The Story of the Kirkwall Ba' Game* (Aberdeen,
1967).

47 M. M. Banks, *British Calendar Customs: Orkney and Shetland* (London and Glasgow,
Folk-Lore Society, 1946), p. 4. This is repeated in B. J. Cohen, 'Norse imagery in
Shetland: An historical study of intellectuals and their past in the construction of
Shetland's identity, with particular reference to the period 1800–1914', unpublished
Ph.D. thesis, University of Manchester, 1983, p. 461.

48 R. Hutton, 'The English Reformation and the evidence of folklore', *Past and Present*
148 (1995), p. 114.

49 R. Hutton, *Stations of the Sun: A History of the Ritual Year in Britain* (Oxford,
Oxford University Press, 1997), p. 419.

50 Smith, *Shetland Life*, pp. 46–92.

4

Mischief and misrule
at Yule 1800–72

The rise of 'mischief' as custom

I N 1888, a writer in the *Shetland Times*, who signed himself 'Uvhan', reviewed the development of Christmas and New Year customs in Lerwick over the previous one hundred years:

> In the later part of last century and even at the beginning of the present, it was no uncommon thing for a huge fire, made of an enormous conglomeration of peak-stacks, to be seen blazing from knows and eminences all through the Mainland [island of Shetland] in honour of Yule morning . . . In the year 1789 Lerwick was one of the tamest places in Shetland, as far as regards anything like unity in celebrating Christmas or New Year's Day. However, by the year 1810 the usages of country sailor lads has penetrated to Lerwick. First footings and the introduction of bonfires were the order of the day. In 1814 the Lerwick boys and sailor men lodging in town made a great demonstration in Lerwick. . . . The wars had made Britain bellicose, and sailors coming from America brought numerous small arms and what they called blunderbusses. From that time on to the [18]40s the Lerwick boys were, it is believed, the roughest lot in Europe on Christmas Morning and Old New Year's Morning.[1]

Uvhan's account has three vital elements. First, it argues that Lerwick Yuletide was transformed from relative passivity to celebratory zeal around 1800, induced by a mixture of native Shetland and 'outside' influence. Second, it argues that Lerwick Yuletide celebrations became extreme, 'the roughest lot in Europe'. Third, the 'roughness' was transitory, lasting about a quarter of a century between roughly 1815 and 1840. Though the dating of this period of 'rough Yule' may be questioned, these three elements were keys to the development of the Lerwegian Christmas and New Year festival.

Between 1790 and 1840, the nature of the Lerwegian economy and society changed significantly. First, the late eighteenth century had witnessed an intensification in smuggling. As the sea lanes became busier with commercial growth, opportunities for illicit trade boomed. The commodities smuggled became more diverse. As well as gin, the smuggling of tea, tobacco, timber and wood goods was big business, primarily with Rotterdam (the centre of the gin trade) in Holland, Hamburg in north Germany, and Bergen and Christiansand in Norway. Around 1791, the landowners withdrew from the gin trade (though they continued smuggling in other commodities), leaving it in the hands of Shetland – and predominantly Lerwegian – merchants.[2] With the coming of the Revolutionary and Napoleonic Wars between Britain and France during 1793–1815, smuggling in some years was enormous. However, Shetland merchants ended direct participation in gin smuggling in 1816 after intense Customs and navy activity, and whilst Dutch and English smugglers kept it going very profitably for another seven years (landing more than 10,000 gallons each year, mostly in the remote islands of Shetland), smuggling as a separate trading enterprise ceased in the mid-1820s.[3]

With this, Lerwick merchants moved into the cod fishing industry. The French wars were good for Lerwick merchants, for in addition to profits from smuggling they gained naval prizes from the war: in 1780, Shetland had only six trading vessels with a tonnage of 291, but by 1809 it had ten with a tonnage of 768.[4] Smuggling and war booty helped to capitalise Lerwick merchants in the cod and herring fishing industries which were to grow in importance between 1820 and 1870. One-man enterprises developed rapidly in the 1820s and 1830s into around six large firms – one of which later evolved into the P&O shipping company – which financed and owned the majority of the boats used in cod fishing. Lerwegian merchants had now diversified; in addition to running cod fishing companies, they were import–export agents, shopkeepers, shipowners and entrepreneurs in the smaller herring fishing and inshore 'haaf' fishing. They were intense capitalist operators, and many suffered from the vicissitudes of risk-taking and went bankrupt. But the town had become a centre of frenetic business development and change (including the establishment of the Shetland Bank in 1821[5]), and its economy was starting to grow and diversify.

The merchants dominated the structural development of Lerwick. In the 1790s, they started to build stone lodberries – stores erected on piers on the beach – at the south end of Lerwick, and by 1814 there were

twenty-one of these. In the 1810s and 1820s, the town's port activities increased as a result of growth in fishing and the Greenland whaling industry. Cod fishing boats laid up here during winter, and herring-curing stations were set up around 1830. By then, the north end of town was developing rapidly as a result of dock facilities erected at Freefield and Garthspool – the former built in about 1822 with shipbuilding and repair facilities, creating a new focus of manufacturing beyond the existing town envelope. It introduced skilled manual occupations to Lerwick, and exemplified the diversifying economy. As the Revd James Catton observed of the town in 1838:

> It is a place of great extent and business for Shetland. Here is the principal fishing station in the Islands, and the great numbers of coopers are employed in making herring barrels. Boat and Ship-Building is going on; sawyers, smiths, masons, all are busy; vessels and boats loading and unloading; indeed, the business done here, in a good fishing season, is astonishing.[6]

With the addition of increasing cattle trade from the hinterland of Lerwick, the town also developed a market function. In 1818 it was erected a burgh of barony (the lesser of the two main forms of Scottish burgh) to establish markets for agricultural goods and a magistracy and police force. Though no proper market was developed for some decades, it helped to mark the rise of Lerwick to the status of an economically important burgh.

Lerwick remained dominated by visitors, especially seamen, and in the 1810s and 1820s by smugglers. The latter were predominantly Dutch and English who were heavily armed, and who spent their time evading Customs and Navy ships. The Greenland whalers were what they had always been – hard men undertaking arduous work far from home for many months – and Lerwick was a town of resort for enjoying their leave.[7] With the foundation of the docks and barrel-making for the herring industry, Lerwick from the early 1820s started to acquire an industrial workforce. The north end of Lerwick around Freefield became the manufacturing and herring-curing quarter, and an artisanal structure of masters, journeymen and apprentices developed, even if informally. With it came the attitudes and customs of artisan culture: of pride in skill, trade unity, and apprentices' rites of passage. A new breed of machismo culture was developing at the north end of town.

It was in the midst of these changes to the economic structure of the town that Lerwick started to develop robust Christmas and New

Year (OS) celebrations. The following account relating to 1806 is the earliest description of any Yuletide in the town, described thirty-one years later by a man who, as a young boy, was a participant in what happened early on Yule morning:

> The rendezvous and plan of campaigne were all laid down by the chief captain some days since. And here we are, a troop of some sixty or seventy – men of all arms, assembled at the north end of the walk at three o'clock of a Shetland winter morning. Every man carries firearms, from the humble sheep-leg gun up to him whose wealthy sire enables him to sport the proud blunderbus. Behold our band of music too! two fiddlers in the van, followed by a half a dozen drummers . . . So, hark! the word is given; off we go. Strike up, fiddlers! – rattle go the cannister drums, – crack! crack! pop! go the guns, pistols and blunderbuses – crash goes a 'lozen' here and there; and thus away moves the procession through the high streets, yclept 'the walk' of Lerwick, – for we have decreed that whoever of her denizens hopes to sleep on a 'Yule morn' shall hope in vain.[8]

The air of violence in this account is striking. The narrator says that he, like all the others, carried a firearm – a pistol which he had bought in the same year. He recounted that there was one piece of damage – a window of 'Jeemie's' house – on account 'for some former tricks'. This theme of revenge, though downplayed (perhaps deliberately) in this account, is important, for it is one that was to grow into a major aspect of Yule in the town over the next half century. However, the narrator stressed that there was also self-inflicted damage; 'Jamie', he says, has 'blown up; his powder magazine which he always carries in his breeches pocket, has caught fire.'

After 1806, we have periodic references for three decades of events of an identical tenor being repeated at Yule. In 1818 the Justices of the Peace prohibited the use of guns and drums, and at the end of the years 1824 and 1826 there are references from the town council concerning 'improper practices which exist in the town'.[9] Then in 1836, a total of eighty-eight panes of glass were broken at Yule and New Year, caused by what the procurator fiscal – the local law officer – described as 'crackers or combustible balls'. These consisted of up to four pounds of gunpowder wrapped in paper, and tied up into a fist-sized ball into which a match was inserted. A sheriff officer, employed to enforce the orders of the local court, reported: 'The ball is placed in any situation that the person using it inclines, and then left to explode, which it does with a

noise little short of a cannon, and with certain destruction to any window that may be in the neighbourhood.'[10]

Three years later, in 1839, there was apparently an important addition to the Yule proceedings. According to an anonymous writer fifty years later, there was an elaborate carnival at around 3.30 a.m. or 4 a.m. on Christmas morning (OS). A procession was led by a vehicle on eight wheels called a 'krate' with between sixteen and twenty people on board. The krate was made of wooden stoneware crates, and put together by the docks' apprentices and carpenters. Decorated with flags at each corner, the krate was rolled through the town:

> Six fantastically dressed guizers marched on either side [of the krate] carrying torches, while a motley, eager band of guizers and others pushed and drew the rolling 8 wheeler, the fare of which consisted of two fiddlers and a bagpiper wherever he could be got. . . . At certain times monied men, both home and foreign, have been known to disguise themselves, enter the krate for an hour or two, and throw handfuls of coins among the young folks.[11]

The procession moved all through Lerwick, starting from Fort Charlotte and moving along the town's main thoroughfare, Commercial Street. At the Union Bank, he said, it stopped and the participants and spectators got together for dancing in the street. In succeeding years, the narrator goes on, the use of flaming tar-barrels took over, and the people-carrying krate declined in importance, to disappear eventually in 1845.

The early 1840s was evidently a key period in the emergence of Yule customs in Lerwick. The dating of the emergence of the krate relies on this one source, written a half century later, and may be imprecise. Certainly it was not mentioned in 1842, when a newspaper correspondent described the events common to both Christmas and New Year's Day (OS):

> A stranger to be suddenly planted in our good town, early on either of the mornings of those days, would think a bombardment if it was in active operation, and would no doubt begin, in the first impulse, to look to his own safety: but it all ends in smoke. No harm is done by the loud and startling explosions of guns, pistols, &c., a practice which the lads and boys here are very fond of on those occasions, and by which the sleep is driven from the eyelids of every one disposed to it. Owing to the long standing of this practice, the local authorities cannot effectually put a stop to it. Some other amusements of a more

pleasing nature takes places when daylight arrives. Fellows with red coats, cocked hats, swords, and flags overhead, accompanied with fiddlers, drummers, &c. &c., go the rounds amongst the gentry, and from the proceeds of their benevolence, amuse themselves by dancing to the tunes of 'the Shoals o' Foula,' and 'the Scalloway lasses,' and ending, as sometimes happens, with the tune of 'Daydawn,' when daylight is abroad of course.[12]

From this point, the historical sources become much more eloquent about Lerwick's Christmas festivities. We know with some certainty that by 1850 an established pattern of activities had emerged on both Christmas morning and New Year's Day morning to last, with little alteration, until 1874. These activities were composed of two main elements. First, full-blown guizing had developed, where groups of men dressed in costumes and masks, carrying and discharging firearms, went round on both mornings knocking on doors seeking favours – usually food and drink – either at the doorstep or inside the house. Those who refused admittance or food risked a penalty – usually 'tarring' where tar was smeared on doors and windows, though sometimes the breaking of windows (on at least one occasion by bullets).[13] Younger guizers, referred to as 'peerie [small] guizers', did the same less aggressive tour during the day in search of food or money, though with less impressive penalties at their disposal.

The second element in the festivities was tar-barrelling. The burning of tar-barrels was not an uncommon sight in nineteenth-century seaports. Like all fires, it was a source of heat and a focus for casual social gatherings in streets. A visiting sea captain in Lerwick in autumn 1822 reported being greeted on every street by flaming tar-barrels – very probably the output from the town's recently established barrel-making enterprise.[14] But what developed in the town in the early 1840s was the incorporation of flaming tar-barrels into a ritualised event of considerable spectacle. The anonymous former guizer 'Uvhan' recalled in the 1880s what he did in his youth:

> there . . . appeared in our tortuous streets a huge fish tub filled with tar, oil, old ropes, pitch, and anything most combustible. Sometimes there were two tubs fastened to a great raft-like frame knocked together at the Docks, whence the combustibles were generally obtained. Two chains were fastened to the bogie supporting the capacious tub or tar-barrel . . . [and] eked to these were two strong ropes on which a motley mob, wearing masks for the most part, fastened.[15]

The bulk of later accounts described the construction of the krate as a large wooden sledge (now, unlike 1839, without wheels), using strong timbers from stoneware packaging; however, in the late 1850s and 1860s – as we shall see – it was often an old boat that was used. Securely fixed in the krate or boat were between four and twelve half-barrels full of combustible rags and material. These were covered in tar and lit, and the krate towed by a gang of guizers back and forth along Commercial Street on heavy chains.[16] Because of the narrowness of the street, the design dimensions of the krate were critical. There were also intermittent reports from later narrators that the krates of this period carried effigies, though we have no information as to who they were meant to represent or whether the effigies were ceremoniously burnt.[17]

These were the characteristic elements of the revels at 3 a.m. and 4 a.m. on both Christmas and New Year's Day (OS) between 1845 and 1874. The locus of activity was Commercial Street, which had now become the theatre of misrule for two days in winter. It was – and remains today – the main shopping and trading street of Lerwick (and indeed the Shetlands as a whole). Preserved today broadly as it was then, it is a street whose overall north–south direction meanders snake-like beside the shoreline because buildings on either side were not erected to a common line. The street widens and narrows repeatedly, from some thirty to ten feet, whilst in the mid-nineteenth century it narrowed to little over six feet at a famous point known as 'the Roost', where the fiery tar-barrelling krate frequently got jammed. Running westward up the hill from this street are the steep narrow lanes or 'closses' on which many of the inhabitants of Lerwick lived (and a few still do), whilst eastwards is the sea. In the early nineteenth century the shore was still predominantly beach, but as merchants' lodberries were built, and with the construction of the harbour, piers and docks, this was gradually receding, until today when there is only a small stretch of accessible sandy beach at the extreme south of the town. At the northern end of Commercial Street (known locally as the Street), and looming over it, stands Fort Charlotte, built in the 1660s and refortified in 1782 as an hexagonal battery and barracks of formidable presence. Halfway along this half-mile street a small opening between buildings forms the Market Place with its Market Cross in the centre – the scene of much of the Yuletide festivities in the mid-Victorian period.

This half-mile stretch along Commercial Street formed the battleground on which the authorities engaged from around 1845 in their attempt to suppress the krate and its uproarious attendants. Municipal

records show that it was already customary by that year for the town council to appoint special constables to quell the event and prevent the carriage of the krate.[18] One local writer, Thorwald Strong, recalled in 1887 that the blazing krate of tar-barrels was dragged from one end of town to the other 'attended by an admiring crowd, many of whom were got up in ancient uniforms, including cocked hats', whilst others hid in the closses and lodberries 'and kept up an incessant fire of small-arms in spite of the frantic efforts of the "constables" to suppress the fusillade'.[19] In 1847 it was reported that Yule had 'passed over more quietly than usual, efficient steps having been taken by the authorities for the

12 The 'Roost'. This was the point in Commercial Street where the tar-barrelling krates of the 1840s, 1850s and 1860s could become stuck, occasionally two from opposite directions. Named after a narrow sea passage, it was removed by later street improvements. (Courtesy of the Shetland Museum)

prevention of outrage, by the shutting of the public houses at an early hour and by their parading the town, in company with a number of special constables'.[20]

Such success by the authorities was short-lived. The krate became the focus of contest between guizers and police. It did not, though, have any other symbolism. None of the local nineteenth-century sources seek to explain it, which in itself is instructive. Those who described it, writing mostly in the 1880s once it was banned, were writing at the birth pangs of Up-helly-aa itself, and were to prove in other respects very imaginative in developing historical symbolism and meaning to understand later developments. Their failure to extract some Norse or other connection from the krate as it was used between the late 1830s and early 1870s would suggest that there was none. The guizing outfits were clearly many and varied, without a coherent theme. The 'ancient uniforms', often reputedly red, with cocked hats, swords and flags, seem to indicate little more than the use of military clothes brought back from military service. Equally, there is strikingly no reference to a theme for the dressing of the krate – as a Norse ship or anything else.

The krate-based pastimes were located in a void of overt thematic intent. The participants were either wholly or predominantly male, the vigour of their activities underscored with considerable drinking. These young men were demonstrating prowess with the greatest symbol of power in the winter morning – fire. They had created in the krate a test of their strength, ingenuity and daring, having to move it whilst licking with flames from one end of a very narrow street to the other whilst evading the police sent to stop them. A plan of campaign was clearly needed in order to succeed in the endeavour: thus the use of firearms by additional men to create both covering fire and diversion. The challenge was always, so the accounts tell us, to get all the way from the north end of the Street, through the Roost, to the south end where there was a rock known as the Cockstool, at which point the krate had to turn – the 'squad' in charge of the krate being told by their leader to 'Sweep her! Sweep her!'; 'round would swing the long double line of guizers, jostling the crowd back and getting in one another's way . . . till the chain tightened and jerked them back into order again.'[21]

At some point in the late 1850s or early 1860s the number of krates increased from one to several, each with its own large group of guizers in attendance. Christmas Day 1853 (OS) produced 'wonted merriment':

At a very early hour in the morning, numbers began to parade the streets, and tar barrels were seen blazing in all directions. Six couples of dancers – the males arrayed in cocked hats, and the 'soi disant' females in 'braw' caps and streamers, then appeared, followed by fiddlers and parties bearing flags and torches. During the day fireworks were discharged at intervals.[22]

Later accounts emphasised the existence of two krates hauled by opposing groups of young men. The first group were the 'Northerners', also known as the 'Docks boys', composed of carpenters and other workers based in the docks and boat-building area around Freefield, Garthspool and Skipidock in north Lerwick. The second group were called the 'Southerners' (possibly an American Civil War reference) composed of the young men of the town proper around Commercial Street. At Yule and New Year's Day by the 1860s, each group was building its own krate, and making a contest by building it as big as possible (with the greatest number of flaming tar-barrels aboard), and by dragging each from different ends of the Street and challenging the other for passage.[23] This kind of territorial division was very common for recreational purposes in British towns of the eighteenth and nineteenth centuries, often for the purposes of playing apprentice-boys pre-rules football matches (as in Derby and other English towns on Shrove Tuesday), in Kirkwall, and elsewhere.[24]

It seems likely that the multiple krates of the 1850s gave way in the 1860s to two principal ones of the dock's boys and the townsmen (Northerners and Southerners), and the krate duel between them was a late development lasting some fifteen years from the early 1860s to about 1874. Its significance probably lay in both the territorial and occupational character of the respective sides. The Northerners were from the fast expanding manufacturing end of town, dominated by its shipbuilding trades, and whose krate was a product of some of those skills. The Southerners were likely to have been drawn from those manual workers in the town who undertook a range of occupations in the merchant, trading and retailing trades – probably mostly unskilled jobs in labouring and warehousing. Notwithstanding such likely occupational and territorial differences, it might be a mistake to read too much into this as evidence of a fractured Lerwegian proletariat. There is little evidence of the krate duel leading to anything serious by way of conflict between the two sides; there is only episodic evidence of major fights, for instance. The descriptions that we have from municipal and participant

sources stress that the essential divide was between all the guizers collectively on the one hand and the 'authorities' on the other.

Guizing and tar-barrelling took place amidst a variety of pranks aimed at the town's elites – or at least specific members of that elite. Incidents involving exploding bombs or crackers on the mornings of Yule and New Year's Day against the front doors of prominent citizens expanded after the 1830s. In January 1849, Lerwick's joint procurators fiscal, James Greig senior and junior, issued threats against the revels, and the guizers responded by placing bombs on their doorstep. Greig senior wrote to the town's bailies (the magistrates): 'Such was the enormous force of the explosion that it shook the houses, broke the windows, and alarmed and endangered the persons of the inmates. The whole town heard the shock and the street around was covered with the burning substances.'[25] Greig reported this as the latest of a long line of similar events over earlier years.[26] The town council was much more relaxed about the event, and certainly felt that little could be done. It replied that the perpetrator was unlikely to be detected:

> Whether the establishment of a night watch would afford protection against the perpetration of mischief so secretly concocted and completed is another question, but . . . all we can say is, that if you deem it advisable to have a meeting of the inhabitants called for the purpose of considering the propriety of adopting the watching clauses of the Police Act, we shall readily take the necessary measures for calling such a meeting.[27]

This was probably a bluff by the councillors, for they knew that forming a police force was not a realistic option in Lerwick; the ratepayers would not countenance the expense under this Act, and when a superintendent of police was appointed in 1857 it was done under an older (and thus cheaper) provision.[28] In short, at that juncture in 1849 the council was either not that concerned or – perhaps – was actually a little amused at the fiscal's predicament.

In any event, it seems clear that the use of bombs made of gunpowder was selective: if used haphazardly, they were generally exploded away from people and property; if used closer to property, they were targeted at a small number of specific individuals like the procurators fiscal themselves. However, attacks could be seriously life-threatening. The year 1855 witnessed two impressive exhibitions of *force majeure* by the revellers: 'Our urchins on Christmas-Eve (old style), were as boisterous as ever; but some parties, not satisfied with the numerous reports

of pistols, pop-guns, sky-rockets, squibs, and crackers, which were constantly annoying the public, fired a Royal Salute from two of the large cannons in the Fort.' The gunners had had to scale the walls of the fort where the cannon, pre-loaded with dead cats, had been fired, resulting in a large number of glass windows being shattered. Local tradition had it that two men were involved and that they emigrated to New Zealand to evade justice.[29] This was followed seven days later at New Year by a most dangerous episode:

> While the peaceable inhabitants of this town were welcoming in the Old New Year, a band of ruthless characters paraded the public street and lanes of the burgh, and, not being satisfied with making a great deal of noise, went to Ansbrae, the residence of our much respected townsman and Procurator-Fiscal, Mr. Duncan, and after smashing in the fanlight above the door, threw into his lobby a miniature bomb-shell, which, on touching the floor, burst with a loud noise, broke in pieces a glass door inside, and created a good deal of consternation amongst the peaceable family. On examining the lobby, it was found that there was a goodly number of spikes or garron nails in the shell, any of which, had it struck the inmates, would have wounded them most severely.[30]

This band was also blamed for smashing windows in the house of the parish schoolmaster some hours later. 'Plunder was not their aim,' said a newspaper correspondent, 'but pique and malice.'

The more common method of attack on property was tarring. From around 1850 there were frequent reports that tar was smeared on the doors of houses or shops of individual residents. Tarring on Christmas and New Year's mornings (OS) was more widely reported, though with less detail as to the victims, in the middle decades of the century than later. The property most affected – certainly by the early 1870s – was that belonging to merchants, shopkeepers and law officers of the town. The cases occurred not just at Christmas and New Year, but at other times too. In November 1874 the premises of leading figures in Lerwick society, George Reid Tait and the shop front of Messrs Leisk and Sandison, were smeared with tar; the Council offered £10 reward for information on the culprits, and the victims a further £10.[31] In March 1878 the Sheriff's house was tarred, resulting in a dispute between the fiscal and the town council over the 'the state of matters in your Burgh . . . which merits immediate consideration'.[32] The function of tarring was best explained by Peter Garriock (1857–1939), Lerwick Burgh Treasurer, who told a local historian in the 1930s:

'Tarring' was the recognised method of bringing home to curmudgeons that 'spoil sports' and miserable spirits would not be tolerated during the festive season; not a legal method but one which met with the singular approval of the healthy minded citizens. Is there a single one among you who could not name some person you know would be none the worse of being taught a lesson in tolerance and whom you would not cheerfully put in the pillory? Our way was 'Tar Law' – reprehensible, illegal, call it what you will, it was effective.[33]

The misrule at Lerwick's yule was thus not a simple divide between elites and people. The power structure of the burgh appears on the surface to have been challenged, but in reality the elites – the merchants, councillors, sheriff and fiscal – were being split by the mischief. The world was being 'turned upside down', but the question of who was at the bottom of this inversion is complex.

Policing the revels

The local authority – the town council – was the responsible body for maintaining law and order in Lerwick. The key element in its failure to police Yule festivities was its unwillingness to spend money on proper policing of the burgh. Despite its lawless character, and despite the large number of visiting sailors and fishworkers, law enforcement was feeble. After the town was elevated to a burgh of barony in 1818, a considerable proportion of its government was in the hands of two other bodies: the Commissioners of Police and the Feuars and Heritors of Lerwick. The history of much of Lerwick's municipal development both in the nineteenth and in the twentieth century is a story of the town council trying to pass over responsibility for governing the town, and especially expenditure, to the Feuars and Heritors, the County Road Trustees and, after 1888, to the county council.[34] Nonetheless, the town council from the early 1840s was increasingly having to confront its responsibilities.

The nature of the problem for the authorities was twofold: on the one hand control of the rapidly changing physical environment for enterprise, and on the other hand control of plebeian behaviour, overwhelmingly at Yuletide. The physical environment of Lerwick was transforming between 1845 and 1875 with reconstruction and urban in-filling in the old town, development of the docks area to the north, an enlarging list of burgesses (who, in Lerwick's 'sett' or burgh constitution, directly elected the town council each year), and growing traffic and

sanitary problems. In the mid-1850s there was considerable building activity, especially on the shoreline parallel to the Street, and at Freefield to the north with the arrival of new fishing stations and a gasworks. The Street became gaslit, with gas pipelines laid underneath the stone slabs. But the Commissioners of Police, who demanded plans from builders and invited comments from neighbours and interested parties, together with the town council, found in the late 1850s and early 1860s that their attempt to defend the public foreshore was lost when landowners won the legal right to build below the high-water mark. The foreshore was the town's open sewer; its sand was discoloured and it was quite unusable by boats at low tide. In 1858 the council sought to tackle 'the disgusting nuisances of gross outrage [and] public decency daily occurring in the neighbourhood of the Market Cross from the want of [a] Public privy and a suitable depot for town manure'. Ashes and 'town fulzie' was being thrown into the Victoria Wharf, rendering it so filthy that boats could only enter at high water. As a result, the council built a public privy and ash pit on the beach, and paid for the remaining foreshore to be levelled and tarmacadamed for boat draining. But the problem did not go away. In 1866 the town's drains into the sea were choked, with effluent terminating well above the high-water mark, with 'their discharges oozing over the whole beaches and filtering into the sands'. There were also traffic problems. In 1862 movement of cattle through the town were banned because of the 'considerable danger to the Lieges generally' in the narrow Street, and the council managed in the same year to pass over the costs of road maintenance in the burgh to the County Road Trustees 'thus relieving the heritors of Lerwick of a very serious burden'.[35]

This was a small burgh of around five thousand permanent residents, and up to twice that number coming during summer months, which was trying to cope with intense urban problems. From 1857, the Burgh's one policeman, grandly named the police superintendent, was at the sharp end of the council's attempts to cope with urban growth and congestion. He was sent on several occasions on unsuccessful missions to stop landowners (usually merchants) 'beach-grabbing' by in-fill dumping of rubbish and rubble, and he was patently unable to prevent the public nuisances at the Cross.[36] But at the same time that the town council instructed the police superintendent to control beach-builders, it also ordered him to 'protect persons and property from injury' at Christmas and New Year; indeed, on one occasion, these were combined in a joint council injunction to him.[37]

By 1845, the town council was habitually calling annual special meetings 'to suggest measures for preserving the Public Peace on Old Christmas and New Year's day mornings'. At that time the town had no resident policeman, and it was the duty of one of the bailies to enrol and instruct thirty special constables for these two days. In addition, the town officer and the bellman gave public notice 'prohibiting the firing of Guns, Pistols and other Fire-arms, and generally from creating any disturbances in the Streets' on those days, and the town officer was instructed to acquire one dozen additional batons for the use of the special constables at the festivities.[38] In the following year of 1846, New Year's Day was celebrated 'with more than usual spirit':

> The boys and young men paraded the streets with guns, pistols, &c. Tar barrels were set on fire, and dragged through the town. Many of the youths had their faces blackened. Upwards of 40 special constables were sworn in, but they had to cut and run, and take refuge in the town-house, where they were followed by the crowd, who shut them in, burning the tar barrels under their very noses. The windows of the town house were smashed, while some of the constables got pretty severe knocks on their shins, heads, and other parts of their bodies.[39]

By 1849, Yule was causing the town council considerable anxiety, and at the following year's festivities it was unanimously agreed:

> that the dragging of burning tar-barrels or other vehicles carrying burning tar along the [Commercial] Street or closes of the Burgh should by all means be put down, and that whatever number of constables may be considered necessary for that purpose, should be sworn in by the Magistrates, because that whatever opinions may be held as to any of the other modes of displaying usually adopted on these occasions, that one is particularly dangerous.[40]

These actions, repeated every Yuletide between the 1840s and mid-1870s, did little to quell the Yuletide celebrations, and tar-barrelling continued. In 1854, what was described as 'the usual mischief' occurred with the breaking of between two and three hundred panes of glass 'smashed by way of pastime'; on this occasion, three men, all natives of the neighbouring island of Bressay, were caught, with one being given ten days hard labour and a second fifteen days.[41] Successful policing of the events was episodic. Having appointed the police superintendent, his role at Yuletide was deemed in 1858 'so inadequate and inefficient for the purpose' that it was decided 'to attempt wholly to suppress the amusements customary on these occasions'. A new factor adding

urgency was the arrival of gas lighting in the town, and 'the great risk of injury to the Street-Lamps'; though unstated, perhaps there was also fear that the heavy flaming krate, drawn on skids not wheels, might actually breach the gas pipeline and cause an explosion. In any event, Superintendent Dickson was given ten men to prevent tar-barrelling, with access to another fifteen only 'in the event of any special emergency'; he was also permitted to recruit the constables again in the spring with the arrival of vessels bound for Greenland and the Davis Straits.[42]

Some effects were noted from the increased police action. In 1860 the exertions of Dickson's successor, Superintendent Christie, his assistant Mr Brims and six special constables were attributed with Christmas Day (OS) passing off 'very quietly this year', with little drunkenness, no fighting and only three street lights smashed.[43] By this year, Christmas seems to have emerged as the day for 'young misrule', with the 'boys' making mild mayhem and accomplishing some very fine 'pranks'. In one of these, at Christmas 1861, the parish schoolteacher had a few senior pupils in to share a breakfast pie. However, some 'mischievous person' had got access to the pie before it went to the baker and had mixed in some jalap, a Mexican herbal purgative. All who ate it became very ill, the teacher and his wife being reportedly in a life-threatening condition. The procurator fiscal investigated and took precognitions, the formal evidence required by the Scottish legal system, and the remaining portion of the pie was preserved to be sent to Edinburgh for analysis.[44] Dangerous as it was, this would have been regarded as a classic amongst Lerwegian pranks for its mobilisation of the 'spoilsports' of the legal system.

At New Year 1860 (OS), misrule in its full glory was less successfully confronted by the authorities. The early hours of the morning witnessed extensive rowdy behaviour with more damage to street lights (including the removal of gaspipes), a great deal of pistolfiring and 'cow-horn music'. Nevertheless, five ringleaders were arrested and the large boat that was to be used for the tar-barrels was seized and locked up inside Fort Charlotte. However, 'the guisards were not to be thus deprived of their tar-barrel' and another boat was stolen, set on fire, and dragged along Commercial Street with paint being daubed on doors and window shutters of shops. In addition, the police superintendent was attacked 'by several villains in disguise, who were armed with large boat-hooks' and was struck twice, almost breaking his arm. Yet, in the midst of danger there was also humour, as a few hours later it was noted:

A gentleman residing in one of our lodging houses here, and who had retired to rest, was suddenly awakened by the sound of laughter and the jingling of glasses proceeding from his sitting-room. He immediately threw on his cloak, armed himself, and proceeded to the parlour, where he found some four or five masked figures, who were hard at work upon the cake and wine which he had accidentally left upon the table when going to bed. On his entrance the masters immediately rose, bowed politely, requested him to be seated, wished him good-night, and quickly disappeared, leaving the naval gentleman in no little amazement.[45]

In the 1860s, Christmas was for boys' pranks, New Year was for men's full-blown 'mischief'. In 1861, Christmas morning was again considered tame with one tar-barrel and one boat, stolen by young boys, dragged flaming along the Street. At New Year, by contrast, two tar-barrels burned in the Street and 'as usual the constabulary and the boys were pulling against each other – the one party endeavouring to extinguish the fire, the other to do as much mischief as possible'. The damage was much greater, with a grocer's shop being singed and a cracker blowing out the windows of a merchant's house. Three men, one a rifleman with the Volunteers, paraded the streets, threatening people with a bayonet. Yet, law enforcement appeared to be improving. The rifleman was identified, and the four lads who had stolen and burnt the boat on Christmas Day, along with two seamen, were arrested and imprisoned.[46] Possibly as a result of this success, the authorities became more relaxed about Christmas in 1862, appointing no special constables and allowing 'the Lerwick boys' favourite amusement' of a single tar-barrel at 3 a.m. The result was that 'the boys having been allowed to have their fun in their own way, there has been no mischief done'.[47] The following year this policy was repeated, but failed. There was a return to 'pure mischief' when the boys left a burning barrel beside the wooden lamp-post at the Market Cross, threw stones at the police superintendent (cutting his lip and breaking two teeth), and loaded and fired one of the cannons in Fort Charlotte which resulted in more than thirty panes of glass being broken in the town.[48] At New Year, the police again backed off from the revellers, offering no opposition to five tar-barrels; 'the fun was not so varied as in the good old times', the *John O'Groat Journal* reported, 'when there was generally a few skirmishes with the improvised police'. Yet the result was deemed a partial success, for no 'mischief' was reported and no windows or gas lamps broken.[49]

This pattern of a boyish 'prankful' Christmas, followed by a New Year when older men were given considerable latitude for serious tar-barrelling, persisted during the 1860s. New Year's Day (NS) was marked for the first time in Lerwick in 1864 when someone broke into the Episcopal Church and started ringing the bell – resulting in this becoming a congregational custom the following year. Meanwhile, at old style Christmas and New Year the boys and the men were unhindered by the police and 'enjoyed themselves to their heart's content'.[50] Damage to glass and gas lamps was receding in the mid-1860s, and the police policy appeared to be working. In 1865, however, the constables did try to snatch one Christmas tar-barrel that was poorly manned by youngsters, but were outwitted when the boys abandoned it in the narrow Roost in Commercial Street, removed the drag chain, and left the police to worry whether it would burn the buildings. As a result, the police made no further intervention that night, leaving new barrels to appear unmolested, and a large number of guizers to parade the town until dawn.[51]

The 1860s was the high-point of the tar-barrelling. The krate and the guizers continued to make their promenade of the Street year after year – though in 1864 the chief magistrate reportedly gave half a sovereign to the guizers to sponsor the revival of the people-carrying krate of the 1840 era as a more acceptable alternative to the tar-barrels, but the revival was soon dropped.[52] At some point in the 1860s the guizers are said to have locked seventy or eighty special constables in the prison till dawn of New Year's Day (OS) to allow the proceedings no hindrance.[53] An ineffectual containment was the most that the police could hope for. The ineffectualness may have been partly due to insufficient numbers of police, or, more likely, to their lack of enthusiasm for the task. One of the problems was that there was a very rapid turnover of police superintendents; there were four in the eight years after 1866, and even by 1875 the incumbent was only being paid £5 per year plus £5 for his uniform. In addition, the police superintendents in the 1850s and 1860s were each promoted to be the procurator fiscal; saving money also meant that from 1872 the appointees held both posts simultaneously and, from 1875, the post of Sheriff's Criminal Officer as well.[54] As for the special constables, one theory that has been floated is that it was the ringleaders of the tar-barrellers who were sworn in on Yule eve in an attempt to break the will of the guizers and krate-haulers.[55] However, the surviving recruitment list for Yule 1866 does not throw any light on this idea; of the eighteen named 'recruits', only six were from the docks area (reputedly the source of the roughest revellers), two were sailors and two

were shoemakers.[56] These may have included potential participants, but there is no way of knowing.

By the late 1860s, it seemed that the policy of the police watching but rarely intervening when the tar-barrellers took to the streets was working. Injury to property and to persons had by 1870 generally disappeared, and no arrests made.[57] The events were by now widely referred to as 'custom' and 'time-honoured', and had grown in scale from a single tar-barrel to numerous ones – especially at New Year. The guizing had become much more widespread, with Commercial Street and its thirty or so adjoining 'closses' or lanes being thronged with guizers wearing masks of 'the most fantastic description'.[58] A truce of sorts had been created during the 1860s: the police and tar-barrellers had come to an accommodation which reduced confrontation, violence and damage. The result was that more of the citizens, including – it seems likely – larger numbers of women, took to the streets to see the spectacle as the krates of flames were drawn on chains along Commercial Street. Where in the 1850s the police had caused the night's celebrations to end in battles for control of the krates, they were now allowed to burn out peaceably, with the men in large numbers adorning themselves with guizing outfits. The streets were peopled with spectators, investing the event with a greater sense of community ownership.

However, there was also a growing disquiet amongst some of the citizenry with the nature of the event. If the mischief of tar-barrels, guns and bombs had lessened, the custom of committing 'pranks' or practical jokes was growing in audacity throughout the 1850s and 1860s. In a sense, the daubing of tar and placing of bombs were being replaced by greater ingenuity in escapade – such as the lacing of the schoolmaster's pie on Christmas Day 1861. One spate of pranks attributed to boys after New Year in 1856 was taken as a sign of increasing lawlessness in Lerwick society. In that year the pranks included chaining and padlocking 'a gentleman's town mansion', forcing him to take lodgings for the night; puttying-up the keyhole of the gate to Fort Charlotte; and chaining and padlocking the Congregational Church while the band and choir were at practice. The Congregationalists formed the backbone of the emerging teetotal movement in Lerwick, so this appears to have been a symbolic act. For one newspaper correspondent, 'it shows a screw loose somewhere'.[59] Pranks were by no means solely associated with the celebration of Christmas and New Year. A considerable number of pranks between 1860 and 1864 were attributed to one man, William Alexander Grant (1828–65). He reputedly placed a stone slab bearing home-made

'runic' inscriptions spelling 'ASSES' in the local Clickimmin broch for the elite members of the newly formed Lerwick Literary and Scientific Society to find on their archaeological field-trip, and in November 1861 he smeared tar on the pulpit and choir seats of the Church of Scotland.[60] Grant was not the only prankster. In 1867, the Shetlanders' love of practical joking was said to be 'manifested on all fitting occasions', a fine example of that year being a rumour put about that there had been a Fenian raid on the islands – the culprit of which, despite 'keen inquiries', was not uncovered.[61] Pranks constituted an assault on 'spoilsports' – invariably law officers, the police superintendent and senior merchants and local 'notables' – and became concentrated as a seasonal activity in Lerwick in early January. They symbolically marked the settling of scores during misrule when they reminded the elites – especially the Colonel Blimps and spoilsports amongst them – of the people's strength. The balance of power in the social hierarchy should not be upset by excessive police, judicial or civil action at Yule, for the masked guizers felt themselves licensed to impose their will against those who disturbed the social equilibrium.

The increasing diversity of pranks during the 1850s and 1860s tended to lessen the emphasis on obvious lawlessness. Bombs were one thing, padlocks another. Yet the targets were widening. It was not merely the police chief or the procurator fiscal who were on the receiving end, but churchgoers, the schoolmaster and his pupils and houseowners. One particular 'prank' that attracted attention in the late 1860s and 1870s was the new practice of spilling coal-tar from unlit tar-barrels on to Commercial Street so that it stuck to people's feet for days after – 'a custom' one local remarked 'that would be more honoured in the breach than in the observance'.[62] Such indiscriminate pranks were starting to rouse hostility.

Direct confrontation at Yuletide had fallen off during the 1860s, but Christmas Day (OS) in 1871 changed the atmosphere. A series of minor incidents were dealt with by the magistrates, including a merchant who created a disturbance in his own house on Yule eve and was imprisoned for twenty days. As a result of this, the police Superintendent was targeted by the tar-barrellers who threw stones, one of which wounded a local bank agent in the head. During the following week the police arrested the Yule reveller considered 'the most notorious for mischief' and kept him secure through New Year; nobody else 'seemed inclined to act a similar part on the 12th' and it consequently 'passed off more quietly than was expected'.[63] But it was not merely a matter of renewed

police activity towards Yuletide misrule. There was a rising groundswell of opinion that the events included unacceptable social behaviour. 'It is full time', the *John O'Groat Journal* correspondent wrote, 'that such barbarous amusements as are practised here at this season were done away with. The drinking and blasphemy is disgraceful were there nothing else, and all this countenanced and enjoyed by what are otherwise thought respectable members of society.'[64] A conflict of cultures was starting to take shape, as 'respectability' – that most powerful of Victorian sensibilities – mustered within Lerwegian society. Behind it lay a popular religiosity that Shetland had not experienced before.

Religion and respectability

Evangelicalism came late to Shetland. Though the Methodists had enjoyed some success in the 1820s in recruiting in rural Shetland, and despite the appearance of a few presbyterian dissenting congregations in the early nineteenth century, it was a pre-industrial form of presbyterianism rooted in kirk-session discipline and church obligation that governed the islands until comparatively late. In the larger urban centres of Scotland, like Edinburgh and Glasgow, kirk-session justice was failing from the 1780s and 1790s amidst the dramatic influx of population, the anomie of urban life and the rise of dissenting churches. However, in smaller communities kirk-session justice was still remarkably effective until the 1840s and 1850s. In most villages of a few thousand people – including those with new textile working and factories – there was still an effective justice system, though it was noticeable how by those years cases of drink-related offences and 'rough' behaviour were becoming more common.[65] In rural areas, the system was even more resilient. In rural Shetland there is clear evidence that the power of the kirk session was undiminished in the first half of the nineteenth century, with a large number of sexual offence cases and severe penalties being imposed. As late as 1823, a kirk session at Hillswick in northern Mainland instructed a midwife to undertake pressing of a woman's breasts to provide proof of her having had a child – a barbaric form of ecclesiastical law more characteristic of the seventeenth than the nineteenth century.[66] In Sandwick parish in the 1830s, the kirk session was dealing with as many as four fornication cases per meeting, and the accused and witnesses were appearing and submitting to discipline.[67] The session there was still pursuing *famas* or pieces of gossip with ruthless determination. In 1841, for instance, a scandal was abroad in the parish that

William Tait, a married man of some substance, and his servant Ursula Smith 'had been seen to exhibit appearances of intimacy and familiarity unbecoming in their circumstances'. The session investigated this extremely thoroughly, summoning and interrogating five witnesses, who spoke of four instances of 'intimacy': one when the woman was 'sitting close before William Tait, as he thought upon his knee', a second when they were spied 'being seen together sitting and walking arm in arm', a third 'one wet night walking arm in arm under an umbrella', and a fourth time when, after being seen talking together in the open air, 'they afterwards came into the Chapel and sat down beside one another in the same seat'. By modern standards, and even by the standards of many places in Scotland in the 1840s, the 'scandal' here was minor. Yet, after hearing the evidence, William Tait 'confessed that he had conducted himself unprudently with Ursula Smith' and professed sorrow and promised 'to guard against such conduct in future'.[68]

Lerwick presents a contrast to both Lowland Scotland and rural Shetland. The kirk-session system had never worked properly in the town, and after 1790 it fell to pieces. Little had changed in the sexual climate of the town, with visiting seamen and merchants still the cause of local women becoming pregnant. In 1795, Carle Ghisel was named as the father of a child; he was described as 'a man well known here, he is married at Ostend'. However, the woman refused to appear for discipline.[69] This was symptomatic of the collapse of the session system in the town. In the first three years of the 1790s there were only two disciplinary cases in Lerwick, and between 1793 and 1797 the kirk sessions were in virtual abeyance. The minister was apparently often drunk, screaming obscenities from the pulpit, and he had raped a servant.[70] The elders claimed that the he was failing to call session meetings, and such cases of discipline that did reach the session in those years fell apart when the accused refused to appear or to submit to purgation. Finally, in November 1796, the elders started to resign in protest against the minister, complaining of the 'irregularity of his behaviour in session'.[71] A new minister was in post by 1797 and sought to catch up on the backlog of discipline cases – in one case trying to discipline a woman for fornication four years after the offence. The session was quite unable to impose the traditional penalties of fining and up to twenty-six appearances in the church; instead, it merely absolved the culprits. During the first decade of the nineteenth century, a shortage of 'men of knowledge, piety . . . and exemplary conduct' to act as elders contributed to the weakness of the Church of Scotland in the town, and led to continuing

absolution rather than punishment of those who admitted sexual offences.[72] The 1810s saw no improvement; the kirk session held only a few meetings per year, dealt with around three or four cases, and became mild-mannered in its treatment of offenders. The paucity of cases in a town of growing population, growing 'rough' culture and weak religious dissent indicated that the kirk was failing. By the late 1830s, fornication cases had virtually ceased. The kirk-session system had collapsed.

Things changed with the development of evangelicalism in Shetland. From the 1820s religion started to be something no longer imposed and conformed to, but something to be experienced. On the one hand, this process involved the appearance for the first time of dissenting churches, but on the other hand the salvationist gospel of rebirth started to transform the religious experience. Men returning from service in the Napoleonic Wars had been exposed to a more vital religious experience, encountering evangelical preachers and serving with men who had been immersed in the religious revivals of eighteenth-century mainland Britain. This had a dramatic effect when, in 1806, a second walkout from the Lerwick kirk session was instigated by an elder returning from war service, taking other elders with him who first sought Methodist support and, when that failed, formed an Independent church.[73] This was followed in 1822 when Methodist missionaries from England arrived and found astonishing welcome in many parts of the islands. These missionaries were by all accounts less aloof than kirk ministers, eating and sleeping with the people as they travelled around the Mainland and from island to island.[74] At the same time, they gave an impression of heightened piety, more willing to preach the gospel than sustain kirk sinecures. One of the Methodist preachers felt that he made an immediate impact in January 1823: 'This is Old Christmas Day to which the natives attend. They formerly kept it in "rioting and drunkenness". Today they came in flocks to hear the Gospel of Peace.'[75] Though the Methodists achieved greater recruiting success per capita in Shetland than anywhere in Scotland, dissent as a whole remained weak. By 1837, 88 per cent of church members in Shetland still belonged to the Church of Scotland, though in Lerwick and the west side of Mainland dissenters made up around a quarter of members. The disruption of 1843, when 37 per cent of the clergy and between 40 and 50 per cent of the members of the Church of Scotland left to form the Free Church of Scotland, had little impact on Shetland. Two Free Church ministers commented that 'the doctrinal errors' of Arminianism propounded by

Methodists, Baptists and Congregationalists had 'blinded many' in the islands.[76]

Though dissenters never became very numerous in either Lerwick or Shetland as a whole, a diffusive evangelical culture had started to be constructed. The first and the most enduring form of this was the tee-total movement. In many ways, the absence of dissenting churches in the islands was to be counterbalanced by the development of this movement into an alternative moral and recreational structure. The teetotal movement emerged in Shetland around 1840, and the most important day in its calendar was New Year's Day (OS). Drink was the very essence of what evangelicals thought was wrong about Lerwegian society. It had been ingrained until the 1820s in the smuggling trade, but more widely within the social celebration of fishing. John Dunlop, the leading Scottish temperance reformer, stated of the herring industry in 1834:

> At importing salt, several glasses of whisky are given to each man daily, and at sailing for the fishing stations, the men are frequently put on board drunk. In hiring boats, whisky flows profusely; those are esteemed the best employers who give the most drink, and fishcurers supplant one another by bribes of whisky. Each well-filled boat, on arriving at the curing station, gets a bottle of whisky, besides a couple of glasses to each man. The women who gut the fish have three glasses a-day. . . . In a slack fishing, a vessel having 300 to 400 barrels [of fish] requires above 60 gallons of whisky. Thus educated, the fishermen, not content with their morning's supply, frequently go ashore and drink at their own cost, and spend the day (particularly Saturdays) in rioting and wickedness.[77]

Views such as these began to be aired commonly in the newspapers of the northern fishing areas of Scotland in the 1840s. Awareness of drinking customs as a 'social problem' rose especially with the shift from mere temperance (which advocated moderation) to teetotalism, involving signing the pledge of total abstinence from alcohol. Temperance societies had been formed in Shetland by March 1840, and by 1846 the teetotallers of Lerwick had already established New Year's Day as the occasion of their soirée, held in the town's Subscription Rooms, and presided over by the Free Church and Independent ministers.[78] The Independents in Lerwick were the main force behind the teetotal movement locally, led by a solicitor William Sievwright. By 1851 the event had grown enormously, and involved a second event on Christmas Day (OS). A Christmas 'Total Abstinence Demonstration' was held at which

musicians led three hundred children, 'each wearing a favour of white ribbon, and the office-bearers ornamented with a sash of the same material'. It was noted that the children were 'guarded from molestation' by the adult members as there were drunks on the street.[79] The children's teetotal parades were deliberately timed for the most bacchanalian days of the year. Newspaper accounts of Christmas and New Year's Days in Lerwick reveal a stark polarity between the noisy, drunken and violent events of the early hours of those days and the sober processions of the white ribboners – or 'the cold water band' as they were dubbed.[80] In 1852 there were two hundred on parade on 13 January, but in the following year the numbers were decimated by an outbreak of scarlet fever which had killed many children and even fewer turned out the following year.[81]

Christmas and New Year (OS) were developing into the focus of a struggle between 'rough' and 'respectable'. Yule-day and New Year's Day had become occasions for extremes of social behaviour by which diverging moralities were being paraded. As the *John O'Groat Journal* reported of 1857:

> The small hours [of Christmas and New Year's Day] were hardly ushered in when the firing of guns, pistols, crackers, &c., announced that the roisterous were on the qui vive, and the mirthful season had commenced. During the night a large number enjoyed themselves in dancing . . . and burraing around a blazing old boat which was dragged along the principal street. This ancient and barbarous custom was indeed duly and fully attended to, although some of the sober-minded lieges had set their faces entirely against it. Some window panes were smashed, and several knocks and bruises given and taken, but no property of much consequence was damaged. As a conclusion to the season's festivity, a soirée was held in the public Subscription Rooms, Queen Street . . . where a large number of the respectable inhabitants of our burgh enjoyed themselves to their heart's delight. Coffee, fruit, &c., of the best quality, were distributed in abundance, and a number of very suitable addresses were delivered by some of the most popular speakers . . . The whole arrangements showed an anxious desire on the part of the managers of the Total Abstinence Society to combine pleasure with useful instruction. One feature of the night was the voluntary closing of the premises of several publicans, some of whom also set a good example by uniting heart and hand in furthering the night's proceedings. The evil results of intoxication were seen in a row which took place on the public street about 9 o'clock, while the coffee drinkers were enjoying themselves in sobriety.[82]

The Total Abstinence Society of Lerwick was joined in the early 1870s by a lodge of the International Order of Good Templars, an American-based teetotal organisation that arrived in Scotland in 1869 and which had 84,000 members there within seven years.[83] It rapidly became the leading working-class institution of teetotalism in Lerwick as in Scotland as a whole, and it followed the precedent of holding its annual soirée on New Year's Day (OS). By 1873, this was attended by four hundred people in the Free Church – an occasion with a distinct revivalist air. For five hours the meeting mixed hymns ('See the Conquering Hero Comes') with speeches from clergy and 'brothers' of the order – speeches which took biblical texts to argue the finer points of alcohol abuse, and with the chairman prophesying that 'a good time was coming' for the abstinence cause.[84] With Templar lodges spreading quickly throughout the Shetlands, the evangelical movement was creating an important foundation for popular puritanism, a moral culture which seemed – on the face of it – to clash with the spirit and the reality of Yuletide 'mischief'.

An alternative culture was developing at Yule, a rational recreation of sobriety and 'useful instruction'. Christmas Day was the lesser in importance for organised 'respectable' activities, but it saw the annual procession of the Odd Fellows' Lodge. In 1862 this numbered about seventy men, forming 'the finest and most showy turnout . . . since the Lerwegians began to lose their taste for displays of this kind':

> The uniform worn by the officers, and especially by the office-bearers, is very becoming and very showy – blue and white satin sashes, satin aprons, embroidered with gold or silver lace, according to the rank of the wearer, a number of beautiful flags, &c., had really a splendid appearance. Fortunately the weather was very fine, so that the streets were thronged with people, all dressed in holiday attire. The members dined together in the Subscription Rooms at 4 o'clock, and the day's proceedings are to conclude with a ball, to which each member can bring as many of our pretty Lerwick girls as he is inclined to purchase tickets for.[85]

During the early 1860s, the Oddfellows' procession was a growing institution of Christmas Day (OS), forming a colourful parade which, from 1866, was joined by the music band of the local secondary school.[86] The Juvenile Temperance Soirée was held in the evening of Christmas Day.[87] New Year's Day (OS), however, was by far the more important; just as it witnessed in the early hours the worst of 'mischief', so in daylight it

witnessed the most vigorous and varied of 'respectable' culture. It included the annual parade of the Royal Naval Reserve Force, which in the 1860s and 1870s processed from Fort Charlotte in late morning, accompanied usually by the firing of cannon, parading at the Market Cross with the town's flute band, followed by a large crowd to witness what a local poet called 'the marshalled array of Zetland's chivalry', ending the day with a dance at the Fort.[88] In 1861, this was joined by another event which quickly took precedence – the annual shooting competition of the newly formed local Volunteers, the Zetland Rifles.[89] This developed between the late 1860s and the 1890s into a major occasion in the calendar, with large numbers of men participating for prizes of shotguns, field-glasses, bibles, and books of Longfellow's poems. Further shooting competitions were held three days later, with games of football and refreshments, rounded off with a parade through the town. The Volunteers' shooting competitions involved considerable bonding between the officers and men, with the prizes and refreshments presented at the commander's expense. With the juvenile temperance parade also being held during the day, followed by the Senior Temperance Soirée in the evening, New Year's Day became during the 1860s a day of considerable 'respectable' and patriotic activity.

Taken together, the 1860s witnessed a concerted attempt by the forces of 'rational recreation' to fill the festive calendar with so many events of a religious, temperance, charitable or militaristic nature that 'mischief' was squeezed out. Between Yule and New Year (6–13 January), a variety of events was held by religious and charitable organisations – including the bazaars of the Ladies Dorcas Society and the Lerwick Clothing Society, the latter held on New Year's Eve.[90] One apparent success in infusing 'respectable' activities into the festive season was noted in 1865 when the traditionally uproarious annual meeting of the Freemasons on St John's Day (7 January, the day after Yule) was noted as a much subdued occasion:

> surely the glory of this once illustrious body has departed, for no more notice was taken of them by the public than if they had been members of a temperance committee. Alas! it was otherwise in the days of yore. The St John's Day was a day of note, looked forward to by all young people as a holiday. At the hour of meeting, assembled crowds of young and old saluted each venerable member as he entered the hall with cheers and volleys from tube-guns, pistols, and any other guns that could be improvised for the occasion. Then there was the procession, when, with bands playing and flags flying, this

respected body, each member adorned with the various badges pecu-
liar to the order, marched through the town, subjects of wonder and
admiration to the joyous crowds that followed them. But on this
occasion we had none of these things, and the day was like any other.[91]

The creation of an institutionalised 'respectable' culture in Lerwick
was not limited to the festive season in winter. In February 1861 the
Zetland Literary and Scientific Society was formed, chaired by the local
sheriff.[92] It met in various locations: the Congregational Church, the
Subscription Rooms and the parish school, and its office-bearers through-
out the 1860s and 1870s included the sheriff and church ministers. The
society's talks covered Shetland life, history and nature, continental travel,
and – in 1863 – 'Woman'.[93] One of its founding members was Arthur
Laurenson who, as we saw in Chapter 2, conducted much research and
writing on Norn language and Norse history in the Shetlands. As a man
who was embedded in positions of authority in Lerwick civic life (being
closely connected with the secondary school and later becoming chair-
man of the Lerwick School Board, amongst many other roles), he was
a key figure in prompting the middle classes to recognise the serious
history of Norse tradition, and prompting the society to undertake
'archaeological' work of the type which attracted the mocking prank of
the 'runic stone'.[94]

If the 'learned' society helped develop civic 'high culture' in Ler-
wick, a far greater influence on respectable recreation was evangelical-
ism. Religious organisations started to operate in the 1860s with a greater
evangelistic intrusiveness. One practice that developed was designed to
tackle the begging of the 'peerie' guizers – the children – at Yuletide. In
early January, children were recruited in the Sunday schools to under-
take charitable collections – or 'begging', as one complainant called it.
According to one local, the Sunday school children used by the United
Presbyterian, Methodist and Congregationalist congregations constituted
'a pest to this otherwise well regulated community':

> These urchins, dirty and ill-bred many of them, each supplied with a
> small passbook, are let loose upon society, and thereafter swarm into
> our houses and shops, and have the run of the town for a week or so,
> by which time the purses and the patience of the most benevolent and
> most Christian amongst us are fairly exhausted.[95]

Other religious activities flourished in the late 1860s and early 1870s as
new voluntary organisations were started, following similar trends in
mainland Scotland. A Choral Union was formed in the late 1860s giving

two concerts in the week after New Year, both religious and secular pieces – ranging from Handel's Hallelujah to 'Scotch' songs.[96] Most of the Lerwick churches joined together in supporting the Foreign Missionary Society of the local United Presbyterian Church, which held its annual religious service around 3 January – a service involving Wesleyan, Free Church and United Presbyterian clergy and laity.[97] So many new activities were created that the complaint was raised in 1868 that the New Year lecture (on 'The Power of the Scriptures') of the newly formed Young Men's Christian Association (YMCA) clashed with the Choral Union's concert.[98]

What one historian has described as the 'associational ideal'[99] of Victorian religion came to Lerwick late, but it came with a vengeance, creating a morally charged culture environment which had its focus on the festive period between Yule and New Year week. This culture demanded choice and commitment: choosing 'respectable' behaviour and committing oneself to evangelical religion and the pledge of total abstinence. It challenged directly the 'time-honoured' customs of festive 'mischief' of the previous seven decades – 'customs' which had developed into a culture of pranks and confrontation with authority. The judicial and civil authorities had since the early 1840s been demanding suppression of the ever-expanding festivities, but had tried – with some success – to permit moderation through an element of freedom from police interference from the early 1860s. But by the end of that decade, a moral 'turn' in popular culture seemed to be under way. An evangelical-based ethical code based on sobriety, decorum, philanthropy and rational recreation was taking root – a code which was in clear conflict with the traditions of Yuletide 'mischief'.

Mischief as misrule

The Lerwick Yuletide of 1800–75 was a veritable carnival of mischief: drunken revelries, mobile sledges of flaming tar-barrels, the tarring of houses, the firing of guns, demands for money, food or drink from masked guizers, and the carrying of effigies during the pitch darkness of the early hours of Yule morning and New Year's Day (OS). Unruly behaviour was by no means confined to that part of the year. Sir Walter Scott noted on a visit in 1814 that 'the streets are full of drunken riotous sailors from the whale vessels', whilst in 1820 a shipwright on board a whaler commented on the refuse-strewn streets of Lerwick being full of 'companies of sailors, the greater part of them reeling drunk, parading

about as if the island belonged to them'.[100] What the visiting seamen did in spring, summer and autumn, Lerwegian men did in winter, but by the 1840s their 'mischief' was becoming increasingly ritualised.

Class politics have an obvious bearing on these Yuletide events. It is possible to view them as the annual breakdown of what E. P. Thompson called the paternalism–deference equilibrium between elites and plebeians.[101] Social relations were changing in Shetland at the end of the eighteenth century as they were elsewhere in Britain; a member of the local elite remarked in 1809 that the islands' gentry were convinced of the deteriorating 'respect for those distinctions of rank which their forefathers acknowledged, and which were seldom infringed', blaming the change on the rise of commerce.[102] In mainland Britain, plebeians expressed the new tensions in a variety of ways – in the defence of customary agrarian rights, in the growing attendance at dissenting churches, as well as in the older form of King's Birthday riots and mock Mayor ceremonies.[103] Lerwick was a town without agriculture, dissent and a mayor or provost (having only a 'chief magistrate' until the 1870s), but the Yule revelries may have acted partly in the same way. They were occasions when the elites could not only be mocked but were also physically made aware of the common people's defiance of pomposity and hierarchy, when perpetrators of recent local developments could be ridiculed – and generally without the revellers being recognised or being caught. Out of the more general mischief of firearms and gunpowder at the start of the century emerged this new form of seasonal social protest. It would be incautious to dismiss out of hand that this was the expression of authentic class struggle – or at least of latent struggle. The tarring of doors and the exploding of bombs were overt assaults on the rich and powerful. This was a town in which the arrival of dockwork and shipbuilding, the growth of commercial fishing and its associated trades, created a class structure of an industrial society. There was a consciousness of class embedded in the tar-barrelling, and more specifically in the use of bombs and tarring of property. The customary Yuletide conquest of the darkened streets by apprentices from the docks and the town in a ritual explosion of violent mockery and plebeian machismo, directed at the burgh's elites, was clearly being perceived as an increasing threat by the authorities by the mid-1850s. The structural and behavioural patterns of town life became the object of very considerable focus to the town councillors in that decade, and in the context of controlling the cattle market, lighting the streets with gas, imposing building control, and solving the sanitary problems, an integral element

of civic improvement was the suppression of the Yuletide mayhem. This increased the vulnerability of such 'spoilsports' to having their own property tarred, and when in the mid-1870s tarring became more widespread outwith the carnival season it was clearly the law officers and the leading retailers who were the victims.

A different perspective comes from historical parallels in the early-modern period. Lerwick revels were 'the world turned upside-down', the occasions – usually calendar occasions – on which traditions had emerged in medieval and early-modern Europe of inverting the social order. They were occasions when the social order was reinforced – ironically – by its temporary and ritualised inversion, highlighting an individual's status by giving him or her a different one for a few hours or a day. The inversion of the social order meant reversal of status, with the plebeians – almost entirely male – taking control of an abbey or palace or, as in Lerwick's case, the narrow Commercial Street where the flames from large chain-drawn krates or boats licked the walls and wooden fixtures of the shops and houses they passed.

In Reformation Germany, Bob Scribner has shown how carnival 'met a psychological and social need of the new faith in its early stages',[104] whilst in France in the same century Natalie Zemon Davis has shown how charivaris (or carnivals) were occasions important to youth culture, leading to boys being 'elected' bishops, creating youth-abbeys where for a few days the social (and age) order of the society was inverted.[105] In certain places at certain times, the inversion became the cue for social revolt as at Romans in the province of Dauphiné in France in 1579–80, when the winter festival in February in two successive years became the occasion when the inversion became more than short term and turned into a popular uprising.[106] In eighteenth-century England, Bob Bushaway has described occasions like the harvest home when status was reversed by farmers and landowners serving the harvesters at the celebratory meal, and on various occasions of doling when the plebeians elected a leader – going by various names, including 'king' and 'queen' – to demand gifts of food and drink from the wealthier households in the community.[107] Doling – as Bushaway makes clear – was not seen as 'charity' for the poor or the paupers, but a symbolic act of general disbursement to the common people as a whole.

In these customs stretching throughout the early-modern period, there were recurring features. Most common of all was guizing, with the plebeians adopting clothes of mock authority ('crowns' or bishop's robes, mayoral outfits and so on), the more specific in the guizers'

impersonation of individuals to allow mimicry, mock protest and mock assault by other guizers. The outfits also acted as disguises, empowering the plebeians to demand their dole from the wealthy, and gelling the men in camaraderie to ensure their anonymity in case of reprisals by employers or the powerful. The garish and colourful outfits, frequently lit by flames from torches or tar-barrels, exaggerated the sense of misrule. In addition to status reversal, there was also gender reversal. In many places – in France, Germany and England in the early-modern period – the guizing involved considerable cross-dressing, especially of men as women. It was a practice of customary activity that often entered occasions of actual social protest – as during resistance to crofting evictions in the Scottish Highlands in the eighteenth and nineteenth centuries.[108] Men guizing in women's clothes, though infrequently mentioned, was known in Lerwick between 1845 and 1874;[109] it was to become common after 1890 and still is today in the modern Up-helly-aa. However, we do not know much of the adopted identities of the guizing outfits, and, in any event, as Robert Colls has observed, plebeian rituals consisted of a 'whimsical world of symbols'.[110] Most of the references are to 'red coats', 'uniforms' and 'cocked hats', accompanied by flags, swords and guns, implying very strongly that it was themes of military, naval and perhaps Customs authority which, between the 1800s and the 1860s, were the main object of mockery and status inversion.

It is relatively easy to pick out the elements of Lerwick's Yuletide misrule which have parallels throughout Europe across several centuries. But this is problematic. The misrule featured in this chapter is from the nineteenth century, not the sixteenth or seventeenth centuries – nor even from the agrarian economy of rural southern England of the eighteenth and nineteenth centuries. Misrule is a concept deployed largely by the historians of the pre-industrial world who see it as a product of the agrarian and craft-based societies of highly refined ranks, orders and guilds, and of the religious and ecclesiastical structures and symbols which gave that society so many reference points. When historians have encountered misrule later, in the changing proto-industrial world of the late eighteenth and nineteenth centuries, they have regarded it as an historical 'survival' from a world which – if not lost – was under threat and fast disappearing, and in which the misrule became the vehicle to express the common people's protest with economic and social change that threatened to obliterate 'traditional' rights and customs.[111]

But whilst there is much in terms of form and ritualised intent which has strong affinities with early-modern and medieval customs,

the events in Lerwick constitute something mostly different. Whilst Lerwick 'mischief' resonated with late-medieval 'misrule', this was a new sequence of customs, born out of – as far as we can know – a late eighteenth-century Lerwegian calendar empty of custom. The misrule was emerging within a new society coming into being as a modernising, semi-industrial and highly capitalistic environment. It was a misrule dominated by men employed in skilled and semi-skilled manual occupations – fishing, seamanship, boat-building, cooperage, dockwork and, by the 1860s, clerical occupations in expanding commercial operations. This is a society in which the tensions of new occupational hierarchies were threatening the unritualised misrule of the seventeenth and eighteenth centuries described in the previous chapter. Smuggling died out in the 1820s as a result of suppression by the Customs and the Royal Navy; by equal measure, the smuggling culture by which Lerwick had been defined since the 1620s was under threat. Mischief translated that culture into a new idiom and focused it on the most widely recognised calendar events of Yule and New Year (OS). The very fact that it was the Old Style events reinforced the claim to the values of a culture that was under threat. In Lerwick's case, mischief was the misrule of an industrial town.

What was happening in Lerwick between 1800 and 1873 was emblematic of what was happening in many modernising industrial towns. Riotous Christmas and New Year celebrations, the firing of guns and bombs, and jousts between opposing groups of men, were to be found in Thurso and Wick in northern Scotland, and New Year's Day (OS) was the occasion for much drinking and shinty matches – and by the 1840s was the day on which annual shooting matches were held.[112] In Wick on New Year's Day 1848 (OS) it was reported that the 'Bacchals' were parading the streets with torches 'threatening considerable danger to property'.[113] In Wick and its neighbouring industrial community of Pulteneytown in 1850, the New Year celebrations were very wild, and it was noted that 'the public are heartily tired of the old style'. This association of the Old Style calendar with a now unacceptable old style of riotous celebration brought nostalgia for an even older form of celebration which had been prevalent in Wick and Thurso until the early 1830s – the game of 'knotty' or shinty, when on New Year's Day 'every individual, high and low, who was able to handle a club, turned out to have a hail'.[114] But tar-barrelling grew in ferocity in Wick and Pulteneytown, and switched at some point to New Year (NS), as in 1880 when a fracas between seventy youths of each town looked to two policemen as if it

might lead to an attempt to fire Wick; however, their intervention led to the Wick boys kidnapping Pultneytown's 'chief peeler' and holding him for many hours as a 'prize'.[115] The *modus operandi* of revellers at Lerwick had an almost exact replica in mainland Wick, and possibly in other places. Equally, just as the nature of customs around the north of Scotland showed great similarity in the nineteenth century, so the rise of 'respectable' moral culture also grew simultaneously. At Wick the Good Templars and their annual temperance parade at New Year (NS) were perceived as important in 1874 to the decline of drinking and unruly behaviour. 'It is gratifying to note', a newspaper correspondent wrote, 'that there is a growing disposition among all classes to enjoy a holiday in a rational way, instead of in ways which are not rational at all.'[116] These sentiments, as we shall see in the next chapter, were ones being echoed simultaneously in Lerwick.

Zemon Davis rightly proposed that misrule was a generic plebeian activity, not restricted to a pre-industrial society but present in all cultures, and with an ability to evolve so that it can act both to reinforce the existing social order and suggest alternatives to it.[117] Scottish locations of tar-barrelling, 'clavies' and tar-coated torch-carrying, such as Lerwick, Wick, Campbeltown, Burghead and Comrie, were communities either being created or re-formed by industrial enterprise – in the first four cases based on capitalist fishing enterprise (with Campbeltown having a diverse industrial base including coalmining and whisky-making), and in the case of Comrie on textile manufacture. The customs developed in these places should perhaps not be regarded as 'survivals' of, or 'borrowings' from, pre-industrial society, but as the newly constituted elements of 'industrial misrule' of the period between the 1810s and 1860s. Tar-barrels, clavies and tar-coated torches were less likely articles to waste in profusion in isolated small communities in early-modern Scotland. With commercialised fishing, barrel-making and ship-building in Lerwick from the 1820s (and tar stolen from the gasworks after 1855), the means of misrule were the products of an industrialising economy.

One way in which Lerwick seems to have been distinctive was in the degree to which its new customs involved firearms and gunpowder. Though firearms were reported in use at New Year (OS and NS) in Wick, Lerwick presented an extreme case. Shetland was to a great extent an armed society by the 1850s, where with increasing prosperity most adult males would have owned a gun, both for agricultural purposes and for hunting. Seal-hunting was based in the islands on shooting,

which developed into a 'gentleman's sport' in the mid-Victorian years.[118] Men in Lerwick were familiar with guns even before the formation of the Royal Naval Reserve and the Volunteers in 1860–61. Many came home from the Americas and the Napoleonic Wars around 1800 with small arms and blunderbusses, and possession of a gun or pistol was clearly an essential accoutrement for very large numbers of those men who participated in festive mischief. Gunpowder and guns were freely available without effective state restriction in Britain for most of the nineteenth century. Gun licences were only introduced in 1870, and offences of carrying arms existed only in the vicinity of Liverpool after 1851 and when the bearer was intoxicated.[119] Even after 1870, there were so many exemptions from requiring a licence,[120] and the penalties so relatively light, that the possession of firearms was far from being heavily policed. In this context, male Lerwegians' casual familiarity with such deadly weapons, so evident from the accounts, is explicable. They were used freely to fire in the air, through doors and glass, and the firing of cannon in the Fort was clearly within the capabilities of pranksters. This was not a 'wild west', a violent frontier society, but it *was* an armed society and, for two nights of the year, it was a gun-toting society. Firearms, gunpowder and flaming chariots of fire became the essential ingredients of social inversion in the celebration of Christmas and New Year (OS).

Amongst some historians of early-modern carnival, it has been suggested that misrule was permitted, or even connived at, by civil and ecclesiastical authorities because the elites saw it as a social safety-valve.[121] It allowed for a letting-off of steam, preventing worse from happening. Zemon Davis and Scribner have been critics of the dominance of this interpretation, for they argue that misrule also allowed certain values of the community to be expressed and perpetuated as what Bakhtin called a 'second life of the people'.[122] The evidence from Shetland, if not some of the other places too, suggests that this was also a phenomenon of industrial society, when misrule created for one or two nights a year a different social cosmology and medium for deflating the dignity of the prevailing order. But it is important to stress how Lerwick's smuggling heritage seems critical to the origins of misrule, with the machismo of an unbending popular will, preserved and eulogised at Yule, shifting the object of resistance from the external agencies of the state to the agencies of the rising burghal state – the 'spoilsports' of the town's merchants, police and procurators fiscal. The 'black economy' had tested loyalties in Lerwick's early days: misrule was the 'black culture' which succeeded it and which continued to test loyalties. It is interesting that

retailing shops belonging to Lerwick merchants, and their houses, came in for tarring from the guizers in the mid-Victorian period. If this analysis is correct, some merchants were clearly failing to pass the test – they had become outsiders, renegades from the values of Lerwegian 'belonging', and joined the military and the Customs officers as nominal community 'outsiders'. Though the tar-barrelling procession clearly offered a physical representation of boundary by processing from one side of town to the other, the symbolic definitions of boundary were more important. Misrule tested the boundary of 'insider' and 'outsider' by seeking dole at the doorstep from the good and the great; those who refused were 'outsiders', 'spoilsports' who refused to enter the 'spirit' of the occasion.

However, this does not mean that all Lerwick's merchants had become 'spoilsports', and that misrule was necessarily perceived as a social threat or a social nuisance. Despite its apparent 'us-and-them' character, the guizing-dole custom was not a threat to social order unless the 'higher-class' person in the relationship felt it was so. The tradition with guizer-doling in Lerwick, as in England in the eighteenth and nineteenth centuries, was that it was an accepted bond, a consensual bond – or 'commensality' as Bushaway has it – between high and low in society. It was expressive of the unity of the community, not of its division – again, unless there was resistance to it by the dole-giver. In this context, civil authority could be lenient. In Lerwick, the tenor of the responses of the town council during the 1840s and 1850s to the threat of the tar-barrelling krate seems to be so tame as to contain a hint of their secret admiration, if not connivance, in the misrule. As Brian Smith notes, even two police constables in 1836 were discovered in possession of a home-made bomb.[123] If prosecution for tar-barrelling had become really tried, a local historian asked in the 1910s, what would have happened?

> Who would prosecute, and who would judge? All the lawyers would be in it, and all the Town Council, all the cler[gy] – (no, I wouldn't say that), all the bankers and officials, all the teachers, all the merchants and their assistants – in fact, nearly the whole town. So how could a prosecution come off? Who would bell the cat? . . . In the event, unthinkable, of a court being held. 'What good purpose did it serve?' It celebrated the greatest event in history; and it recalled to many Lerwegians 'the days of long ago.' Verdict – No case.[124]

Despite the opposition of police and the forces of evangelical 'respectability', there remained a sense of commonality in the festive customs. By the late 1850s words like 'custom', 'time-honoured' and

'ancient' were being widely attributed to the revels – especially the tar-barrelling, which was only fifteen years old. In part, there were ingredients in the events – the guizing, music and dancing – which had direct links to an older Shetland culture and which could 'justify' such terms. Yet, even those were now elements of a new ritual, for the format of narrative story within which they had previously existed in rural Shetland had been fading long before – even in the outlying island of Unst in the 1770s – and had never existed in Lerwick. More strikingly, the guizing of nineteenth-century Lerwick was constructed from scratch, seemingly unstructured by old folk narratives. The themes of the masks and dresses were about authority, with those who imposed new forms of civil rule becoming the target. Thus, those guizing outfits were inverting the new order as soon as it needed to be inverted. The agencies of civil power were making claims that challenged the spirit and ethos of Lerwick, and had to be checked by ritualised misrule. The more the authorities sought to exert their power over the ritual, the more the ritual grew. Cocking the snook changed from being an economic way of life to being a customary activity, encompassed not just in the tar-barrel but in firearm, bomb and prank.

Lerwegian misrule was in other ways contemporary and not historical. It symbolised a growing gender ideology of 'separate spheres', or men's place in the public sphere of work and women's place in the private world of home and family. The discourse on the 'angel in the house' was, ironically, given emphasis in the mayhem of the Yule and New Year. Men were the guizers, ruling the streets with guns and flames, whilst women were the domestic hostesses who, when the tar-barrels had burnt out by 5 or 6 a.m., received the guizers. Gender roles were being reinforced and celebrated. However, hostesses were condoning drunken male mischief and 'unrespectability'. Evangelical culture, and especially its teetotal constituent, placed special responsibilities upon women as moral guardians of the family and the rescuer of dissolute men. The belated rise of evangelicalism in the town in the 1860s could not but put the nature of the revels under challenge.

For other reasons, Lerwegian Yuletide frolics were coming under threat. Between the 1850s and 1870s, the venue for the carnival – Commercial Street – was becoming an unacceptable location for misrule. Retailing premises, hotels, banks and houses were undergoing considerable reconstruction, with the shops acquiring the characteristic large windows and decorated façades of the mid-Victorian period.[125] This was when Lerwick started to move architecturally from rather plain,

shed-like buildings of undressed stone to the aspiring elegance of decorative and spacious grandeur. Merchants and shopkeepers could not countenance the continued defacement of their premises by singeing from the flaming krates, tarring from guizers, and bullet holes from firearms. More profoundly, increasing fashionability in architecture and shopping reflected a wider cultural aspiration in which the elites of the town became an enlarged middle class, bolstered by new professional occupations in commerce and public affairs. Yuletide mayhem was inconsistent within such a society. It was 'rough', unruly and criminal, and in addition by the late 1860s it was unrespectable, irreligious and 'irrational'. With a resurgence of police action in the early 1870s, the future of misrule was starting to look shaky as the forces for change started to muster in real strength.

Notes

1 *Shetland Times* 22 December 1888.

2 H. D. Smith, *Shetland Life and Trade 1550–1914* (Edinburgh, John Donald, 1984), pp. 81–2, 97.

3 Ibid., pp. 102–3.

4 Ibid., p. 230.

5 Ibid., pp. 104–7.

6 James Catton, *The History and Description of the Shetland Islands* (London, 1838), p. 66, quoted in Smith, *Shetland Life*, p. 124.

7 Until 1824, whaler ships were prohibited by a parliamentary act of 1786 from employing Shetlanders because they had to muster crews before leaving home (i.e. mainland British) ports to qualify for the Board of Trade bounty; G. Jackson, *The British Whaling Trade* (London, A. and C. Black, 1978), pp. 89n, 119.

8 *Shetland Journal* 1 April 1837.

9 Quoted in B. Smith, 'Up-Helly-A' – separating the facts from the fiction', *Shetland Times*, 22 January 1993, p. 24.

10 Quoted in ibid.

11 *Shetland News* 5 January 1889.

12 *John O'Groat Journal* 4 February 1842.

13 *Shetland News* 26 December 1891

14 *The Private Journal of Captain G. F. Lyon* (1824), pp. 466–8. I am grateful to John Ballantyne for this reference.

15 Uvhan, quoted in Smith, 'Up-Helly-A', p. 24.

16 C. E. Mitchell, *Up-Helly-Aa, Tar-Barrels and Guizing: Looking Back* (Lerwick, T. and J. Manson, 1948), pp. 17–27, 41–2.

17 *Shetland Times* 30 January 1892.

18 SA, TO1/1, Lerwick Town Council minutes (hereafter LTC), 3 January 1845.

19 *Shetland News* 29 October 1887.

20 *John O'Groat Journal* 22 January 1847.

21 Mitchell, *Up-Helly-Aa*.

22 *John O'Groat Journal* 21 January 1853.

23 Mitchell, *Up-Helly-Aa*, pp. 4–12, 17–19; B. J. Cohen, 'Norse imagery in Shetland: an historical study of intellectuals and their use of the past in the construction of Shetland's identity, with particular reference to the period 1800–1914', unpublished Ph.D. thesis, University of Manchester, 1983, pp. 463–4.

24 J. Robertson, *Uppies and Donnies: The Story of the Kirkwall Ba' Game* (Aberdeen, 1967).

25 Quoted in Smith, 'Up-Helly-A', p. 24; *John O'Groat Journal* 2 February 1860.

26 V. Newall, 'Up-Helly Aa: a Shetland winter festival', *Arv* 34 (1978), p. 80.

27 Quoted in Smith, 'Up-Helly-A', p. 24.

28 R. M. Urquhart, *The Burghs of Scotland and the Burgh Police (Scotland) Act 1833* (Motherwell, Scottish Library Association, 1989), p. 22; R. M. Urquhart, *The Burghs of Scotland and the General Police and Improvement (Scotland) Act 1862, Part II* (Motherwell, Scottish Library Association, 1991), pp. 322–3.

29 Newall, 'Up-Helly-Aa', pp. 80–1.

30 *John O'Groat Journal* 26 January 1855.

31 SA, TO1/1, LTC, 14 November 1874.

32 SA, TO3/4, LTC and Commissioners of Police (hereafter CP), 2 April 1878.

33 Quoted in Mitchell, *Up-Helly-Aa*, p. 41.

34 W. R. Steele, 'Local authority involvement in housing and health in Shetland *c.*1900–1950', unpublished M.Phil. thesis, University of Strathclyde, 1992, pp. 20–67.

35 SA, LTC, TO1/1, 1 September 1853, 7 December 1855, 31 December 1858, 25 October 1859, 20 March 1862, and 4, 16 and 30 September 1862; SA, TO3/1, LTC and CP, 1833–77, passim for building control.

36 Letter from Charles Duncan entered in SA, TO1/1, LTC, 30 September 1862.

37 Ibid., 31 December 1858.

38 Ibid., 3 January 1845.

39 *John O'Groat Journal* 30 January 1846.

40 SA, TO1/1, LTC, 31 December 1850.

41 *John O'Groat Journal* 10 February 1854.

42 Ibid., 31 December 1858.

43 Ibid., 19 January 1860.

44 Ibid., 24 January 1861.

45 Ibid., 2 February 1860.

46 Ibid., 17 and 24 January 1861.

47 Ibid., 16 January 1862.

48 Ibid., 15 January 1863.

49 Ibid., 22 January 1863.

50 Ibid., 14 and 21 January 1864, 12 January 1865.

51 Ibid., 19 January 1865.

52 *Shetland News* 5 January 1889; SA, TO1/1, LTC, 4 January 1866 and 2 January 1867.

53 Smith, 'Up-Helly-A', p. 24.

54 SA, TO1/1, LTC, 26 February 1866, 13 December 1872, 2 June 1874, 31 August 1875.

55 This is reputed to have been the strategy of Superintendent (and later procurator fiscal) George Mackay in the mid-1860s; Mitchell, *Up-Helly-Aa*, p. 5.

56 The list of special constable recruits is given in SA, TO1/1, LTC, 4 January 1866.

57 *John O'Groat Journal* 16 January 1868, 20 January 1870.

58 Ibid., 20 January 1870.

59 Ibid., 1 and 15 February 1856.

60 B. Smith, 'The tarry kirk, the bogus runes and a priestly poker', *Shetland Times* 24 December 1987, p. 12.

61 *John O'Groat Journal* 7 February 1867.

62 Ibid., 18 January 1866.

63 Ibid., 26 January 1871.

64 Ibid., 19 January 1871.

65 C. G. Brown, *Religion and Society in Scotland since 1707* (Edinburgh, Edinburgh University Press, 1997), pp. 72–3.

66 SA, CH2/286/2, Northmavine kirk session minutes, 12 January 1823; Brown, *Religion and Society*, pp. 71–2.

67 SA, CH2/325/1 *et seq.*, Sandwick kirk session minutes, 15 November 1835.

68 Ibid., 7 November 1841.

69 SA, CH2/1072/3, Lerwick kirk session minutes, 27 September 1795.

70 I am grateful to Brian Smith for these points.

71 SA, CH2/1072/3, Lerwick kirk session minutes, 30 November 1796. H. R. Bowes, 'Revival and survival: Methodism's ebb and flow in Shetland and Orkney, 1822–63', unpublished M.Th. thesis, University of Aberdeen, 1988, pp. 22–4.

72 Ibid., 25 August 1809, 6 February 1810, 2 March 1810, 20 August 1810.

73 Bowes, 'Revival and Survival', p. 12.

74 For their reactions to Shetland, see D. Flinn, *Travellers in a Bygone Shetland: An Anthology* (Edinburgh, Scottish Academic Press, 1989), pp. 136–7.

75 H. R. Bowes (ed.), *Samuel Dunn's Shetland and Orkney Journal 1822–25* (n.pl., n.pub., 1976), p. 19.

76 Quoted in B. Smith, 'The churches in Shetland 1800–1987', unpublished lecture to Lerwick Churches Council, 1990, upon which this paragraph relies.

77 Quoted in *John O'Groat Journal* 31 January 1840.

78 L. Edmondston, 'General Observations on the County of Shetland', in *The New Statistical Account of Scotland vol. xv, Shetland* (Edinburgh and London, Blackwood, 1845), p. 157; *John O'Groat Journal* 30 January 1846.

79 Ibid., 31 January 1851.

80 Ibid., 13 February 1852.

81 Ibid., 21 January 1853, 10 February 1854.

82 Ibid., 30 January 1857.

83 E. King, *Scotland Sober and Free* (Glasgow, Glasgow Museums, 1979), p. 16.

84 *John O'Groat Journal* 30 January 1873.

85 Ibid., 16 January 1862.

86 Ibid., 15 January 1863, 18 January 1866.

87 Ibid., 19 January 1865.

88 Ibid., 14 January 1864, 26 January 1871.

89 Ibid., 17 January 1861, 21 January 1864, 16 January 1868.

90 Ibid., 12 and 19 January 1865.

91 Ibid., 12 January 1865.

92 Ibid., 14 February 1861.

93 Ibid., 22 January 1863, 14 February 1867.

94 C. Spence (ed.), *Arthur Laurenson: His Letters and Literary Remains: A Selection* (London, Fisher and Unwin, 1901), pp. 13–23.

95 Anonymous letter in *John O'Groat Journal* 15 January 1863.

96 Ibid., 30 January 1868.

97 Ibid., 19 January 1871.

98 Ibid., 30 January 1868.

99 S. J. D. Green, *Religion in the Age of Decline: Organisation and Experience in Industrial Yorkshire 1870–1920* (Cambridge, Cambridge University Press, 1996), passim.

100 Quoted in R. Sandison, *Christopher Sandison of Eshaness (1781–1870): Diarist in an Age of Social Change* (Lerwick, Shetland Times, 1997), pp. 37–8.

101 E. P. Thompson, *Customs in Common* (London, Merlin, 1991), pp. 83–96.

102 Dr Arthur Edmonston, quoted in J. W. Irvine, *Lerwick: The Birth and Growth of an Island Town* (Lerwick, Lerwick Community Council, 1985), p. 60.

103 Brown, *Religion and Society*, pp. 76–80; C. Whatley, 'Royal day, people's day: the monarch's birthday in Scotland *c.*1660–1860', in R. Mason and N. Macdougal (eds), *People and Power in Scotland* (Edinburgh, John Donald, 1992).

104 Bob Scribner, 'Reformation, carnival and the world turned upside-down', *Social History* vol. 3 (1978), p. 328.

105 N. Z. Davis, 'The reasons of misrule: youth groups and charivaris in sixteenth-century France', *Past and Present* 50 (1971).

106 E. le R. Ladurie, *Carnival at Romans: A People's Uprising at Romans 1579–1580* (first published 1980; Harmondsworth, Penguin edn, 1981).

107 Bob Bushaway, *By Rite: Custom, Ceremony and Community in England 1700–1880* (London, Junction, 1982), pp. 180–90.

108 E. Richards, *A History of the Highland Clearances: Volume 2: Emigration, Protest, Reasons* (London, Croom Helm, 1985), pp. 334–5.

109 Smith, 'The tarry kirk'.

110 R. Colls, *The Pitmen of the Northern Coalfield: Work, Culture and Protest 1790–1850* (Manchester, Manchester University Press, 1987), p. 219.

111 Ibid., passim.

112 See, for instance, *John O'Groat Journal* 14 January 1842.

113 Ibid., 14 January 1848.

114 Ibid., 18 January 1850.

115 Ibid., 8 January 1880.

116 Ibid., 8 January 1874.

117 Davis, 'The reasons of misrule', p. 74.

118 For a 'gentleman's' account of the sport of seal-hunting from boats in Shetland, see *John O'Groat Journal* 16 January 1857. I am grateful to Ian Tait, Shetland Museum, for his advice on guns in Shetland.

119 Licensing followed game-hunting certification, and both were measures for tax-raising rather than restricting possession, being controlled by the inland revenue and not the police. Not until 1920 were the police given powers to recommend revocation of licences. See Game Licences Act 1860, Gun Licence Act 1870, Customs and Inland Revenue Act 1883, Firearms Act 1920.

120 Including guns which never left private property, which were used for the scaring of birds or killing of vermin, and which were used by Volunteers in target practice; G. Watson, *Bell's Dictionary and Digest of the Laws of Scotland, Seventh Edition* (Edinburgh, Bell and Bradfute, 1890), pp. 495–6. I am grateful to Professor Hew Strachan and David Caldwell of the National Museums of Scotland for help on gun ownership.

121 Peter Burke, *Popular Culture in Early Modern Europe* (London, 1978), p. 201.

122 Davis, 'The reasons of misrule', p. 49; Scribner, 'Reformation, carnival', pp. 322–4.

123 Smith, 'Up-Helly-A', p. 24.

124 T. Manson, *Lerwick During the Last Half Century* (1867–1917) (first published 1923; Lerwick, Lerwick Community Council reprint, 1991), p. 91.

125 A considerable number of new premises were erected in this period: the Queen's Hotel 1860s (combining two former lodberries), Quendale House 1865 (the town house of a Shetland laird), Commercial Bank 1871; M. Finnie, *Shetland: An Illustrated Architectural Guide* (Edinburgh, Mainstream/RIAS, 1990), pp. 11–17.

5

'Perfectly in custom': the birth of Up-helly-aa, 1873–1906

The turning point

THE CRITICAL change to winter customs in Lerwick started in the the early 1870s. Up to that point, all the 'mischief' of guizing, tar-barrelling and associated activities took place on Yule day and New Year's Day (OS) – 5 and 12 January. Then, fragmentary reports started to appear of small-scale mischief on 29 January, marking 'the end of the Christmas holidays' on 'four-and-twenty night', and on other nights. In 1873 and 1874, single flaming tar-barrels were drawn by small numbers of youths along Commercial Street. A newspaper correspondent made elliptical reference to the 'country people having given up keeping holiday at Christmas', the youths of Lerwick resolved on 29 January 1873 to 'attend to the amusements, lest they may fall entirely into disuse'. 'The herring barrel', it went on, in clear reference to tar-barrelling, 'seems to be losing its usual attractions, for on the 29ult., when the Christmas festivities were brought to a close, and public notice given to that effect in the usual way, the attendants at the barrel procession was not so numerous as on former occasions, though they tried to keep up as much noise as possible all night'.[1]

One man was caught and imprisoned for twenty-one days. The following year, the tar barrel made two unpredicted appearances. The first was on 23 January when the Zetland Rifle Corps and the local Royal Naval Reserve formed the core of a display to mark the Duke of Edinburgh's marriage, ending in the evening with the town being 'illuminated' and rockets and fireworks being fired; 'as the finishing touch', it was reported, 'came the members of the fire squad with their blazing tar barrel'. This was apparently unscripted, for the squad was criticised for 'thinking more of themselves than of all that had gone before'.[2] Then, exactly a week later, 30 January was:

126

observed by the youth of the town here as the last of the Christmas holidays, and hence it is called 'up-haly-a'. Groups of guizards dressed in various styles perambulated the streets during the evening and night. They honoured several families with a visit, but behaved very quietly. Each company was provided with musicians. The never-failing tar-barrel wound up the proceedings as usual, but its attractions seem to be on the decline. A few panes of glass were broken before morning.[3]

These reports are intriguing. Just when tar-barrelling on Christmas and New Year came under effective challenge, the practice was re-appearing in the midst of civic ritual and at a different calendar occasion. The celebration of 'the last of the Christmas holidays' at the end of January is unreported in Lerwick before this date, and the implication that it is a customary event does not quite ring true. For one thing, it was not usual for the tar-barrel to end the proceedings: it preceded visits to homes by guizers. Second, the use of the term 'up-haly-a' is entirely novel in Lerwick and, moreover, it occurred in the precise year that Arthur Laurenson spoke of 'Uphellia Day' in his paper to the Society of Antiquaries of Scotland.[4] Our curiosity at this coincidence should be aroused. If tar-barrelling was being eased out of Yuletide, was it being deliberately deployed on other occasions in acts of defiance or, possibly, in attempts to invent or transplant a new ritual in the town?

Tar-barrelling and 'mischief' were certainly spilling out from Yuletide. A spate of incidents followed, the first in November 1874, when the judge at Lerwick's sheriff court, Sheriff Mure, happened to be walking through streets at the north end of town and chanced upon a flaming tar-barrel being towed by a group of raucous young men who were carrying and discharging firearms. 'A movement among the lower orders was apparent,' he wrote to the town council; 'a blazing tar-barrel was dragged through the streets, frequent gun shots were fired, and numerous parties of men paraded the streets.' To make matters worse, he reported, 'the opportunity was taken seriously to destroy new premises at the north end of the town, and to commit an act of disgraceful malicious mischief'.[5] On the twelfth of the same month, two premises were smeared with tar: the first belonged to George Reid Tait, a prominent member of Lerwegian society, and the second was the shopfront of Messrs Leisk and Sandison, drapers and merchants, in Commercial Street. A total of £30 was offered by the victims and the council as a reward for the capture of the culprits.[6] It was reported in one paper that 'acts of this kind have become so common of late that all classes now seem anxious that the guilty should be discovered, and treated according to

desert'.[7] Six weeks later, as Yuletide approached, it seems that there was considerable public pressure for action, and a public notice was issued by the Commissioners of Police warning of arrest for breach of the peace, and for theft and reset (of krate materials), of any who did 'the DISGRACEFUL and BARBAROUS practice of dragging burning "TAR-BARRELS"'. Parents were asked to curb their children and warned of increased rates if injured parties claimed against the burgh. However, in an interesting statement of equivocation, the notice contained a post-script that 'the Commissioners have no intention of interfering with out-door harmless amusements'.[8]

A year later, at Yuletide 1875, a repeat proclamation was issued (though by the town council rather than the Commissioners of Police), advising young people that 'the public would be more ready to admit them into their houses were the streets kept free from coal-tar'.[9] As a later writer recalled, 'good wives complained that their houses were destroyed, as no one for days after could go into the street without bringing home tar on his feet'.[10] Certainly, Christmas Day and New Year's Day (OS) passed off quietly, but a sixteen-year-old apprentice baker was convicted of dragging a tar-barrel through the town at the end of January, and was fined a guinea and given a 'suitable and kind admonition'.[11] Though this crackdown extended for a further two years to 1876 and 1877, attempts were made to restore the 'traditional' revels: flaming tar-barrels made less than spectacular appearances at both of these New Years (with two barrellers being imprisoned for eight days in 1876), and there was breaking of windows, doors and gas lamps.[12] The following year 1878, there was no tar-barrel – though perhaps by way of retribution against the prime 'spoilsport', the Sheriff's house was tarred in March, resulting in a dispute between the fiscal and the town council over 'the state of matters in your Burgh . . . which merits immediate consideration'.[13] Despite suggestions that tar-barrels appeared in later years, there have been no more verified 'sightings' on Christmas or New Year's Days (OS).

Misrule appeared to be withering. It did not decay because of police action, for the Lerwick police force remained small (composed of one police superintendent backed up with special constables) who were little more effective than they had been in the 1850s and 1860s. More arrests were being made, but these were mostly single individuals at each incident. The town council was clearly not trying to suppress the celebration as a whole, for the Commissioners of Police stated that they had 'no intention of interfering with out-door harmless amusements'.

Much more significant from the reports is the evident falling number of tar-barrellers. In place of the multiple duelling krates and boats of the 1850s and 1860s there was by the early 1870s only a single contraption, possibly with only a single tar-barrel on board, and the reports strongly suggest that there was a relatively small number of attendants. With depleted numbers, the police were able to pick off an individual tar-barreller more readily. The streets were becoming more peaceable in the early hours of Christmas and New Year's Day (OS) as the young men of Lerwick were deserting their 'time-honoured' custom of several decades. The town council and the police may have taken the credit, but a change in popular behaviour was under way.

Rough and respectable

The 1870s was a decade of enormous change in Lerwick and Shetland as a whole. In the early part of the decade, emigration from the islands was at an extraordinary level, the result of evictions by lairds readying their lands for sheep, creating a growing and indelible sense of injustice in Shetlanders' consciousness. By the later 1870s, however, the islands were transformed by the herring boom. Lerwick became the principal summer base for the vast British herring fleet constituting hundreds of boats, with a further vast number of support workers – principally young female fish-gutters – who laboured at curing stations at the north end of Lerwick and at other stations, notably Baltasound on the northern-most Shetland island of Unst. The influx was enormous, creating huge camps and lodging houses to accommodate the temporary migrants. Many of the women were Gaelic-speakers from the strict presbyterian Western Isles of Scotland, whilst the fishermen came from all over – from the Moray Firth, Fife, the north-east of England and East Anglia. In their train came a large army of 'hangers-on': preachers, tract distributors, carnival acts and entertainers. Between the 1870s and the 1920s Baltasound became a four-month town, growing between May and August from nothing to as many as several thousand people, whilst Lerwick's population probably doubled during the same months.

The herring boom brought prosperity for local traders. Shop premises on Commercial Street were plate-glassed, and above the Street a 'new town' grew at Hillhead: a grid of spacious streets and mostly detached houses, many of highly ornate individual design, whose main artery, Hillhead, ran parallel to Commercial Street but half a mile away at the top of the hill. This was a stark physical and social division, really

the first social segregation that the town had seen. During the 1870s and 1880s, the town moved from being an eighteenth-century ribbon development of one passable street and many tight lanes along the shoreline, to being a prosperous Victorian small town of variegated social and physical style. The town's built environment started to reflect the seasonal migrants: mission halls and churches grew, tract-distributors found premises, and the town became the venue for the most extraordinary struggle between the late Victorian forces of evangelical puritanism and the instinctive tendency to drunken dissipation characteristic, especially, of the Greenland whalers who still came to Lerwick as they had done for a century.

The explosion of the herring industry accelerated Lerwick's sense of itself as a prosperous provincial capital. More than in previous centuries, it attracted large numbers of single women to the town in summer, bringing with them a keen sense of Victorian religious morality. The evangelical churches – the Church of Scotland, the Free Church, the United Presbyterian Church, and the Methodists, Baptists and Congregationalists – found themselves joined by independent preachers drawn to evangelising work by the example and popularity of Dwight Moody and Ira Sankey. Moody and Sankey were virtually unknown American evangelists until they visited Scotland in 1873–74 and were the focus of a religious revival (centred on Glasgow) which turned them into international religious celebrities and which spawned a veritable industry of evangelistic associations for both adults and children.[14] Moody was invited to Shetland by twenty-nine of the islands' clergy, and though he declined (being considered 'unfit for further exposure to the sea'), evangelistic meetings were held regardless and 'many precious souls' were awakened.[15] The Moody–Sankey revival had a considerable influence on working-class religion in Shetland, as in Scotland as a whole, for it provided a new form of religious service (including Sankey's hymns which remained popular into the 1930s), a distinctive emphasis on re-birth as a joyous experience rather than a deep contemplation of sin, and an almost unprecedented focus on young men's religious and moral condition (evident in the promotion of teetotalism and organisations like the YMCA). Revival meetings continued in Lerwick throughout the autumn of 1874, and evangelicalism developed its strong and enduring association with the fishing industry.[16]

Coinciding with the rise of the distinctive sensibilities of evangelical religion was the suburbanisation of Lerwick. The suburbs grew up in front of the new town hall on the brae-top – built, some said, symbolically

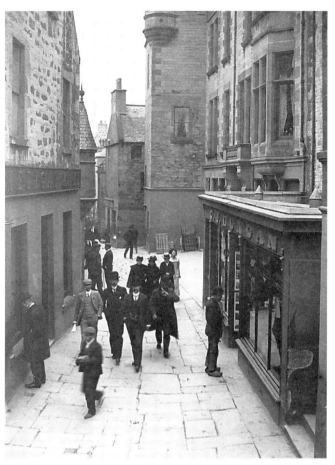

13 Commercial Street in the late Victorian period. 'The Street', as it is known locally,
was (and to this day remains) the fulcrum of Lerwick life. By the time this
photograph was taken, it had acquired modern shopfronts whose owners were less
than happy with the danger that gunshots and flaming tar-barrels posed at
Yuletide. (Courtesy of the Shetland Museum)

with its back to the old town and seafront.[17] It was composed of spa-
cious Victorian villas with front and back gardens, arranged around
large public gardens with railings and young trees. With the herring
boom sustained in the 1880s, the villas mushroomed – including one of
the grandest, Lystina House of 1885, built by George Reid Tait (the local
notable whose previous house suffered tarring eleven years before). New

public buildings – including the Zetland County Buildings and school-board schools – were built in customary Victorian finery, and new churches (a Methodist Church, and later a special church for Dutch seamen) were added. Less grand middle-class houses were erected here too, creating a characteristic late Victorian middle-class suburb in which churches and church organisations for children and adults defined community activities throughout the week.[18]

In this new atmosphere of renewal, prosperity and refined sensibilities, there was considerable pressure for the era of misrule to be at an end. In 1875, a newspaper campaign against tar-barrelling and its associated 'mischief' started. The municipal authorities, sheriff, merchant elites and the press were involved – even, as is hinted by many sources, if these groups included now-respectable ex-tar-barrellers. The two main Lerwick newspapers wanted to see the transformation of the events into, in the words of the editor of the *Shetland Times*, 'a season of repose and rationable [*sic*] enjoyment'. He complained of the 'time-honoured institution of the tar-barrel, with its hurdle and chains, its noxious smoke and scorching flame, its yelling imps and barbarous dances, its masquerade and saturnalia, inspiring fear, and threatening destruction of property and life'. Yearly, he wrote, he had to chronicle 'a number of hair-breadth escapes and bodily fractures, broken panes and burned doors, marred houses and tar-stained streets'. For the relative quiet of 1875 he praised 'the alteration which Magisterial wisdom and firmness has inaugurated', and the advent of 'a rich and great variety of innocent and entertaining amusements, the which we hope to see improved on in a more histrionic fashion, and perfectly in custom'.[19] Here is a tantalising suggestion that 'tradition' should not to be stamped out, but rather 'improved on in a more histrionic fashion'.

In 1877 an anonymous satirical flysheet was distributed in Lerwick, headed *An Earnest Appeal for the Restoration of the Ancient Norse faith of Shetland*. In a meandering and verbose text, the sheet pokes fun through local jokes at the various churches in the town – the Established, United Presbyterian, Free Church, Wesleyan, Plymouth Brethren, and the Independent Chapel 'which has during late years given forth from its pulpit a variety of opposing and conflicting Faiths'. It talks of installing putative Norse gods in each church, and of constructing 'a Thing' on one of the pierheads; this was possibly an ambiguous reference to a Norse 'ting' or parliament of the sort that was held in Shetland in the medieval period, thereby signifying the institution of an historic 'democratic' process. The flysheet ended with a plea for subscribers and for a meeting at the

Market Cross 'next Wednesday at eight o'clock, to explain our views more fully. Nevertheless, BE THERE. FESTIVAL OF UPHELLY 'a, 1877. No Surrender !!! Remember the eyes of the Vox Populi are upon you.'[20] The significance of this document seems clear. It appeared in the year that the end of the tar-barrels seemed imminent, after thirty-two years as the town's 'custom'. In acknowledgement of some popular dismay – certainly amongst the diminishing numbers of male tar-barrellers – the flysheet was headed by a mock advertisement for 'Holloways' Ointment – Cure for All: Never Despair', showing a bare-breasted woman in classical toga with child and doric column.[21] It was addressed 'Dear Brother, and still more dearly Beloved Sister'. This document, reputed by virtually all sources to have been written by James Laurence, editor of the *Shetland News*,[22] is the first mention of the term 'Up-helly-aa' in the documents relating to Yuletide celebrations in Lerwick, and only the second reference to its use in Shetland.[23]

Whether the meeting mentioned in the 1877 flysheet occurred, and what transpired at it, is unclear. In all probability, very little happened except an idea for change based on 'resurrecting' some putative 'older' custom. A *John O'Groat Journal* correspondent reported:

> According to custom that has prevailed here during some years of late, Monday last was observed as what is here called 'Uphelly a'. It is said by some to be an old custom, but if so it has changed greatly like many other things. It must be confessed that with the increase of kirks, and the change in the mode of education, the morals of many of the young have not improved. This is to be regretted, since it gives cause for the enemy to blaspheme and rejoice. . . . A band of reckless youths went through the town on the evening of Monday last with masked faces and quotesque [*sic*] dresses, and about midnight doors and windows were broken and some of the street lamps made useless for a time.[24]

With the last and subdued appearance of the tar-barrel at New Year (OS) in 1877, no 'precautions' had been taken for 29 January. 'Such ruffianism', the *John O'Groat Journal* correspondent thundered, 'cannot be allowed to go unchecked.' The ritualised misrule of large numbers of Lerwick men had dissolved into the 'ruffianism' of the few. The following year, 1878, it seems that the idea of a new festive occasion on 29 January was gaining some ground, for that day was reported as being 'observed here by most of the young people as Uphaly a', or close of the Christmas holidays'. Conduct of revellers was mixed; 'the majority behaved with some degree of decency', but a few defied the authorities

and 'general public feeling' by setting a single barrel alight (though not apparently in a krate or boat), and dragging it some distance before being discovered and stopped. Though it was alleged there were other 'aiders and abettors', the behaviour was said to be 'so offensive to the inhabitants generally'.[25]

'Decency' now became a watchword for opponents of mischief. Christmas Day (OS) in 1878 was marked by guizers doing their rounds 'with more decency than in former years'. Some were dressed in straw, an attire common in rural Shetland but rare in Lerwick, and they were welcomed into the homes of some of the 'aristocratic families'.[26] A year later, Christmas and New Year (OS) in January 1879 were said to be distinctive for 'so much quietness and decorum'. Whilst guizers were out on Christmas morning, an innovation seems to have been a 'guizers' torchlit procession' on New Year's morning with crowds of people in every lane to watch. This was now a decorous event, and fitted into the dense programme of church services, the Good Templar Soirée in the Seaman's Home, the 'tea-meeting' of carols and hymns at St Magnus Episcopal Church, and the Wesleyan Chapel bazaar in aid of a chapel organ.[27]

A public will for decorous conduct had pacified misrule. Lerwick was starting to emerge into its late Victorian blossom with the herring industry furnishing a new prosperity, and a sentiment in favour of gentility and modernity was gaining ground. In 1880, the town made a symbolic innovation – abolishing the Julian calendar. In 1752, Britain had moved by parliamentary edict to the Gregorian calendar. This fostered some popular resistance to the interference with calendar customs that resulted, and ironically gave some old calendar festivals what Robert Poole has described as 'a more pointedly festive air'.[28] Plebeians in some parts of Britain continued to observe calendar festivals – and notably Christmas and New Year – by the Old Style calendar. As far as is known, Shetland was the only place where the observation of 5 and 12 January continued to be observed formally, with the town council agreeing to its observance.[29] A custom had developed in Lerwick in the 1870s of the merchants and householders formally requesting the town council to declare Christmas and New Year's Days (OS) as holidays. However, when they presented their annual petition in December 1878, the magistrates and town council agreed to their request only on the condition that from the following year the public holidays were moved to the New Style dates – 25 December and 1 January. This was duly enforced in 1879,[30] but the customary 'mischief' was still expected, though now for the first time on New Style Christmas Eve, 24 December. However, the

town council wished to ensure a smooth transition and six special con-stables were enrolled, but this was considerably less than the normal number of twenty of the mid-1870s.[31] In any event, they were not needed, as the population of Lerwick duly shifted its Christmas celebration to 25 December 1879 when guizers went out early and 'everything was con-cluded quietly'. A greater than usual crowd watched processions by the Royal Naval Reserve and the Oddfellows, and the Freemasons moved part of their St John's day festival gathering to Christmas Day (NS). Though two seamen were convicted of breach of the peace by fighting and mak-ing a noise in 'foolish observance of Auld Yule', the calendar change was uneventful and the New Year was celebrated quietly on 1 January 1880.[32]

Reform of the calendar capped the reform of Christmas custom – or seemed to. Though Old Style Yule and New Year were effectively ended in Lerwick, the new Up-helly-aa on 29 January, the twenty-fourth night after Old Style Christmas Day, started to acquire the activities and flavour of what had happened at around 4 a.m. on old Yuletide in the 1840s, 1850s and 1860s – after the tar-barrels had burned out. On Up-helly-aa 1880, young people 'paraded the streets in the usual guizers' dress, accom-panied by fiddlers, and having a dance at the houses they visited'. Some saw this as bizarre behaviour by those 'who choose to persist in this odd and almost forgotten custom'.[33] The same happened the following year when a modest torchlight procession was organised – reputedly by an anonymous committee. The same was organised the next year, 1882, but the guizers' procession suddenly achieved fame.[34]

In January 1882, Prince Alfred, the Duke of Edinburgh, came to Lerwick to lay the foundation stone of the new town hall, and the date of the planned procession was changed at the suggestion of the town council.[35] This was to be the town's first dedicated municipal building, and was carefully designed by the local antiquarian, Arthur Laurenson, that it should be 'if possible Scandinavian and not English, nor even Scottish'. The main hall on the first floor was designed to be like a Viking long-house with a curved vaulted roof, dark panelled walls, and stained-glass windows depicting Norse heroes and heroines from Shet-land's past.[36] To celebrate its new self-confidence in 1882, the town council gained official approval for its design of a coat of arms featuring a Norse galley and a black raven – features engrossed in the decoration of the new town hall. To mark the Duke's visit on 24 January, a procession of 130 guizers with torches was organised, bringing forward the celebration of what was described as 'their ancient festival of "Uphelly a"' five days later. Headed by a 'Worthy Chief Guizer' (who was a journalist with the

Shetland Times), the guizers marched past the royal podium, giving the Duke three cheers. Afterwards, the guizers visited homes and danced to fiddle music.[37]

From this point, Up-helly-aa started to develop its own customs very rapidly – a process that was to continue with some pace down to 1906.[38] By 1885 an active committee was organising the event, with placards appearing in 1886 instructing intending guizers to assemble at the Market Cross at 8.30 p.m. on 29 January. Later that year a mass meeting of guizers met to discuss various issues, including making representations to employers to allow more workers off work early on the evening of the procession. In 1887 one newspaper carried a message from 'the Committee of Management' thanking all those gentlemen who had made subscriptions – totalling £3, probably used towards the cost of making torches. From 1888 only authorised guizers were allowed to join the procession, and a brass band took part. In 1889 the first galley appeared, which, though modest in size, was set alight and dragged onto Commercial Street in a final echo of the tar-barrelling. In 1891 the committee posted a large placard at the Market Cross announcing the date and time of the procession, and it also issued torches. In 1892 things got grander, with an attempt by some guizers to lead the procession on horseback; the horses would not settle with the lit torches, and the attempt was never repeated. However, there were one hundred torches followed behind by 'a Norse galley, gaily decorated, with an artistic-looking "deck-house" aft, in which were seated a number of fiddlers'.[39] The procession was peaceable, the police superintendent and his constables described as being on 'not an arduous duty', and the procession stopped outside the houses of two solicitors who had done much to secure a public park for the town – a public park which is now, in the late twentieth-century, the scene of the galley-burning. Afterwards, the guizers went on house-to-house visitations, a new-found peaceable process described in later years as 'of coming into a house for a few minutes, having a dance and a snack of something, and then rushing out again in order to cover as much ground as possible'[40] – a development seen as auguring well for the future of Up-helly-aa.

It is tempting to see the royal salute from Queen Victoria's second son to the guizers in 1882 as the transformation of the Up-helly-aa procession into a civic event and its greater organisation in the later 1880s as the result. In reality, despite a developing ritual, there was still little of a permanent civic occasion about it. The festival continued to be an occasion for young working men of the town to don a variety of

guizing outfits, process through the town with torches, and then proceed to call on houses for food, drink and dancing to fiddle music. Though some of the houses were those of the 'gentry' (or middle classes), there is no evidence of a bourgeois influx into the guizers' ranks. Parading the streets, even now in peaceable ordered fashion, was a plebeian recreation. The organisers of the event, the emerging Up-helly-aa Committee, were drawn from the guizers, and seem to have been members of the town's working class. There is no evidence to suggest any change in personnel between the tar-barrelling era and that of Up-helly-aa. Working men were gathering together, as they were doing in so many fields of recreation and political life in the 1880s and 1890s, to organise, to form a committee, to create for themselves the paraphernalia of chairmen, secretaries, minute-takers and resolutions, to practice self-governing democracy.

This could be seen clearly by 1896 when the organising committee advertised in the two local newspapers, giving very precise instructions about mustering, the deployment of guizer squads, the lighting of torches on cue, a defined route for the march, and the method of final burning of the ship – with singing of 'The Hardy Norseman' en route and of 'Auld Lang Syne' at the boat-burning. And in 1899, the Proclamation on the Market Cross was replaced by the 'Bill', a satirical commentary on local events, which the *Shetland Times* regretted had 'personal allusions which . . . prevent its reproduction'. The satirical Bill had made its first appearance, clearly copying the style of the 1877 flysheet, and just very possibly written or suggested by the same author.

However, increasing organisation did not obliterate the romance of the former misrule. Relics of the older 'customs' survived. Guizers in face masks appeared on both Christmas and New Year's Day mornings (NS) in 1884/5; the men divided into squads, and, on New Year's morning, they smashed five gas lamps in Commercial Street and in the docks, and broke in several doors.[41] 'Rough' and 'respectable' versions of the former Yuletide customs survived side-by-side for some years, most notably in December and January 1891/92. Christmas Eve (NS) (24 December) saw 'peerie guizers' – young boys and, possibly, girls – out seeking food and money during the hours of daylight, as they had been doing in the middle decades of the century. When evening came, events were reported as being 'hotted up':

> As the shops began to close, the big 'guizers' commenced to issue from their retreats, and soon real pistol shots were heard, accordions

breathed forth gasping hornpipes, and well-rosined bows ground out soul-inspiring reels out the national instrument [the fiddle]. There were, it is reported, nearly a dozen 'squads' out, and notwithstanding the Influenza . . . there were a good few houses open for their reception. There was nothing, of course, like a general opening, for that is a thing of the past, but the guizers managed to put in the time very well, and in some cases daylight had dawned upon them before they found their homes. The dresses were as usual of a mixed kind, but a good few were new, and got up at no little trouble and expense. . . . The only depredation reported is a piece of mischief that might have been better left undone – a revolver bullet being fired through a shop-shutter.[42]

It must be emphasised that this was not the organised Up-helly-aa, but the 'unauthorised' events on Christmas Eve. A month later, another piece of mischief took place in clear defiance of the organised Up-helly-aa festival. On 29 January, an hour before the organised Up-helly-aa festival was due to take place, a squad of unofficial guizers towed an effigy seated on a small barrel bearing a label 'Tar Barrel'. This was set alight and drawn up Commercial Street to Market Cross where it was seized 'by the hand of authority, and dragged down to the pier' where it was thrown into the sea.[43] This mock krate and tar-barrel was a forlorn last resistance to the hijacking of the central symbol of misrule. For the winter fire festival of the early and mid-Victorian apprentices and young men of Lerwick was already rescheduled in the calendar, pacified and organised.

The consequence of the creation of Up-helly-aa was a slow decay of Christmas and New Year as the occasion for customary activity. Guizers continued to go out on Christmas night for many decades; 'not a few' of those in 1900 were rumoured to be women: 'If this be the case,' commented the *Shetland News*, 'the ancient pastime is probably going to take a new lease of life.'[44] The same process of modulation between old and new customs was taking place elsewhere in Shetland. In the same year at Ulsta on the island of Yell at Old Style Yule (6 January), the bugle sounded at 4 a.m. summoning men to a tar-barrel procession. After drinking a 'drap o' da auld kirk' (a drop of – probably – whisky at the Church of Scotland), they lit the tar-barrel, processed with a fiddler, a fog-horn, a melodeon and an old tin tea-box, then drank and danced round the burning barrel till dawn, ending with a 'tea, supper and dance' given by the local factor.[45]

But despite the lingering of spontaneous guizing and imitation tar-barrelling on other days, it was the organised torchlit procession on Up-helly-aa night, 29 January, that emerged into the twentieth century as

the major winter festival of Lerwick. It grew gradually in scale, but more importantly in status, for by concentrating community festive energy on that event Lerwick's celebration of Christmas and New Year faded. What was left by the inter-war period was largely the same as elsewhere in Scotland – a quiet Christmas Day in which many workers still worked (for it did not become a public holiday in Scotland until 1957) and the family customs of Hogmanay and early New Year's morning, involving drinking, singing and first-footing, followed by a complete shutdown of work on New Year's Day. Meanwhile, Up-helly-aa prospered, flourishing in a way no other winter festival in Britain did in the twentieth century.

Symbols and ideologies

Between 1880 and 1905, Up-helly-aa was not a Norse pageant. It was an event with no overt single theme – the guizing outfits were many and varied, the Worthy Chief Guizer dressed in a variety of clothes, and the galley (introduced in 1889) stood beside other mock boats of varying design. However, Norse symbols and songs started slowly to infuse the festival in the 1890s, apparently linked to the growing movement of Shetland cultural revival. At the same time, other influences came to be felt in the festival. Lerwick in the late nineteenth and early twentieth centuries was a place much like anywhere in Scotland (or indeed Britain) where issues of class, national and imperial identities were entering political and recreational activities. And moral issues such as teetotalism and prohibition were being widely aired. Between the mid-1880s and 1905, Up-helly-aa was forming within a wider framework of community politics.

Most influential to the future thematic content of the Up-helly-aa festival was the Shetland cultural movement. From the early 1870s, a number of disparate individuals in various parts of Shetland were actively promoting research and interest in the islands' Norse heritage.[46] They wished Shetlanders to share in a recovered Norse culture: through reading guidebooks, history books, novels and poems written in dialect, the use of Norse place names, and the cultivation of lessons in Norse history as part of the curriculum in the islands' day schools. These individuals included writers, journalists and teachers: J. J. Haldane Burgess, a blind poet and short-story writer; J. B. Laurence, the editor of the *Shetland News* (and reputed author of the Up-helly-aa flysheet of 1877), Arthur Laurenson, an antiquarian and prominent figure in Lerwick's civic affairs, and Laurence Williamson who became well known in Scottish folklorist circles as the chronicler of oral tradition, especially dialect

renditions of rural Shetland folktales. These men were not friends and allies, for their politics were far asunder – from the developing Marxism of Haldane Burgess to the right-wing Conservatism of Laurenson. However, they collectively assisted in the infusion of an awareness of the Norse past into the Shetland public consciousness at the turn of the century.

These men thrived on a mixture of gloom and exultancy: gloom at the death of Shetland's heritage, and exultancy at the work of rescue and revival of that heritage. Laurence Williamson (1855–1936), a resident of the island of Yell, was dedicated to what he called 'the living past'. He wrote in 1892:

> I would say that it ever more broods over my mind and heart that such mass or lore belonging to our native Isles, folklore, linguistic matter, traditions, living historical matter, enough in the hands of some genius to form a small literature or wealth of poetry, should be year by year slipping into the grave. This is a transition time such as never was before. The old Northern [Norse] civilisation is now in full strife with the new and Southern one, and traditions, customs which have come down from hoary antiquity, are now dying for ever. The young don't care for their father's ways. I mean what was estimable in them. The folklore and family traditions and picturesque stories yield fast to the *People's Journal, Glasgow Mail, Ally Sloper's Half Holiday* and such like.[47]

The work they undertook gave Shetland a printed written culture really for the first time, engrossing novels, poems, books of Shetland history and folklore, and most critically of dialect and Norn language – including the recovery and restoring of Norn place names in the islands. The individuals were extremely keen to involve the community in this work, to make children and adults alike not only conscious of the Norse heritage which had been suppressed and sublimated by Scottish influence since the sixteenth century, but also part of a revivification of that heritage and culture within modern society. Some of them perceived Shetlanders' fortunes as suffering at the hands of Scottish and later British authorities, 'outsiders' who had culturally overwhelmed the islands, and a few were sympathetic to Lerwick's tradition of defying authority by 'cocking a snook'.

In the 1870s and 1880s, some Shetland intellectuals flirted with racial theories of Shetland identity. There was a reassertion of Shetlanders as an authentic 'race' discrete from that of the Scots. Arthur Laurenson wrote in the *Shetland Times* in 1872:

Our near kinsmen across the East Haaf [northern North Sea] – the 'Wester Haaf' it is to them – the Norwegians have a better understanding of the importance of racial characteristics. They carefully foster the national feeling, and never let their children forget that they are the heirs of that old race which, coming out of the north and east, gave laws and lords to all Europe.[48]

In the same year, he told the Society of Antiquaries of Scotland: 'The native population of the Shetland Islands is Norse in blood and origin. There is not, nor has there ever been, any appreciable Celtic element in it. To this day the Norse physiognomy of the people is distinctly marked; nowhere do you find the Celtic type.'[49] J. B. Lawrence told the Lerwick Mutual Improvement Association, of which he was president, that 'the poetry and music of our dear Old Fatherland long lost to us, but still part of us, could alone in the truest sense thrill the depths of the soul'.[50] Working in the 1870s and 1880s through these various media, and through the schools and through folklorist research into oral traditions, men like Laurenson and Laurence brought a sense of Shetland's Norse past to a popular consciousness. Shetland was being erected not just into a former colony of Norway, but as a crucible of civilisation: of parliamentary democracy (as represented by the medieval 'lawting', whose site lay five miles to the west of Lerwick), heroic deeds and a separate identity. The intrusions of the British state – of state education under the Education (Scotland) Act of 1872, and perhaps also the intrusions of Scots and English with the herring invasion between July and September each summer from 1875 – were referred to by Laurenson in the same breath as the influence of the 'ill fated Stuart Earls whose career is a black page in our past'.[51] This denigration of things Scottish, and of language derived from Scots or English, has been traced by Brian Smith as a vein running through Shetland philosophy from the early eighteenth century; he describes it as an 'anti-Scottish theory of modern Shetland history, a theory of biological or racial determinism'.[52]

Only one of these intellectuals – J. J. Haldane Burgess (1862–1927) – had a significant influence on the festival of Up-helly-aa. He published various collections of his works, including one short story in which a character encouraged the revival of Shetland names:

> It was the schoolmaster who had got old Siimunt Shoordson and his daughter-in-law to call the little girl Hilda. The schoolmaster was a Shetland man, and knew about old Norse things, and he was anxious to revive the old Norse names as much as possible. He had also got the old man to agree to having his own name remodelled. The old

man had always thought that his right name was Simon Georgeson, but the schoolmaster told him that it really should have been Sigmund Sigardson, and that it had been broken down in course of time from that pure old Norse name. Old Siimunt felt very proud when he heard that, and was quite pleased to have it changed back to something like the old right way.[53]

Burgess is attributed with suggesting the key elements of Norse symbolism in the Up-helly-aa procession. Most of these contributions cannot be with documentary certainty laid at his door, but they are generally credited to him. First amongst these was the idea of having a Norse longship, soon termed the 'galley', in the procession, first appearing in 1889. The *Shetland News* remarked on the occasion: 'This festival, as most Shetlanders know, was an institution among Scandinavian people of religiously strict observance.'[54] His second major contribution was *The Up-Helly-A' Song* which he wrote for the 1897 festival, and which has been sung each year since then – originally to the tune of 'John Brown's Body' but then to a special tune written in 1921.[55] For the most part a stirring song of Norse daring-do, the last verse contains a strong radical sentiment:

> Our Galley is the People's Right, the dragon of the free,
> The Right that, rising in its might, brings tyrants to their knee;
> The flag that flies above us is the Love of Liberty;
> The waves are rolling on.[56]

The third major contribution attributed to Burgess was the renaming in 1906 of the Worthy Chief Guizer, first elected in 1882, as the Guizer Jarl, who henceforth was to be dressed in Viking costume.[57] Such was Burgess's contribution to Up-helly-aa and modern Shetland literature that Lerwick town council gave him a public funeral on his death in 1927.[58]

Other elements of Norse symbolism were introduced. In 1893, the longship acquired a mast and a raven banner – taken to be an emblem of the Vikings. At some point, a separate bow mast was added with a red wooden hand on top, taken to represent an epic story whose origin is obscure (possibly drawn from a Victorian illustration in the first translation of the *Orkneyinga Saga*) of how two Norse jarls raced in separate boats to claim an island as their own, and how one of them won by severing his own hand with an axe and throwing it ashore.[59]

Separate from these have been two other key rituals in the Up-helly-aa event. First, the Collecting (or Subscription) Sheet upon which 'gentlemen' – usually merchants and the upper-middle classes – were

asked to subscribe money to defray costs. The need for revenue was apparent by the early 1880s, initially for the purchase of the elements to make the torches; where previously tar-barrellers had merely purloined or stolen from the gasworks and boatyards, civic recognition required there to be no hint of crime. The Collecting Sheet is reputed to have first appeared in 1891, though the earliest extant one I have traced is from 1894.[60] They are illuminated, with designs on the front of Norse longships and scenes. The Guizer Jarl signs the Collecting Sheet (like the Bill) with the words: 'We axe for what we want' – a linguistic joke referring to the Jarl's axe, but also alluding to the phonetic sound of 'ask' in the Shetland dialect and intimating the power of the people to the merchant and professional classes to whom the Sheet is taken. It is a joking reference which links to the guizer-doling of the mid-nineteenth century – essentially, a 'trick or treat'. The Sheet was, and to this day still is, circulated in the weeks before Up-helly-aa, raising £9 9s 6d. from eight subscribers in 1894 and an impressive £5,003 in 1981.[61] The Sheet has been an important part of the ritual, designed to offer a conspicuous role to wealthier, possibly ex-guizing Lerwegians who pass the baton from one generation to the next.

More important than the Collecting Sheet in the long term has been the Bill. In the early years of Up-helly-aa, in the 1880s and 1890s, the Worth Chief Guizer and the Up-helly-aa Committee announced the date, time and place for the 'muster' of guizers, and the route for the procession that followed, by placing a placard on the Market Cross. By the late 1890s, the festival was so well organised that this information was advertised in the newspapers, so the announcement at the Cross became redundant. However, in 1899 it was replaced by a large placard, usually measuring up to eight feet by four feet, on which a long text of contemporary local jokes was given. It became a satirical placard using misspelt words, emboldened in a different colour, to ridicule local councillors, public figures and institutions. Signed by the Jarl (in some years by custom with his footprint), it was composed by a Joke Committee which was formalised by the Guizer Assembly in 1913.[62] The Bill, posted to the Market Cross on the morning of Up-helly-aa, quickly became a keenly awaited document appreciated by Lerwegians for its scathing attacks, and after its initial year it was, by careful allusion and avoidance of the laws of defamation, reprinted verbatim in the local press every year.

By 1906, most of the key elements of the Up-helly-aa 'tradition' were in place: the Subscription Sheet, the Bill, the Norse galley (with raven, red hand, dragon head, shields and oars), the procession of squads

headed by the Guizer Jarl and his Norse squad, followed by other squads in a strict order chosen by ballot, a final burning of the galley by lit torches to the accompaniment of singing, and parties afterwards with guizing acts, dancing and non-alcoholic refreshments. Despite departures in some years from this ritual, later developments were relatively minor: the Jarl changed his sword for an axe in 1912, and his squad – after dressing in a variety of costumes, including Norse ones in 1906 and 1912, was only to become permanently dressed in Viking costumes in 1921; and there were changes in the boat design, from a twelve-footer in 1894 to a thirty-footer in 1912.[63]

The creation of the Up-helly-aa ritual took place most rapidly in the period from 1897 to 1914. The formative influence was Burgess, but amongst those taking other key roles in the development of the rituals there was a significant concentration of like-minded activists in the Shetland labour movement. There was a very prominent socialist, and also teetotal, involvement in the organisation of Up-helly-aa at the end of the nineteenth and start of the twentieth century. Burgess himself was described at his death as instrumental in the early organisation of the labour movement in Shetland around 1900. That beginning, it was said of him, 'was largely due to the enthusiasm of our late comrade for all the things that made towards social progress and the betterment of conditions of life of the masses'.[64] His enthusiasm for Up-helly-aa was not isolated. The first two socialist members of Lerwick town council were active Up-helly-aa organisers (one of whom organised the 1882 procession); the first labour provost of the burgh was Up-helly-aa Jarl in 1909; and four of the first eight Jarls between 1906 and 1914 were members of the British Socialist Party.[65]

Why should Lerwick's nascent labour movement take such an instrumental part in the design of Up-helly-aa? The late nineteenth and early twentieth century was a period in which the very severe conditions of life of the Shetland people became more fully appreciated. Perhaps more forcefully than elsewhere in Britain, the nature of employment and wealth creation – being a highly seasonalised activity – left a greater than usual shortfall in health and housing conditions. Housing conditions were especially poor. The level of domestic overcrowding in Shetland in 1861 and 1901 was the worst of any county in Britain; in the former year, there were an average of 3.18 persons per room in Shetland compared to 2.04 in Glasgow, the most overcrowded of Britain's major cities.[66] Municipal intervention in housing was a clear priority for the Shetland labour movement, and because they were widely acknowledged

with pioneering the issue within the islands in the face of conservatism of other local politicians, they achieved significant representation on Lerwick town council – where other councillors deferred to their leadership in the process of planning council housing.[67] Though Lerwick was slow to achieve success against the high level of housing need, it was noteworthy how in an island context the labour movement's agenda was widely accepted by 1910 as vital to the people as a whole. It was equally noteworthy that the movement's representatives achieved a place of unusual consensual acceptance in the town. Its success was matched in other spheres – notably the rapid development of local branches of trade unions. In few places in Britain could labour representatives have achieved such an influential role within the community before the First World War.

As well as political action, Lerwick's socialists were important in the development of working-class recreational organisations. The 1890s and 1900s was a period of frenetic organising by the male working class of Britain – not just in trade unions and emerging political parties, but in sports organisations (the Clarion Clubs), debating societies, libraries and socialist Sunday schools. The passion for organising built on the tradition which had been especially active since the 1870s of working-class 'lodge' organisations – including teetotal bodies like the International Order of Good Templars and the Independent Order of Rechabites.[68] In Lerwick, Up-helly-aa became in part an element in this passion, with the difference that the Up-helly-aa Committee was to exhibit an extraordinary endurance and symbolic power within the community.

From its inception, labour activists were acutely involved in the actual organisation of Up-helly-aa.[69] The first known organiser – of the procession before Prince Alfred in 1882 – was a twenty-year-old apprentice compositor, Alex Ratter, who was to go on in 1905 to become Lerwick's first socialist town councillor. He went to Edinburgh in 1893 and there with another Shetlander, James Robertson (1873–1911), they joined the Social Democratic Federation, Britain's first Marxist political party. On his return to Lerwick in 1896, Robertson embarked on what Brian Smith has termed 'a sort of pioneer political crusade', befriending and converting Haldane Burgess to socialism. Robertson was elected to the School Board in 1897, and promoted socialist policies there – including free textbooks for pupils. He gave public lectures on socialism (with titles like 'Socialism, the Workers' Only Hope', and 'The Class War') to meetings of the Young Men's Guild and the Literary and Debating Society. The latter, founded in 1902, was a strong socialist organisation,

and was followed in 1905 by the establishment of the Lerwick Working Men's Association, which rejected the Independent Labour Party as too tame, and affiliated instead to the Social Democratic Federation of which the Association subsequently became its Lerwick branch. With two hundred members by 1914, it was claimed to be the biggest and best organised in Scotland. In 1905, it gained two seats on the Lerwick town council (one being Alex Ratter), and a third joined them the following year. One seat was gained on the county council, and three were elected to the School Board.

Some of these socialists also had close connections with the temperance movement on the islands. Though the Templars was the major temperance organisation in Lerwick in the 1860s and 1870s, it was the Rechabites, Britain's foremost temperance friendly society, which grew rapidly in importance in Lerwick after its branch was set up in 1890 – one of its founding members was James Robertson. Rechabites, like the members of most youth and religious voluntary organisations of the period, had to take the pledge of total abstinence from alcohol as a condition of membership, and have tended to be seen as the very essence of Victorian and Edwardian religious-based puritanism. Yet in Lerwick, the Rechabites were strongly tinged with socialist politics. Converting the people to total abstinence was seen as part of a radical solution to the condition of the working classes, and they put forward a candidate in 1894 for the town council election – who, though unsuccessful, was elected as a socialist candidate to the county council ten years later.

The Rechabites – and more broadly the temperance movement – had an important impact on the formation of Up-helly-aa proceedings. As the event grew in size, attracting visitors from landward parts of Shetland and from amongst ferry visitors, the 'open houses' could not cope, and in 1903 the Rechabite and Masonic Halls were used, the first of these being possibly facilitated by William J. Greig, a keen Rechabite who sold Up-helly-aa masks and costumes from his barber's shop.[70] This experiment continued with the Templar Hall opening in 1905, as well as the town hall and other venues including hotels being utilised in subsequent years; by 1928 the organised halls had completely replaced the domestic 'opening' of houses.[71] In this manner, both socialists and Rechabites invested heavily in Up-helly-aa. It was, as Brian Smith has stated, 'the first working-class cultural movement in Shetland'; for socialists and radical teetotallers, it 'fulfilled the same desires and occupied the same people'.[72] A nexus of socialists, Rechabites and others organised the early festivals from at least 1882. Smith recounts that as the principal

organiser in 1882 Ratter received an aggressive letter from the local sheriff informing him that he himself would be held accountable for any damage inflicted by the procession. Ratter is reputed to have taken the letter to John Leask, a local draper and keen Rechabite. Smith recounts: 'Leask read the letter and grinned. "Alick," he said, "haes du ony monay?" "No Maister Leask, I cudna say dat I hiv." "Heh, heh! I tocht dat: du hisna a penny. Du needna worry about damages. Go du ahead. Damages! Ha, hah! Damages! Ha, ha, Hah!" '[73] In this way, Smith plausibly argues that Up-helly-aa was 'a working men's festival', a recreational event in which the mid-Victorian Yuletide traditions of the Lerwegian male working class could be sustained. As one element of that, the 'Dock's boys', those working in shipbuilding and related trades at the northern industrial end of town, were given a special prominence in the festival in the 1890s and 1900s, having their own seat on the committee and being responsible for the variously designed model ships which appeared in the procession.

14 Admiral Tojo's Flagship, 1905. Models such as these were built by the Docks boys and paraded alongside the Viking galley at the start of the century. They resonated with contemporary themes of imperialism and naval power, as well as reflecting the pride of Lerwick's skilled tradesmen and the important role they had in Up-helly-aa. (Courtesy of the Shetland Museum)

The development of the festival in the late 1890s into an event of some organisation and grandeur brought major changes to the symbolism contained within it. Whereas the guizing outfits of the tar-barrelling years of misrule were reputedly limited in scope (being mostly of a military nature and cross-dressing), the symbols in the 1890s and 1900s became associated with overseas news and with imperialist issues in particular. One of the key expressions of this was in the design of the model boat that accompanied the galley at Up-helly-aa. Until 1911, it became common to make representations of warships – the *St Vincent*, the *Great Harry*, Admiral Tojo's flagship, the *North Dakota*, and the *Dreadnought*. Lerwegians were perhaps becoming aware of themselves as increasingly part of a wider British working class – not merely through labour activists but more broadly from the connections created by the herring boom, the arrival of the telegraph in the islands in the 1880s, and improving steamer connections. Another way in which this happened was through the growth of emigration from Shetland. Rural Shetland suffered badly in the second half of the nineteenth century, and especially after 1865. Large tracts of crofters' arable and pastoral land was taken – or 'confiscated' as it was perceived locally – to make large sheep farms which paid better rents to landowners, and those crofters who held onto their land experienced big increases in rents during the 1870s and 1880s. Though the Crofters' Act of 1886 (which applied to most of the Highlands, Hebrides and the Northern Isles) gave crofters a unique set of rights to secure tenancy at fixed low rents, social damage had already been inflicted. After 1861, the population of Shetland fell for the first time in recorded history. Whilst urban Lerwick boomed – its population rising from 3,143 in 1861 to 5,533 in 1911 – the islands as a whole experienced the loss of 12 per cent of their population in the 1860s, 15 per cent in the 1870s, and 10 per cent in the 1880s. In the thirty years after 1861, the islands' net emigration totalled 11,090, a figure equal to a third of their total population.[74] This situation was not lost on promoters of Shetland culture, nor on working-class radicals, and fed alarm at the loss of Shetland culture. But one of its effects was to create a Shetland diaspora – with emigrants characteristically moving to Canada, South Africa and Australia, as well as the United States. Awareness of the Empire, and of a lost generation from rural Shetland, became apparent within Up-helly-aa. By 1905, photographs of guizer squads were being taken in formal poses and converted into postcards which were sent to exile Shetlanders in Britain and around the world. The festival was starting, in a small but significant way, to represent the symbolic

centre of the Shetland diaspora, and acknowledged that the community was no longer limited to those who lived there but enveloped those who had been forced to emigrate.

Up-helly-aa became between 1880 and 1906 a type of festival that needed symbols. For hundreds of men to guize and draw model boats, it invited symbols. The symbols were becoming increasingly planned and carefully constructed. The Norse theme rose in importance as the period wore on, but it was not a dominant theme in the way it was to become later. Though there was a galley, there was no Jarl in Viking dress until 1906 (and even then he changed into other guizing gear after the procession); there was no Jarl's squad of Vikings, and though there were Norse songs by 1900, the Viking theme was in many ways more vocalised than symbolised. At the same time, the organisation of the festival was growing by leaps and bounds in the increasingly prosperous decades of Lerwick's herring boom, and the influence of local versions of national moral and political agendas were important in the organisation. For the predominantly working people of Lerwick, the festival marked some of the issues that divided them – notably the division between teetotal 'dry' halls and and alcoholic 'wet' halls from 1903 onwards.

Up-helly-aa was in many ways a different 'thing' from the misrule that preceded it. It became ordered, respectable, 'rationable', as the editor of the *Shetland Times* had wanted in the mid-1870s, and 'histrionic' beyond his wildest expectations. On the face of it, the end of misrule – of tar-barrelling, tarring, gunshots and drunken revels in the darkness of old Yuletide – was an abrupt success for the forces of law and order. The ending of misrule owed something to the campaign of the sheriff, town council and Commissioners of Police, backed up by newspaper opinion. But to account for its ending as the product of 'social control' – or to use a more sophisticated variant, 'cultural appropriation' by the elites – is too crude. The town council's attempts at suppression were successful because there was a new sensibility in the puritanising atmosphere of the 1870s – a change of sensibilities which led to what Brian Smith has called a 'capitulation' by 'Young Lerwick' which he puts down to an increasing interest in the one surviving element – the guizing, and 'its artistic possibilities'.[75] The ending of tar-barrelling was clearly in view by 1877, but minor skirmishes of misrule characteristics stayed alive until 1891. It is in that decade that vestiges of mid-Victorian misrule disappears, and the critical development seems to be the maturing of the replacement – Up-helly-aa – into a community festival that could legitimately inherit its mantle. It was a festival that retained its rights to

process the streets at night by torchlight, led by its inverted 'king of misrule' (who in the Edwardian period was appropriately enough often a Marxist), and to satirise the elites and the events of the day in its Bill. Open street conflict was gone, but the symbols of that defiant mayhem were encapsulated – albeit contained and subdued – in the new winter festival.

It was not, however, civic ritual. It was not an event commandeered, engineered, plotted or promoted by the town council, the elites or the churches. In 1882 it was used in the manner of a carnival routine, a jolly jape to show to Prince Alfred: Lerwick's loyal and distinctive plebeians putting on a torchlit show. Even in that year, not all in 'authority' were convinced, as the sheriff's concern over damage to property makes clear. But though it had municipal acceptance after 1882, and many councillors and officials were reputed to be ex-tar-barrellers (as we saw in the previous chapter), it was a festival mounted by a committee elected from the overwhelmingly – if not virtually exclusively – working-class guizers of the town.

The shift from misrule to Up-helly-aa was not the product of social control. In the early 1870s, Yule (OS) was already a much subdued affair and New Year's morning (OS) was witnessing a decline in the numbers attending to the tar-barrels. The mischief of the remaining, perhaps most ardent, guizers was a little more extreme than before, but with reduced numbers the police specials were in a more advantageous position to interfere with effect. Feeling inhibited at Yule and New Year (OS), the result in 1873 was that a small number of youths took to the streets with a tar-barrel for the first time on 29 January. According to the sources, this was the very first occasion on which that date was celebrated in Lerwick. Though it was clearly a conscious selection of a calendar event known in rural Shetland, it cannot be described as an act of cultural appropriation.

In their death-throes, the tar-barrel and the misrule were spilling out across the calendar in minor acts of protest, marking defiance by the 'Lerwick lads' at the root of Up-helly-aa. During the remainder of the 1870s and into the early 1880s, it remained a relatively small affair, as misrule was withering before its replacement was in place. At its birth, what was happening on 29 January was the same 'thing' as at New Year (OS); it was a flaming tar-barrel, the symbol of plebeian power, and not a pacified 'rationable' event. It was only gradually during the 1870s that this became a more ordered event, the tar-barrel making a last appearance on that date in 1878. The pacification of misrule was from within,

and not an imposition, a change undertaken by the town's youths themselves. Lerwick Up-helly-aa was created by young, male Lerwegians who gave it their *imprimatur* because they made it the *same* 'thing' as the tar-barrelling of the mid-Victorian period. The liturgical developments of the festival in the 1890s – the towing and burning of a boat, the songs and the Bill – mimicked the krate, the street songs and the 'cocking of the snook' in a conscious act of preserving the 'time-honoured' customs. They represented the physical strength, the bravado and the satirical power of the people to mock and even humiliate the elites. If you like, the smuggling culture of the town between its foundation in the 1620s until the end of the separate smuggling trade in the 1820s was alive and well. Spontaneous, robust, anarchic and dangerous street culture of the early hours of Christmas and New Year's mornings (OS) had been ordered and tamed, but it was a transformation founded on a shift in the moral sensibilities of Lerwick society as a whole and not one imposed by 'authority' or the elites.

Notes

1 *John O'Groat Journal* 13 February 1873. Corroboration of this report appeared in the *Northern Ensign*, SA, D6/292/8, Newspaper cutting.

2 Ibid., 5 January 1874.

3 Ibid., 12 February 1874.

4 A. Laurenson, 'On certain beliefs and phrases of Shetland fishermen', *Proceedings of the Society of Antiquaries of Scotland*, vol. 10 (1872/3–1873/4), p. 713.

5 Quoted in B. Smith, 'Up-Helly-A' – separating the facts from the fiction', *Shetland Times* 22 January 1993, p. 25.

6 SA, TO1/1, LTC, 14 November 1874.

7 *John O'Groat Journal* 26 November 1874.

8 Ibid., 3 December 1874; SA, D1/133 Public Notice [on tar-barrelling etc.]. Clerk to the Lerwick Commissioners of Police, 12 December 1874.

9 Shetland Museum, Public Notice [on tar-barrelling etc.], Clerk to Lerwick Town Council, December 1875.

10 *Shetland Times* 4 March 1911, quoted in B. J. Cohen, 'Norse imagery in Shetland: An historical study of intellectuals and their use of the past in the construction of Shetland's identity, with particular reference to the period 1800–1914', unpublished Ph.D. thesis, University of Manchester, 1983, p. 466.

11 *John O'Groat Journal* 21 and 28 January, 18 February 1875.

12 Ibid., 20 and 27 January 1876; Smith, 'Up-Helly-A', p. 25; C. E. Mitchell, *Up-Helly-Aa, Tar-Barrels and Guizing: Looking Back* (Lerwick, T. and J. Manson, 1948), p. 43; Cohen, 'Norse imagery', p. 468; J. W. Irvine, *Up-Helly-Aa: A Century of Festival* (Lerwick, Shetland Publishing, 1982), p. 19.

13 SA, TO3/4, LTC and CP, 2 April 1878.

14 C. G. Brown, 'Religion and the development of an urban society: Glasgow 1780–1914', unpublished Ph.D. thesis, University of Glasgow 1982, vol. 1 pp. 436–57.

15 *The Christian* 14 May and 3 September 1874. I am grateful to my BA Hons dissertation student, Angus Nicholson, for these references.

16 *John O'Groat Journal* 19 November 1874; P. Thompson et al., *Living the Fishing* (London, 1983).

17 Though another explanation was that the builders got the plans upside-down; I am grateful to Brian Smith for this.

18 A. A. MacLaren, *Religion and Social Class: The Disruption Years in Aberdeen* (London, Routledge and Kegan Paul, 1974); C. G. Brown, *Religion and Society in Scotland since 1707* (Edinburgh, Edinburgh University Press, 1997).

19 *Shetland Times* 18 January 1875.

20 SA, D11/153/4, Anonymous 'Uphelly A' flysheet, 1877.

21 Holloways' Ointment was a familiar product in the North of Scotland between the 1840s and 1880s, advertised constantly in the local newspapers. Its promotional copy had obvious satirical potential; in 1872 it offered relief from 'short fevers, influenza, inflammation, diphtheria, and a host of other complaints' (including piles), but by 1878 it also cured 'gout, rheumatism and neuralgia', as well as 'Bad Legs, Bad Breasts, Old Wounds, Sore Nipples and Sore Heads'; *John O'Groat Journal*, 8 February 1872, 24 January 1878.

22 Smith, 'Up-Helly-A', p. 25.

23 The first was Arthur Laurenson in his paper to the Society of Antiquaries, published in 1875. See above, page 32.

24 *John O'Groat Journal* 15 February 1877.

25 Ibid., 14 February 1878.

26 Ibid., 17 January 1878.

27 Ibid., 30 January 1879.

28 R. Poole, '"Give us our eleven days!": calendar reform in eighteenth-century England' *Past and Present* 149 (1995), p. 138.

29 Though the Bank Holidays Act 1871 stipulated Christmas and New Year's Days (NS) as bank holidays in Scotland, and though this was extended to Customs, docks, bonded warehouses and inland revenue by the Holidays Extension Act 1875, powers over public holidays first became available to Scottish burghs by the Factory and Workshops Act 1878. By the Factory and Workshops Amendment (Scotland) Act 1888 they were allowed to substitute Christmas Day (and Good Friday) with holidays on the Church of Scotland's *local* (i.e., parish) fast days for 'every child, young person and woman' employed in a burgh factory or workshop. This latter measure became the origins of Scotland's distinctive system of local rather than national holidays, and led to the general non-observance of Christmas (NS) as a holiday in Scotland until it was separately legislated in 1957.

30 SA, TO3/4, LTC and CP, 26 December 1878 and 2 December 1879.

31 Ibid., 23 December 1879.

32 *John O'Groat Journal*, 8 and 22 January, 12 February 1880.

33 Ibid., 12 February 1880.

34 Irvine, *Up-Helly-Aa*, p. 13.

35 SA, TO3/4, LTC and CP, 6 and 18 January 1882, 2 February 1882.

36 The stained-glass windows, which can still be seen today, depict Norse heroes and heroines from Shetland's past; of the sixteen figures represented, only two – James III and his wife Queen Margaret – were neither Shetlanders nor Norse.

37 Arthur Laurenson, quoted in Cohen, 'Norse imagery', p. 452, and pp. 448–54; M. Finnie, *Shetland: An Illustrated Architectural Guide* (Edinburgh, Mainstream/ RIAS, 1990), pp. 26–7; SA, TO3/3, LTC and CP, 6 and 18 January 1882, 2 February 1882; *Shetland Times* 28 January 1882.

38 This paragraph is based on Mitchell, *Up-Helly-Aa*, Irvine, *Up-Helly-Aa*, and Smith, 'Up-Helly-A'.

39 *Shetland Times* 30 January 1892.

40 Ibid., and *Shetland News* 30 January 1904.

41 *Shetland Times* 31 January 1885.

42 Ibid., 26 December 1891.

43 *Shetland News* 30 January 1892.

44 Ibid., 6 January 1900.

45 Ibid., 13 January 1900.

46 Much of the following material on the Norse revival is drawn from Cohen, 'Norse imagery', pp. 443–82.

47 Quoted in L. G. Johnson, 'Laurence Williamson', *Scottish Studies* vol. 6 (1962), pp. 52–3.

48 Quoted in Cohen, 'Norse Imagery', p. 446.

49 Laurenson, 'On certain beliefs', p. 711.

50 Quoted in Cohen, 'Norse Imagery'.

51 Arthur Laurenson, quoted in ibid., p. 452.

52 B. Smith, '"Lairds" and "improvement" in Shetland in the seventeenth and eighteenth centuries', in T. M. Devine (ed.), *Lairds and Improvement in the Scotland of the Enlightenment* (n.pl., n.pub., 1978), p. 11.

53 Quoted in Cohen, 'Norse imagery', pp. 444–5.

54 *Shetland Times* 2 February 1889, quoted in Cohen, 'Norse imagery', p. 474.

55 B. Smith (notator), *Up-Helly-Aa: The Songs, the History and the Galley Shed* (Lerwick, Up-helly-aa Committee, n.d.), pp. 4–5; Irvine, *Up-Helly-Aa*, pp. 103–5, 106–7.

56 Smith (notator), *Up-Helly-Aa*.

57 *Shetland Times* 3 February 1906.

58 SA, D6/294/2, E. S. Reid Tait Scrapbook, Lerwick Burgh Notice of Public Funeral of J. J. Haldane Burgess MA, on 19 January 1927.

59 Irvine, *Up-Helly-Aa*, p. 47.

60 The imputation of an earlier one is in ibid., p. 80. The earliest preserved one is in SA, D11/153/4, Up-helly-aa Collecting Sheet, 1894 (with, intriguingly, a copy of the 1877 Up-helly-aa flysheet pasted on front).

61 Irvine, *Up-Helly-Aa*, p. 47.

62 SA, D11/202/1, Up-helly-aa Committee minutes, 26 December 1913.

63 Irvine, *Up-Helly-Aa*, passim.

64 The vice-chairman of Lerwick Labour Party, quoted in ibid., p. 110.

65 Smith, 'Up-Helly-A', p. 25.

66 C. G. Brown, 'Urbanisation and living conditions', in R. Pope (ed.), *Atlas of British Social and Economic History since c.1700* (London, Routledge, 1989), pp. 176, 178.

67 W. R. Steele, 'Local authority involvement in housing and health in Shetland, c.1900–1950', unpublished M.Phil. thesis, University of Strathclyde, 1992, pp. 20–32.

68 There was a veritable profusion of such lodge organisations in Scotland in the late nineteenth century, including the Druids, the Gardeners, the Foresters, the Hibernians, and the Sons of Scotland, not to mention the Orange Lodge and the Freemasons.

69 The following paragraph is based on B. Smith, 'Temperance, Up helly aa, socialism and ice cream in Lerwick, 1890–1914', unpublished lecture to Shetland Civic Society, 1984.

70 Smith, 'Up-Helly-A', p. 25.

71 Irvine, *Up-Helly-Aa*, pp. 71–2.

72 Smith, 'Up-Helly-A'.

73 Ibid.

74 Figures relate to decennial census decades. Calculated from data in A. T. Cluness (ed.), *The Shetland Book* (Lerwick, Zetland Education Committee, 1967), p. 50.

75 Smith, 'Up-Helly-A', p. 25.

6

Twentieth-century festival

Moral politics and the decline of 'Herringopolis', 1906–70

'CHRISTMAS DAY is endured, New'r Day is suffered, but Uphelly A'
is enjoyed by all classes.'[1] So wrote the *Shetland News* in 1904.
In 1906 the herring boom reached its peak in Lerwick, gaining it the
name of 'Herringopolis'. At the same time, the festival of Up-helly-aa
matured. Mischief and tar-barrelling were now fondly remembered mem-
ories, the subject of newspaper articles and local history. Certainly,
celebrations at the New Year (NS) retained a little of their old character;
in 1905, the 'peerie [small] guizers' accompanied older guizers in a vari-
ety of fanciful dresses – though they had bowed to religious sensibilities
by coming out on the night of 2–3 January as New Year's Day (NS) itself
was a Sunday.[2] In the midst of thriving economic conditions, the fest-
ival appeared as socially consensual, marking happy compromises be-
tween not only social division (as the *Shetland News* felt) but also between
festive celebration and evangelical religion. However, though Up-helly-
aa acquired new attributes between 1903 and 1908 which marked its
emergence into a format that was to survive the twentieth century virtu-
ally unchanged, the economic and moral climate of Lerwick society was
to prove turbulent for more than fifty years.

By the early twentieth century, the festival had grown so large that
its own success was endangering some of its existing traditions. The
'opening' of houses after the procession to receive the guizers for songs,
dancing and refreshment was proving difficult, with two hundred par-
ticipants and very much larger numbers of spectators, who by then were
including visitors and 'country' guests from rural Shetland. As an ex-
periment in 1903, some 'ladies' hired the Rechabite hall to hold a more
formal event, ostensibly free from alcohol, and so successful was this
that by 1905 a total of five 'halls' opened, including the Masonic and
Good Templar halls. So big was the event, and so 'rationally' organised

had it become, that the opening of houses was no longer sufficient. More halls followed, including hotels, and by 1928 the opening of private houses had completely ended. By this enlargement, the festival ensured that the crucial elements of guizer pantomime and dancing were preserved alongside the fiery procession and krate-like galley, and the evocation of domestic hospitality was sustained in the form of the host and hostess in each hall.

Other changes occurred in the same years. In 1906, as has already been mentioned, the Worthy Chief Guizer was renamed the Guizer Jarl. Two years later the Up-helly-aa Committee secretary started the practice of registering all guizer squads, as well as his other tasks of organising mass guizer meetings from October to January (held in the Town Hall or local theatre), collecting details (and since 1922 photographs) of each squad outfit in advance to check for possible duplication with previous outfits, and recording the minutes and decisions.[3] Also in 1908, the Committee obtained the agreement of merchants and the town council to move the date of Up-helly-aa from 29 January (an inconveniently moving feast) to the last Tuesday in the month, followed the next day by a public holiday.[4] Thereafter, most of the changes to the festival were relatively minor: the procession route was moved (which since 1923 no longer passes along Commercial Street, but has been progressively confined to the 'new town' streets in front of the Town Hall); an extra song was added in 1927; and there were changes in the boat design from a twelve-footer in 1894 to a thirty-footer in 1912, with a new design since 1949 involving elaborate painting of its superstructure and adornments.[5] The move of the procession route from the lower to the upper town was accompanied by a change in the location of the burning site for the galley: until 1912 the Market Cross, between 1913 and 1939 the esplanade in front of the Cross, in 1950–56 an out-of-town site adjacent to the ancient monument of Clickimmin Broch, and in 1949 and after 1957 in Gilbertson Public Park in front of the Town Hall, where Lerwick town council provided from the early 1960s a permanent gravelled area where the burning could take place in safety.[6] One of the most significant of changes came in 1921, after which the Jarl's squad always donned Viking outfits, replacing the variety of guizer costumes worn hitherto.

As the scale of the event grew – from fewer than a hundred guizers in 1881 to 200 in 1906, and 400 in 1939,[7] the level of organisation clearly had to rise. Between 1881 and 1914, the organisation of each year's festival started close to its date, usually in the first week of January; the construction of the boat, the acquiring of dress outfits, the manufacture

of torches and the election of the Guizer Jarl took place in little over three weeks. By the inter-war period, organisation started in December, and by then there were festival programmes and a full photographic record of every squad. The level of organisation involved the assignment of literally hundreds of tasks to individuals and groups to put on the festival. To take the central workforce alone, the previous year's Guizer Jarl acted as chief marshal for the procession, there were separate teams for torch-making and galley-construction (with carpenters, painters, sailmakers, a sculptor) and an illustrator (for the Subscription Sheet and the Bill). The Up-helly-aa Committee assumed some of the responsibilities of an employer; in 1926 it paid compensation of 30s a week to a man who broke his ankles whilst building the galley, National Health and Unemployment Insurances for galley carpenters in the late 1930s (at 11*d*. per hour), and lump sums of £8 to each torch-maker.[8] The level of civic recognition of the event also grew. A visit to the Town Hall on Up-helly-aa morning was established early in this century, and such recognition extended further to charitable functions for the Jarl. In 1925 the Up-helly-aa Committee was asked to put on a fancy-dress parade the day after the festival to raise funds for the local hospital, and did so during most of the inter-war years.[9]

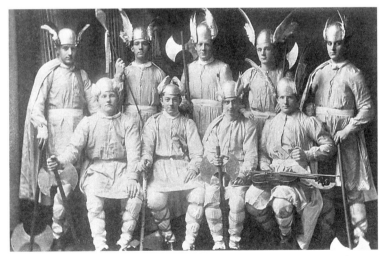

15 Viking squad, 1906. This squad appeared in the year that the Worthy Chief Guizer was renamed the Guizer Jarl, but it was not until 1921 that the Jarl's squad became permanently dressed as Vikings. (Courtesy of the Shetland Museum)

Up-helly-aa not only appeared to be a roaring success, but seemed to reflect a thriving community united in celebrating its recovered Norse heritage. A writer in a local newspaper said in 1931:

> Up-Helly-A' comes from a long past when the Northmen held sway in these Islands, as elsewhere, and celebrated the four-and-twenty days of Yule with entertainment and feasting. The dark days of mid-winter were a period of enforced idleness ashore, and the other Yuletide festivities came to an end with the festival of Up-Helly-A', the final rejoicing of the 'holy' days, bringing the time when longships were made ready for sea with the approach of spring and the strengthening of the sun.[10]

The same perception was made by the outside world whose media were increasingly drawn to the spectacle of this apparently revived medieval pageant. A talk given on BBC radio in 1933 claimed:

> Norse blood tingles in the veins of the Shetlander as he takes part, even as a spectator at 'Up-Helly-Aa'. On such a night and with such a scene before him, Shetland seems to speak to him of its past and of the great strong men who lived there in the ages that are gone. He sees the Viking galleys as they flash past like eagles of the sea and he pictures their stalwart crews, these fearless rovers of the sea, those founders of Colonies and of Kingdoms, and he feels a thrill of pride that in his veins still runs the fiery Northland blood, and that some of the strong qualities which marked his forefathers then, are in our people still and never mean to die. Carried on the wings of his imagination, he sees in this symbolical tribute to a past age, the Sea King speeding in his burning longship to the Valhalla of the Gods.[11]

Such fanciful embellishment outshone anything claimed by Up-helly-aa's organisers, yet would not be totally disclaimed. Added lustre is always welcomed by festival organisers. In the 1930s a murder mystery was published which used Up-helly-aa as its context, with a body being found in the charred remains of the burnt galley.[12] And in 1949 there was live commentary of the event on BBC radio in Scotland, which was also transmitted to France and Sweden as well as on the BBC World Service.[13] Lerwick and Shetland were well on the way to being symbolised by Up-helly-aa. Despite the element of whimsy in Lerwegians' own perception of the Norse symbolism, the 'trail' of the festival's origins in the early nineteenth century was starting to be lost. The tar-barrellers of the era of misrule were dying out in the inter-war period, and though many left

written accounts of those years and a book on the Up-helly-aa festival appeared after the Second World War, the Norse account began to dominate popular memory.

Nevertheless, the significance of the festival during the first seven decades of the twentieth century was markedly less than it became in the last three. Before 1939, Up-helly-aa did not require the level of pre-paration that became necessary in the 1990s. Most guizing outfits were prepared in only a week or two before the event rather than over months, and the outfits were much more ramshackle affairs than the carefully designed and painstakingly made costumes of the 1990s. There was more of an impromptu air about the proceedings, and the festival procession was, by all accounts, much less punctiliously regimented, timed and choreographed than it was to become later; indeed, it is said that the radio broadcast of 1949 tightened up the precision timing for the needs of live transmission. Most obviously, though, the festival of the inter-war years reflected something much more fundamental about the com-munity in which it was located: the declining economic fortunes of both Lerwick and Shetland.

From its peak year in 1905 the herring industry started to decline. In 1880 at the start of the boom 38,000 crams of herring were landed at Lerwick, 300,000 in 1900, and the extraordinary figure of 645,000 crams in 1905. By 1914 catches were down to 267,000, but in 1920–21 the indus-try slumped and, as elsewhere in Scotland, went into deep depression from which it never fully recovered.[14] Though the herring fisheries remained important to the Lerwick economy in the inter-war period, its decline signalled the start of a prolonged economic malaise for both the town and Shetland as a whole. Fishing and crofting remained the main-stay of most families on the islands, but they provided a precarious and unimproving source of livelihood. The First World War turned the islands into an armed fortress for the naval battles of the North Sea, but peace heralded large problems. Returning Royal Navy sailors are re-puted to have brought tuberculosis to the islands, which ravaged the community, and smallpox and typhus – diseases much reduced in main-land Britain – broke out amongst the largely unvaccinated people of Shetland.[15] Health facilities were slow to be developed in the islands: the first hospital, the Gilbert Bain, opened only in 1901, the first consultant surgeon was not appointed until 1922, and there was constant parsi-mony and sluggishness on the part of the local authorities to extend medical provisions. The diminution of Shetland's self-subsistence in

food brought pre-packaged foodstuffs by ferry from Aberdeen – including chocolates and sweets which in the early 1930s produced a veritable plague of dental caries to schoolchildren on the islands.[16]

The most acute of the islands' social problems was housing. In 1901 Shetland had a level of overcrowding on a par with industrial Lanarkshire, and in Lerwick the herring boom had created a virtual shanty town on the burgh boundaries after 1895.[17] Pushed by the minority socialist groups, the town council agreed in 1919 to build 400 council houses, but only erected 120 by 1930.[18] Unimproved town and croft houses could not be replaced fast enough. By 1951, Shetland houses were the poorest equipped with each of the three key domestic conveniences of any county in the whole of Britain; more than half did not have a water-closet (compared to 6 per cent in Scotland as a whole and 8 per cent in England and Wales), 72 per cent were without a fixed bath (30 per cent in London), and more than half did not have piped water.[19] So many houses were unfit for human habitation, and so intractable was the problem of implementing town planning and public-sector housing, that when Lerwick's new burgh engineer was appointed by post in 1916 and arrived (after a seasick-making crossing from Aberdeen) to walk round the town to look at his new charge, the crisis he surveyed prompted him to walk back to the harbour and embark on the boat for its return to mainland Scotland.[20] In the Second World War Shetland became an armed camp again, acting amongst other things as the base for the supply of the Norwegian resistance to Nazi occupation. The peace again heightened social problems, with homeless ex-servicemen and their families squatting in an RAF camp demanding new houses.[21]

The crises in fishing and crofting brought chronic unemployment from the early 1920s onwards, and to get on Shetlanders more often than not had to get out. The population of Shetland had fallen from 31,371 in 1871 to 27,238 in 1911 mostly as a result of falling family size, but emigration then caused it to fall to 24,117 in 1921 and 21,229 in 1931 with almost 4,000 people a decade leaving in the 1920s and 1930s. The fall resumed after the Second World War, reaching 19,102 in 1951 and 17,812 in 1961. Overall from 1901 to 1961, net emigration amounted to 10,030 people, and the population had fallen by 45 per cent between 1861 and 1961. Lerwick stopped growing, with the burgh's population fluctuating between 4,000 and 5,500 people during 1911–61, but the town became ever more vital to the Shetland economy and community; it held 10 per cent of the islands' population in 1861, 20 per cent in 1911, and 32 per cent in 1961.[22]

16 Council-house scheme squad, *c.*1922. This squad celebrated the controversy over the construction and letting of Lerwick's first council houses under the Addison Act of 1919. (Courtesy of the Shetland Museum)

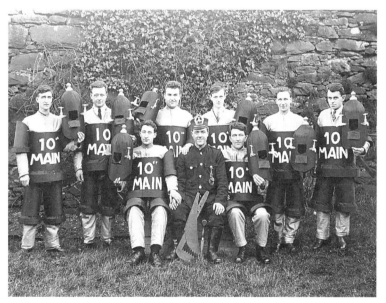

17 Ten-inch mains squad, *c.*1923. Council affairs, especially expensive capital projects, have been a constant target for squads during the twentieth century. (Courtesy of the Shetland Museum)

161

The 1920s and 1930s were hard decades for the majority of the people of Lerwick, and the slump endangered the festival as it did the community. With high unemployment and emigration, and lowered incomes, guizing and hospitality became a burden. A letter-writer to the *Shetland Times* in 1929 urged more emphasis on Viking themes in the Up-helly-aa procession, giving a list of Norse kings and gods whom guizers might impersonate. The secretary of the Up-helly-aa Committee replied to the writer: 'Is he aware that the proper impersonation of a Norse king is quite beyond the purse of the average guizer? . . . Our Norse heritage is indeed not poor but so much, unfortunately, cannot be said of the average guizer.'[23] Economics were a significant issue to Up-helly-aa in those years. It was an expensive undertaking not only to seek donations from businesses for the construction of the galley and torches, but the making of costumes (especially for the Jarl's squad) and the hospitality of the halls required considerable outlays. Consequently, at the peak of the slump in the winter of 1931–32, the poverty of Lerwick's guizers and their families instigated a move to cancel the festival.[24] Though it went ahead in that year, economic fragility remained during the 1930s and after the Second World War. Up-helly-aa was suspended for the duration of the conflict, and was not resuscitated again until 1949 – a break of ten years, the longest since its inception. It was the period of rationing of food and clothing, making difficulties for the creation of guizing outfits, but in addition Lerwick felt acute social problems at the peace, with a large number of families homeless or squatting in military camps. Even so, the 1949 festival saw a huge turn-out of forty-nine squads and more than six hundred guizers, though they were considered 'rather more drab than was customary'.[25]

Claims to social consensus became strained in the context of economic hardship. This affronted Lerwegian socialists particularly: 'Shetland monied people', wrote one in 1939, 'may seek to fraternize with working class lads at Up-Helly-Aa or Masonic festivals, under the pleas of "Common Viking ancestry".'[26] One development of the period which seemed to reflect this was the increasing independence of the festival's organisers. Perhaps in part because of the withering recession of the inter-war period, the festival had developed its own internal momentum, its maintenance a matter of fierce pride to the overwhelmingly working-class guizers. As Brian Smith has put it, 'the Up-Helly-A' boys continued to regard the festival as a law unto itself'.[27] An important consequence of this was the increasing number of incidents where the

festival organisers fell out with 'the establishment' of Lerwick. Indeed, it is clear that for much of the twentieth century there were some tense moments in the relations between the Up-helly-aa Committee and the Lerwick elites. The festival's organisers considered themselves to be the holders of a popular mandate to spurn directives from authority. This was evident when the festival was threatened with postponement or cancellation. Apart from the two world wars, the Up-helly-aa Committee was – and remains – reluctant to adjust the ritual. It was cancelled at Queen Victoria's death in 1901, though local legend has it that the Dance Committee persisted with invitations to the dance, with the customary letters 'RSVP' being reputedly substituted with 'RSBD' – supposedly meaning 'Royal Sovereign Be Damned'.[28] In 1936 the burgh's provost attended the mass meeting of guizers to persuade them – at some length – to postpone the festival because of the death of George V, and then left the committee in some perplexity about precisely how long 'the period of national mourning' should be.[29] In the following year they bowed willingly enough to the Medical Officer of Health's recommendation to postpone the event for two weeks because of an influenza epidemic,[30] but the death in 1965 of Sir Winston Churchill led to much division. The Lord Lieutenant of the county apparently 'took counsel' on the matter, and advised the town council to postpone; councillors met in private and had a majority vote in favour of issuing 'a directive' to the Up-helly-aa Committee to postpone. Most townsfolk reportedly dissented, and the local newspaper delighted in telling the tale in the manner of nine 'meek' councillors who toed the outsider-establishment line.[31]

Such incidents are vital to the Up-helly-aa mythology of 'cocking a snook', and are cited in the festival's literature with considerable pride.[32] But one feature of the years of slump during the inter-war period was increasing friction between the festival and the burgh's elites. A notable example is the relations between the Up-helly-aa Committee and the local hospital trustees which, in 1929, were especially strained. The Up-helly-aa guizers had been happy to undertake charitable work for the Gilbert Bain Memorial Hospital during the 1920s and 1930s, turning out at the hospital's summer carnival. This was a period before the arrival of the National Health Service, when many of the British working classes and the poor were insufficiently insured to cover their medical needs. In consequence, working-class community organisations like Up-helly-aa were extremely active in the 1920s and 1930s in doing fund-raising for hospitals and medical dispensaries. However, they were affronted in

1929 when the Hospital Carnival Committee demeaned the guizers by offering a prize of £5 to the best squad outfit.[33] This was taken to be a misunderstanding of the nature of the event – taking it to be a fancy-dress parade or a mere gala day. But this incident was as nothing to what followed. In 1928 there had been a scandal in Lerwick about the wastage of eggs at the local hospital where there had been over-ordering and then disposal of the excess. The following year, the Up-helly-aa Bill tied to the Market Cross contained a joke about it. The trustees of the hospital took 'very strong exception', and by letter summoned the Guizer Jarl and the Up-helly-aa secretary to appear before them at their daytime meeting. The committee intimated to the trustees in their reply that they would attend 'en masse', but – making a pointed social statement – only if the meeting was shifted to the evening, as the committee members were at work.[34] The trustees did not reply, but that year the official Up-helly-aa Committee photograph showed each member holding an egg.

Such incidents encapsulate what for many Lerwegians became the essence of the spirit that Up-helly-aa represents: a highly-ritualised form of misrule governed by the people – or, more precisely, by the mass meeting of guizers, the Up-helly-aa 'parliament'. The guizers' meeting elected the committee and ultimately decided major issues of policy. In this sense, it became a democratic people's event (or, rather, male people's event) in which the local establishment was opened to ridicule when it was deserved. In the inter-war period the ridicule was often sharply directed at the attempts of the council to provide welfare support for the people of the town; there were scandals over council housing (and who was getting the lets), and over municipal and county council projects for social improvement. It became an annual political cartoon, and noticeably in the acid polemic evident in the Bill between the 1910s and the 1930s. The commentary was not necessarily socialist or from any particular party position, but it tended to emphasise the festival's working-class credentials and composition. Even in the late 1940s and 1950s, this lingered on. The arrival of the welfare state and the beginning of planned economic development could not eradicate the poor economy of Shetland. Lerwick remained a rather depressed provincial town, clinging to a fishing industry which had never recovered the halcyon years of the 1890s and 1900s. Brian Smith recalls as a child in 1960 being taken out by his father on the night of Up-helly-aa: 'I thought what a dark, black, poor town we live in.'[35] The festival of Up-helly-aa seemed to him resonant with that provincial poverty in which the bulk of Shetlanders grew up in the first seven decades of the century.

Up-helly-aa did not merely resonate with the economic experience of ordinary Lerwegians. The festival had been born in the 1870s in a cultural atmosphere charged with changing sensibilities. A moral faultline developed within Lerwegian society in the 1860s, contrasting a battery of essentially evangelical sensibilities with those of Yuletide misrule, with the agencies of the new puritanism deliberately positioning their principal annual meetings, fund-raising, processions and concerts of sacred music at Yule and New Year's Day (OS). That was a faultline that persisted into the next century and remained an important influence upon the character of both the working people of Lerwick and their festival of Up-helly-aa.

A flavour of the cultural context can be obtained from James W. Irvine, the leading local historian of Up-helly-aa. He was born in 1917, his sense of Shetland's heritage fostered in a crofting-fishing family at the Ness at the extreme south of Mainland Shetland. Contact with the land and the sea shaped his personal landscape, as did an upbringing dominated by the place of evangelical religion. As in the islands as a whole, his community was well served by Baptist, presbyterian and in-dependent evangelists. He recalled how his spiritual welfare was a prime concern of his grandfather:

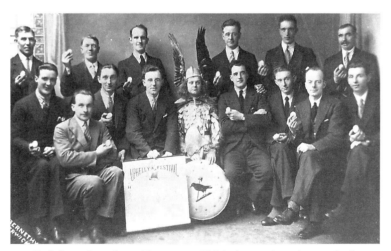

18 Up-helly-aa Committee with eggs, 1929. This is the notorious photograph of members of the committee holding eggs which caused offence to the trustees of the hospital where it was alleged food was being wasted. (Courtesy of the Shetland Museum)

From an early age I was expected to accompany him every Sunday morning to the Baptist Church, nearly three miles away. Bored stiff by the sermon, and sadly lacking in musical ability, the hour-and-a-quarter service was mild purgatory for a small boy. After the morning service we would adjourn to the house of my other grandfather, just along the road from the kirk, where we would have lunch. After lunch the two grandfathers would engage in a lengthy and deep discussion on the merits and demerits of the morning sermon, and, indeed, on religion in general. . . . Later my aunt would add to the proceedings with some hymns on the organ. Five o'clock, and it was back to church, for a repeat of the morning's session. Then home across the parks, frequently just in time to be nobbled by my mother for a third late evening session of the Good Word in the Bruce Memorial Hall . . . The services here were different. Sometimes they would be taken by enthusiastic evangelists, sometimes by local lay preachers. . . . If it was an evangelist on duty, he was usually of the tub-thumping type who dished out liberal doses of hell-fire and damnation. . . . There was frequently a sneaking dread that some night the flames might suddenly appear up through the wood of the hall floor.[36]

This charged evangelical atmosphere was a common experience in the islands, including Lerwick, in the first half of the twentieth century. It textured the moral politics which played such a prominent part in the community's development from the 1890s until the 1940s. The rise of evangelicalism in the 1860s and 1870s, and of religious revivalism and teetotalism in particular, led on to intense struggle over moral politics in the town between 1905 and 1947 – involving principally evangelists, promoters of prohibition and the labour movement.

In Lerwick, community politics became reshaped in the Edwardian period by the ice-cream question. Ice-cream shops were opened in almost every Scottish town after 1895 by Italian immigrants, and a countrywide moral panic ensued between 1900 and 1920: they permitted unchaperoned liaisons between boys and girls, were the location for automatic gambling machines (the forerunners of one-armed bandits), and were widely suspected of allowing unlicensed drinking of alcohol. Most of all, they attracted Protestant outrage for being conducted by Roman Catholic 'foreigners'.[37] They were also vilified by the churches for opening on Sundays. This became a cause célèbre in Lerwick when Harry Corrothie's Ice-Cream Parlour on the North Esplanade became the target of evangelical hostility for opening on Sundays; the local branch of the British Socialist Party met in the parlour, and sided with the owner and other parlour operators over the question of Sabbath

opening. On the afternoon of Sunday 2 July 1905 a demonstration was organised by members of the evangelical churches, who processed from the usual open-air Congregationalist service at the Market Cross round to the Esplanade. There, a platform with an organ had been erected in front of the ice-cream shop, and a crowd of around two thousand people, led by the clergy of the Church of Scotland, the United Free Church, the Congregationalists and the Baptists, sang hymns and heard speeches against Sunday opening of ice-cream shops and 'the injurious effect they had upon the youth of every town where they were planted down'.[38] A campaign was begun to obtain powers to close the shops on Sundays, and a private plebiscite organised by ice-cream opponents in 1912 seemed to indicate that 747 out of 1,000 ratepayers of the town were in favour of Sunday closing. The town council bowed to evangelical pressure by recognising the plebiscite, and passed bye-laws to end this form of Sunday trading. However, the local sheriff, who was required to confirm all new bye-laws, turned his hearing into a five-day public inquiry on the issue, and after much evidence on the alleged immoralities caused by the parlours (from drinking to smoking), concluded that the plebiscite was unfair and that there was a legitimate right to trade on Sundays under Scottish law – albeit limited by him to the four months of summer when the town was awash with herring-fishers and gutters.[39] The religious lobby did not give up; at the municipal elections in November 1913, they put forward four 'Sunday-closing' candidates who were elected; two opposing socialists candidates, who stood in favour of Sunday trading, lost.[40] 'To me,' wrote one of the victorious anti-ice-cream campaigners, 'the contest appeared to be the Churches of Lerwick versus Socialism. The Philistines have been routed before the Ark of the Lord.'[41]

At the end of the day, the ice-cream shops remained open on Sundays during the summer months. But it was a defining moment for the community, for it brought into sharper focus the complexity of local moral allegiances. Both the socialist and Sunday-closing candidates at the 1913 election included Rechabites, thereby demonstrating both how divisive the issue had become and how broad could be the support for prohibition. The events of the ice-cream issue became the subject of satirical comment in the Up-helly-aa Bill, but it also cast a pall over the future of socialist influence in Lerwick municipal politics. The socialists had been remarkably successful and, more important, very influential in certain areas of policy (notably the promotion of council-housing[42]), but the move of evangelicals into the political domain, and the damage to socialists, were to continue after the First World War.

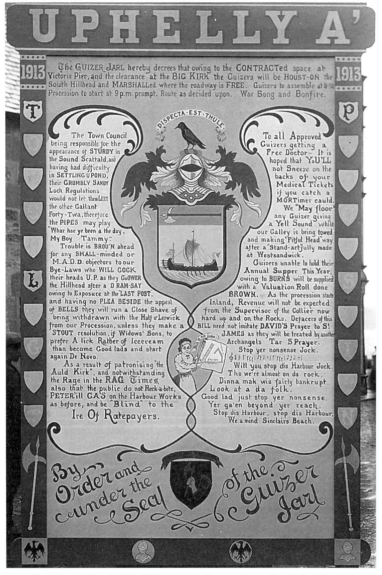

19 Up-helly-aa Bill, 1913. The Bill has adopted a common style of satire since the 1890s, and can be obscure to outsiders. This one refers to the local 'ice-cream war' of 1905–13, to the Rechabite Temperance Friendly Society which was so influential in the festival's development, and to Mr. Collier, the Superintendent of the Inland Revenue, whose lawyer immediately threatened the Guizer Jarl with legal action for slander (letter in SA, D 6/294/57). (Courtesy of the Shetland Museum)

The significance of moral politics in Scottish communities reached their high point in 1920 when the Temperance (Scotland) Act of 1913 came into force, permitting local plebiscites to give electors the power to close all public houses or reduce their number. Scotland became the only place in Britain where prohibition, in the form of the Local Veto as it was known, became legally possible. Some 584 local communities held local polls in Scotland in 1920–21 under the Act, but only 40 reached the required threshold of 55 per cent of votes and 35 per cent of eligible voters opting for prohibition.[43] Lerwick was one such place that voted itself 'dry'. Intense campaigning by the churches, Rechabites and the Good Templars, children's Bands of Hope and independent evangelists overwhelmed the 'wet' lobby organised by the drinks trade and tacitly supported by many members of the labour movement. At the poll in Lerwick in December 1920, 67 per cent of electors voted for prohibition, and Lerwick's public houses closed and, through various re-polls (permitted under the Act every three years), continued to stay closed until 1947.[44]

This symbolised a wider shift in Lerwick's moral and political balance. In the early 1920s socialists lost influence in both municipal politics

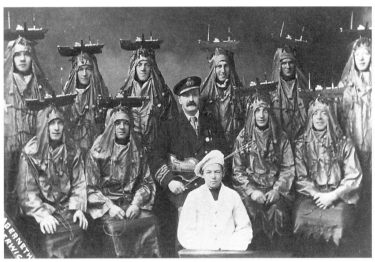

20 Earl of Zetland squad, 1925. These guizers are mocking the running aground in
 1925 of the *Earl of Zetland* on Robbie Ramsay's Baa, a sunken rock in Bressay
 Sound named after an earlier grounding in 1878 caused by the local pilot, Robert
 Ramsay. The fiddler is guizing as the ship's captain, emphasising the mockery.
 (Courtesy of the Shetland Museum)

169

and many local societies. One result was that by 1924 there was not a single active socialist on the Up-helly-aa Committee.[45] This did not necessarily imply any changes to Up-helly-aa policy, but it did mark the continuing rise of evangelical culture, and the evangelical agenda, within the community. It helps in understanding the significance of the 'dry' (or ostensibly 'dry') halls which have characterised the festival since 1903. With the advent of Rechabite and Good Templar halls, the moral politics of the town were brought within the festival in a very acute form. Revellers at Up-helly-aa were now split between teetotal 'dry' parties and other halls which exhibited exceedingly drunken 'wet' parties. Here was a moral division of the most acute and personal type, one that had to be contained within a community's winter festival.

James Irvine's memoirs illuminate the moral complexities and contradictions. He recollected that as a secondary-school boarder in Lerwick in the late 1920s and early 1930s, there were three main initiation rites for young lads in the town: playing billiards in temperance halls, open-air beer drinking in 'dry' Lerwick, and the very 'wet' Up-helly-aa. 'The Rechabites', he remembered, 'had a billiard table, and one or two of us joined the Rechabites, motivated I fear, more by billiards than temperance.' Indeed, in the next breath he recalls how 'boys are always impatient to be men', and though Lerwick had no pubs during its 'dry' era between 1920 and 1947, beer was bought wholesale in crates, sold by the bottle on the Esplanade, and drunk there in the cold in 'a clandestine and somewhat sleazy atmosphere'.[46] Up-helly-aa completed the initiation. He was inducted into it in his teens during the early 1930s:

> Down through its history Up-Helly-Aa has been generally recognised as a festive occasion when rather a lot of liquor is consumed, but there is little or no drunkenness. In [secondary-school] classes four, five and six, we entered a squad for the Festival, and a good time was had by all, though I am bound to say our behaviour would not stand comparison with the squads of today. Our costumes were colourful enough, but dictated by economy rather than style. No great trouble was taken in preparing an act, and indeed the emphasis on that seemed to be much less at that time. We were young and silly, with all of the squad of the same age and no older hand among us to lend a restraining influence, so we probably had too much to drink and were far from a good advertisement for a higher seat of learning. Those were the days when the Drill Hall was reserved for country visitors [those from outwith Lerwick], admission 1/- (5p). My recollection of the hall is that there was little organisation or control, and it was a bit like a Wild West saloon, except that nobody was carrying a six-shooter.[47]

Up-helly-aa was continuing to evolve as the location for contradictions. In the 1870s and 1880s it had contained both 'rationable' order and symbolic misrule. With the emergence of 'dry' halls came the equal and opposite development of 'wet' halls (most often the hotels), relocating the free-wheeling music, drink and dancing from the traditional 'open house' to a series of public venues, thereby institutionalising both moral order and disorder.

Lerwick's era of prohibition between 1920 and 1947 coincided with its era of most profound economic depression, poverty and social problems. In the 1930s, Shetland had no tarmacadam roads, there were few cars, no electricity, only enthusiasts had a wireless (for the poor reception from a transmitter at Aberdeen two hundred miles away), and the furniture in most houses was home-made.[48] By the 1960s, things had started to change. Though nearly all roads remained single-track with passing places, there was electricity (from a single power-station in Lerwick), most homes had telephones, and television arrived. The era of the welfare state brought some alleviation to the extremes of deprivation; as elsewhere in Britain, council house construction rose, and the worst of the poor-quality housing in Lerwick was demolished or upgraded. The National Health Service of 1948 brought improved health care (marked in true Up-helly-aa style by a Child Welfare Centre Squad in 1949),[49] and the education service became as much an arm of child welfare as of opening up educational opportunity. Lerwick started to feel the winds of cultural change. Much to the chagrin of evangelicals, the town voted itself 'wet' in 1947 (following most of Scotland's other 'dry' communities), and an increasingly pervasive liberalism softened the divide between 'rough' and 'respectable'. New breeds of professional with a more liberal temperament emerged in Lerwick. Schoolteachers started to take a greater interest in Up-helly-aa in the post-1949 years, with increased use of the festival in teaching. One sign of this was the formation in 1961 of a teachers' squad to join Up-helly-aa, the first and still the only such fully occupationally based squad; within three decades, there was a total of four teachers' squads.[50] In the 1960s, the islands were starting to change, as more economic-aid and the fruits of improved transport links with Scotland brought new ideas and opportunities.

Oil and festival fetish

A single commodity transformed Shetland – oil. In the early 1970s, the biggest single event in the economic history of the islands started when

oil was discovered beneath the North Sea to the east of the islands, and the oil industry in its full glory came to transform this island community. Suddenly, Shetland was no longer a forgotten periphery but a place where international oilmen, politicians and – increasingly – the 'eurocrats' from centralising Europe came to seek favour with islanders and their political representatives. This single community of 20,000 people held much of the future of Britain's balance of payments in its hands. Sumburgh airport suddenly became a very important destination.

The first licences for oil exploration in the East Shetland Basin were issued by the British government in 1971, and in the following two years a plethora of new fields opened and became household names in Britain: Brent, Cormorant, Thistle, Heather, Ninian and others. 'Brent Crude' became the yardstick for pricing Britain's oil, and was almost nightly aired on British television news. By 1975, 'the island was shaking from construction'.[51] A sheltered harbour fifteen miles to the north of Lerwick called Sullom Voe became a vast oil terminal in the late 1970s where pipelines came ashore from oil-production rigs hundreds of miles out to sea, from where it was transhipped to oil refineries across Europe. Lerwick became the business and manufacturing centre for the northern sector of the North Sea; oil and oil-related companies arrived, and local shipping and engineering companies quickly established footholds in the lucrative market serving the needs of the industry. Thousands of construction workers arrived in the islands, most from mainland Scotland, constructing not only the facilities required for oil exploration, extraction and servicing, but also an entirely new economic infrastructure for the islands. The roads became double-track, harbour facilities exploded in scale and quality, and the islands started to shrink.

The impact on the community of Lerwick in the last quarter of the twentieth century was immense.[52] The population of the islands rose from 17,327 in 1971 to 22,766 in 1981, and that of Lerwick grew to 7,280 in 1991.[53] New factories, docks facilities and warehouses appeared, mostly at Lerwick's north end, and industrial estates grew up the barren hillsides overlooking the town. The social impact of oil was astutely exploited by local politicians. The new-found economic power helped prevent Shetland being swallowed up in the Highlands in local government reorganisation in the early 1970s, and the new Shetland Islands Council of 1975 was given unprecedented powers of taxation on the oil companies to provide a vast community 'chest'. This permitted funds for many social purposes, whilst in the 1980s and 1990s there was increased central government and European Union funds for the construction of

high-quality public-sector houses, a roads network that would be the envy of any rural authority anywhere in Europe, and a large number of superior community centres and sports centres – including the impressive Clickimmin Leisure Centre in Lerwick and others for even the smallest of island settlements. The quality of life constructed out of oil changed the islands incredibly into a thriving community with tremendous collective prosperity and an extraordinarily low unemployment rate (of 3 per cent in 1994[54]). New professionals arrived in the islands (teachers, lecturers, managers and engineers from the mainland with the enticements of good housing, special islands and remote allowances), new housing appeared, and the islands provided some of the best-equipped and most luxurious working conditions to be found in Britain.

Yet, in one important sense the coming of oil reinforced Lerwick's heritage. Oil brought more visitors, more transients. It brought oil workers and, especially, construction workers in large numbers, visitors who stayed for contract periods and some who stayed for years. In addition, deep-sea fishers kept coming, and in the 1980s and early 1990s Russian fish-factory ships – as many as fifty at a time – were anchored in Bressay Sound to buy fish from fishing boats. Some local men made 'killings' from buying state-of-the-art boats; in Lerwick pubs and fish-and-chip shops, you might be nudged and told that the man next to you is a fishing millionaire – in one case, reputedly, giving each of his crew a Christmas bonus of a Mercedes car. Ironically, it was some of the visitors who were now 'the poor': in the early 1990s, signs in Russian at the Market Cross directed seamen to religious missions and charity shops where they could buy clothes and household items to trade on the black market at home. The oil industry brought more affluent foreigners, and Sumburgh airport at the very south of the islands developed during the 1980s and 1990s into a busy centre for oil workers and businessmen. With fast roads and the arrival in the 1970s and 1980s of high-quality ro-ro ferries, the islands became closer to each other and to the outside world, and Lerwick was brought within commuting distance for many islanders.

But all this development had its price to pay. Shetlanders were alarmed at the scale of the invasion of workers, and especially construction workers – many of them from Scotland where heavy industry and coalmining were entering terminal decline in the mid-1970s. The men who came were perceived as 'rough'; they worked hard and played hard, frequenting pubs and clubs, and many of them staying in bed-and-breakfast accommodation in Lerwick. A common local perception was that this invasion caused a crime wave. One local noted that in 1953–54

there had been 84 cases before the sheriff court; by 1978 there were 894.[55] The floating population seemed to overwhelm the islands, endangering the culture and fabric of a community that had nestled happily if poorly on the margins of Europe.

There were important ramifications for Up-helly-aa. In the mid-1970s, construction workers went to town at the festival, the occasion admirably suiting the drunken release that many such men traditionally seek out after periods of hard labour, especially in the cold and darkness of winter. In the 1970s and early 1980s these workers were earning wages well above those of equivalent workers in Shetland; to offset some of the difference, the Islands Council introduced a £700 island allowance in 1979 for its employees and disbursed £75 to every pensioner.[56] If wage differentials caused tensions, the visitors' behaviour caused others. When oil workers started to participate in the festival, Lerwegians became anxious. One guizer and former member of the Jarl's squad recalled:

A We were frightened of these oil people. You know, there were some very nice people and some not so nice people amongst them. They come and get drunk and that's not what it's about. And they'd be able to put in squads as well, and it caused a lot of trouble. I mean [what Up-helly-aa is about] is laughter, music, dancing. . . . It was a tremendous mixture of people, every kind of person. . . .

Q Hard men?

A Yes. I mean some were drunk. I mean some of them I heard sharpening their—, and start fighting with each other. So you did have some of that element. The majority of them were probably excellent.[57]

Part of the issue was to do with the scale of the festival. With increasing wealth, population growth and improved transport links, more and more Lerwegians and exiles were able and willing to take part as guizers, but with numbers over eight hundred it was becoming difficult physically to get all the squads around the available number of halls on the night of Up-helly-aa. As a result, a five-year residency rule was introduced in 1973 to limit the number of guizers and to prevent the entry of casual visitors to the ranks of the squads. Shetland identity was being 'boundaried' in a new and strict way; some felt by the early 1980s that this was actually compromising the tradition of hosting and participation, and the Up-helly-aa Committee suggested in 1982 that the residency rule be reduced to one year.[58] However, the five-year restriction remained in force down to the late 1990s, and with the restricted demographics

of getting almost a thousand guizers around twelve halls in the space of one night it seems unlikely to change.

Another consequence of oil was the changed economic experience of both the Lerwegian people and of Up-helly-aa. By the early 1980s, money from the Council's 'oil chest' started to flow into superb new facilities for the community, and with increased work and rising wage levels the funds available to spend on Up-helly-aa mushroomed. So much money started to become available that the Up-helly-aa Committee was able to abandon some traditional forms of offsetting expenses – such as street collections and a fund-raising 'hop'. In 1970, the Up-helly-aa Committee's Collecting Sheet distributed around Lerwick businesses raised £512; by 1981 it realised £5,003.[59] For individual guizers, the splendour of costumes and the ambitiousness of their guizing satire were boosted. Making the costumes as spectacular as possible – and notably those of the Jarl's squad – became almost a collective mania of Lerwick men. No longer was the working class of an isolated provincial British town seeing itself as inferior in standard of living and recreation. Whilst Lerwegians in their homes and everyday lives remained anything but 'showy' or 'flash' with their wealth, Up-helly-aa in the late twentieth century became a night for seemingly unrestricted expense, generosity and hospitality.

The oil era is not at an end in Shetland. The hunt for exploitable oil fields in the deeper waters to the west of Shetland continued in the 1990s, and the possibility of a new boom remains. However, the good fortune of the islands since the early 1970s faltered in a very serious way in 1998. The 'oil chest' is drying up and local government cuts are incurring serious cuts in social spending. The topsy-turvy history of the islands is adding yet another change in horizons, and it remains to be seen what impact serious economic downturn might have on the current 'tradition' of lavish splendour at Up-helly-aa.

Insiders and outsiders

Oil has another dimension in recent Shetland history. It was clearly an element in the major political events in the islands: achieving its own Islands Council in 1974, the 'No' vote for remaining in the European Economic Community in the same year, the 'No' vote at the Scottish devolution referendum in 1979, and the formation of the Shetland Movement in that year. It seemed that a new 'boundary' – a constitutional boundary, or perhaps series of boundaries – was starting to form in the minds of many Shetlanders.

Most controversial of them was the apparent rejection of the aim of Scottish nationalists. In 1979, Scots voted 52–48 in favour of devolution to Scotland, but Shetlanders voted 73–27 against – the heaviest regional rejection of the proposal (closely followed by neighbouring oil-enriching Orkney, with 72–28 against).[60] The Shetland Movement seemed to some outside commentators to symbolise a new direction in Shetland politics in which the possibilities of oil-rich independence were being considered should Scotland seek separation from the United Kingdom.[61] In reality, this was a 'party' founded with an inchoate manifesto promoting Shetland independence; it lacked a clear ideological basis (resting on an issue-by-issue approach to local concerns), but it was widely perceived as promoting Shetland interest on the basis of oil wealth. It was in a wider and more general sense that the movement perceived itself as a guardian of Shetland interest, identity and destiny. It achieved considerable success; by 1993 it had six of the twenty-five seats on the Islands Council, constituting the largest single party after sixteen Independents, and contrasting with only two Labour seats.[62]

The co-founder of the Shetland Movement was James W. Irvine. His 1982 history of Up-helly-aa, with its dramatic photographs of guizers and galleys, and its list of Jarls, is the standard work of reference – the

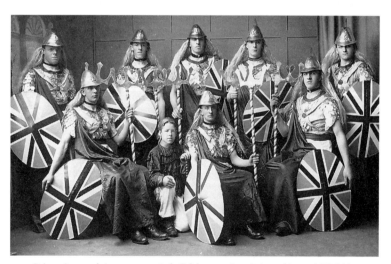

21 Britannia squad, inter-war period. Celebratory jingoistic and imperial British themes were common for guizing squads in the first four decades of the century, but symbols of Scottishness have usually been satirical and occasionally mockery. (Courtesy of the Shetland Museum)

Wisden – of Up-helly-aa. Though Irvine took little part in Up-helly-aa history himself, he saw it as very important to his vision of modern Shetland. 'As an onlooker who has never played a leading role in Up-Helly-Aa affairs,' he wrote, 'I am convinced that Shetland life would be very much the poorer without this famous old Festival of ours.'[63] Irvine's experiences and memories which have featured in previous pages – of childhood evangelicalism, teetotal billiards halls, drinking in 'dry' inter-war Lerwick, and Up-helly-aa – encapsulate much of the melting-pot of popular culture in twentieth-century Shetland. One of his many volumes of local history provides some evidence for understanding how Shetlanders were reacting to change in the 1970s and 1980s. In his history of Lerwick, he places emphasis on the profound nature of the shock that islanders – and Lerwegians in particular – felt with the arrival of the oil boom. Shetlanders were much more ambivalent about it than the coming of the herring boom in the late 1870s or the arrival of commercial expansion between 1790 and 1820. The disruption caused by construction was enormous, but it was the nature of the migrant workers which aroused so much concern: the 'rough' men who seemed to instigate the rise in crime.[64]

Shetlanders were less concerned with big constitutional issues in the referendum votes of 1974 and 1979 than with the protection of their very immediate interests. Asked now about the 1979 vote, some Shetlanders can remember voting 'no', but have trouble recalling precisely why.[65] Brian Smith has explained the 1979 vote as the product of islanders' conservatism and wariness of change.[66] But it is possible to see it another way. In the context of (relatively) overpaid, drunken and 'rough' Scots invading their pubs and local festival, of negotiations with the Scottish Office and Westminster over oil-taxation, and of a strident 'It's Scotland's Oil' nationalism on the neighbouring mainland, the 'no' vote was a critical reminder to 'authority' of Shetlanders' interests and feelings. Shetland had seen the carpet-baggers before: the Scottish land-grabbers of the seventeenth century and the greedy lairds of the eighteenth and nineteenth centuries. This was a defiant 'cocking of the snook' to the establishment 'outsiders' who needed prodding in the age of mature parliamentary democracy.

By the late 1990s the worst excesses (and the best prizes) of the oil boom had moderated. Despite economic retrenchment in public expenditure on the islands, the Shetlanders are thriving in comparison to much of their twentieth-century history. As a result, the 'boundaries' that were being drawn by the community in the 1970s are starting to

ease. Shetlanders voted 62–38 in favour of Scottish devolution in September 1997, having secured guarantees for Shetland interest in a new Parliament in Edinburgh.[67] Immediate, conservative interests are again secured for Shetland.

If oil helped Shetlanders to articulate their collective identity in the political forum, Up-helly-aa has done this too in the arena of calendar customs. In Shetland's second township of Scalloway six miles to the west of Lerwick, the Christmas night 'custom' of having a huge bonfire on the pier started to change in 1898 when a ceremonial boat appeared which was burnt on the pier on New Year's Day. In 1905 it was reported that the event was now called 'Up-helly-aa', helping to break 'the monotony at this season'.[68] In subsequent years, a procession of guizers pulled the boat on Christmas morning, followed by a torchlit procession at night with a decorated cart and either an old boat or a model 'galley'. This festival in the inter-war period openly mimicked the Lerwick affair – with a Guizer Jarl, a Subscription Sheet and a 'hall' opening at the end of the procession. But unlike Lerwick, it was located at Christmas not late January. Being a small community, the parades were small, and in fact lapsed in 1959. The spin-off of oil prosperity marked its revival in 1979, when a galley, a Bill and six guizing squads appeared, and the Jarl and his small squad visited old folks' homes in the same manner as the Lerwick Jarl, and three 'halls' opened. Though this is a much less grand affair than Lerwick's, and the quality of the guizing outfits is distinctly poorer, it has become sufficiently large, and its Jarl's squad is sufficiently well turned out in dress, to be taken in the late 1990s by Shetlanders – and by television news programmes – as the start of what is now referred to by some as 'the Up-helly-aa season' from January to March.

Up-helly-aa spread to other villages: Uyeasound (founded 1912), Hillswick (1912, though in abeyance from 1914 until the late 1970s), Ollaberry (1912–*c*.1928), the isle of Bressay opposite Lerwick (1933), Nesting (1958, then held intermittently until its permanent revival in 1975), Cullivoe (founded by the local badminton club in 1958), Brae (1970), Northmavine (1975) and Mossbank (*c*.1981); in addition, the northernmost village in the islands, Baltasound on the island of Unst, Waas, and possibly other places had their own Up-helly-aa's in the 1980s and 1990s. Each Up-helly-aa is a relatively modest affair, rarely rising above more than two hundred guizers and often a lot fewer. They take place on different dates from early January to March, and they are all direct copies of the Lerwick festival. They use Lerwick's Up-helly-aa songs, have Guizer Jarls and Jarl's squads, and galleys – some of them burned

(including one at sea). They started in a variety of ways. At Brae twenty-five miles north-west of Lerwick, boys collecting wood for the school-organised Guy Fawkes bonfire found an old boat for burning; a local remarked that 'a Guy Fawkes bonfire was a poor funeral for a boat – it should be part of an Up-Helly-Aa', and the local festival was born. At Cullivoe, the Up-helly-aa was started by the local badminton club.[69] In each case, the organisation and values of the original festival in Lerwick are adhered to. Jarls are annually elected, 'in good democratic fashion', and the satirical Bills lampooning local people, events and authorities have developed. Though some of these festivals date from before 1914, it is in the 1970s when the majority were created or permanently revived. Such timing was significant. The arrival of oil, and of single-tier local government in the form of the Shetlands Islands Council in 1975, dispersed both wealth and a more unified sense of community, immeasurably enhanced by the creation of an improved road network. The Viking in horned helmet, shield and axe, standing in the prow of a 'galley', became a community icon that was replicated in different parts of Shetland.

Up-helly-aa festivals spread even further afield. With large-scale emigration from Shetland – especially rural Shetland – between the 1870s and the 1930s, Shetlanders formed an international diaspora. In May 1928, the Shetland Society of New Zealand held one of the first overseas Up-helly-aa festivals in Wellington with a galley, a Jarl and his squad and most of the trappings of the original. Further Up-helly-aa festivals followed in successive decades, and the images, songs and ritual of the Lerwick original became an international symbol for the 'roots' of exiles around the world.[70] Overseas Shetland societies then started to develop into something else. In summer 1960, members of the Shetland Society of New Zealand organised a 'hamefarin', or homecoming, when groups of exiles returned to Shetland, attracting fifty-two people from New Zealand and smaller groups from Canada, the United States and Australia. A week of receptions, reunions, excursions and pageants was so successful that more hamefarins followed – in 1962, 1969 and 1985. The last two were very important, with as many as five hundred people visiting Shetland, and massive celebrations took place around the islands. The place to which they returned was much transformed by oil wealth, and this permitted a 'reverse hamefarin' in 1987 in which a party of eighty-four Shetlanders went to New Zealand where the interest aroused led to the formation of new expatriate groups.[71] The Lerwick Guizer Jarl and his squad has developed into a vital element in the hamefarin, whether at home or abroad, and they now travel to form the focus of the event.

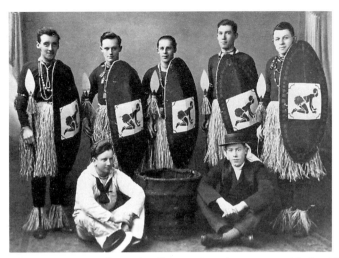

22 African/New Guinea tribe, masks off, *c.*1920s. Race themes appeared in Lerwick
 Up-helly-aa in various ways, including as native peoples and as black minstrels.
 Ironically, the wearing of straw skirts by this squad had a resonance with the
 Shetland folklore tradition of the guizing 'skekklars' who were covered in straw.
 (Courtesy of the Shetland Museum)

Up-helly-aa as a core set of symbols is at the close of the twentieth
century a key definition of Shetland belonging, whether in the islands or
overseas. But the different Up-helly-aa festivals are not all alike. Indeed,
it is important to note that within Shetland, the regional Up-helly-aas –
that is, those outwith Lerwick – have major key differences from the
original. For one thing, women take part. For another, for small crofting
and island communities of a few hundred people, the annual Up-helly-
aa has become a very intimate community festival in which the satirical
elements of the Bill, the guizing and the dramatic skit are used with care
and affection towards individuals in the community. Great pride is taken
in the quality of the satire in some of these. On the small island of
Bressay lying a mile off Lerwick, a good proportion of the community
of 353 people meet on the last Friday in February to drag their perman-
ent galley round a windswept route, meet to burn a 'stand-in' galley,
and then hurry off to put on their guizing outfits for very carefully
rehearsed dramas in the local hall. In 1996, one squad did a complex skit
based in part on the new craze of line dancing (for which the squad
members took lessons), and in part based on the Jarl of that year. A
local woman recalls:

> I wasn't in a squad last year and I got hauled in at the last minute. My
> sister-in-law that was doing it and my brother-in-law was the Jarl. So
> it even had a local flavour, it wasn't just line dancing. They did this
> line dancing, but my brother-in-law fishes a lot, and it was a wee skit
> on the Jarl. I was him out in a boat. It was haulin' in a line; we had
> fish and cans of beer and all the things that pertain to him hanging on
> this line. It [the squad] was called 'What a catch'. And on the very end
> of the line was his wife, followed by the rest of the squad and we
> hauled them in on the end of the line. This was the catch – Isabel.
> And then they did their line dancing, and then we changed into a Up-
> Helly-Aa squad and went out.[72]

If anybody does anything unusual, 'silly' or controversial – crashes a
car, stands for the local council, gets a posh pedigree dog (a rash of
which afflicted Bressay some years ago) – then locals say, 'that's one
for the Bill' or for a squad to enact. Conspicuous consumption rarely
afflicts such regional Up-helly-aas. On Bressay, participants claim to
spend little more than £10 a year on guizing outfits; one resident said: 'If
you're representing somebody on the island, you try and borrow the
identical clothes to what they usually wear.' Another recalled: 'I had a
phone call a week before Up-Helly-Aa. Somebody wanted to borrow
my jacket. I wear an old army parka. I got a phone call from Ray wanting
to borrow it. So immediately I thought "Hah hah".'[73] Participants in
regional Up-helly-aas tend to regard the Lerwick event as 'too com-
mercial' and 'too showy' and say that 'you'll find the most genuine
Up-Helly-Aas take place in country areas'.[74] One says:

> Up-helly-aa is just a nice — it's a fun thing . . . [In Lerwick] they
> wheel the Jarl Squad throughout the year. If there's a visiting dig-
> nitary comes along – oh they bring oot the Jarl Squad. And they
> come and parade. I'm frightened that folk take this seriously and
> really believe — The Jarl Squad actually seems to be representing
> what Shetland means and it doesn't. . . . It's very impressive, but I'm
> frightened folk are getting the idea that *this* is Shetland.[75]

This may be a sentiment not entirely shared in Lerwick. Though
many Lerwegians travel to regional Up-helly-aa festivals (and enter
squads in some of them), they are seen as something different. As one
Lerwick guizer said, 'It's copied in the country, but they have fire fest-
ivals, not Up-Helly-Aa. And they have men and women; they go out
carrying torches whereas in Lerwick it's just men.'[76] This remark is of
very great importance, for it reveals one of the major issues in the
modern community festival – gender. If Up-helly-aa has since the 1880s

coalesced the boundaries of ideology and moral politics in Lerwick, has 'boundaried out' transients and oil workers and has, more recently, become a portable and symbolic boundary for all claiming Shetland origins, it still leaves in the 1990s the sex of guizers as the major unresolved boundary conflict.

Symbols of gender

The *Shetland News* remarked in 1901 how parading guizers 'skirl' on seeing ladies: 'our nineteen-twentieth century girls are still, despite all the inventions and improvements which have been going on for the last 10,000 or 20,000 years, daughters of that very human woman, Mother Eve.'[77] The Lerwick festival has upheld the 'tradition' of gender divisions, and Up-helly-aa continued to do so in unchanged form through to the late 1990s. Women acted as 'hostesses' and tea-makers, whilst men acted as the guizers, the Vikings and the members of the squad 'drinking clubs'. Whilst the festival was sensitive to other divisions in Lerwick society and absorbed different aspects of popular culture within it, its gender division has remained a constant, apparently unyielding to feminist impulses and the changing role of women in twentieth-century society.

Like everywhere else in Britain, Shetland has experienced considerable expansion of women's rights and accepted opportunities during the twentieth century, especially since the 1960s. Women have a long continuity in economically active roles in Shetland; we noted early in this book how they were selling socks in the 1620s to Dutch traders at the beach booths at the foundation of Lerwick. In the nineteenth and early twentieth century, Lerwick was a major centre of female employment for the hundreds of fish-gutters who came from all over Scotland to work at the herring-curing stations during the summer season.[78] Work as home knitters has survived over many centuries as an unbroken tradition for native Shetland women. In 1971 there were 2,268 home knitters representing approximately 30 per cent of the female population aged 15–74, and with other sources of work on the croft or in the more urban economy of Lerwick, women were extremely economically active. However, home knitting declined after the arrival of oil; the number of home knitters halved between 1977 and 1981 and continued to fall – though more slowly – in the 1990s. But at virtually the same time the proportion of women in Shetland who were classified as economically active rose from 28 per cent in 1971 to 53 per cent in 1991. In

Lerwick, as in Britain as a whole, women had become very important to the economy by the end of the twentieth century; in Lerwick by 1994 women made up 49 per cent of the employed labour force.[79] Like almost everywhere in Scotland (and indeed Britain), women in Lerwick having been moving with accelerating speed into paid employment, claiming not only a major role in the generation of family income but also equal opportunities in economic life.[80]

Yet, throughout the misrule of the tar-barrelling era and the century and a quarter of Up-helly-aa, Lerwick's winter calendar custom has upheld sharp divisions in the role of men and women. In both periods the festive celebrations divided men into guizers, pranksters, tar-barrellers and bombers, and women into spectators and hostesses. Misrule contained spirited portrayals of 'manhood': the virility and daring of toting and firing guns, carefree carriage and ignition of gunpowder bombs, the hauling of fiery tar-barrels, the escapades to elude the police with diversionary gunshots, and the haulage of the heavy krate by its chains along Commercial Street. The Up-helly-aa festival may call for less 'manly' daring, but still demands strength and endurance in carrying the large torches in the midst of winter weather. The symbols of gender division have been just as important. The guizing outfits have often exaggerated masculinity: the military clothes of mid-nineteenth-century misrule and the Viking outfits of Up-helly-aa. The representation of women by male guizers has been a perennial theme. Before the 1870s, there was a tradition for some of the guizers to cross-dress as women, and this grew in frequency in 1900–14 and 1920–39. Many Up-helly-aa squads appeared as women or portrayed women's roles: for example, as suffragettes in 1910 (who were also much mocked in the satirical Bills of the pre-1914 era), 'Tyrolese Girls', 'pretty Cake-walk Girls' and 'Homely-looking but perfect Dutch Vrouws' (all 1902), 'Schoolgirls of the Sixteenth Century', 'Butterfly Girls' and 'Japanese Girls' and 'Nurses' (all 1907).[81] The predominance of 'girls' rather than 'women' in the titles of these squads might be interpreted as affirming a diminutive characterisation of females, reinforcing a discourse on subordination and vulnerability; at the same time, this might have been a 'safe' representation when the guizers' womenfolk were watching. Women were usually represented as young, pretty or (as in the case of suffragettes) troublesome, but rarely as economically active; when they were, it was usually as hand-knitters which fitted well with the prevailing discourse on women's place in the domestic sphere. However, it is as well not to overlook the obvious; as one Up-helly-aa enthusiast says: 'I dinna ken what it is aboot men; they

just enjoy dressing up as women.'[82] Cross-dressing may have more to say about the guizer's real rather than inverted sexuality.

Women might be portrayed, but not involved. Significantly, there appears to have been no move since 1914 – as was common in many community festivals – to provide a 'Queen' or 'Jarl's wife' – though in the 1960s, the Jarls' duties included crowning the 'Viking Princess' at Lerwick's Carnival Week in June.[83] The very structure and overt symbolisms of Lerwick Up-helly-aa exude the contrasts between almost archaic and 'traditional' male and female roles in society. The festival became – and remains – one of the strongest and most enduring statements of gendered roles to be found in Shetland. The guizers have all along been officially men only, though at times, notably in the first decade of the century, there were reports of women disguising themselves as men (and perhaps then portraying women) to take part.[84] Unfortunately, we know nothing of the circumstances of the inclusion of women as guizers in the 1900s – whether this was merely a prank, or was some form of ideological statement by feminists or others. The role of women as organisers of the halls has been, in its way, an important development of the twentieth century. Moreover, the creation of 'dry' halls owes much to women's portrayal by the teetotal and prohibition cause in the early decades of the century. The prohibition of public houses in Lerwick between 1920 and 1947 had a strong bearing on gender as, here as in other parts of Scotland, the campaigns of the prohibitionists focused on women and children, cultivating the female vote by campaigning on what they (and their children) had to suffer at the hands of drunken fathers. Obversely, the pro-drinks lobby relied on men drinkers for their votes. Letters to the *Shetland Times* during the 1920 Local Veto poll illustrated this: two 'housewives' said that 'there is not a woman with any God's fear in her nature that will not vote No-Licence, and gladly do so'. One prohibition campaigner argued that 'every woman on the roll of voters has a distinct call' to vote for the closure of public houses on the grounds that those whose husbands, brothers or sons were 'addicted to temperance' were bound to do so, whilst those 'who fear the danger for those whom they love' must do so to save themselves and others from the miseries of drunken men.[85] The 'dry' halls at Up-helly-aa draws on this heritage of the gendered teetotal cause.

Pressure for the admission of women to Lerwick Up-helly-aa has been muted. In the 1980s, women opposing male domination in the squads of guizers pinned an alternative Bill in a shop window near the

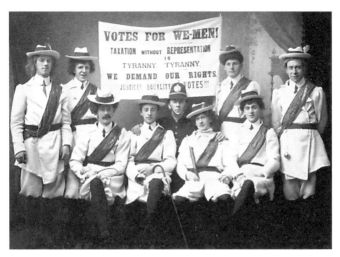

23 Votes for We-men squad, *c.*1911. The suffragettes were an obvious target for the
male guizers. Women have been excluded from the Lerwick Up-helly-aa, though
they have been prominent in almost every other of the regional Up-helly-aa
festivals in Shetland's rural communities (Courtesy of the Shetland Museum)

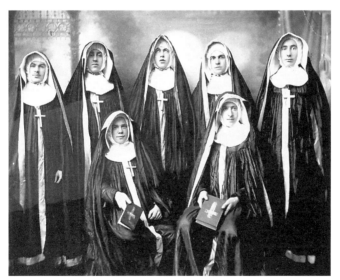

24 Nuns squad, 1920s. The depiction of nuns has been a standard cross-dressing
theme in Up-helly-aa during the twentieth century. Shetland has had few resident
Catholics, but offence has on occasion been taken by local priests. (Courtesy of
the Shetland Museum)

Market Cross, but this was perceived by many women – including those who are active supporters of Up-helly-aa – as unhelpful: 'I remember the furore that it caused at the time,' says one woman, 'but I think sort of most women at that time thought "Oh my God, it's embarrassing women more than helping them."'[86] A group of women who had planned to press for admission to Lerwick Up-helly-aa abandoned the idea, and in the late 1990s there appears to be little prospect of it being revived.

The Lerwick Up-helly-aa contrasts starkly with the regional Up-helly-aas in the rural parts of twentieth-century Shetland. Nearly all of these festivals – some eleven of them at the last count – allow women to participate as guizers, though rarely as members of a Jarl's squad. The first to admit women was Bressay Up-helly-aa in 1930, and since its resuscitation in the 1960s women are critical to its survival. Their involvement changes the nature of the squad; instead of being a male drinking club, all-female squads are reported as full of 'great hilarity and laughing', where the men are talked about in ribald terms – 'mostly your husbands'.[87] Women join in both single-sex and mixed-sex squads, but they have never been allowed to join the Jarl's squad or become the Jarl. Indeed, there seems to be little pressure for such an innovation. Two of the most ardent female participants in Bressay Up-helly-aa do not consider it a 'serious enough issue to get excited aboot, to be quite honest'; if asked to join the Jarl's squad, one said: 'I would go in it, but I wouldna feel that I was doing a feminist thing. I would feel that I was going in it because me pal had asked me – pal being a bloke. I wouldna feel that I was making a feminist statement . . . I would go for the crack.'[88] At Waas in another regional Up-helly-aa, the affair is actually all-female, organised by the Brownies with an all-female Jarl's squad (complete with sheepskins, helmets, shields and swords), and other girl squads (including one dressed as the Spice Girls in 1997).[89] Though there are some women who, excluded from the Lerwick Up-helly-aa, are reputed to travel to the regional festivals in order to participate (and use some of the guizing outfits previously worn by men in Lerwick), the resistance to the admission of women to the biggest and the first of these festivals seems almost total.

The arguments against the admission of women as guizers in the Lerwick Up-helly-aa come down to two forms: the practical and the ideological. On the practical side, it is widely said by both men and women that to admit women would overload the event with too many guizers, and some men would have to fall out. Another argument is that

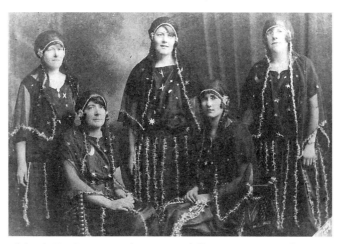

25 All-female Tea Coupon squad, Bressay Up-helly-aa, *c.*1931. Women have
 participated in that island's festival since the 1930s, though never as members of
 the Jarl's Squad. The idea for this squad came from motifs of moons and stars
 which appeared on tea coupons. (Courtesy of the Bressay History Group)

if women are dressed as guizers, and men are as well, who is going to
dance with whom at the halls. On the ideological side, it is invariably
plainly stated that it would destroy 'the tradition' of the event (and
Shetland winter custom) to have women dress as guizers. However, it is
not beyond the bounds of possibility that the law may force a change.
The mid-1990s witnessed an intense community struggle in Hawick in
the Scottish Borders over the exclusion of women from the formal pro-
ceedings of the Common Ridings. When two young women sought to
join the procession in 1994, the community erupted into two camps of
'traditionalists' favouring the exclusion of women and the reformers.
When the women took their case to the Equal Opportunities Commis-
sion, and won their case easily in a sheriff's court, many local commen-
tators feared that the community could not heal the deep scars that had
been created.[90] It seems that this judgement means that equal oppor-
tunities legislation extends to recreational as well as employment and
educational affairs. If it were pressed as an issue, Lerwick women could
go to law to gain equality of rights in their town's Up-helly-aa.

Though it seems unlikely to happen in the near future (judging
by general opinion in Lerwick), it is tempting to suggest that such an
innovation would actually be following the most inherent of 'traditions'
in Lerwick Yuletide custom – namely, adapting the festival to a new

community context. Throughout its history, as we have seen, this calendar custom has changed in very dramatic ways to keep pace with economic, cultural and social changes. For the symbolism of Up-helly-aa to maintain its encapsulation of all of Lerwick's principal internal boundaries, it may have to modernise and keep up with changing gender roles. In theory, this might be relatively easy to achieve. The nature of the event itself incorporates the 'tradition' of gender cross-over in guizing dress, and in the Norse theme tackles the representation of machismo. Couple that with the intrinsic misrule of the festival – of cocking a snook, of the formal role of 'jokes' and fun, and of turning the world upside-down – and there is a possible recipe for the happy inclusion of women as a natural evolution of a calendar custom that has already permutated several times over two centuries to keep pace with community progress. Just as teetotalism and drink, 'rough' and 'respectable', civic ritual and misrule were contained in various symbolic and organisational ways within the evolving festival between the 1870s and the 1930s, so the admission of women as guizers at Lerwick Up-helly-aa would maintain the 'tradition' of encompassing boundaries and would be 'perfectly in custom'. Above all, if the regional Up-helly-aa festivals can do it, located in the most rural and generally most 'conservative' of social contexts, it seems ironic that the more urbane and 'modern' Lerwick has not.

Notes

1 *Shetland News* 30 January 1904.
2 Ibid., 7 January 1905.
3 SA, D11/202/1, Up-helly-aa Committee (hereafter UHAC) minutes, 3 January 1908, 24 January 1922.
4 SA, D11/202/1, UHAC minutes, 2 January 1908; James W. Irvine, *Up-Helly-Aa: A Century of Festival* (Lerwick, Shetland Publishing, 1982); pp. 23–4.
5 Irvine *Up-Helly-Aa*; Charlie Grant (narrator), *Up-Helly-Aa 1994* (video cassette: Lerwick, 1994, Norfilm).
6 Irvine, *Up-Helly-Aa*, pp. 50–7.
7 Ibid., p. 69.
8 SA, D11/202/1, UHAC minutes, 19 January 1926; D11/202/2, 21 December 1937.
9 SA, D11/202/1, UHAC minutes, 20 January 1925.
10 *Shetland Times* 31 January 1931.
11 SA, D1/218/5, BBC typescript of radio broadcast by M. H. Williamson *anent* Up-helly-aa, 6 February 1933.
12 L. A. Knight, *The Viking Feast Mystery* (London, Sampson Low, n.d.), p. 15.
13 B. Smith, 'Up-Helly-A' – separating the facts from the fiction', *Shetland Times* 22 January 1993, p. 25.

14 Figures from J. W. Irvine, *Lerwick: The Birth and Growth of an Island Town* (Lerwick, Lerwick Community Council, 1985), p. 154.

15 W. R. Steele, 'Local authority involvement in housing and health in Shetland *c.*1900–1950', unpublished M. Phil. thesis, University of Strathclyde, 1992, pp. 74, 79–89.

16 Ibid.

17 Ibid., p. 35.

18 Ibid., pp. 33–45.

19 C. G. Brown, 'Urbanisation and living conditions', in R. Pope (ed.), *Atlas of British Social and Economic History since c.1700* (London, Routledge, 1989), pp. 178–9.

20 Steele, 'Local authority involvement', pp. 29, 37–40.

21 Ibid., pp. 103–5.

22 All the above figures are from, or calculated from, A. T. Cluness (ed.), *The Shetland Book* (Lerwick, Zetland Education Committee, 1967), pp. 45, 50, 52–3; and *Shetland in Statistics 1996* (Shetland Islands Council, Lerwick), p. 12.

23 *Shetland Times*, quoted in Smith, 'Up-Helly-A', p. 25.

24 Ibid.

25 Irvine, *Up-Helly-Aa*, p. 28.

26 Peter Jamieson, quoted in B. J. Cohen, 'Norse imagery in Shetland: an historical study of intellectuals and their use of the past in the construction of Shetland's identity, with particular reference to the period 1800–1914', unpublished Ph.D. thesis, University of Manchester, 1983, p. 320.

27 Smith, 'Up-Helly-A'.

28 *Shetland News* 26 January 1901; Irvine, *Up-Helly-Aa*, p. 14.

29 SA, D11/202/2, UHAC minutes, 21 January 1936.

30 Ibid., 18 and 19 January 1937.

31 *Shetland Times* 29 January 1965.

32 Irvine, *Up-Helly-Aa*.

33 SA, D11/202/1, UHAC minutes, 24 January 1929.

34 Ibid., 8 February 1929, 23 December 1929; Smith, 'Up-Helly-A', p. 25.

35 A remark made to the author.

36 J. W. Irvine, *The Years Between* (Lerwick, A. Irvine Printing, 1993), p. 12.

37 C. G. Brown, 'Popular culture and the continuing struggle for rational recreation', in T. M. Devine and R. J. Finlay (eds), *Scotland in the Twentieth Century* (Edinburgh, Edinburgh University Press, 1996), pp. 219–21.

38 Quoted in *Shetland News* 8 July 1905.

39 Ibid., 19 April 1913.

40 Ibid., 8 November 1911.

41 Quoted in B. Smith, 'Lerwick's ice-cream war', unpublished lecture to Lerwick Rotary Club, 1990.

42 Steele, 'Local authority involvement', passim.

43 C. G. Brown, *Religion and Society in Scotland since 1707* (Edinburgh, Edinburgh University Press, 1997), pp. 146–7; Temperance (Scotland) Act, 1913, s. 1(3)(a).

44 The campaign is detailed in *Shetland Times* 5 June–18 December 1920. In all, seven areas of Shetland voted, and four went 'dry' – Lerwick, Tingwall, Sandsting and Aithstring, and Unst, *Shetland Times* 25 December 1920.

45 B. Smith, 'Temperance, Up helly aa, socialism and ice cream in Lerwick 1890–1914', unpublished lecture to Shetland Civic Society, 1984.

46 Irvine, *The Years Between*, p. 40.

47 Ibid., pp. 40–1.

48 Ibid., p. 1.

49 Irvine, *Up-Helly-Aa*, p. 68.

50 SOHCA/10/03, p. 1, interview with Peter Black (pseud.).

51 Irvine, *Lerwick*, p. 280.

52 This paragraph is heavily based on ibid., pp. 274–300.

53 *Shetland in Statistics, 1996* (Shetland Islands Council, Lerwick), pp. 11–12.

54 *Shetland Times* 17 September 1994.

55 Irvine, *Lerwick*, p. 288. These bald figures may not give a 'true' reflection of crime trends because of changes in methods of counting over this period.

56 Ibid., p. 282.

57 SOHCA/10/03, p. 5, interview with Peter Black (pseud.).

58 Irvine, *Up-Helly-Aa*, p. 30.

59 Ibid., p. 83.

60 Figures calculated from data in *The Scotsman* 18 June 1997.

61 M. Dowle, 'The birth and development of the Shetland Movement 1977–1980', in H. M. Drucker and N. L. Drucker (eds), *Scottish Government Yearbook 1981* (Edinburgh, Paul Harris, 1980), p. 211.

62 *Shetland in Statistics 1993* (Shetland Islands Council, Lerwick), pp. 63–4.

63 Irvine, *Up-Helly-Aa*, p. 11.

64 Irvine, *Lerwick*, passim.

65 'I just can't remember. I'm sure I voted no. There was fear that [oil] money would go to the central belt of Scotland.' SOHCA/10/03, p. 6, interview with Peter Black (pseud.).

66 Personal communication to the author.

67 *The Scotsman* 13 September 1997.

68 *Shetland Times*, quoted in Irvine, *Up-Helly-Aa*, p. 139.

69 Irvine, *Up-Helly-Aa*, p. 143.

70 S. Butterworth and G. Butterworth, *Chips off the Auld Rock: Shetlanders in New Zealand* (Wellington, Shetland Society, 1997), pp. 146–50, 194.

71 Ibid., pp. 194–8, 204–11.

72 SOHCA/10/06, p. 7, interview with Jane Manson.

73 Ibid., quotes from Barbara Anderson and Jane Manson respectively.

74 Ibid.

75 Ibid., pp. 12, 19, Barbara Anderson.

76 SOHCA/10/03, p. 4, interview with Peter Black (pseud.).

77 *Shetland News* 5 January 1901.

78 H. D. Smith, *Shetland Life and Trade 1550–1914* (Edinburgh, John Donald, 1984), pp. 191–4.

79 *Shetland in Statistics 1996* (Lerwick, Shetland Islands Council), pp. 15–16, 27.

80 A. J. McIvor, 'Women and work in twentieth-century Scotland', in A. Dickson and J. H. Treble (eds), *People and Society in Scotland, vol. III, 1914–1990* (Edinburgh, John Donald, 1992).

81 *Shetland News*, 1 February 1902, 3 February 1906; Irvine, *Up-Helly-Aa*, p. 64.

82 SOHCA/10/06, p. 14, interview with Barbara Anderson.

83 *Aberdeen Press and Journal* 15 June 1968, in SA, D11/153a/8, newspaper cuttings.

84 'The female sex, it is whispered, was well represented amongst the masqueraders.' *Shetland News* 1 Feburary 1902; other references occur in ibid., 6 January 1900 and 5 January 1901.

85 *Shetland Times* 2 October 1920; Brown, *Religion and Society*, pp. 198–202.

86 SOHCA/10/06, p. 16, interview with Barbara Anderson. J. T. Church, 'Political discourse of Shetland; confabulations and communities,' Ph.D. thesis, Temple University, 1989, p. 202.

87 SOHCA/10/06, p. 14, interview with Barbara Anderson.

88 Ibid., pp. 12, 17, interview with Jane Manson.

89 Information supplied to Brian Smith from an unnamed source in Waas.

90 *The Scotsman* 22 August 1997.

<div style="text-align: center">

7

</div>

Community, custom and history

History and boundaries

RAPHAEL SAMUEL wrote in 1994: 'Historians today don't knowingly forge documents. But by the nature of our trade we are continually having to fabricate contexts.' By fabrication, he meant – or at least I think he meant – that we assemble contexts, not that we manufacture false ones. For he went on: 'The art of historical writing is that of making a master narrative out of chaos.'[1]

The topic of this book has been more than usually chaotic, and the narrative that has been imposed upon the last three centuries of Lerwick's history has involved leaps of topic, approach and the imagination. A series of changing contexts from the seventeenth to the end of the twentieth centuries have been structured in a way that makes the community's winter customs explicable. It may not be the only valid structure, and it may not be applicable to customs in other places. The historian's treatment must fit the case.

It has been proposed that between the 1620s and 1820s Lerwick was a community lacking civic systems and symbols of identity (such as a town council or ecclesiastical tradition), and in which the hierarchy of power was externalised to 'outsiders' (the kirk session, the Customs and the military) who attempted, forlornly, to impose order and obedience. The town was founded on portable nations, making no single language a definer of 'belonging', but making smuggling, drinking, conviviality and casual sexual relationships the currency by which visitors became 'insiders'. This was a community of misrule, an outpost of the Scottish and (after 1707) the British state in which the power hierarchy was effectively inverted and in no need of an inversion ritual. But things changed when smuggling gave way to economic commercialisation after 1800. Rapid growth of the population in the town reflected the rise of industrial capitalism, and an effective internal

<div style="text-align: center">

192

</div>

hierarchy of power emerged – a town council from 1818, and the effective legal constraints of resident sheriffs and procurators fiscal. Chaotic yet ritualised misrule at Yule and New Year (OS) provided the town with a highly armed demonstration of plebeian power. The tar-barrel, the gun-barrel and the gunpowder bomb became the new divide between 'insider' and 'outsider', with guizers using the familiar hierarchy and pomposity of military attire to mock, challenge and frighten those whose pretensions of rank 'deserved' it.[2] To obstruct this ritualised mayhem at Yule and New Year (OS) was to invite tar on the door or a gunpowder bomb, and the misrule expanded as the opposition grew. To be an 'upright' and 'respectable' citizen, to be a member of the 'holy' brigade, was to invite in the 1850s and 1860s a 'prank' of one form or another, and as a consequence misrule became in those decades more entrenched.

After two decades of confrontational parades by teetotal organisations on New Year's Day, it was the late rise of evangelical culture in the 1860s rather than police action that challenged misrule. In the mid-1870s Yuletide misrule was spilling out onto many dates in the calendar, one of which was 29 January 1873. Though we may never know precisely why a group of Lerwick lads took a single tar-barrel onto Commercial Street on that day, it marked the small and spontaneous beginnings of Up-helly-aa. Between then and 1881 the event remained relatively modest, but it was increasingly pacified – not by the police specials, but by the crowd itself. The tar-barrel gave way to a torchlight procession of guizers – a popular transformation which progressed sufficiently by 1882 for the town council to summon them to parade before the Duke of Edinburgh. Protest at the change was limited (though, by its nature, spectacular), but its last effective appearance in 1891 could not distract from the success of the new Up-helly-aa. It was successful because Up-helly-aa enveloped the symbols of misrule – the heritage of tar-barrel, guizing, drinking, open houses and, above all, fun – in a new ritual which matched the evangelical sensibilities of late Victorian Lerwick. As the festival acquired a burning galley in the 1890s it mimicked the tar-barrelling krate or boat – the key symbol of mid-Victorian Lerwegian misrule – and thereby completed the ritual representation of its predecessor. With the addition of the satirical Bill in 1899, the inversion ritual was intellectually institutionalised, and the guizing squad developed into a sophisticated dramatic display of fun-poking. From 1906, the Guizer Jarl, aided by his Joke Committee, was the 'Lord of Misrule', and he presided over an event which sustained its plebeian complexion

through the massive changes in economic fortune during the twentieth century.

Throughout this development, the common people recrafted their sense of community again and again. When it appeared between the 1840s and 1860s, teetotalism had been an 'outsider' movement to be mocked by pranks and the drunkenness of misrule. From the 1870s symbols of the evangelical movement to which it became linked were enveloped within Up-helly-aa, merging conflicting community ideologies within the festival. The teetotal and socialist contribution to the festival became important in the 1890s, and the creation of 'dry' and 'wet' halls after 1903 created a vital piece of the cultural architecture of Up-helly-aa.

Up-helly-aa developed another 'boundary' for both Lerwegians and Shetlanders. The medieval heritage of the Norse was being revived in the late nineteenth century at the same time as mid-Victorian misrule was transmuting into a festival. Though the Norse revival was not the cause nor even the reason for the transformation, its theme emerged slowly from the mid-1880s to become by 1921 the central focus: the Guizer Jarl, his squad, the burning galley and the songs of praise to medieval Norsemen. In the inter-war period, the Viking symbol became the modern image of Shetland, an image which in the later twentieth century has been turned into the logo of local government, Shetland enterprise and island merchandising. However, Up-helly-aa has not become a publicity stunt for tourists or the media. Far from it: attempts by the British Tourist Association in 1967 to 'package' the event – including the suggestion of creating a new spring or early summer festival based on Up-helly-aa – got short shrift from the Up-helly-aa Committee; the Jarl of that year said: 'I think it is a lot of nonsense.'[3] Up-helly-aa remained an event for Lerwegians, though increasingly also for Shetlanders and exiles. In the 1900s Up-helly-aa festivals started to appear in rural Shetland, spreading further in the 1930s and especially since the 1960s. Up-helly-aa became a generic form of festival for Shetlanders everywhere, including the Shetland diaspora overseas who, like emigrants in many parts of the world, have developed multiple identities of national belonging. With cheap international airflight, the 'hamefarin' renews that sense of belonging, with the Guizer Jarl appearing as the focal figure, the personification of Shetland. And to cap its modernity, the Internet has made the Up-helly-aa web-page in the 1990s an easily accessible touchstone for Shetlanders anywhere in the world.[4]

Community and ideology

The way in which the community of Lerwick has imagined itself has changed drastically since the seventeenth century. For some historians, the Norse symbolism of the Up-helly-aa festival may appear as a classic form of 'invented tradition', by which Lerwegians – and more recently Shetlanders as a whole – have enabled themselves to 'raid' the past (i.e., history) to create a collective identity.[5] It may appear more particularly to be a classic form of 'counter culture' which emerged to stay or challenge the colonising cultures of 'Scottishness' or 'Britishness'.[6] But Shetlanders are less likely than academics to dwell on such perspectives. The Norse revival was only a politics of separation for a relatively brief period in the late nineteenth century, tinged in its earliest intellectual manifestations in the 1870s and 1880s with mostly right-wing ideas of Shetlanders' racial separateness.[7] Up-helly-aa at its birth in the 1870s had no Norse theme, and only acquired it gradually between the 1880s and 1920s. But by then the dominating ideological currents in Lerwick were far from the past: on the one hand moral politics (ice-cream parlours, sabbatarianism, respectability and, above all, teetotalism) and on the other hand the necessity of applying what were seen as socialist solutions to urgent social problems like poor housing. Up-helly-aa had never been the creation or property of the revivalists of Shetland's medieval past, and never became a symbol of political aspiration to separateness or to 'nation'.

Indeed, the Norse heritage has not been an *ideological* dimension to the definition of community. It contains profound metaphors for the nature of Shetland life – the sea, the darkness of winter, the bravado and the resilience of life on the margins of Europe – and the Viking embodies admirable qualities for contemporary inhabitants of Shetland. But there is no real sense in which Shetlanders believe that the festival they have created provides them with a manifesto for major constitutional change. The protests of the 1970s concerning local government reorganisation, oil money and 'outsider' construction workers were 'taken' to the Bill and the squads, but the festival was merely doing what it has always done – marking boundaries of 'belonging'.

Calendar customs

So much more lies embedded in Up-helly-aa than first meets the eye, and it is unlikely to be unique in this regard. The significance of a

calendar custom is not limited to its overt theme nor to its form. Concentration on Up-helly-aa's celebration of Norse tradition and its characteristics of a winter fire festival can seriously divert the historian from its origins, meanings and significance. In the same vein, issues of 'survival' of calendar custom forms are not the principal points that matter. Contemporary customs are just that – thoroughly contemporary – and they signify how changes in society have been marked by adapting or developing community activities. Equally, they demonstrate the universality of some themes of community politics which are often thought to be purely parts of the world we have lost: misrule, rituals of social inversion, and highly gendered roles. What we find in living and vibrant community customs should not be treated as remnants of a pre-industrial past, nor as signs of unchanging elements in society. Theme and form are veils on a calendar custom; meaning lies within.

Up-helly-aa suggests that popular customary activity is strongly related to the nature of the social and cultural configuration of its community. When the equilibrium of power is heavily leaning towards the common people (as in Lerwick in the seventeenth and eighteenth centuries), then the ritual inversion of the social order is redundant; in those circumstances, the social order *is* misrule. But when that equilibrium shifts power towards elites or newly effective civil authority, then customary activity can spontaneously arise; the experience of returning soldiers and seamen in the 1800s and 1810s generated gun-toting Yuletide misrule which became increasingly ritualised in its use of pranks and bullets, bombs and tar, in targeting the 'enemies' of this temporary popular power. When the custom changed again in the 1870s and 1880s, it was not because of *external* shifts in the equilibrium but because of *internal* cultural change within the community; the boundary of belonging had to be redefined to absorb late Victorian respectability, evangelical sensibilities and teetotalism. The calendar custom was not reinvented because of oppression or appropriation by elites, but because – when we get down to it – the people wanted it to change.

In this way, the nature of what is 'surviving' in this custom is a very important issue. 'Survival' is a word much used by some historians when studying the history of popular customs, but it is not deployed in an entirely 'neutral' manner. The survival of a custom implies longevity, unchanging themes, and the connection of different historical eras through the custom. It has become in recent historiography a word that has connected the customs of the eighteenth, nineteenth and even the twentieth centuries with the customs of the late

medieval and early-modern periods.[8] More fundamentally, it has opened up the late-modern period – from the eighteenth century onwards – as historical territory in which the agendas and perspectives of the historian of pre-industrial society can be applied to industrial and post-industrial society. A custom like Up-helly-aa, though created and rooted in a modernising capitalist society, endears itself for being seemingly in the format of the fifteenth or sixteenth centuries – or perhaps even earlier. But such a view makes the changing economic and social context less important, less critical, less defining of calendar customs – until, that is, they are seen as being displaced, usually from the 1860s, 1870s or 1880s, by 'social control' and 'rational recreation', by customs centred on 'invented tradition', or by the 'mass culture' of cinema, radio and television.[9]

Just as the concept of survival is problematic, so is the 'invention of tradition' – such as Highlandism in Scotland or Norse pageantry in Shetland. 'Invention' is a term some historians use as a tincture of disapproval. It is deployed as a dismissive, an accusation of self-delusion on the part of participants, and as a rebuke to those who fail to know 'real' history or the 'real' past. The pageants of 'invented tradition' – kilts and Viking helmets – are kitsch, either commoditised or fetishes, which delude those with no historical scholarship. No historian says this, but the implication is often there. A more sympathetic, or at least comprehending, interpretation is that 'invention of tradition' is in itself an important characteristic of modern societies, especially of the nineteenth-century when a rage for the past allowed peoples to construct 'biographies of nations';[10] so too for urban communities, for 'racial' groups and social groups, wherever new empires and industries unsettled or revolutionised and there was need of 'roots'.

There is a poverty to our phraseology which needs to be overcome. Survival has, I think, at least three different forms in relation to the modern calendar custom. In the first form, it is the survival of an event at a calendar date over a long period of history, with the content in the modern festival having some degree of likening in theme or activity to its earlier 'equivalent'. In the second form, the function of a custom in symbolising the community's boundary may survive, even though the way that is carried out by the festival may change. And third, a custom may survive in the sense that it carries emblems of the community when its identity has changed in other radical ways; furthermore, and this is critical, a custom may emerge from scratch in order to sustain the identity of a community undergoing change.

The essence of survival is change. In Lerwick's case, a community born in the early seventeenth century had no ritualised community customs for 180 years or so. But it had a community identity embedded in its anti-reverential, anti-government, anti-authoritarian culture, exemplified in smuggling and disregard for the moral authority of the Church of Scotland. That identity was preserved by a new custom born in the town's commercial revolution of the early nineteenth century, and was preserved again in Up-helly-aa when the nature of the community changed in the 1860s and 1870s. In a sense, the question of the survival of customs was not, and is not, the point. The ethos of the community survived, the customs changed to suit. The specifics of change to calendar customs undoubtedly vary from place to place and custom to custom, but it is important to perceive that the calendar custom is an important phenomenon of industrial and post-industrial society and not just a 'hangover' from a world we have lost. It is not a window onto the past, but a window on the present which hides within it the kernel of the community.

From this there are suggestions about the nature of calendar customs in the late modern period of the nineteenth and twentieth centuries, and about the ways in which historians should approach them. First, as was suggested near the outset of this study, the modern calendar custom is different from that of the sixteenth, seventeenth and eighteenth centuries in that a community formerly had a calendar of customs, but in the twentieth century, if it has had one at all, it tends only to have had one. Public holidays and the universal 'mass culture' of Christmas and (in Scotland's case) Hogmanay apart, the pre-industrial calendar of customs in a single town or community gave way around the 1870s and 1880s in Britain – possibly quite quickly – to the celebration of single events, events which developed into major modern community festivals by which each community celebrated itself.

Second, the nature of the singular calendar custom of the twentieth century differs from many of its predecessors by the level of community investment in it by way of preparation, year-round organisation and anticipation, and monetary investment by participants. In the medieval and early-modern periods, one gains the impression that preparation times for most festivals were short, and things to be prepared – guizing outfits, masts and other paraphernalia – required little more than a few days' thought and work.[11] From the late nineteenth century, the calendar custom became increasingly longer to prepare, but only in the later twentieth century has the community festival (as distinct from the

civic-mounted festival)[12] become resonant with consumption – about investment of money and time in preparing equipment, displays, clothes and rituals of amazing complexity and extravagance.

Third, the modern calendar custom is invariably infused with explicit and implicit referencing to 'heritage', 'tradition' and 'time-honoured customs'. Such claims are too often the subject of judgement by historians, and judged on 'professional' tests of historical 'authenticity'. Academic publications judge with words like 'false', 'genuine', 'manu-factured', 'invented', 'contrived' and 'revived'.[13] This is a conceptually impotent approach. It seems to condemn a festival for not being like some calendar custom in the fifteenth or seventeenth century because it has changed – probably very many times – to keep pace with changes in the community. In reality, it is the very act of change which sustains authenticity, preserving underlying characteristics of the community for each period or generation. The activities of which a custom is con-structed require to be 'read' very carefully; the historian's task, as E. P. Thompson put it in relation to eighteenth-century plebeian protest, is 'decoding the evidence of behaviour'.[14] And the act of decoding beha-viour involves in part putting to one side the visible activity of the custom – the tar-barrelling, the burning of a ship, the guizing in Viking tunics and helmets – to reveal longer-term 'meanings' which survive content change. In that respect, 'heritage' surely lies not in the content, but in the meanings, in the symbolic representations of the community. Indeed, a community may itself – as I suspect in the case of Lerwick in the late twentieth century – endow its festival with 'heritage' for all the wrong reasons. Up-helly-aa is 'authentic' heritage not because of the Norse symbolisms of a medieval Shetland past, but because it is the celebration of something Lerwegians (and history) have forgotten – the spirit of freedom from bumptious and interfering authority upon which Lerwick was founded in the early seventeenth century on the barren shores of an empty Sound of Bressay.

Notes

1 R. Samuel, *Theatres of Memory: Volume 1: Past and Present in Contemporary Culture* (London and New York, Verso, 1994), p. 433.

2 For a discussion of guizing in the context of protest, see A. Howkins and L. Merricks, '"Wee be black as Hell": ritual, disguise and rebellion', *Rural History* vol. 4 (1993).

3 (Manchester) *Guardian* 2 February 1967, in SA D11/153a/8, newspaper cuttings.

4 At the Up-helly-aa website at *http://www.up-helly-aa.org.uk*, Brian Smith provides a short history of the event, and pages describe the most recent senior and junior Up-helly-aa.

5 B. Anderson, *Imagined Communities: Reflections on the Origin and Spread of Nationalism* (London, Verso, 1991 edn).

6 P. Worsley, *Knowledges: What Different Peoples Make of the World* (London, Profile Books, 1997).

7 B. J. Cohen, 'Norse imagery in Shetland: an historical study of intellectuals and their use of the past in the construction of Shetland's identity, with particular reference to the period 1800–1914', unpublished Ph.D. thesis, University of Manchester, 1983.

8 R. Hutton, *The Stations of the Sun: A History of the Ritual Year in Britain* (Oxford, Oxford University Press, 1997).

9 P. Burke, 'Popular culture between history and ethnology', *Ethnologia Europaea* vol. 14 (1984), p. 12; J. Walvin, *Leisure and Society 1830–1950* (London, Longman, 1978), p. 134; T. C. Smout, 'Patterns of culture', in T. Dickson and J. H. Treble (eds), *People and Society in Scotland, vol. 4, 1914–1990* (Edinburgh, John Donald, 1992), pp. 261–81.

10 Anderson, *Imagined Communities*.

11 There are undoubtedly exceptions to this, including the mystery plays, but it seems to hold true of the majority of the agrarian customs of village and manor.

12 D. Cannadine, 'The transformation of civic ritual in modern Britain: the Colchester Oyster Feast', *Past and Present* 94 (1982).

13 'in the 1880s a somewhat uncouth yet genuinely Norse "yule" custom of rolling blazing tar barrels through the streets of Lerwick was pushed back towards the end of January and reorganised as the Viking ceremonial of "Up helly aa!"' . . . the 1880s also saw revivals among the Border Common Ridings and the Highland Games', C. Harvie and G. Walker, 'Community and culture', in W. H. Fraser and R. J. Morris (eds), *People and Society in Scotland, volume 2, 1830–1914* (Edinburgh, John Donald, 1990), p. 354.

14 E. P. Thompson, *Customs in Common* (London, Merlin, 1991), p. 73.

Sources

Web Site: http://www.up-helly-aa.org.uk

Primary sources

Unpublished documentary sources
(all located at Shetland Archive (SA), except where indicated)

D1/218/1(1–5), 5–6 BBC typescripts and cuttings relate to broadcasts on Up-helly-aa, 1933, 1949.

CH2/1071/1–2 Church of Scotland, Presbytery of Shetland (later Lerwick), minutes 1700–31.

CH2/1072/2–3, 5–6 Church of Scotland, register and minutes of the kirk session of Lerwick 1751–76, 1790–1842, 1880–85, 1886–92.

CH2/286/2 Church of Scotland, Northmavine kirk session minutes 1823.

CH2/325/1 *et seq.* Church of Scotland, Sandwick kirk session minutes 1755–1842 (transcribed disc version).

TO3/1 Lerwick Commissioners of Police, minutes 1833–94.

TO1/1 Lerwick Town Council, minutes 1818–75.

TO3/4 Lerwick Town Council and Magistrates, acting as Commissioners of Police, minutes 1877–94.

D6/292/8 Newspaper cutting, *Northern Ensign*, 1873.

D6/232/1 Newspaper cutting, letter to *Shetland Times/News, c.* December 1910, from Guizer Jarl E. S. Reid Tait.

D11/153a/8/9 Newspaper cuttings file, 1967–68.

D1/133 p. 110a Public Notice (on tar-barrelling etc.), Clerk to the Lerwick Commissioners of Police, December 1874.

Shetland Museum Public Notice (on tar-barrelling etc.), Clerk to Lerwick Town Council, December 1875.

D6/294/2 E. S. Reid Tait Scrapbook, Lerwick Burgh Notice of Public Funeral of J. J. Haldane Burgess MA, on 19 January 1927.

D11/153/4 Anonymous 'Uphelly A' flysheet, 1877.

D11/153/4 Up-helly-aa Collecting Sheet, 1894.
D11/202/1–2 Up-helly-aa Committee minutes, 1908–38.
D6/294/1/57 Up-helly-aa: letter from solicitors to Guizer Jarl concerning alleged slander in the Bill, 6 February 1913.

Oral History interviews

SA, Tape 85A BBC recording of Mrs Katherine Laurenson of Lerwick, 1955.
SA, Tape 04C BBC Radio Scotland, 'Hogmanay Handsel', *c.*1974.
Untaped interview with Stanley Manson, Secretary of Up-helly-aa Committee, 13 September 1997, by Callum Brown.
SOHCA/10/01, interview with Terry Johnson and Ann Johnson (pseuds.), 1997.
SOHCA/10/02, interview with Michael Peacock and Susan Peacock (pseuds.), 1997.
SOHCA/10/03, interview with Peter Black (pseud.), 1997.
SOHCA/10/04, interview with Margaret Rorie, Headteacher at Bell's Brae Primary School Lerwick, 1997.
SOHCA/10/05, interview with Ian Tait, Curator, Shetland Museum, 1997.
SOHCA/10/06, interview with Barbara Anderson and Jane Manson, 1997.

Original sources

Banks, M. M., *British Calendar Customs: Scotland, Volume II*, London and Glasgow, Folk-Lore Society, 1939
Banks, M. M., *British Calendar Customs: Orkney and Shetland*, London and Glasgow, Folk-Lore Society, 1946
Bowes, H. R. (ed.), *Samuel Dunn's Shetland and Orkney Journal 1822–25*, n.pl., n.pub., 1976
Donaldson, G. (ed.), *Court Book of Shetland 1615–1629*, Lerwick, Shetland Library, 1991
Edmonston, B. and Saxby, J. M. E., *The Home of a Naturalist*, London, James Nisbet, 1888
Goudie, G., *The Celtic and Sandinavian Antiquities of Shetland*, Edinburgh and London, Blackwood, 1904
Gregor, W., *Notes on the Folk-Lore of the North-east of Scotland*, London, Folk-Lore Society, 1881
Guthrie, E. J., *Old Scottish Customs: Local and General*, London, Morrison, 1885
Hibbert, S., *A Description of the Shetland Islands*, Edinburgh, Constable, 1822
Irvine, J. W., *The Years Between*, Lerwick, A. Irvine Printing, 1993
Jakobsen, J., *An Etymological Dictionary of the Norn Language in Shetland, Part II*, first published 1932; reprint Lerwick, Shetland Folk Society, 1985
Jamieson, P. A., *The Viking Isles: Pen Pictures from Shetland*, London, Heath Ganton, 1933

Knight, L. A., *The Viking Feast Mystery*, London, Sampson Low, n.d.

Kyd, J. G. (ed.), *Scottish Population Statistics*, Edinburgh, Scottish Academic Press, first published 1952; 1975

Laurenson, A., 'On certain beliefs and phrases of Shetland fishermen', *Proceedings of the Society of Antiquaries of Scotland*, vol. 10 (1872–4)

Low, G., *A Tour Through the Islands of Orkney and Shetland*, first published 1774; Kirkwall, 1879

Lyon, G. F., *The Private Journal of*, 1824

Mackenzie, D. A., *Scottish Folk-Lore and Folk Life: Studies in Race, Culture and Tradition*, London and Glasgow, Blackie, 1935

McNeill, F. M., *The Silver Bough: Volume One, Scottish Folk-lore and Folk-belief*, first published 1956; reprint Edinburgh, Canongate, 1989

McNeill, F. M., *The Silver Bough: Volume Three, A Calendar of Scottish National Festivals*, Glasgow, William MacLellan, 1961

McNeill, F. M., *The Silver Bough: Volume Four, The Local Festivals of Scotland*, Glasgow, William MacLellan, 1968

McPherson, J. M., *Primitive Beliefs in the North-east of Scotland*, London, Longmans, 1929

Maitland Club, *Miscellany, Volume 4*, Edinburgh, 1840

Manson, T., *Lerwick During the Last Half Century (1867–1917)*, first published 1923; Lerwick, Lerwick Community Council reprint, 1991

Manson's Shetland Almanac and Directory, 1897

The New Statistical Account of Scotland, vol. xv, Edinburgh and London, Blackwood, 1845

Rampini, C., *Shetland and the Shetlanders*, Kirkwall, Wm. Peace, 1884

Sandison, R., *Christopher Sandison of Eshaness (1781–1870): Diarist in an Age of Social Change*, Lerwick, Shetland Times, 1997

Saxby, J. M. E., 'Foys and fanteens (Shetland feasts and fasts)', *Old-Lore Miscellany of Orkney, Shetland, Caithness and Sutherland*, vol. 8 (1915)

Saxby, J. M. E., *Shetland Traditional Lore*, Edinburgh, Grant and Murray, 1932

Scottish Office, *Scotland's Parliament* (White Paper), Cmd. 3658, July 1997

Sinclair, J. (ed.), *The Statistical Account of Scotland 1791–1799: Shetland*, 1978 edn, EP Publishing

Spence, C. (ed.), *Arthur Laurenson: His Letters and Literary Remains: A Selection*, London, Fisher and Unwin, 1901

Spence, J., *Shetland Folk-Lore*, Lerwick, Johnson and Grieg, 1899

Up-Helly-Aa Festival Programmes, 1905–97

Up-Helly-Aa: The Songs, the History and the Galley Shed (notator, B. Smith), Lerwick, Up-helly-aa Committee, n.d.

Watson, G., *Bell's Dictionary and Digest of the Laws of Scotland, Seventh Edition*, Edinburgh, Bell and Bradfute, 1890

Willock, J., *A Shetland Minister of the Eighteenth Century*, Lerwick, Manson, c.1897

Withrington, D. J. and Grant, I. R. (eds), *The Statistical Account of Scotland, vol. xix, Orkney and Shetland*, Wakefield, EP Publishing, 1978

Videos

Amateur video of Bressay Up-helly-aa, *c.*1990
Up-Helly-Aa 1994, Lerwick, Norfilm, 1994
Up-Helly-Aa 1997, Lerwick, Norfilm, 1997

Newspapers and magazines

John O'Groat Journal, 1836–82
Nortaboot, 1984, 1994–97
Shetland Advertiser, 1862
Shetland Journal, 1837
Shetland News, 1887–1913, 1949
Shetland Times, 1875–1997

Secondary sources

Anderson, B., *Imagined Communities: Reflections on the Origin and Spread of Nationalism*, London, Verso, 1991 edn

Bailey, P., *Leisure and Class in Victorian England: Rational Recreation and the Contest for Control 1830–1885*, London, 1978

Bardgett, F. D., *Scotland Reformed: The Reformation in Angus and the Mearns*, Edinburgh, John Donald, 1989

Bottigheimer, R. B., 'Fairy tales, folk narrative research and history', *Social History* vol. 14 (1989)

Brown, C. G., 'Urbanisation and living conditions', in R. Pope (ed.), *Atlas of British Social and Economic History since c.1700*, London, Routledge, 1989

Brown, C. G., 'Popular culture and the continuing struggle for rational recreation', in T. M. Devine and R. J. Finlay (eds), *Scotland in the Twentieth Century*, Edinburgh, Edinburgh University Press, 1996

Brown, C. G., 'The Scottish Office and sport 1899–1972', *Scottish Centre Research Papers in Sport, Leisure and Society* vol. 2 (1997)

Brown, C. G., *Religion and Society in Scotland since 1707*, Edinburgh, Edinburgh University Press, 1997

Brown, C. G., 'Essor religieux et sécularisation', in H. McLeod, S. Mews and C. D'Haussy (eds), *Histoire religieuse de la Grande-Bretagne*, Paris, Editions du Cerf, 1997, pp. 315–37

Brown, C. G., 'The secularisation decade: the haemorrhage of the British churches in the 1960s', in H. McLeod and W. Ustorf (eds), *The Decline of Christendom in Western Europe c.1750–2000*, New York, Orbis, forthcoming

Burke, P., *Popular Culture in Early Modern Europe*, London, Temple Smith, 1978

Burke, P., 'Popular culture between history and ethnology', *Ethnologia Europea* vol. 14 (1984)

Bushaway, B., *By Rite: Custom, Ceremony and Community in England 1700–1880*, London, Junction, 1982

Butterworth, S. and Butterworth, G., *Chips off the Auld Rock: Shetlanders in New Zealand*, Wellington, Shetland Society, 1997

Cannadine, D., 'The transformation of civic ritual in modern Britain: the Colchester Oyster Festival', *Past and Present* 94 (1982)

Cluness, A. T. (ed.), *The Shetland Book*, Lerwick, Zetland Education Committee, 1967

Cohen, A. P., 'The Whalsay croft: traditional work and customary identity in modern times', in S. Wallman (ed.), *The Social Anthroplogy of Work*, London, Academic Press, 1979

Cohen, A. P., *The Symbolic Construction of Community*, Chichester, Ellis Horwood, 1985

Cohen, A. P., 'Symbolism and social change: matters of life and death in Whalsay, Shetland', *Man* vol. 20 (1985)

Cohen, A. P., *Whalsay: Symbol, Segment and Boundary in a Shetland Island Community*, Manchester, Manchester University Press, 1987

Colley, L., *Britons: Forging the Nation 1707–1837*, London, Vintage, 1996

Colls, R., *The Pitmen of the Northern Coalfield: Work, Culture and Protest 1790–1850*, Manchester, Manchester University Press, 1987

Cunningham, H., *Leisure in the Industrial Revolution c.1780–c.1880*, London, Croom Helm, 1980

Davis, N. Z., 'The reasons of misrule: youth groups and charivaris in sixteenth-century France', *Past and Present* 50 (1971)

Davis, S. G., *Parades and Power: Street Theatre in Nineteenth-century Philadelphia*, Berkeley, University of California Press, 1986

Devine T. M., (ed.), *Farm Servants and Labour in Lowland Scotland, 1770–1914*, Edinburgh, John Donald, 1984

Donaldson, G., 'Some Shetland parishes at the Reformation', in B. E. Crawford (ed.), *Essays in Shetland History*, Lerwick, Shetland Times, 1984

Dowle, M., 'The birth and development of the Shetland Movement 1977–1980', in H. M. Drucker and N. L. Drucker (eds), *Scottish Government Yearbook 1981*, Edinburgh, Paul Harris, 1980

Finnie, M., *Shetland: An Illustrated Architectural Guide*, Edinburgh, Mainstream/RIAS, 1990

Flinn, D., *Travellers in a Bygone Shetland: An Anthology*, Edinburgh, Scottish Academic Press, 1989

Foster, W. R., *The Church Before the Covenants: The Church of Scotland 1596–1638*, Edinburgh, Scottish Academic Press, 1975

Geipel, J., *The Viking Legacy: The Scandinavian Influence on the English and Gaelic Languages*, Newton Abbot, David and Charles, 1971

Green, S. J. D., *Religion in the Age of Decline: Organisation and Experience in Industrial Yorkshire 1870–1920*, Cambridge, Cambridge University Press, 1996

Harvie, C. and Walker, G., 'Community and culture', in W. H. Fraser and R. J. Morris (eds), *People and Society in Scotland, Volume 2, 1830–1914*, Edinburgh, John Donald, 1990

Hechter, M., *Internal Colonialism: The Celtic Fringe in British National Development 1536–1966*, London and Henley, Routledge and Kegan Paul, 1975

Howkins, A. and Merricks, L., ' "Wee be black as Hell": ritual, disguise and rebellion', *Rural History* vol. 4 (1993)

Hutton, R., *The Rise and Fall of Merry England: The Ritual Year 1400–1700*, Oxford, Oxford University Press, 1994

Hutton, R., 'The English Reformation and the evidence of folklore', *Past and Present* 148 (1995), pp. 89–116

Hutton, R., *The Stations of the Sun: A History of the Ritual Year in Britain*, Oxford, Oxford University Press, 1997

Irvine, J. W., *Up-Helly-Aa: A Century of Festival*, Lerwick, Shetland Publishing, 1982

Irvine, J. W., *Lerwick: The Birth and Growth of an Island Town*, Lerwick, Lerwick Community Council, 1985

Jackson, G., *The British Whaling Trade*, London, A. and C. Black, 1978

Jamieson, A. G. (ed.), *A People of the Sea: The Maritime History of the Channel Islands*, New York and London, Methuen, 1986

Jarvie G. and Walker G. (eds), *Scottish Sport in the Making of the Nation: Ninety-Minute Patriots?*, Leicester, Leicester University Press, 1994

Johnson, L. G., 'Laurence Williamson', *Scottish Studies* vol. 6 (1962)

Johnson, L. G., *Laurence Williamson of Mid Yell*, Lerwick, Shetland Times, 1971

Joyce, P., *Visions of the People: Industrial England and the Question of Class 1848–1914*, London, Cambridge University Press, 1991

King, E., *Scotland Sober and Free*, Glasgow, Glasgow Museums, 1979

Ladurie, E. le R., *Carnival at Romans: A People's Uprising at Romans 1579–1580*, first published 1980; Harmondsworth, Penguin edn, 1981

Littlejohn, J., *Westrigg: The Sociology of a Cheviot Parish*, London, Routledge and Kegan Paul, 1963

Macinnes, J., *The Evangelical Movement in the Highlands of Scotland 1688 to 1800*, Aberdeen, 1951

McIvor, A. J., 'Women and work in twentieth-century Scotland', in A. Dickson and J. H. Treble (eds), *People and Society in Scotland vol. III, 1914–1990*, Edinburgh, John Donald, 1992

MacLaren, A. A., *Religion and Social Class: The Disruption Years in Aberdeen*, London, Routledge and Kegan Paul, 1974

Malcolmson, R. W., *Popular Recreations in English Society 1700–1850*, London, 1973

Manson, T., *Lerwick During the Last Half Century*, first published 1923; reprint Lerwick, Lerwick Community Council, 1991

Martin, A., *Kintyre Country Life*, Edinburgh, John Donald, 1987

Mitchell, C. E., *Up-Helly-Aa, Tar-barrels and Guizing: Looking Back*, Lerwick, T. and J. Manson, 1948

Mitchison R. and Leahman, L., *Sexuality and Social Control: Scotland 1660–1780*, Oxford, Basil Blackwell, 1989

Neville, G. K., *The Mother Town: Civic Ritual, Symbol and Experience in the Borders of Scotland*, New York and Oxford, Oxford University Press, 1994

Newall, V., 'The Allendale Fire Festival in relation to its contemporary setting', *Folklore* vol. 85 (1974)

Newall, V., 'Up-Helly Aa: a Shetland winter festival', *Arv* vol. 34 (1978)

Newman, S. P., *Parades and the Politics of the Street*, Philadelphia, University of Pennsylvania Press, 1997

Nicolson, J. R., *Traditional Life in Shetland*, London, Robert Hale, 1978

Nicolson, J. R., *Shetland Folklore*, London, Robert Hale, 1981

Owen, T. H., 'The Communion season and presbyterianism in a Hebridean community', *Gwerin* vol. 1 (1956)

Poole, R., '"Give us our eleven days!": calendar reform in eighteenth-century England', *Past and Present* 149 (1995)

Poole, R., 'Signs and seasons: British calendar customs in perspective', *Social History Society Bulletin* vol. 22 (1997)

Prebble, J., *The King's Jaunt: George IV in Edinburgh*, London, 1988

Reid, D., 'The decline of Saint Monday, 1766–1876', *Past and Present* 71 (1976)

Richards, E., *A History of the Highland Clearances: Volume 2: Emigration, Protest, Reasons*, London, Croom Helm, 1985

Robertson, J., *Uppies and Doonies: The Story of the Kirkwall Ba' Game*, Aberdeen, Aberdeen University Press, 1967

Roper, H. T., 'The invention of tradition: the Highland tradition of Scotland' in E. Hobsbawm and T. Ranger (eds), *The Invention of Tradition*, London, Cambridge University Press, 1983

Rudolph, W., *Harbor and Town: A Maritime and Cultural History*, Leipzig, Edition Leipzig, 1980

Ryan, S., *The Ice Hunters: A History of Newfoundland Sealing to 1914*, St. John's, NF, Breakwater, 1994

Samuel, R., *Theatres of Memory: Volume 1: Past and Present in Contemporary Culture*, London and New York, Verso, 1994

Scribner, B., 'Reformation, carnival and the world turned upside-down', *Social History* vol. 3 (1978)

Shetland in Statistics 1971, 1993, 1995, 1996, Shetland Islands Council, Lerwick

Sider, G. M., 'Christmas mumming and the New Year in Outport Newfoundland', *Past and Present* 71 (1976)

Smith, B., '"Lairds" and "improvement" in Shetland in the seventeenth and eighteenth centuries', in T. M. Devine (ed.), *Lairds and Improvement in the Scotland of the Enlightenment*, n.pl., n.pub., 1978

Smith, B., 'James Robertson 1873–1911', parts I and II in *New Shetlander* 149 and 150 (1984)

Smith, B., 'The tarry kirk, the bogus runes and a priestly poker', *Shetland Times* 24 December 1987

Smith, B., 'Shetland, Scandinavia, Scotland, 1300–1700: the changing nature of contact', in G. Simpson (ed.), *Scotland and Scandinavia 800–1800*, Edinburgh, John Donald, 1990

Smith, B., 'Up-Helly-A' – separating the facts from the fiction', *Shetland Times* 22 January 1993

Smith, B., 'The development of the spoken and written Shetland dialect: a historian's view', in D. J. Waugh (ed.), *Shetland's Northern Links: Language and History*, Edinburgh, Scottish Society for Northern Studies, 1996

Smith, H. D., 'The Scandinavian influence in the making of modern Shetland', in J. R. Baldwin (ed.), *Scandinavian Shetland: An Ongoing Tradition?*, Edinburgh, Scottish Society for Northern Studies, 1978

Smith, H. D., *Shetland Life and Trade 1550–1914*, Edinburgh, John Donald, 1984

Smout, T. C., 'Patterns of culture', in T. Dickson and J. H. Treble (eds), *People and Society in Scotland, vol. 4 1914–1990*, Edinburgh, John Donald, 1992

Steele, B., 'Housing in Shetland 1919–1939 part 2', *New Shetlander* 162 (1987)

Stephenson, J. B., *Ford: A Village in the West Highlands of Scotland*, Edinburgh, Paul Harris, 1984

Storch, R., 'The policeman as domestic missionary: urban discipline and popular culture in Northern England 1850–1880', *Journal of Social History* vol. 9 (1976)

Thompson, E. P., *Customs in Common*, London, Merlin, 1991

Thompson, F. M. L., 'Social control in modern Britain', in A. Digby and C. Feinstein (eds), *New Directions in Economic and Social History*, Basingstoke, Macmillan, 1989

Thompson, P. et al., *Living the Fishing*, London, Croom Helm, 1983

Urquhart, R. M., *The Burghs of Scotland and the Burgh Police (Scotland) Act 1833*, Motherwell, Scottish Library Association, 1989

Urquhart, R. M., *The Burghs of Scotland and the General Police and Improvement (Scotland) Act 1862, Parts I and II*, Motherwell, Scottish Library Association, 1991

Walvin, J., *Leisure and Society 1830–1950*, London, Longman, 1978

Waugh, D. J. (ed.), *Shetland's Northern Links: Language and History*, Edinburgh, Scottish Society for Northern Studies, 1996

Whatley, C., 'Royal day, people's day: the monarch's birthday in Scotland *c.*1660–1860', in R. Mason and N. Macdougal (eds), *People and Power in Scotland*, Edinburgh, John Donald, 1992

Withrington, D. J. (ed.), *Shetland and the Outside World 1469–1969*, London, Oxford University Press, 1983

Worsley, P., *Knowledges: What Different Peoples Make of the World*, London, Profile Books, 1997

Theses, lectures and papers

Bowes, H. R., 'Revival and survival: Methodism's ebb and flow in Shetland and Orkney, 1822–1863', unpublished M.Th. thesis, University of Aberdeen, 1988

Brown, C. G., 'Religion and the development of an urban society: Glasgow 1780–1914', unpublished Ph.D. thesis, University of Glasgow 1982

Church, J. T., 'Political discourse of Shetland: confabulations and communities', unpublished Ph.D. thesis, Temple University, 1989

Cohen, B. J., 'Norse imagery in Shetland: an historical study of intellectuals and their use of the past in the construction of Shetland's identity, with particular reference to the period 1800–1914', unpublished Ph.D. thesis, University of Manchester, 1983

Renwanz, M. E., 'From crofters to Shetlanders: the social history of a Shetland Island community's self image, 1872–1978', unpublished Ph.D. thesis, Stanford University, 1980

Smith, B., 'The history of socialism in Shetland to 1945', unpublished lecture

Smith, B., 'Temperance, Up helly aa, socialism and ice cream in Lerwick 1890–1914', unpublished lecture to Shetland Civic Society 1984

Smith, B., 'The churches in Shetland 1800–1987', unpublished lecture to Lerwick Churches Council, 1990

Smith, B., 'Lerwick's ice-cream war', unpublished lecture to Lerwick Rotary Club, 1990

Steele, W. R., 'Local authority involvement in housing and health in Shetland *c.*1900–1950', unpublished M.Phil. thesis, University of Strathclyde, 1992

Vallee, F., 'Social structure and organisation in a Hebridean community [Barra]', unpublished Ph.D. thesis, University of London (LSE), 1954

Index

Notes: 'n.' after a page reference indicates the number of a note on that page; page numbers in *italic* refer to illustrations.

Finns *see* fairies
fire
 celebration with 5–6, 9
 festivals 14–15
 see also torches
firearms 29, 84, 87, 89–104, 108, 110,
 117–18, 125n.119, 125n.120
fishing industry 26–7, 41, 53–4, 63,
 85–6, 107, 117, 173
 see also herring boom
flags, casting 1, 54
flambeaux 40
Flodden, Battle of (1513) 54, 57
folklore 29, 120
folklorists 31–9, 49
 race issues 38
 problems using 44
football 16, 35, 51, 93
fornication 65–71, 104–6
Fort Charlotte 74, 88, 95, 99, 100
France 72
Freemasons 110–11, 146, 155
French Revolution and customs 77

galley 1, 4–9, *8*, 14, 16, 21, 37, 136, 143,
 148, 156, 178, 193
 images of 22
 see also black raven; red hand; Shed
Galley Song 7
gambling, opposition to 51
Garlieston 40
Garriock, Peter 95
gender divisions
 in schools 4–5
 in Up-helly-aa 17–18, 24, 26, 28,
 120, 181–8
 see also masculinity; suffragettes;
 women
general assembly, Church of Scotland
 68–9
George III, jubilee 79
George V, death of 163
Germans 64

gin *see* smuggling
girls, discourses on 183–4
 see also women
Glasgow 130
gleanings 49
Goloshan, drama of 41
Good Templars *see* Templars
Grant, William Alexander 102–3
Greenland 64, 99
Greenlanders *see* whalers
Gregorian calendar *see* calendar
 change
Grieg, William J. 146
Grierson, Betty 73–4
grulacks 35–6, 38, 41
Guizer Jarl 2, 4, 6–7, *8*, 9, 17, 18–19,
 26, 48, 143, 178, 193–4
 as Shetland symbol 179
 costs of being 20–1
 election of 19
 Junior 26
 see also Jarl's squad
guizers 41, 88–121, 136–7, 186–8
 Hop 14
 mass meeting 19
guizing 5–6, 11, 18, 22, 28, 47–8, 77–8,
 99–104, 114–15, 126–7
 children 4, 89, 111
 choosing theme 19–20
 costs of 20
 Highlands 41
 making costumes 156–7
 materials for 20
 military uniforms 23–4, 91–2
 nuns 11, *185*
 race themes 5, *180*
gunpowder 87–8
guns *see* firearms
Guy Fawkes 15, 179

halls 9–13, 24, 48, 155–6, 170–1, 174–5,
 184
 see also skits

Index

Hamburg 85
hamefarin 179, 194
Hanse towns 64
Harvie, Christopher 42
Hawick Common Riding, admission
 of women 187
health 159–60
heritage industry 46–7
herring boom 129, 134, 155, 159–60
 see also fishing industry
Hibbert, Samuel 77–8
Highlandism 50
Highlands 66
Hillswick 104
 Up-helly-aa 178
historians
 community links to 45
 criticism of folklorists 36–9
 denigration of guizing 16
 local 31
 Marxist 49
 professional viii, 29, 39–47, 192
 social 31, 48–51
history
 core curriculum in schools 46–7
 fashionableness of 46
 symbols and 53–8
 see also living history
Hogmanay 78–9
 see also New Year
holidays 198
 bank 50–1
 Lerwick 14
 public 1, 50–1, 139, 152n.29, 156
Holland 85
 see also Dutch
Holloways' Ointment 133, 152n.21
Hong Kong, satire on 40
hospital, egg scandal at 163–4, 165
hostesses 11, 23–4, 120, 137–8, 182
 see also gender divisions; women
houses, opening of 137–8
housing conditions 144–5, 160
Hutton, Ronald 39, 44, 48–9, 79–80

ice-cream parlours 166–8
identity, national 195
 see also nationalism
ideology 195
imperialism 22–3
 see also guizing; race
industrialisation 1, 15, 56, 117, 85–6
Internet viii, 14, 194
invention of tradition see tradition
inversion, social see misrule
Irvine, James W. 41–2, 165–6, 170,
 176–7

Jacobite rebellions 66
Jakobsen, Jakob 33
James II 72
Jarl's squad 2–6, 8, 10, 17, 18–20, 24,
 43, 156
 see also Guizer Jarl
John O'Groat Journal 100, 104, 108, 133
jokes see pranks
Jorvik Centre 18, 47
Julian calendar see calendar change
Junior Up-helly-aa 5, 12, 24, 26

King's Birthday riots 113
kirk sessions 65–71, 74–7, 104–6
Kirkwall 76, 79, 93
knitters, home 68, 182–3
knotty see shinty
krate 90–104, 108
 absence of Norse theme 92
 decline of 126–39
 see also tar-barrels

labour movement 144–7
language, historians' use of 196–7
Laurence, James 133, 139, 141
Laurenson, Arthur 31–2, 111, 127, 135,
 139–41
leisure 51
Lerwick
 absence of agriculture in 68–9,
 77–8

burgh of barony 86
Choral Union 111–12
Clothing Society 110
destruction ordered in (1625) 67–8
Dutch at 63–5
foreigners in 74–5
foundation of 63–5
gas lighting of 99
growth of 96–7
insanitation in 97
Ladies Dorcas Society 110
population of 64, 148, 172
sexual relationships in 63
suburbanisation of 12, 129–32
Sunday opening in 167
sunrise and sunset 1
town council 90, 95–104, 119,
 127–39, 144
town hall 4, 8, *10*, 11, 135, 153n.36,
 135, 156
urban improvement in 113–14, *161*
weather at *see* weather
Lewes, Sussex 40
line dancing 180–1
 see also dancing
Liverpool 118
living history 46–7
 see also history
local veto plebiscites *see* prohibition
 of alcohol
London 14
Low, Revd George 33–4, 75, 77–8

Måløy, Norway 4, *11*
machismo *see* masculinity
Marxists 150
 see also historians
masculinity 1, 17–18, 19–21, 23, 28–9,
 183
masquerade viii, 78
 see also guizers; guizing
McNeill, F. Marion 31, 34, 36–7,
 41–2
memory, theatres of 47

merchants, 73, 80, 85, 121
Methodism 104, 106, 111–12, 130
middle classes *see* Lerwick,
 suburbanisation of
migrants 41
 see also emigration
military 41, 80
 see also Customs and Excise;
 guizing; Royal Naval Reserve;
 Royal Navy Volunteers
Mill, Revd John 71, 73, 75
Minnigaff 40
misrule 192–3, 196
 absence of 81
 concept of 112–21
 decline of 128–39
 end of 149–50
 see also rough culture
Misrule, Lord of 48, 193
missions, religious 173
Mitchell, C. E. 41–2
mock mayor celebrations 113
Moody, Dwight 130
Morayshire 33, 39, 40–1
Morrison, Revd John 72
Mossbank Up-helly-aa 178
Muke Maisters *see* fairies
mumming *see* Goloshan; skits

National Health Service 163, 171
national identities 75
nationalism 58
 Scottish 57, *176, 177,* 195
 see also referendum
National Trust 46
Nazis 4, 11, 160
Neville, Gwen Kennedy 54–8
New Year 49, 84–121
 Day x, 16, 33, 35, 39, 43–4
New Zealand *see* Wellington
Newall, Venetia 39, 43–4
Newfoundland 47
Newton Stewart 40
Norn 26, 75–6, 78

Norse
 archaeology of 18
 heroes, depiction of 11, 17–19
 people 1
 place names 26, 139
 romanticism 57–8
 theme in Up-helly-aa 139–51
Norseman's Home 7
Northerners 93
Northmavine Up-helly-aa 178
Norway 4, 14, 63, 85, 141, 160
Norwegian wartime resistance 4, 11
nuns *see* guizing

Oak Apple Day 49
Odd Fellows 109
oil
 community chest 27
 construction workers 27–8
 industry 26–8, 53, 171–5
 oil-rig repair yard 11
 see also rough culture
opening of houses 156
Orkney 16, 18, 33, 66, 70, 76, 79
Oslo 14
 see also Norway

P&O Shipping Company 85
paganism 40, 49
parish schools 76
parish state 66–71
pay rates 173–4
Philadelphia 76
photography 9, 22
 calendar customs and 16
 Shetland community and 23
Picts *see* fairies
poisoning 29, 99
police 91, 94, 96–104, 116–17, 119,
 127–39
 locked in town house 98
 special constables' recruitment
 101–2
 suppression of customs 51

Poole, Robert x, 34, 39
pop music 11
postmodernism and customs 52
poststructuralism *see* postmodernism
 52
pranks 11, 99–104
 see also poisoning
pre-industrial society 1, 15
presbyterian 78
 dissenters 107
 suppression of customs 78–9
 see also kirk sessions; *under
 individual denominations*
presents, giving of 8–9, 20–1
procurators fiscal *see* police
prohibition of alcohol 13, 51, 169–71,
 184
public holidays *see* holidays
public relations 22
Pultneytown 116
puritanism *see* evangelicalism

race 22–3, 38, 57, 140–1, *180*
radio 14
 see also BBC
Ranselmen 66
rational recreation 50–1, 110, 132,
 197
 see also respectability
Ratter, Alex 145–7
Rechabites, Independent Order of
 146, 155, 167–70
red hand 6–7, 142
 see also galley
referendum
 on European Economic
 Community (1974) 27, 175
 on Scottish devolution (1979) 27–8,
 175–7
 on Scottish devolution (1997) 27,
 178
Reformation 48, 114
 Scottish 65–6